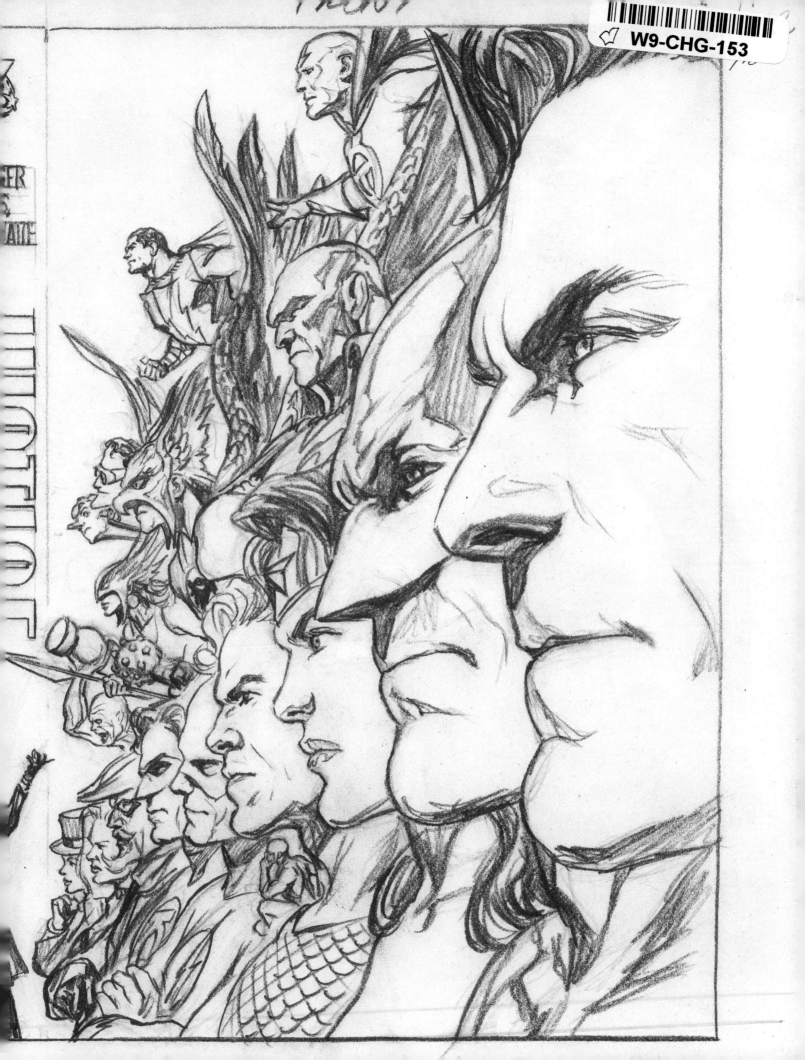

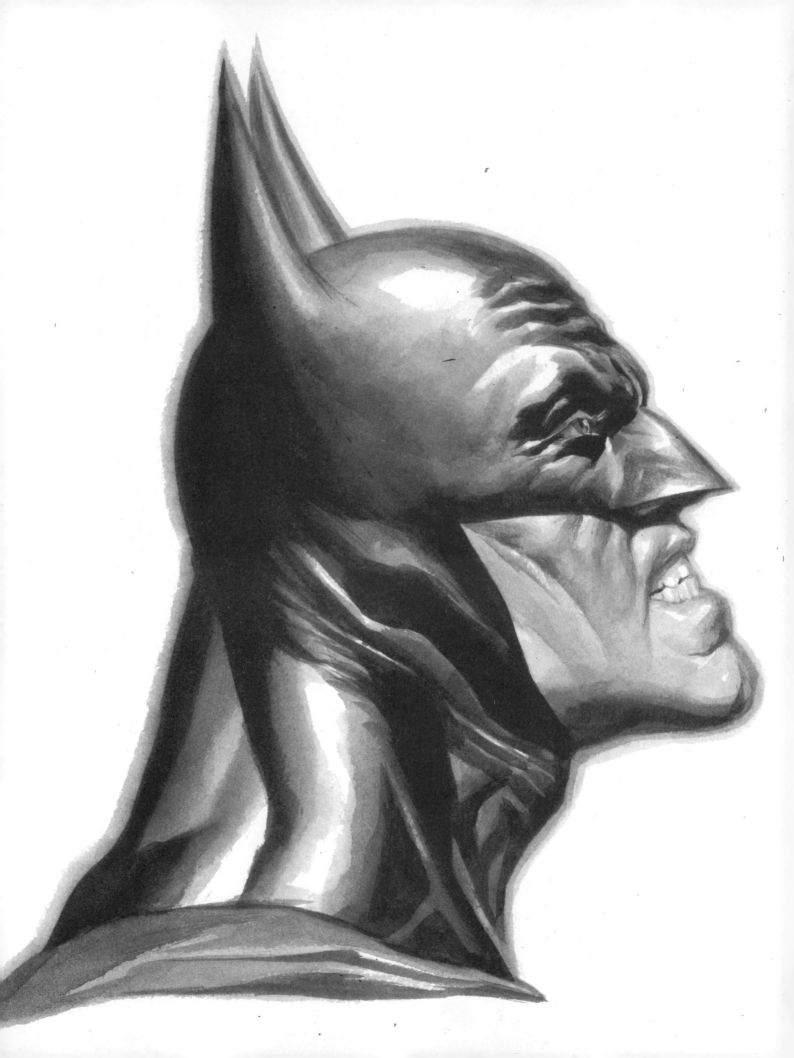

PAGE 1

ROUGH

THE DC COMICS SKETCHES OF

ALEX

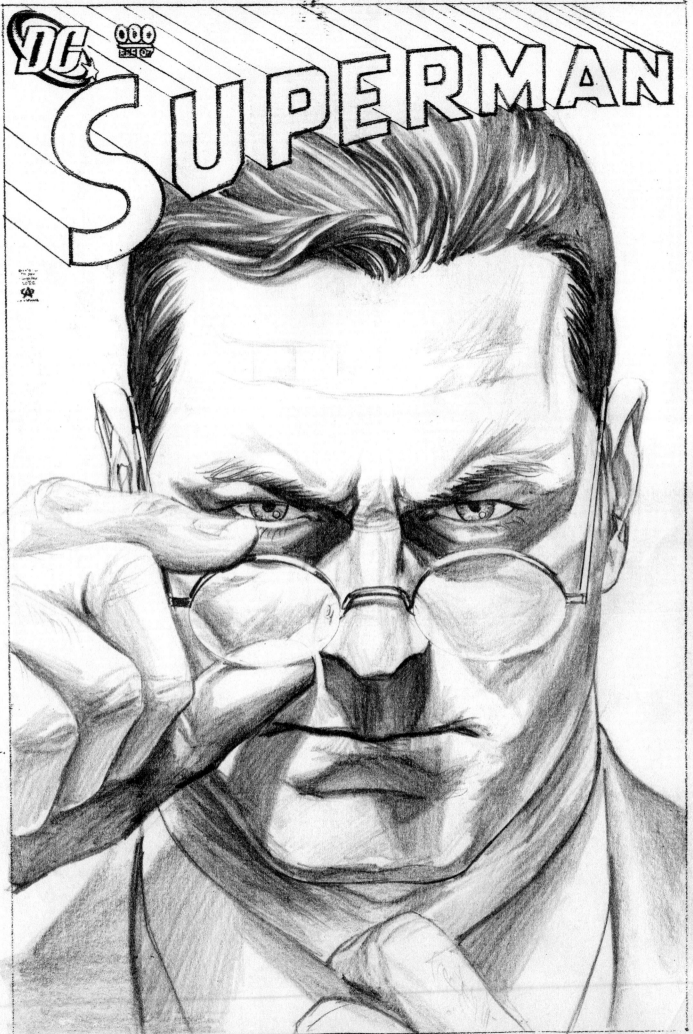

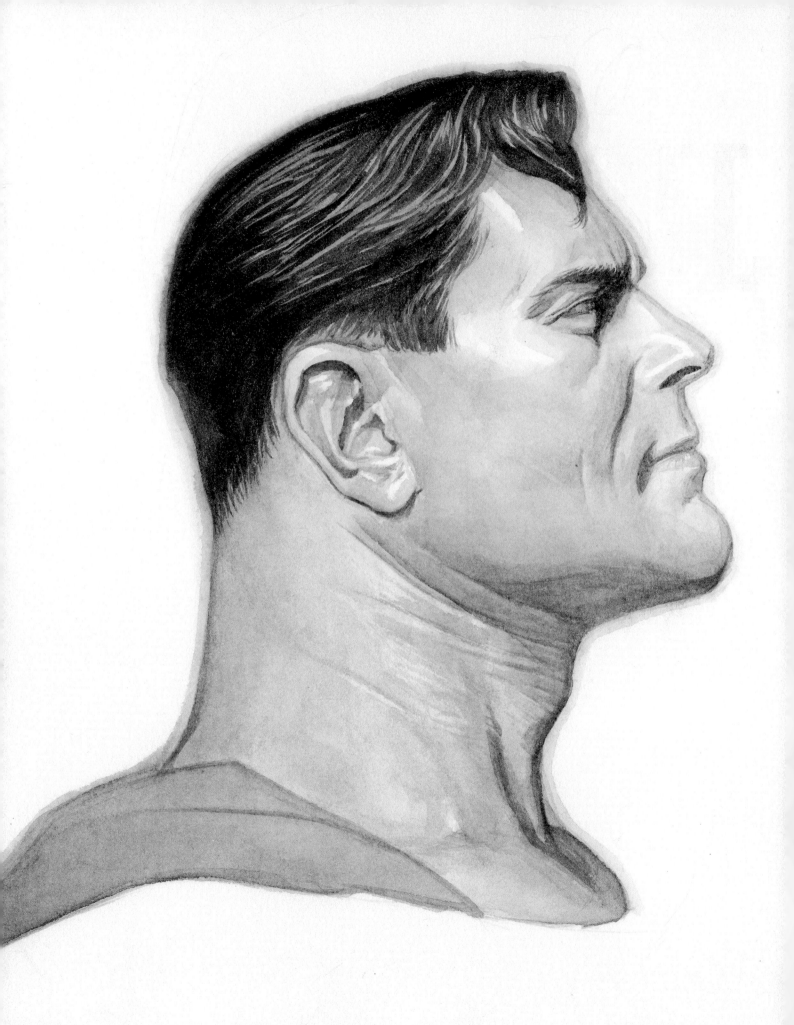

JUSTICE

ROSS

EDITED AND DESIGNED BY CHIP KIDD

Annotations by ALEX ROSS

Pantheon Books, New York 2010

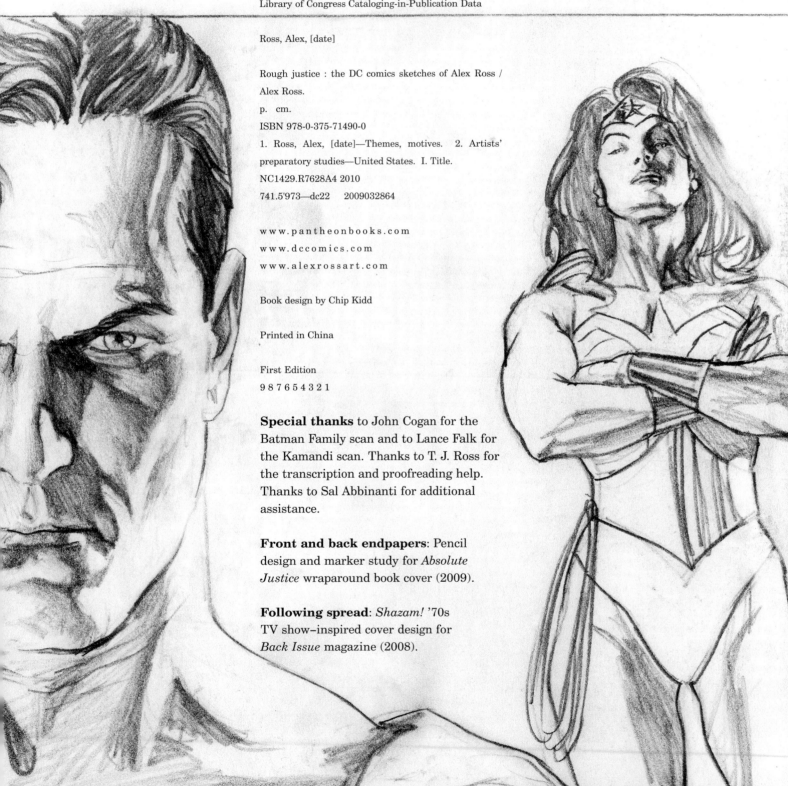

Library of Congress Cataloging-in-Publication Data

Ross, Alex, [date]

Rough justice : the DC comics sketches of Alex Ross / Alex Ross.
p. cm.
ISBN 978-0-375-71490-0
1. Ross, Alex, [date]—Themes, motives. 2. Artists' preparatory studies—United States. I. Title.
NC1429.R7628A4 2010
741.5'973—dc22 2009032864

www.pantheonbooks.com
www.dccomics.com
www.alexrossart.com

Book design by Chip Kidd

Printed in China

First Edition
9 8 7 6 5 4 3 2 1

Special thanks to John Cogan for the Batman Family scan and to Lance Falk for the Kamandi scan. Thanks to T. J. Ross for the transcription and proofreading help. Thanks to Sal Abbinanti for additional assistance.

Front and back endpapers: Pencil design and marker study for *Absolute Justice* wraparound book cover (2009).

Following spread: *Shazam!* '70s TV show–inspired cover design for *Back Issue* magazine (2008).

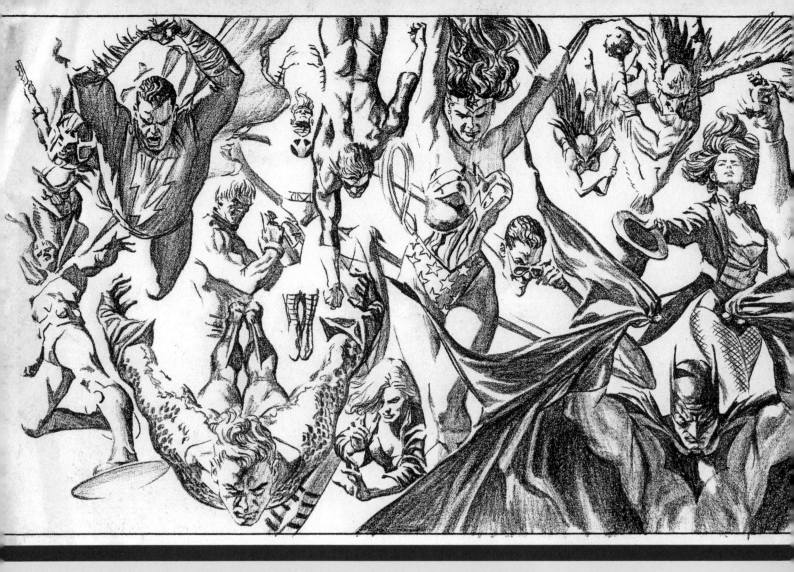

INTRODUCTION

All of Alex Ross's paintings start as pencil on paper. Thinking with lead. It's as simple—and as complicated—as that. Simple because there's no technology involved other than graphite scratched onto a surface to make marks; complicated because once he's started, all the intricate decisions demand immediate attention, as they do for all cartoonists: musculature, angle, scale, lighting, facial expressions, drapery, mood, choreography. And this is all before color is considered.

When you see Alex's finished painted work, it's tempting to take for granted that it arrives fully formed, like some kind of impossible cosmic photojournalism. He is that good, without question. But the cliché of the true genius making it look easy through sheer hard work and skill is borne out on these pages with a refreshing reveal, providing insight into how the directions are formed and the manner in which a successful composition is achieved.

Here on display is all the wonderful, messy stuff of the thought process working itself out on the page. The way figures interact with one another, the options on how to solve a storytelling problem, the myriad ways to depict the same scenario.

But it's not just about form. There are so many ideas. Included here for the first time are two of Alex's overall concept ideas for complete reimaginings of two of DC's preeminent characters, Captain Marvel and Batman (or rather, the son thereof). These, sadly, were not realized beyond the proposal stage, but here we can at least see how these iconic characters could have been reinvented for a new generation. All comments on the following pages come directly from Alex, telling the stories behind the drawings as only he can.

So here are the secret origins of the images that Alex's fans have come to love. Here are the iconic covers both familiar and unseen. Here is the heroic age, stripped of all its polychromatic armor, and all the more heroic for it.

Alex Ross and a pencil. Now THAT'S power.

—C. K., NYC, FALL 2009

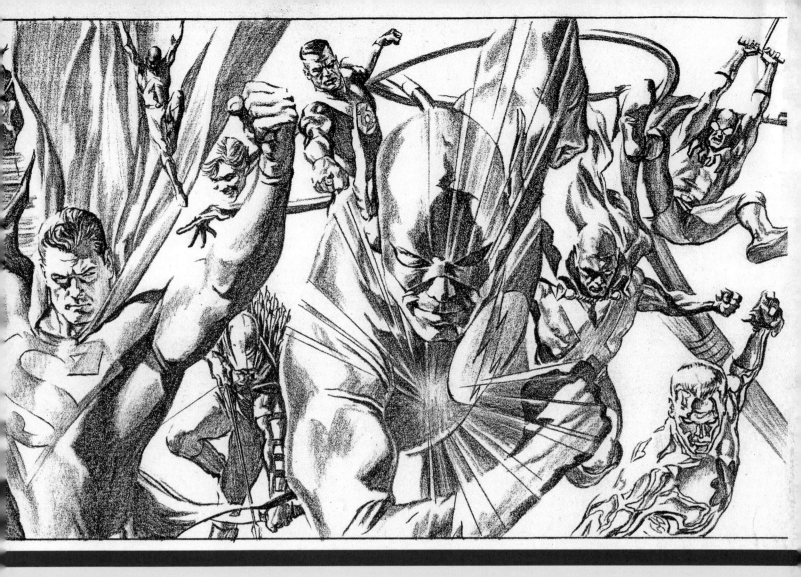

Above: Justice League of America packaging design for the *Vs.* trading-card game by Upper Deck (2005).

Following spread: An experiment to fully render the musculature implied by Golden Age artist Dick Sprang, with rather "comic" results.

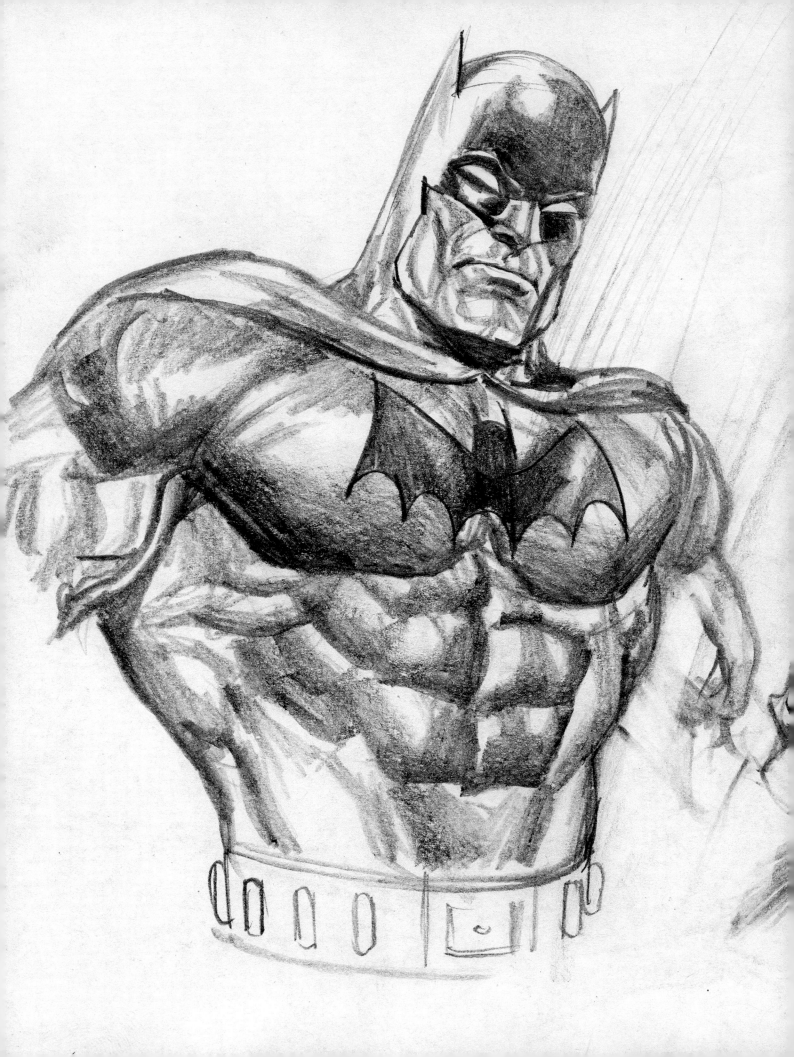

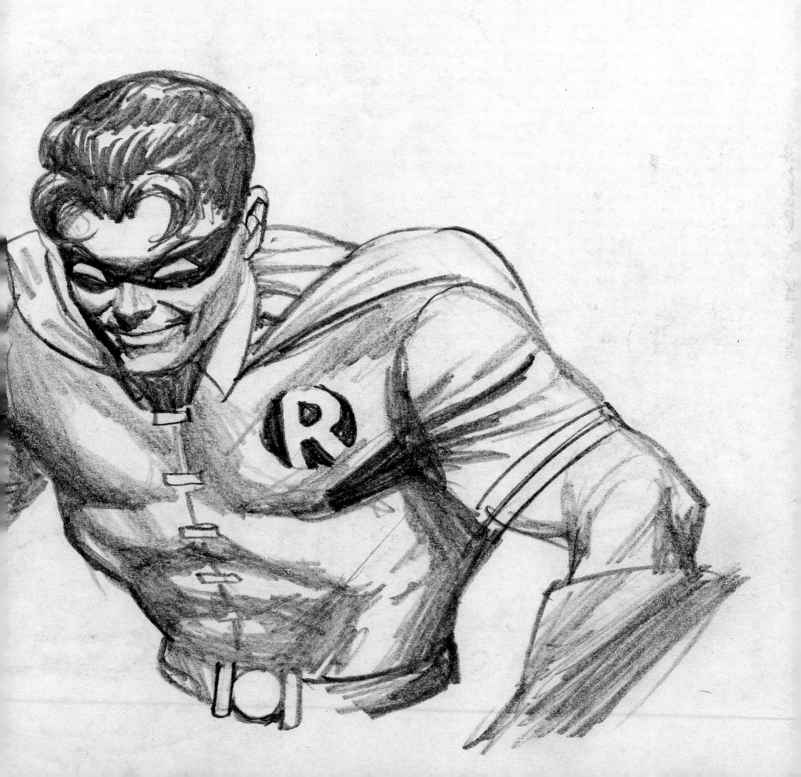

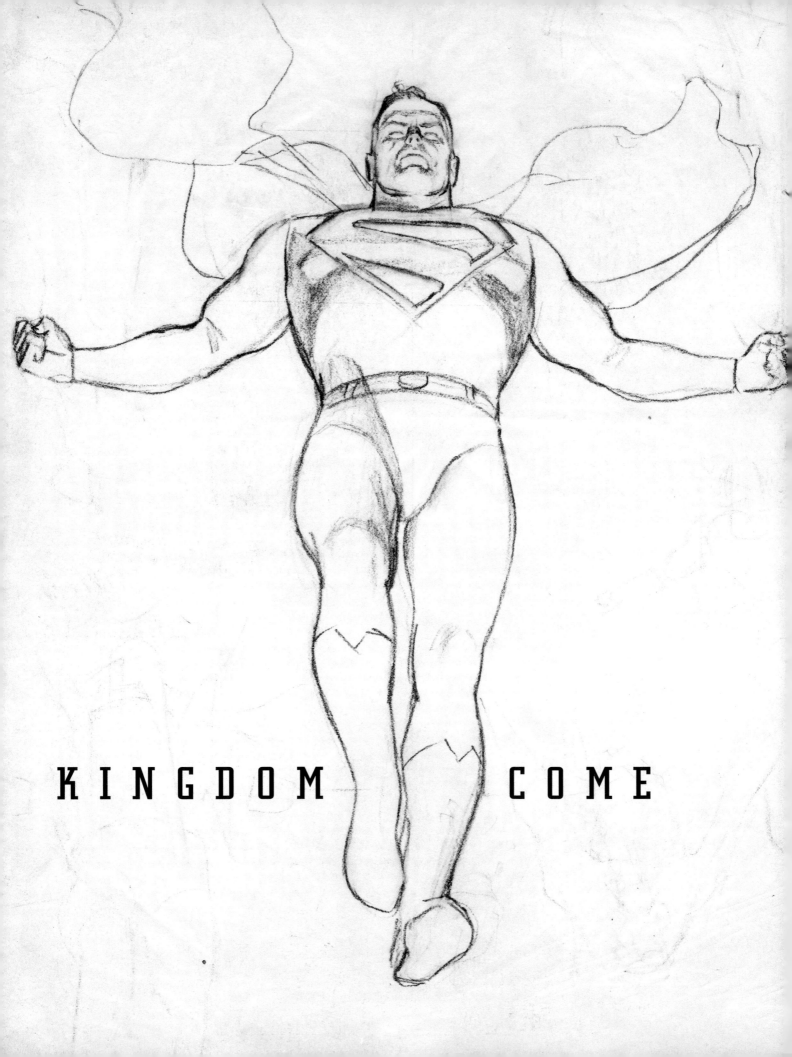

KINGDOM COME

A COUPLE SUGGESTIONS

? ?2

NORMAN

MOST LIKE MOREFUN
COVER AND LIKE PREVIOUS
GIANT SHOT IN #3

CONTRAST TO PREVIOUS
GIANT SHOT IN #3

KINGDOM
COME

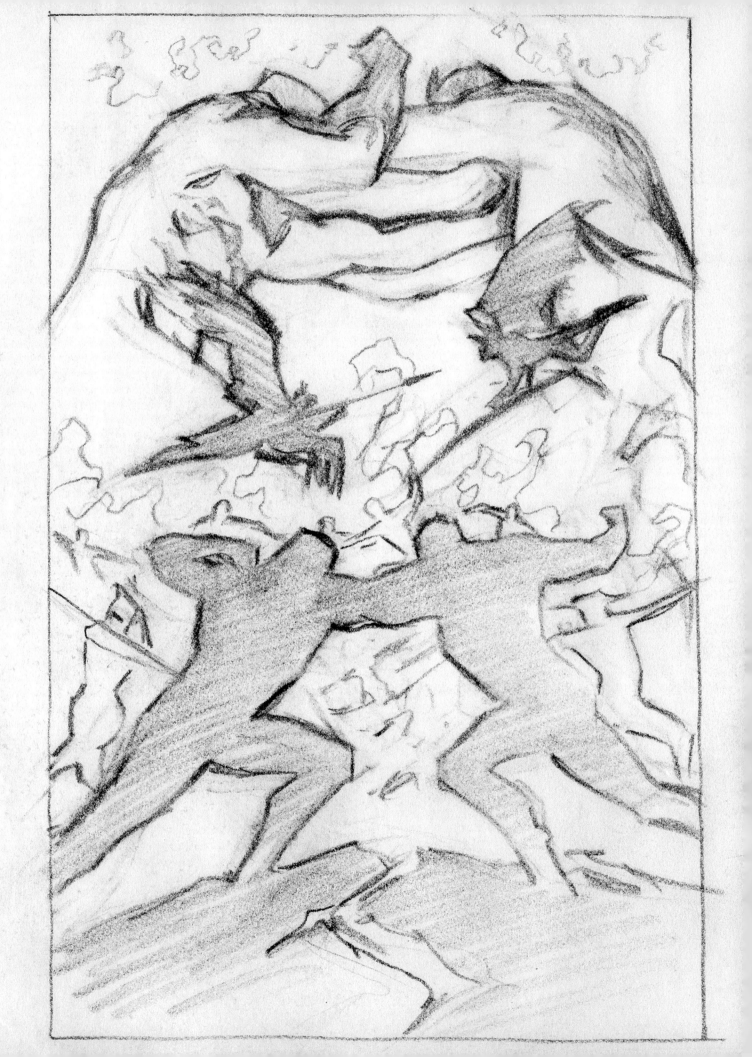

On these many pages are detailed "thumbnail" designs I did for *Kingdom Come*, following the script to lay out roughly, or in some cases very tightly, every page before drawing them at full size. The amount of detail desired for the series demanded this kind of planning, and it was also a clear guide of how to position models to pose for photo reference.

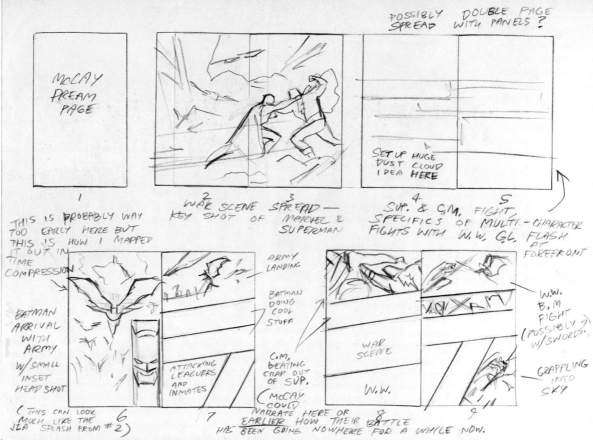

POSSIBLY DOUBLE PAGE SPREAD WITH PANELS?

McCAY DREAM PAGE

1

WAR SCENE SPREAD — KEY SHOT OF MARVEL & SUPERMAN

2 3

SET UP HUGE DUST CLOUD IDEA HERE

SUP. & C.M. FIGHT, SPECIFICS OF MULTI-CHARACTER FIGHTS WITH W.W. G.L. FLASH AT FOREFRONT

4 5

THIS IS PROBABLY WAY TOO EARLY HERE BUT THIS IS HOW I MAPPED IT OUT IN TIME COMPRESSION

BATMAN ARRIVAL WITH ARMY W/ SMALL INSET HEAD SHOT

ARMY LANDING

BATMAN DOING COOL STUFF

C.M. BEATING CRAP OUT OF SUP.

ATTACKING LEAGUERS AND INMATES

(THIS CAN LOOK MUCH LIKE THE JLA SPLASH FROM #2)

6 7

WAR SCENE

W.W.

W.W. B.M FIGHT (POSSIBLY?) W/ SWORDS.

GRAPPLING INTO SKY

8 9

(McCAY COULD NARRATE HERE OR EARLIER HOW THEIR BATTLE HAS BEEN GOING NOWHERE FOR A WHILE NOW.

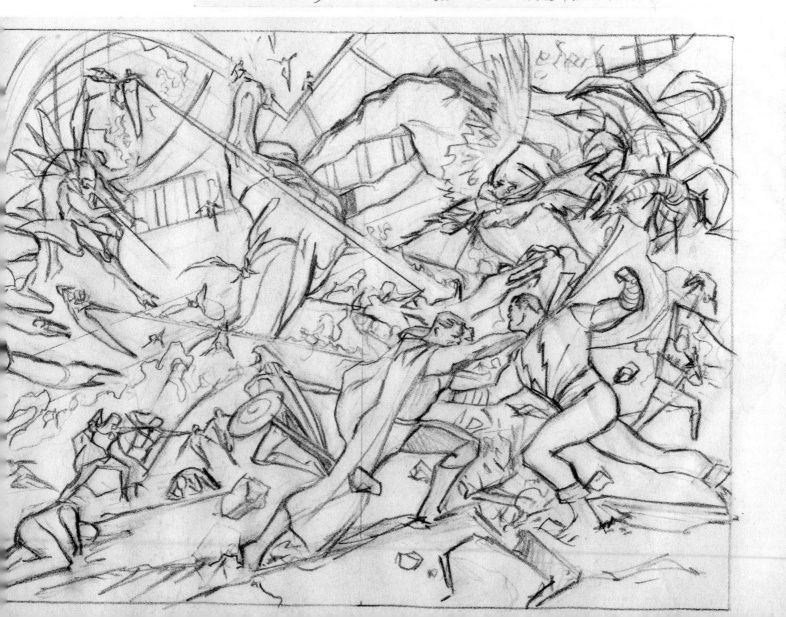

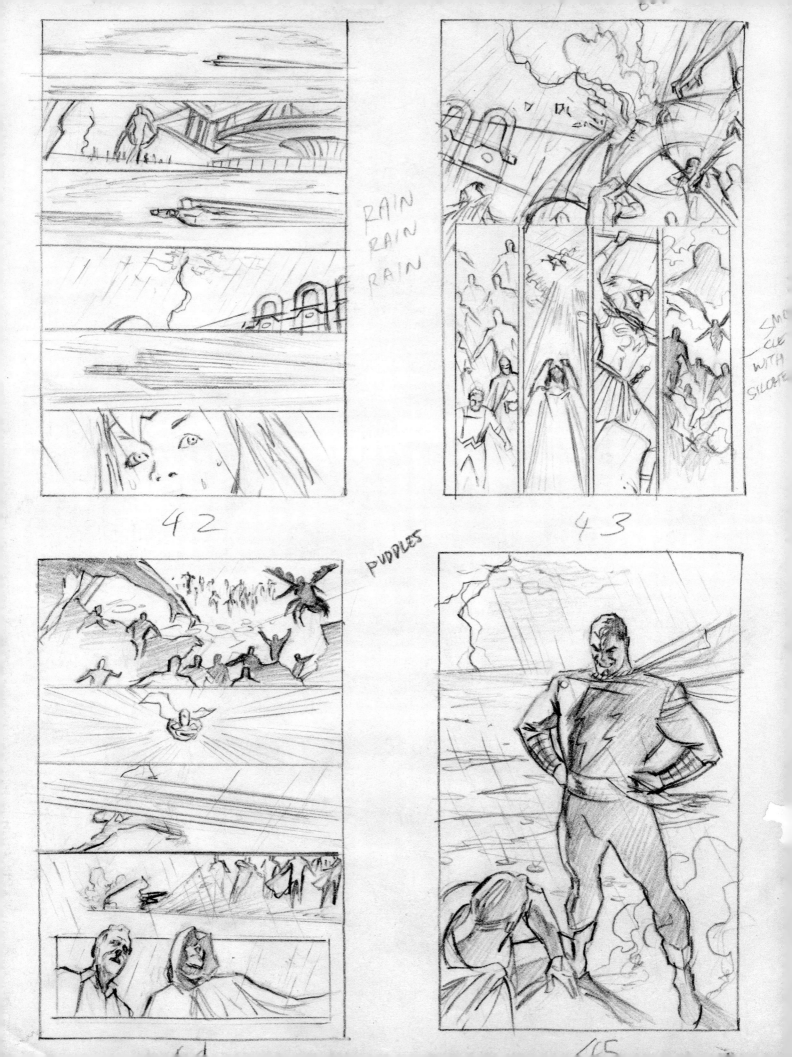

RAIN
RAIN
RAIN

SMO
CUE
WITH
SILONE

PUDDLES

42

43

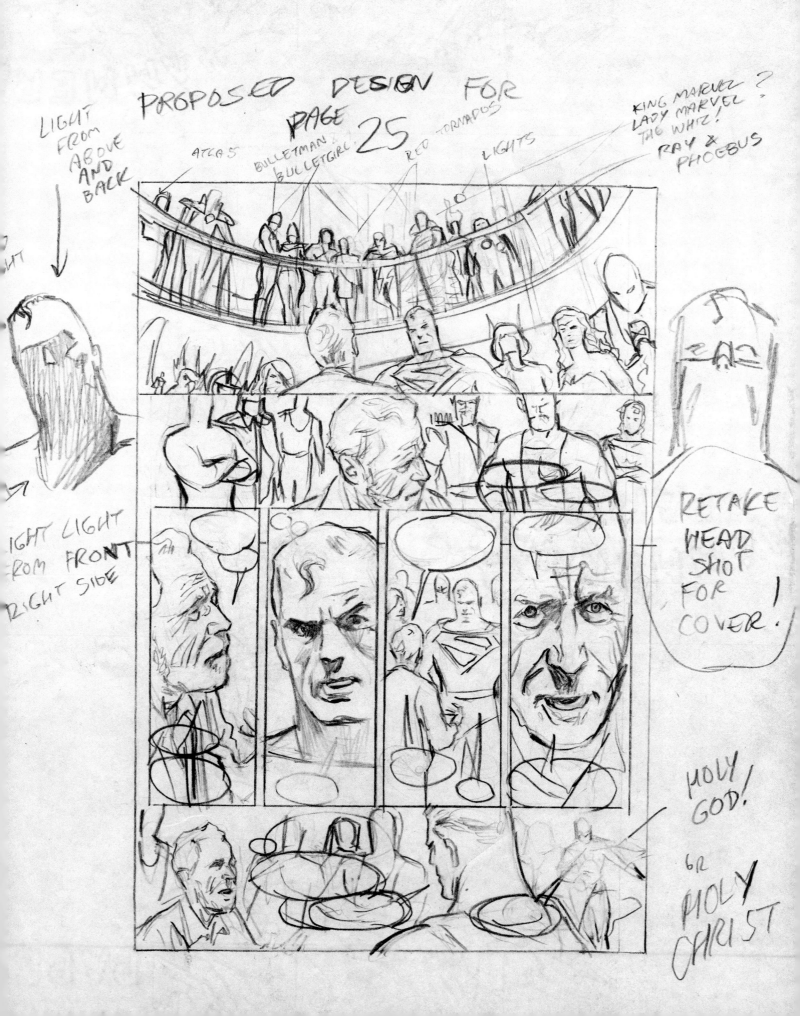

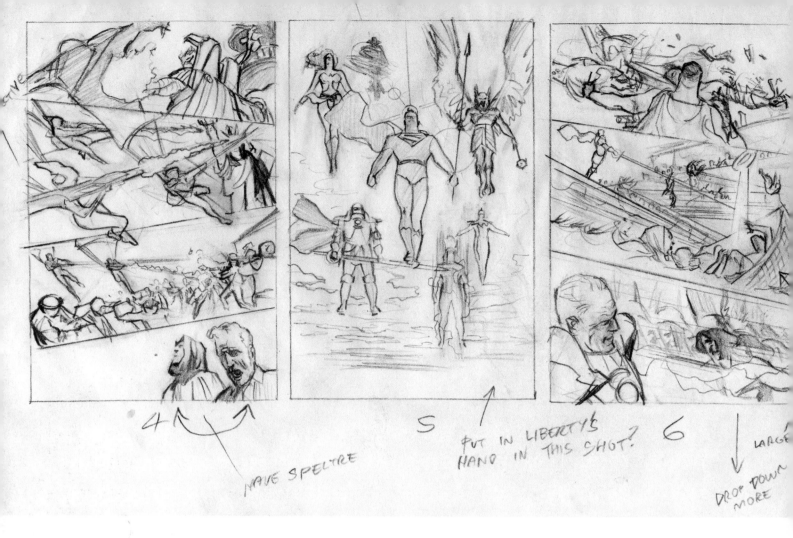

4 ↝ ⤳ MAVE SPELTRE

5 ↑ PUT IN LIBERTY'S HAND IN THIS SHOT? 6

↓ LARGE DROP DOWN MORE

Below: Ten years after the series' release, I created a new gatefold cover design for the trade paperback edition (2007).

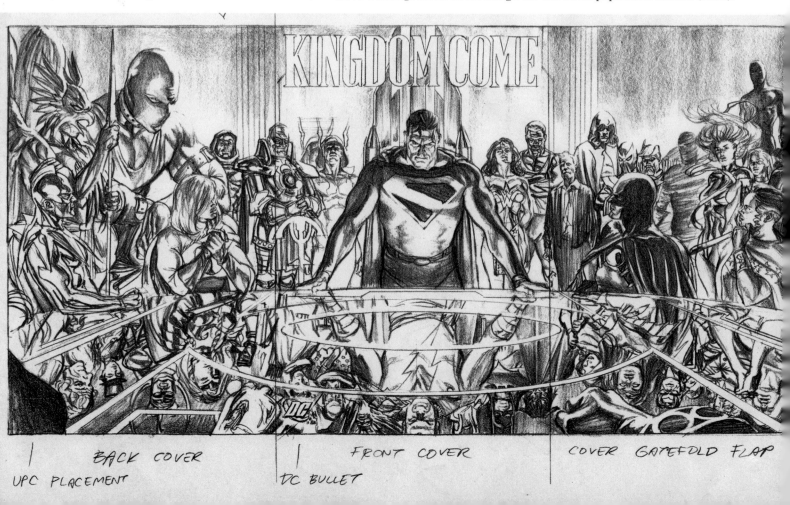

KINGDOM COME

| BACK COVER | FRONT COVER | COVER GATEFOLD FLAP |
| UPC PLACEMENT | DC BULLET | |

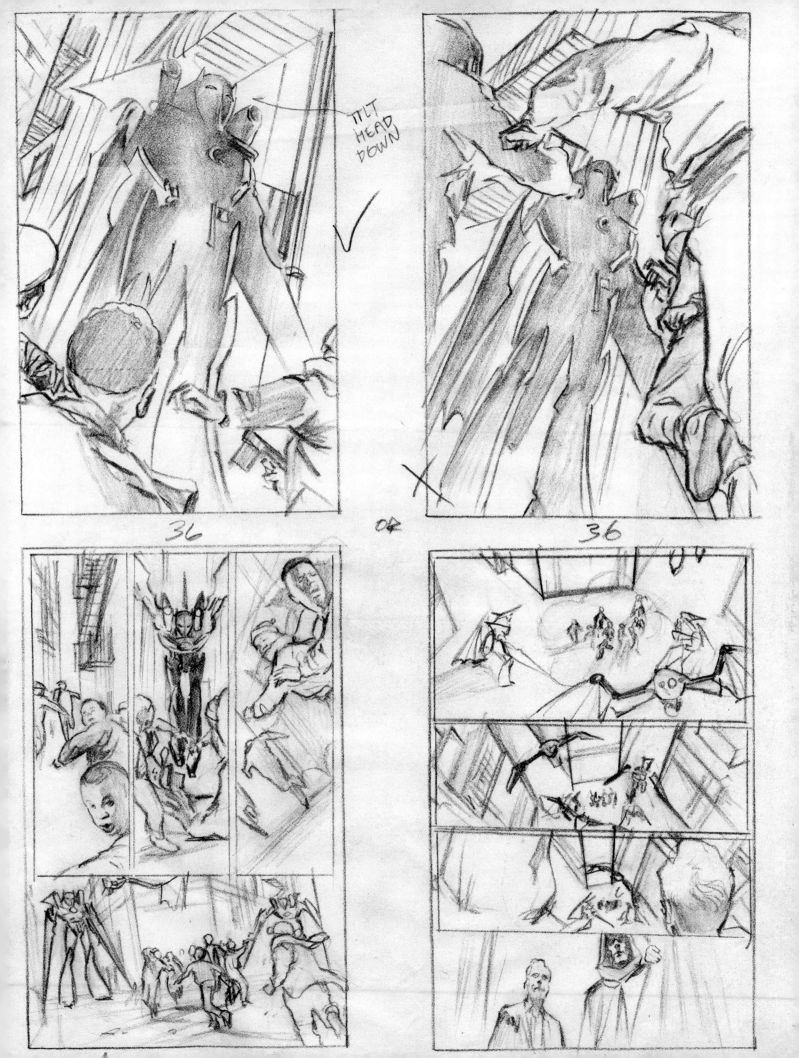

PAGE TEN

SPLASH: SIMILAR TO OUR SECOND ISSUE'S SHOT OF THE LEAGUE ARRIVING AT THE STATUE OF LIBERTY, BATMAN AND HIS TROOPS AND ROBOTS SWOOP IN OUT OF THE SKIES.

INSET PANEL: TIGHT ON BATMAN, A STEELY GLINT IN HIS EYE SUGGESTING THAT THERE'S A PART OF HIM ACTUALLY LOOKING FORWARD TO GETTING INTO ACTION ONCE MORE.

1 CAP: ANYONE.

YELLOW UNDER-LIGHTING

NOT GREEN

Across the next few pages you'll see how the final pencil stage looked, where I left broad areas open for shadow to be placed, focusing mostly on the contours of form and some modeling of surfaces before paint is applied. Because of the initial tightness of the roughs and the additional stage of model reference (not seen here), the rendering of the pages isn't as rough as my normal penciling style might have been. At no point was there any tracing or projection of photo images.

Opposite: Pencils for cover of *Kingdom Come* #3 (1995).

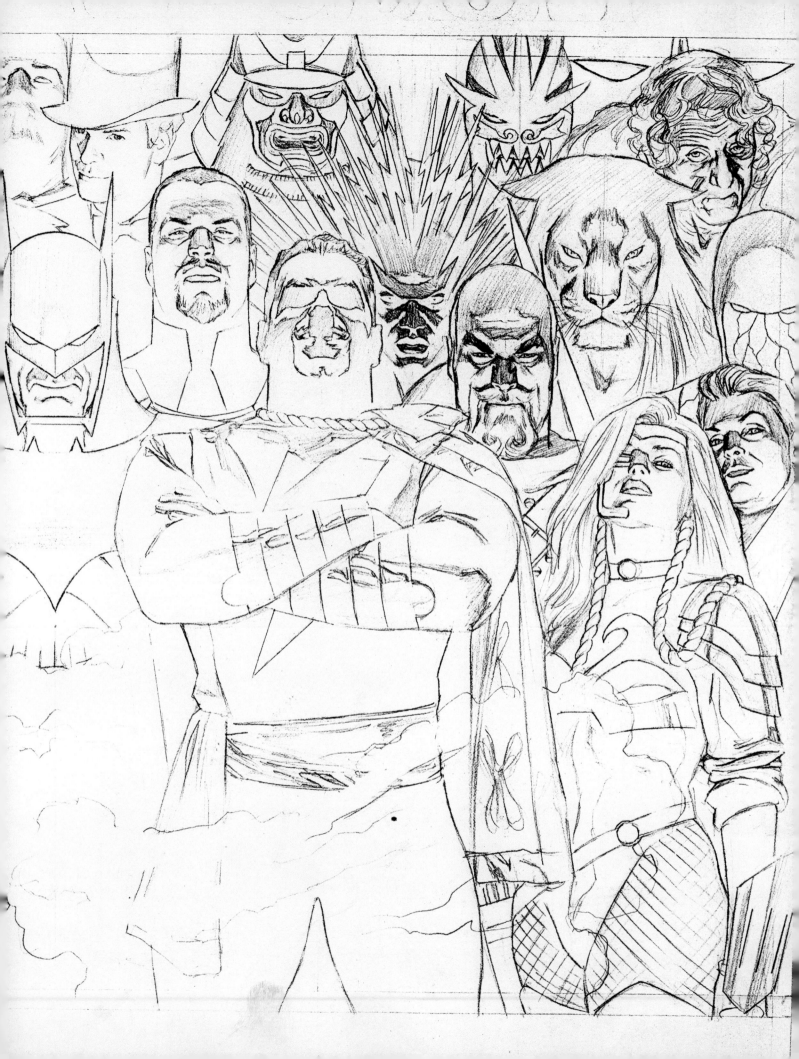

PAGE FORTY-FIVE

FULL-PAGE SPLASH: CAPTAIN MARVEL--FOR THE FIRST TIME, IN ALL HIS
GLORY--HOVERS OVER THE DOWNED SUPERMAN.

1 CAP:　　　　　　...by a single bolt of LIGHTNING.

2 CAP:　　　　　　Armageddon has ARRIVED.

To be continued...

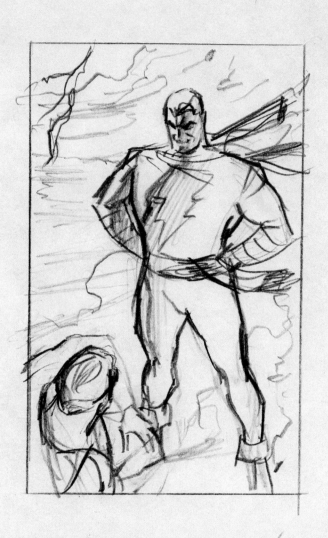

"THERE'S A CHANCE HE MAY HAVE LUTHOR'S DISPOSITION TOWARD YOU"

Opposite: Pencils for splash-page ending of *Kingdom Come* #3 (1995).

Following spread: Color rough for *Absolute Kingdom Come* collection (2006).

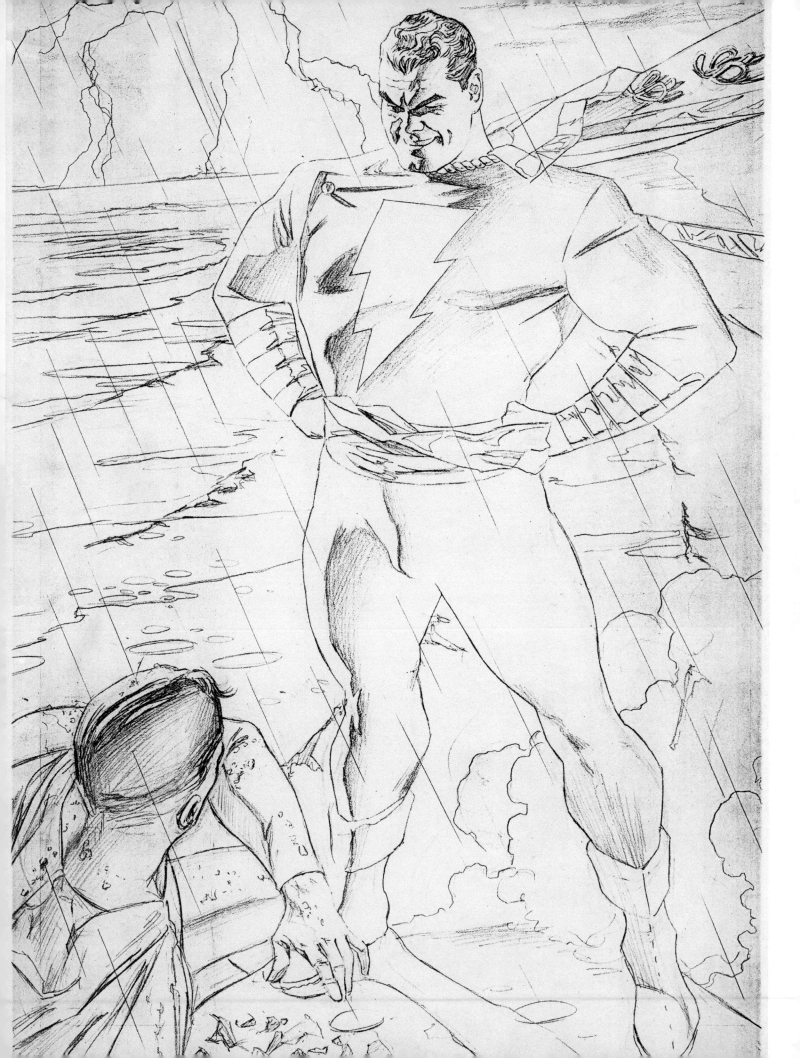

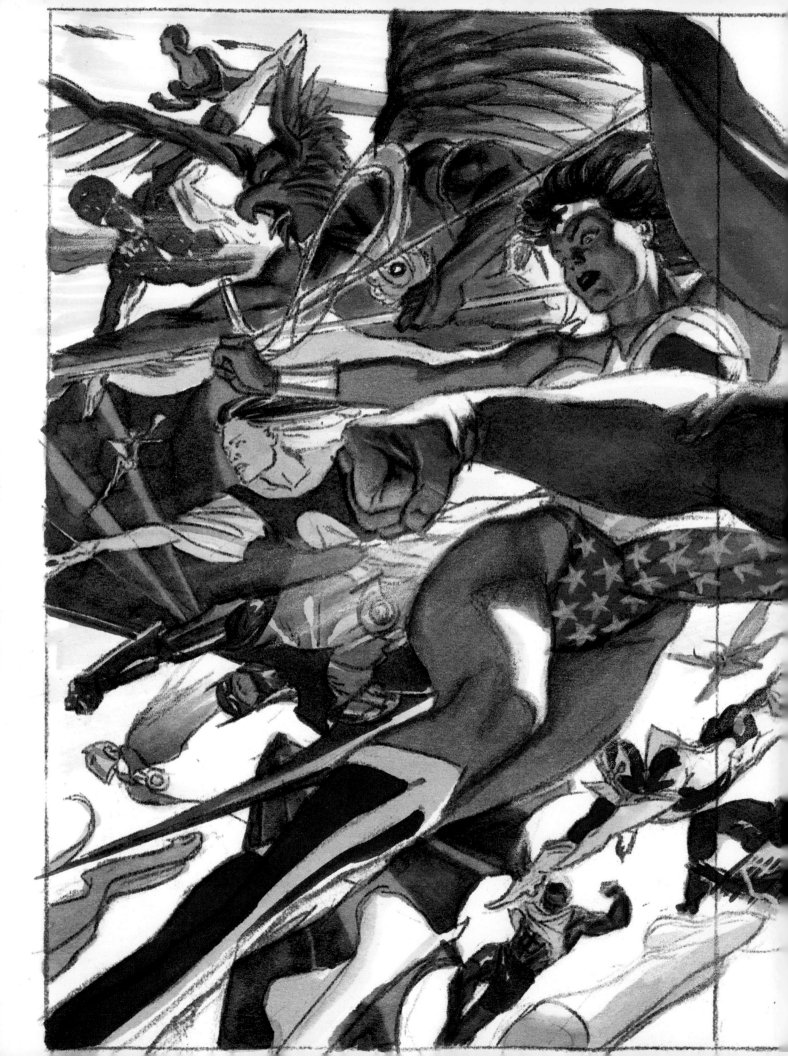

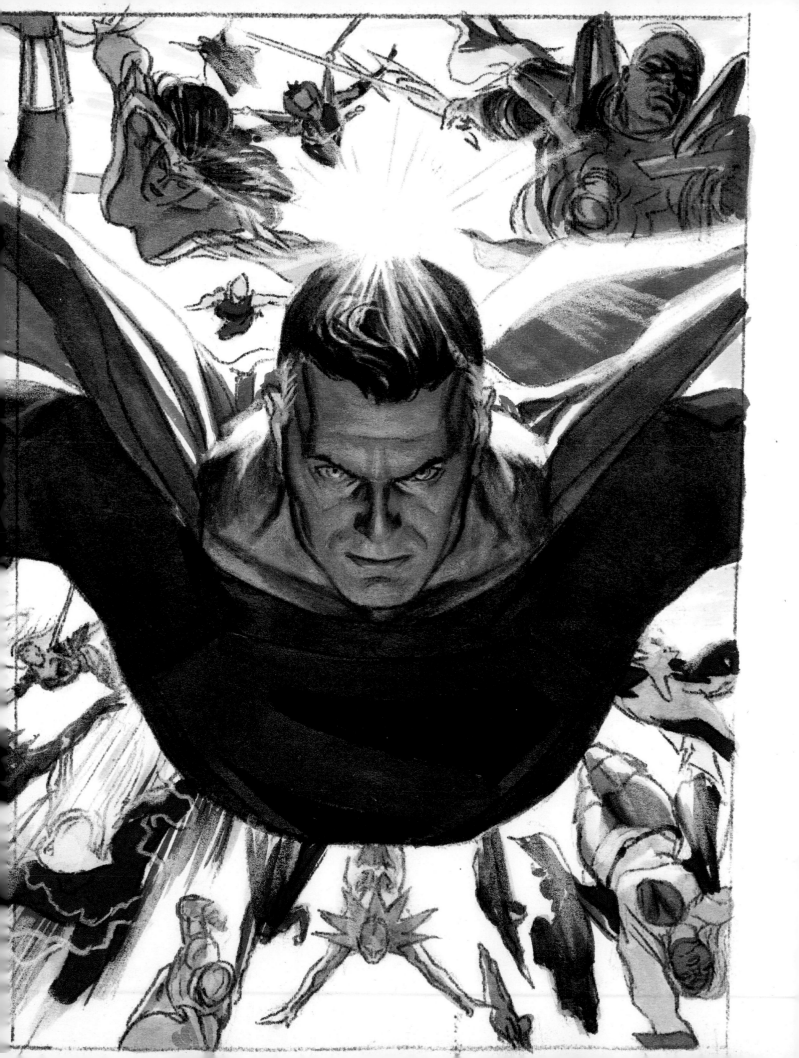

KINGDOM COME
SUPERMAN

6'3"

Below: Turnaround art for *Kingdom Come* Superman action figure from the *Justice Society of America* action figure wave 2 (2009).

Opposite: Pencils for cover of *Kingdom Come* #2 (1995).

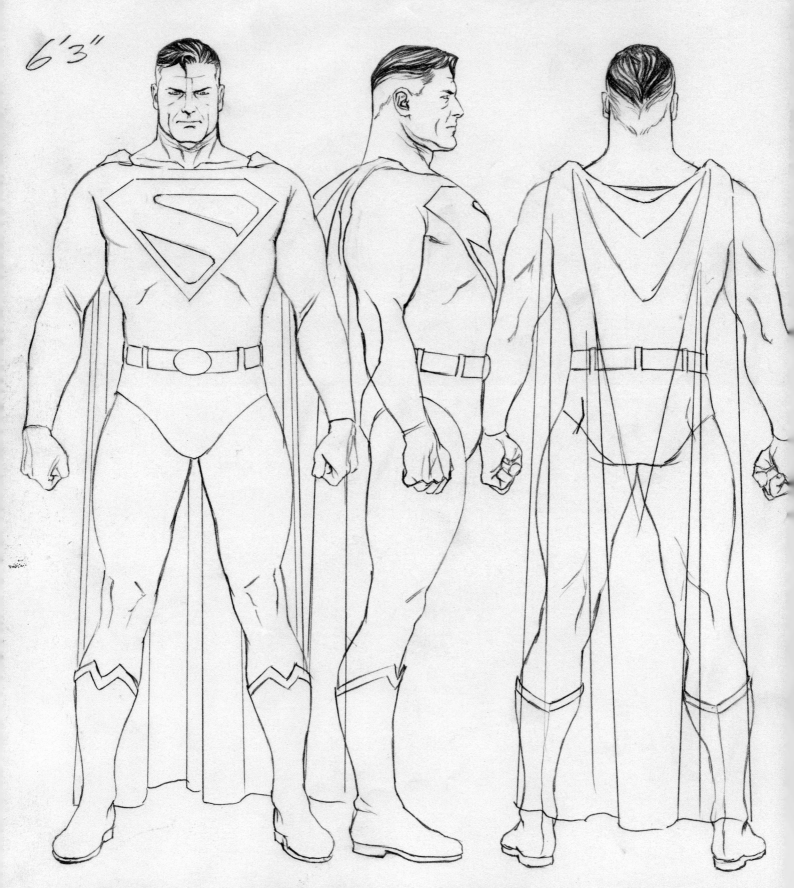

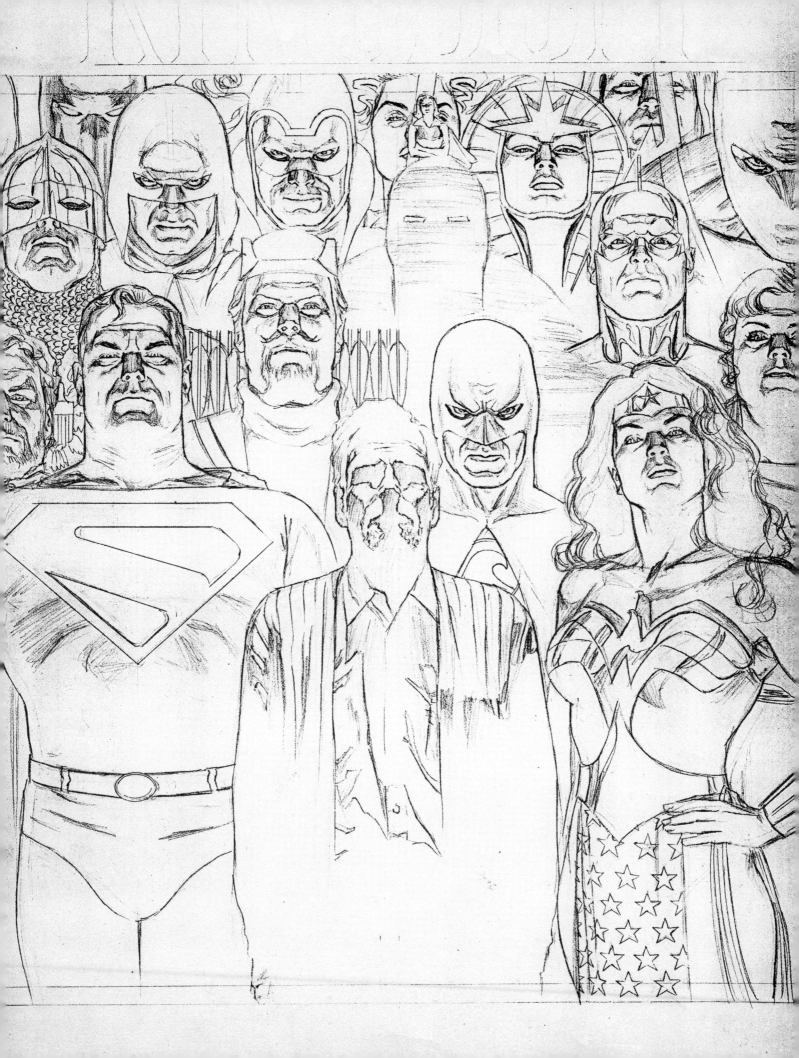

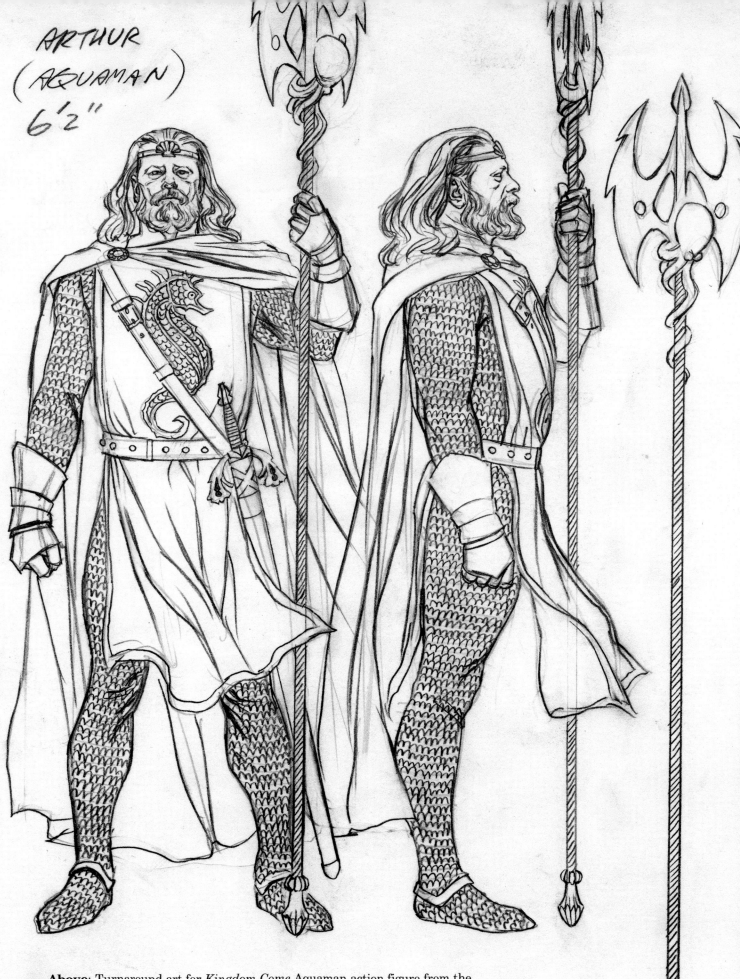

ARTHUR
(AQUAMAN)
6'2"

Above: Turnaround art for *Kingdom Come* Aquaman action figure from the *Elseworlds* action figure wave 3 (2006).

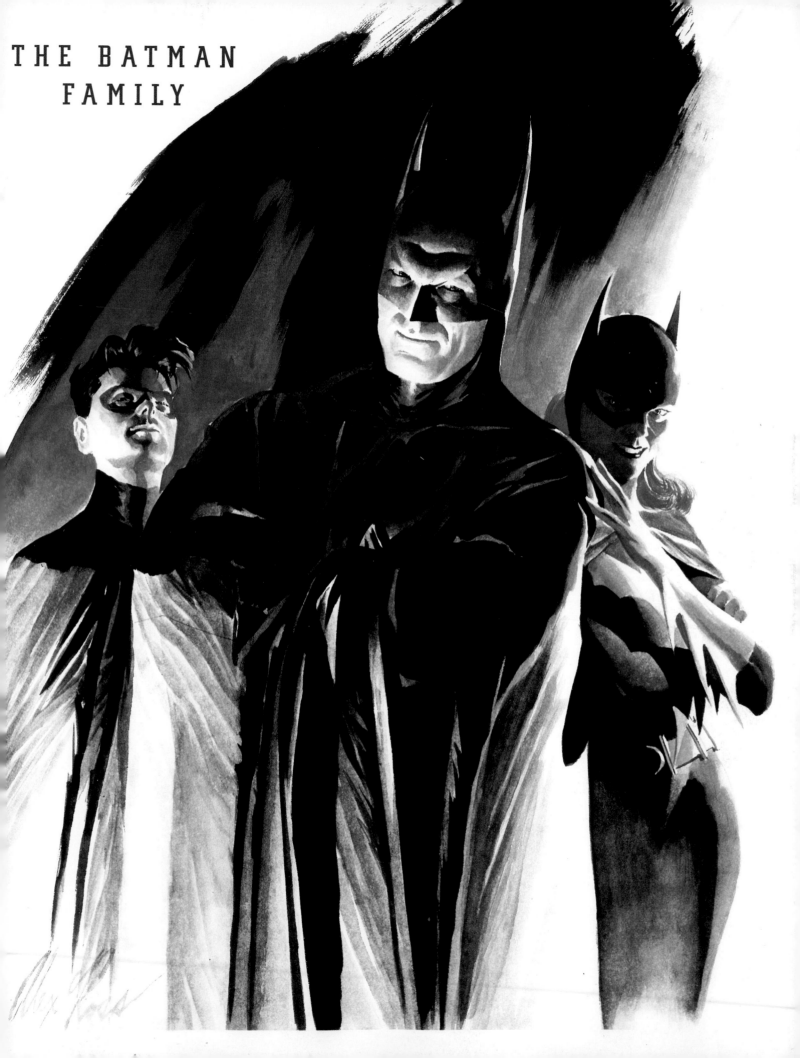

THE BATMAN
FAMILY

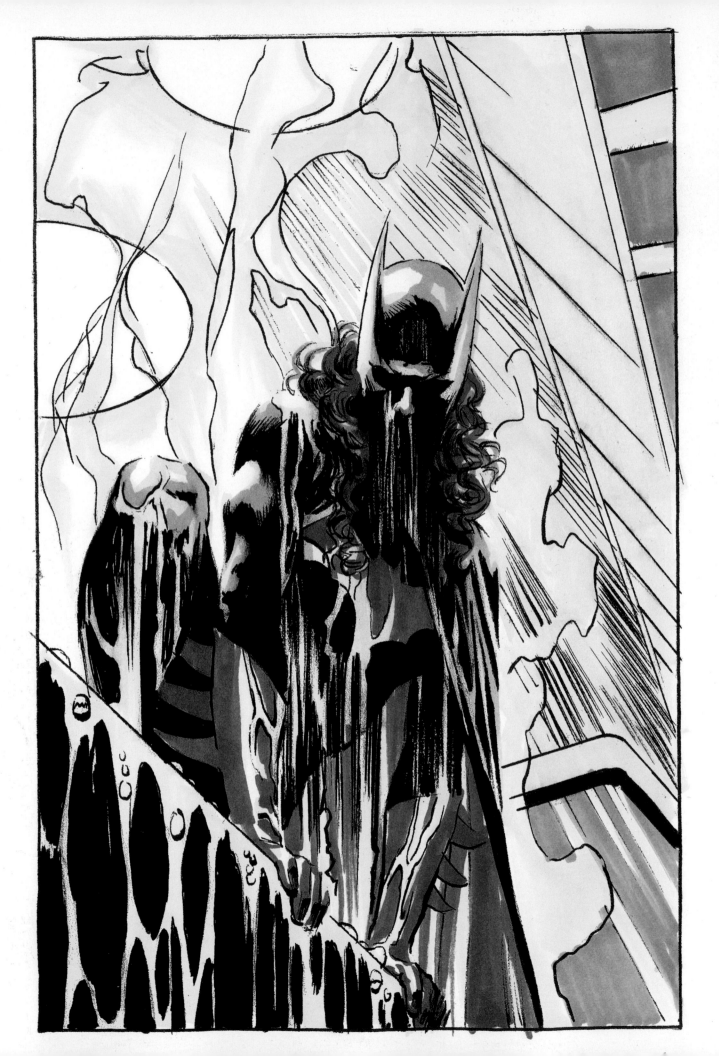

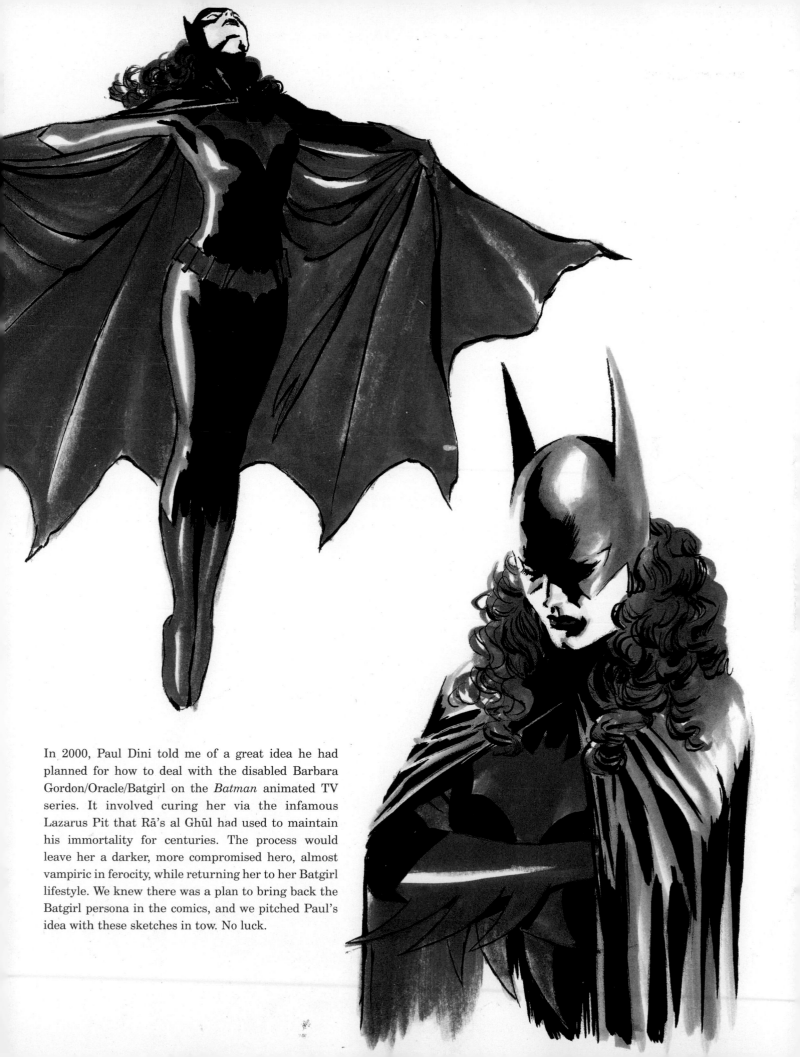

In 2000, Paul Dini told me of a great idea he had planned for how to deal with the disabled Barbara Gordon/Oracle/Batgirl on the *Batman* animated TV series. It involved curing her via the infamous Lazarus Pit that Rā's al Ghūl had used to maintain his immortality for centuries. The process would leave her a darker, more compromised hero, almost vampiric in ferocity, while returning her to her Batgirl lifestyle. We knew there was a plan to bring back the Batgirl persona in the comics, and we pitched Paul's idea with these sketches in tow. No luck.

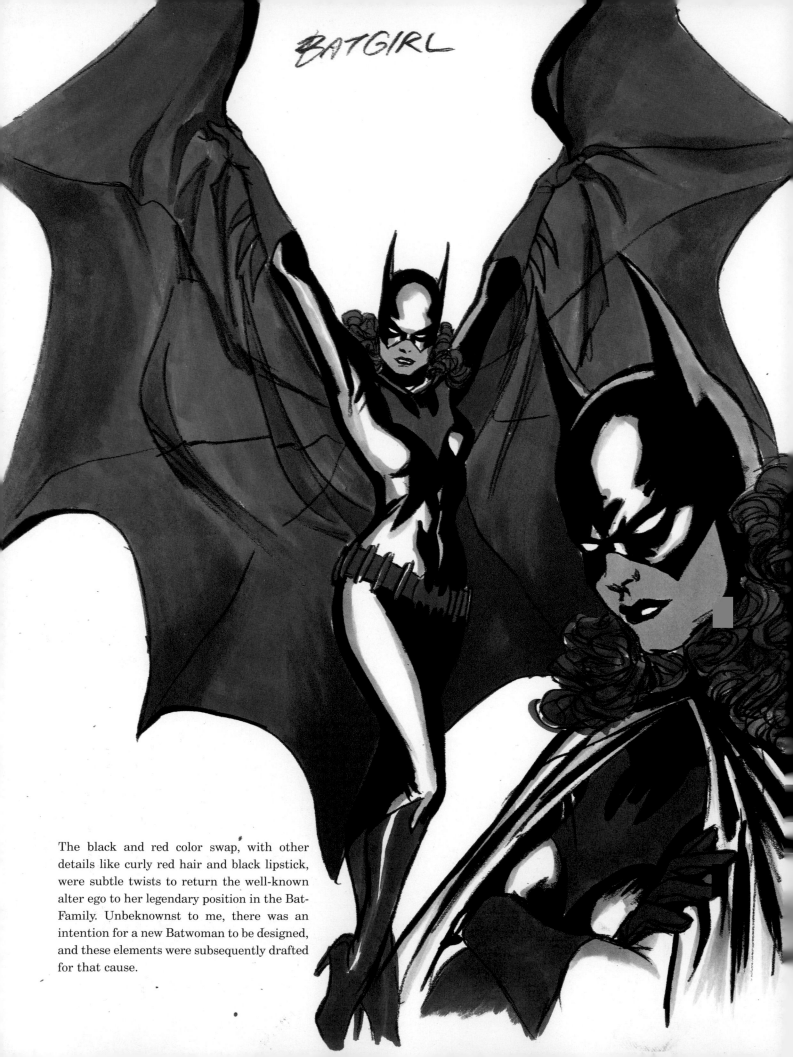

BATGIRL

The black and red color swap, with other details like curly red hair and black lipstick, were subtle twists to return the well-known alter ego to her legendary position in the Bat-Family. Unbeknownst to me, there was an intention for a new Batwoman to be designed, and these elements were subsequently drafted for that cause.

BATWOMAN

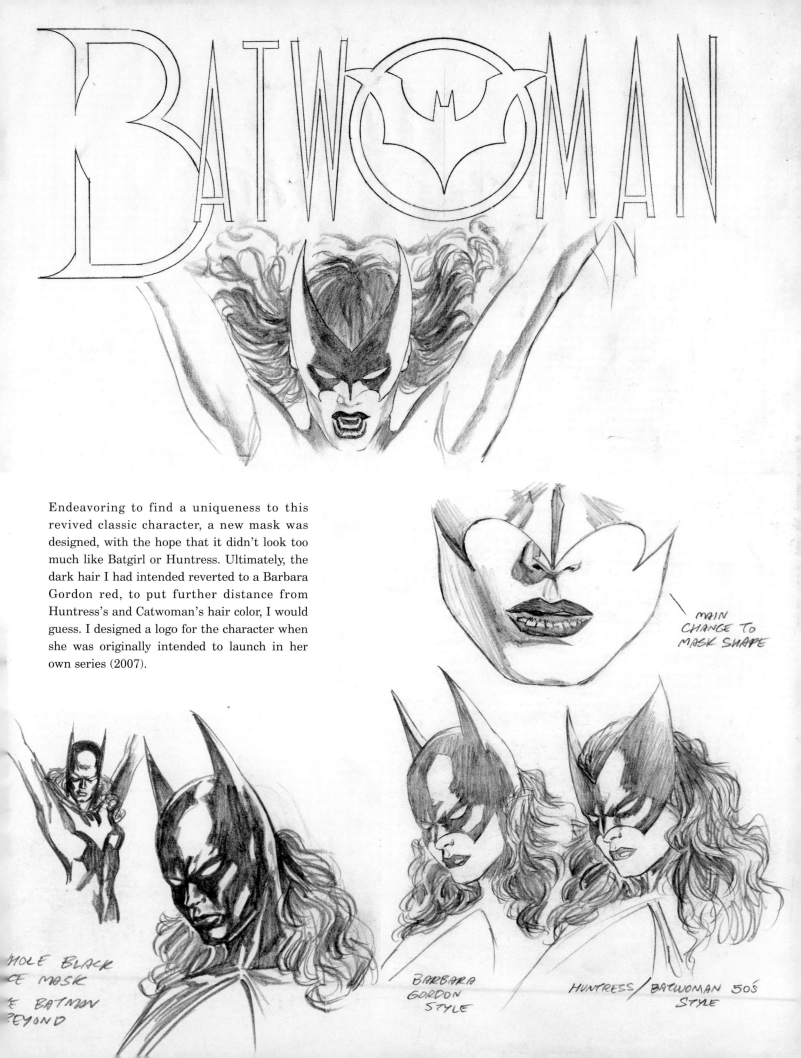

Endeavoring to find a uniqueness to this revived classic character, a new mask was designed, with the hope that it didn't look too much like Batgirl or Huntress. Ultimately, the dark hair I had intended reverted to a Barbara Gordon red, to put further distance from Huntress's and Catwoman's hair color, I would guess. I designed a logo for the character when she was originally intended to launch in her own series (2007).

MAIN CHANGE TO MASK SHAPE

WHOLE BLACK FACE MASK LIKE BATMAN BEYOND

BARBARA GORDON STYLE

HUNTRESS / BATWOMAN 50's STYLE

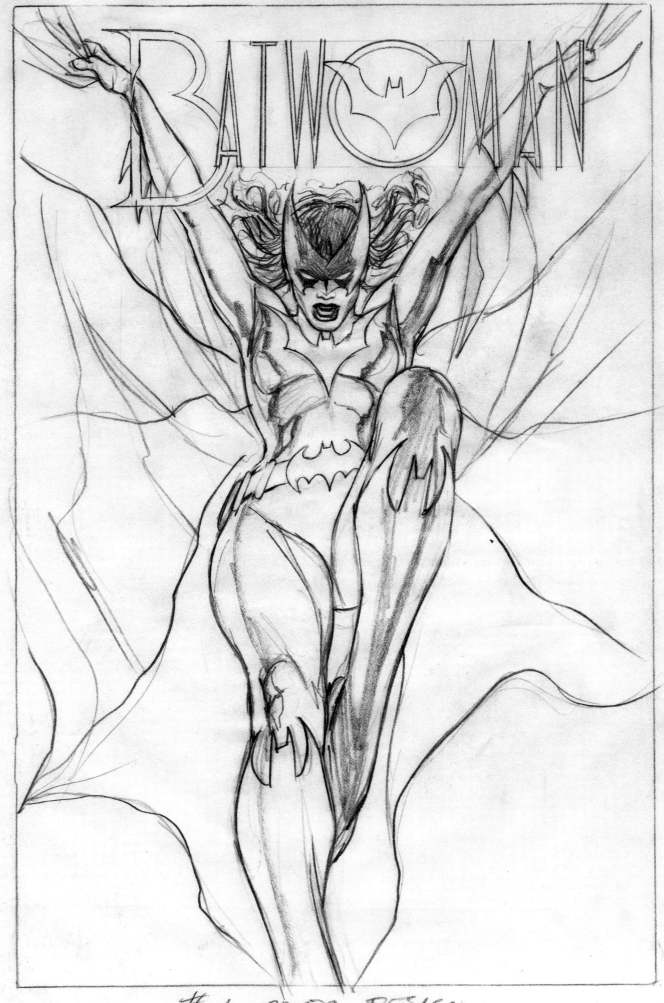

#1 COVER DESIGN
+ MY LOGO

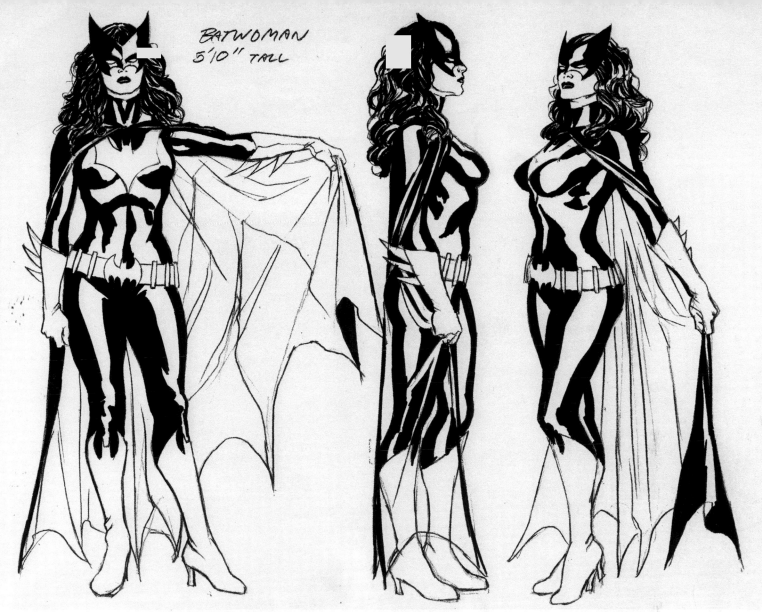

BATWOMAN
5'10" TALL

BATWOMAN HEAD TURNS

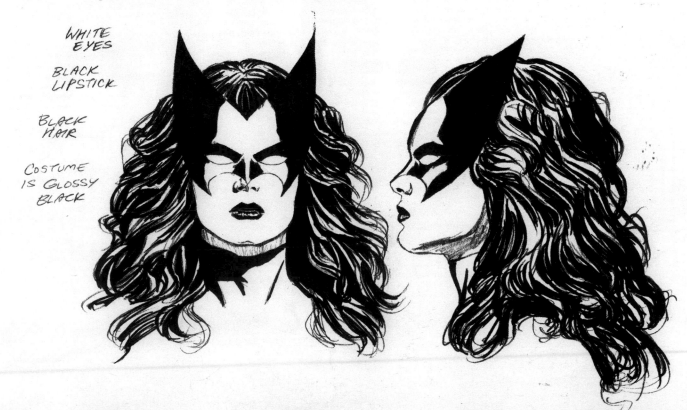

WHITE
EYES

BLACK
LIPSTICK

BLACK
HAIR

COSTUME
IS GLOSSY
BLACK

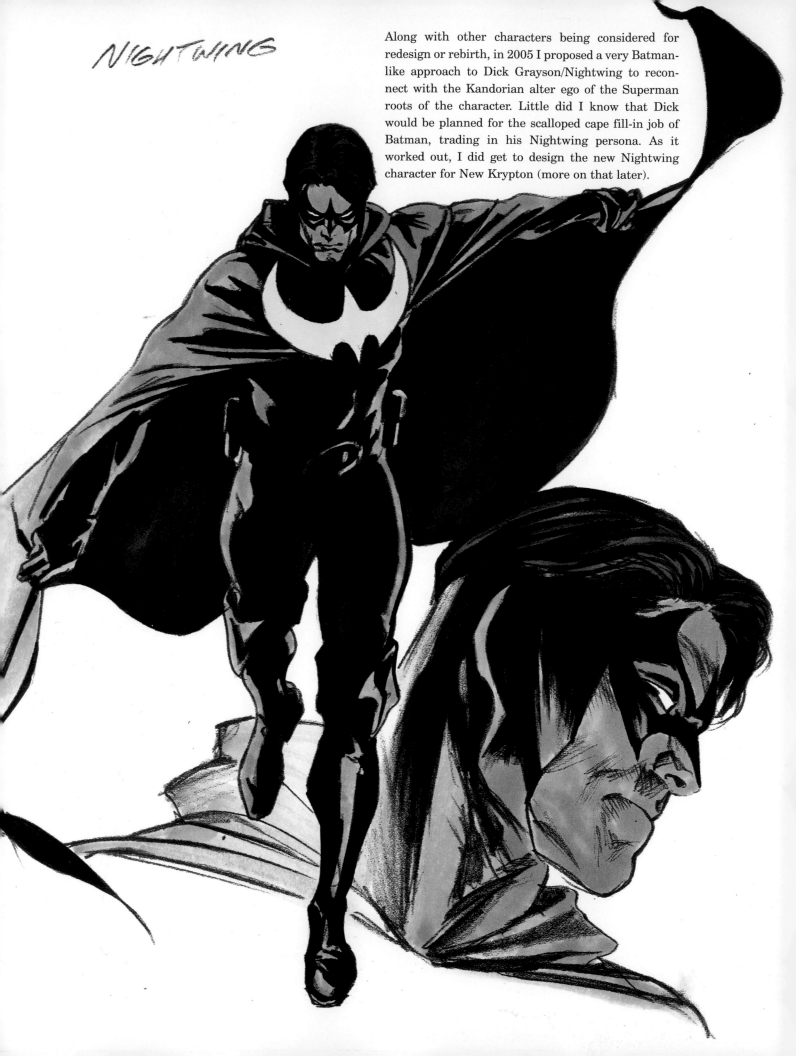

NIGHTWING

Along with other characters being considered for redesign or rebirth, in 2005 I proposed a very Batman-like approach to Dick Grayson/Nightwing to reconnect with the Kandorian alter ego of the Superman roots of the character. Little did I know that Dick would be planned for the scalloped cape fill-in job of Batman, trading in his Nightwing persona. As it worked out, I did get to design the new Nightwing character for New Krypton (more on that later).

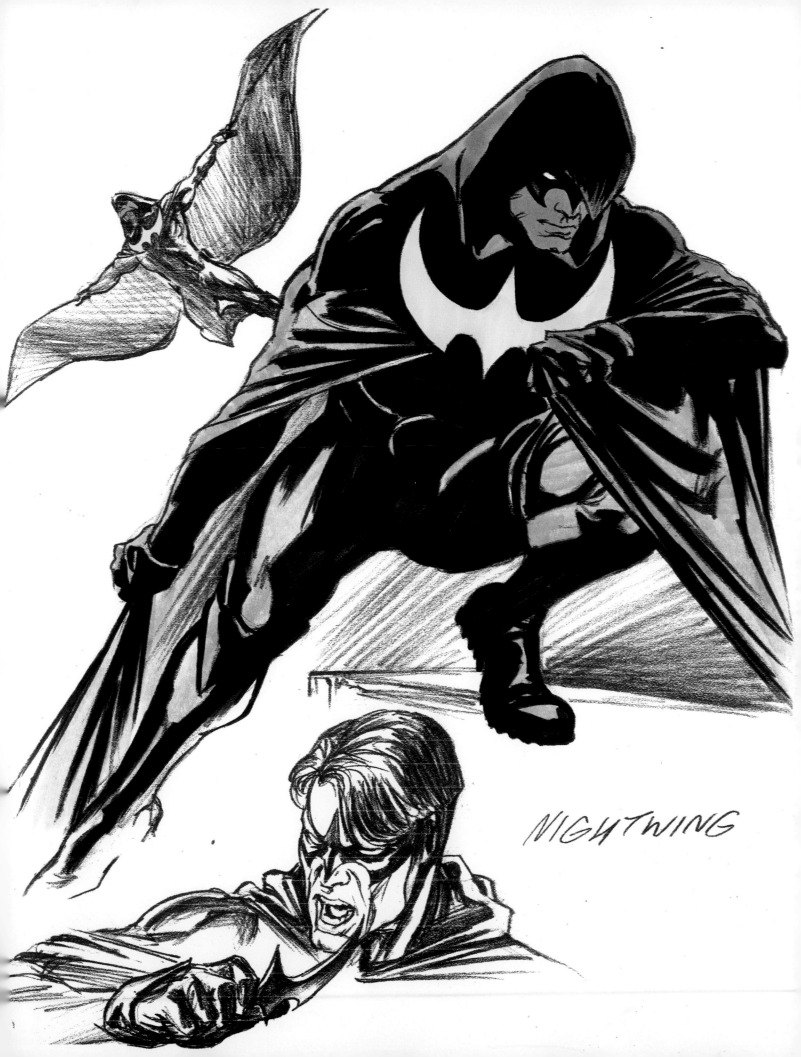

NIGHTWING

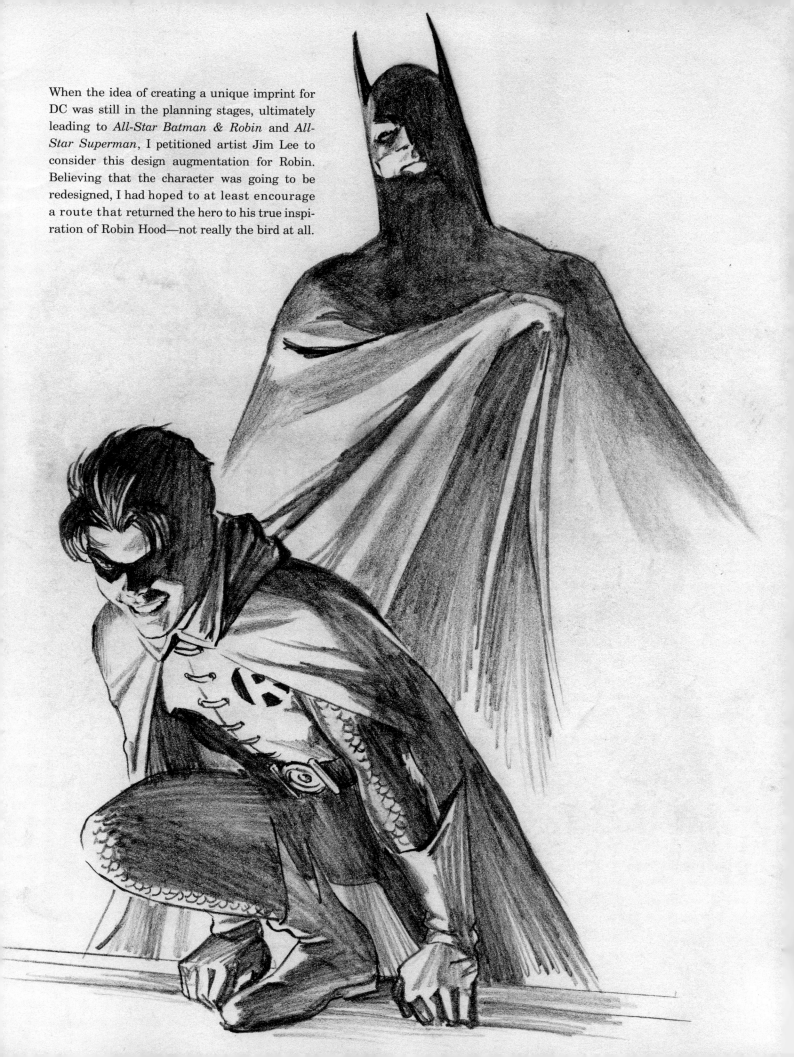

When the idea of creating a unique imprint for DC was still in the planning stages, ultimately leading to *All-Star Batman & Robin* and *All-Star Superman*, I petitioned artist Jim Lee to consider this design augmentation for Robin. Believing that the character was going to be redesigned, I had hoped to at least encourage a route that returned the hero to his true inspiration of Robin Hood—not really the bird at all.

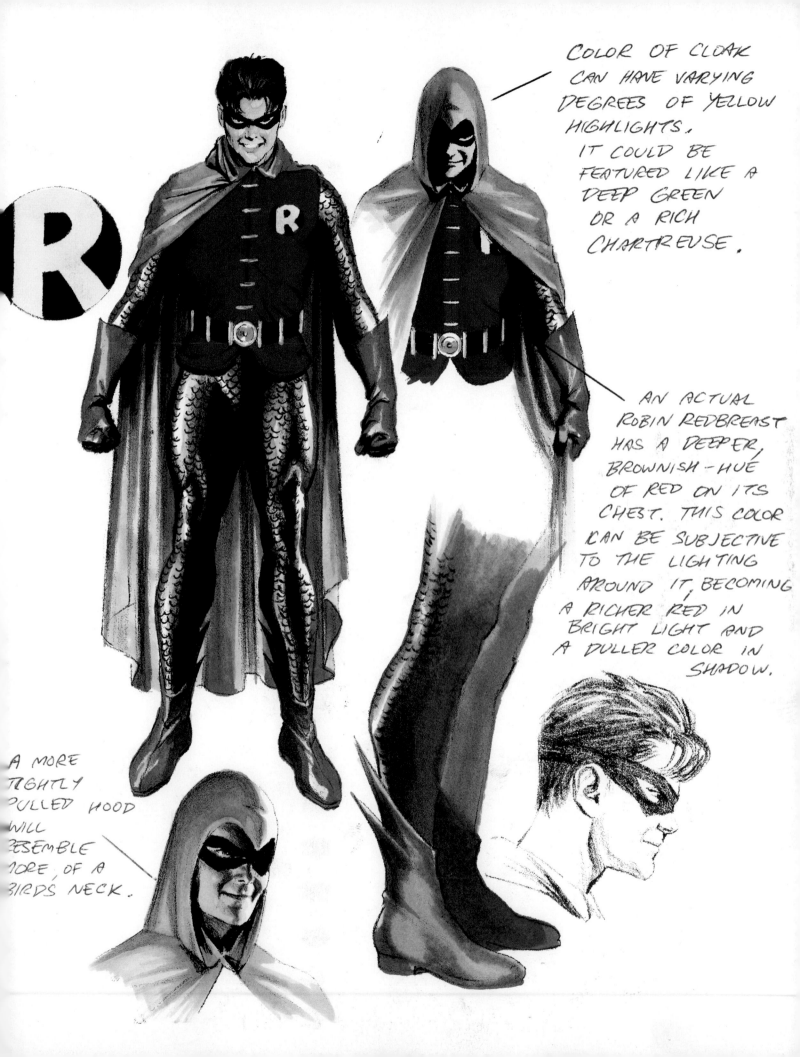

COLOR OF CLOAK CAN HAVE VARYING DEGREES OF YELLOW HIGHLIGHTS. IT COULD BE FEATURED LIKE A DEEP GREEN OR A RICH CHARTREUSE.

AN ACTUAL ROBIN REDBREAST HAS A DEEPER, BROWNISH-HUE OF RED ON ITS CHEST. THIS COLOR CAN BE SUBJECTIVE TO THE LIGHTING AROUND IT, BECOMING A RICHER RED IN BRIGHT LIGHT AND A DULLER COLOR IN SHADOW.

A MORE TIGHTLY PULLED HOOD WILL RESEMBLE MORE OF A BIRD'S NECK.

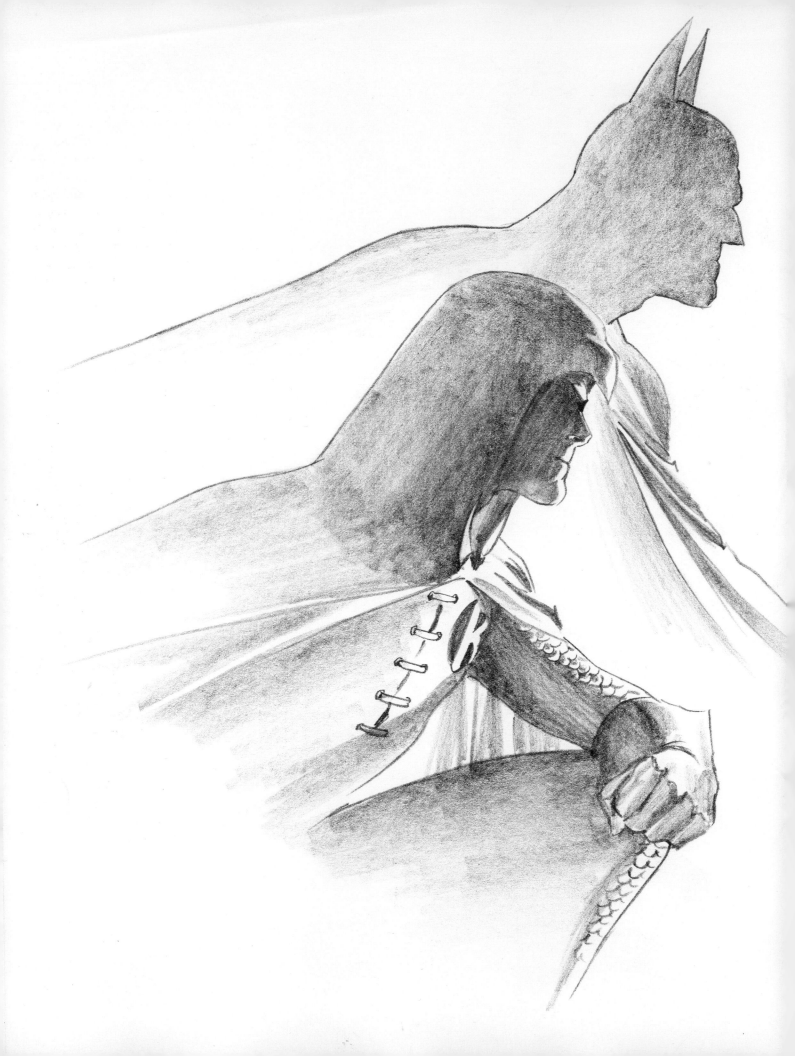

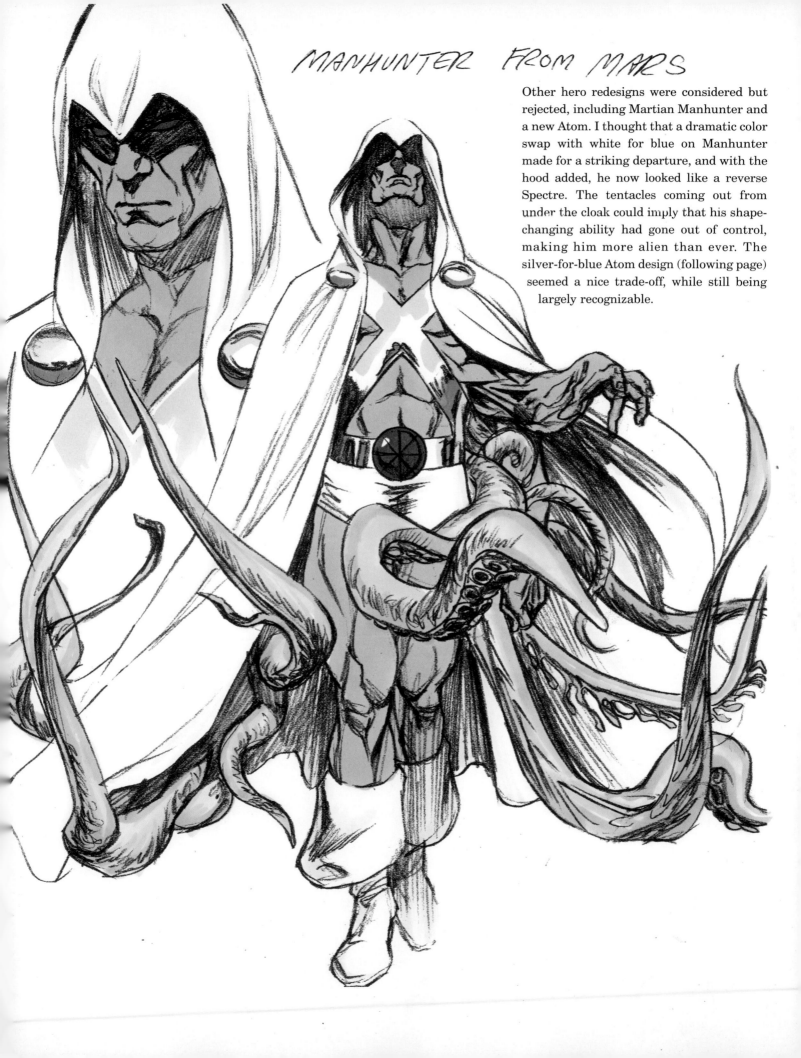

MANHUNTER FROM MARS

Other hero redesigns were considered but rejected, including Martian Manhunter and a new Atom. I thought that a dramatic color swap with white for blue on Manhunter made for a striking departure, and with the hood added, he now looked like a reverse Spectre. The tentacles coming out from under the cloak could imply that his shape-changing ability had gone out of control, making him more alien than ever. The silver-for-blue Atom design (following page) seemed a nice trade-off, while still being largely recognizable.

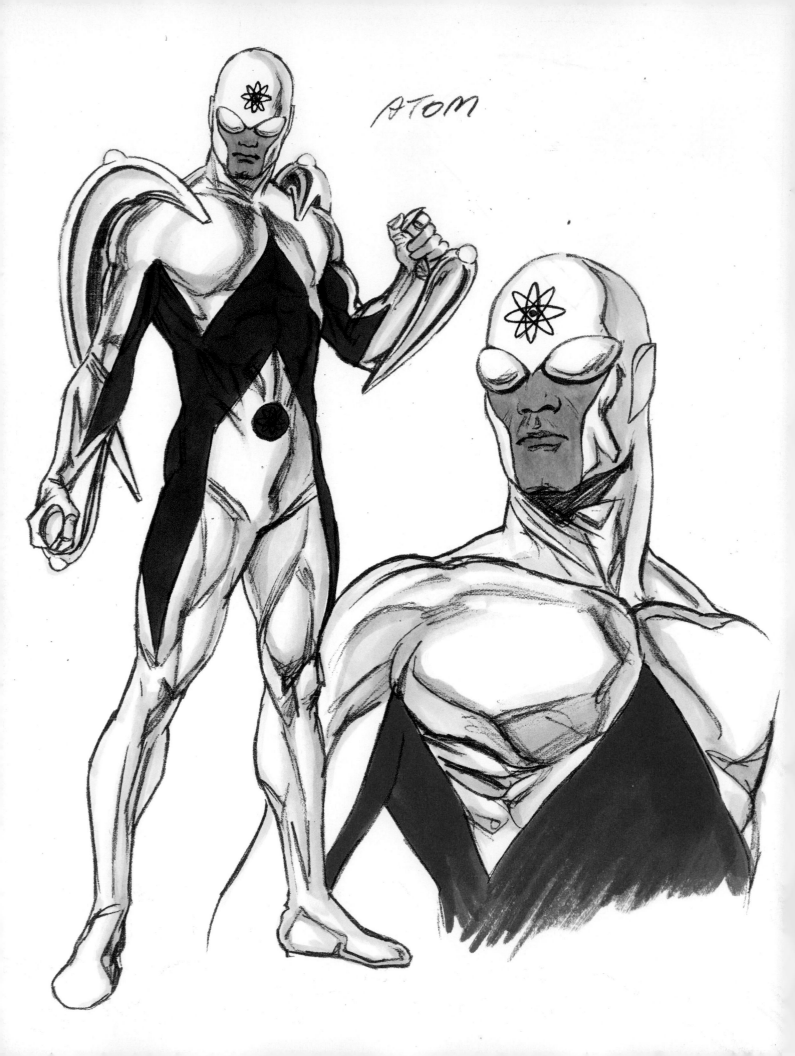

ATOM

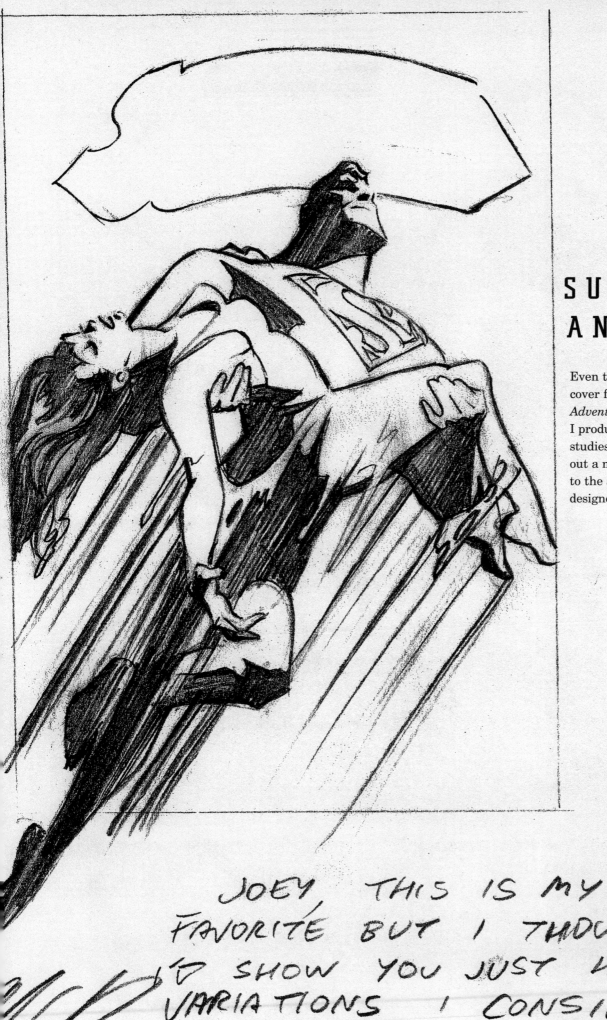

SUPERMAN ANIMATED

Even though I only did one cover for the *Superman Adventures* comic book series, I produced many roughs and studies of the character, trying out a mood-lighting approach to the animation style designed by Bruce Timm.

JOEY, THIS IS MY LEAST FAVORITE BUT I THOUGHT I'D SHOW YOU JUST HOW MANY VARIATIONS I CONSIDERED.

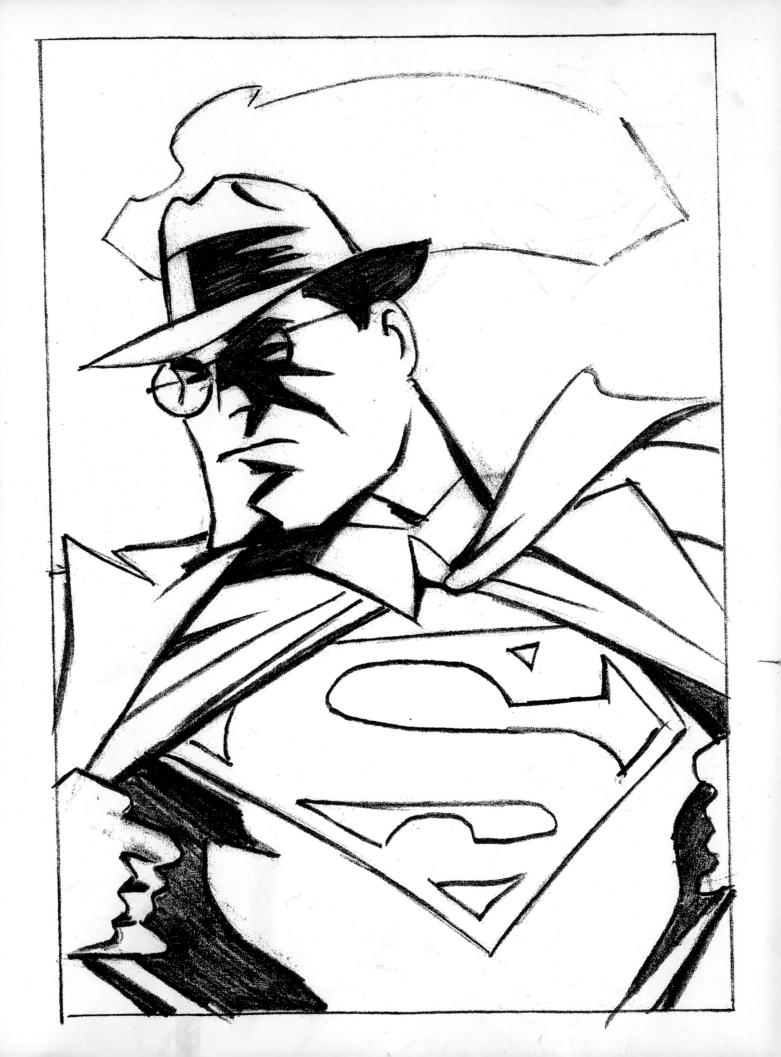

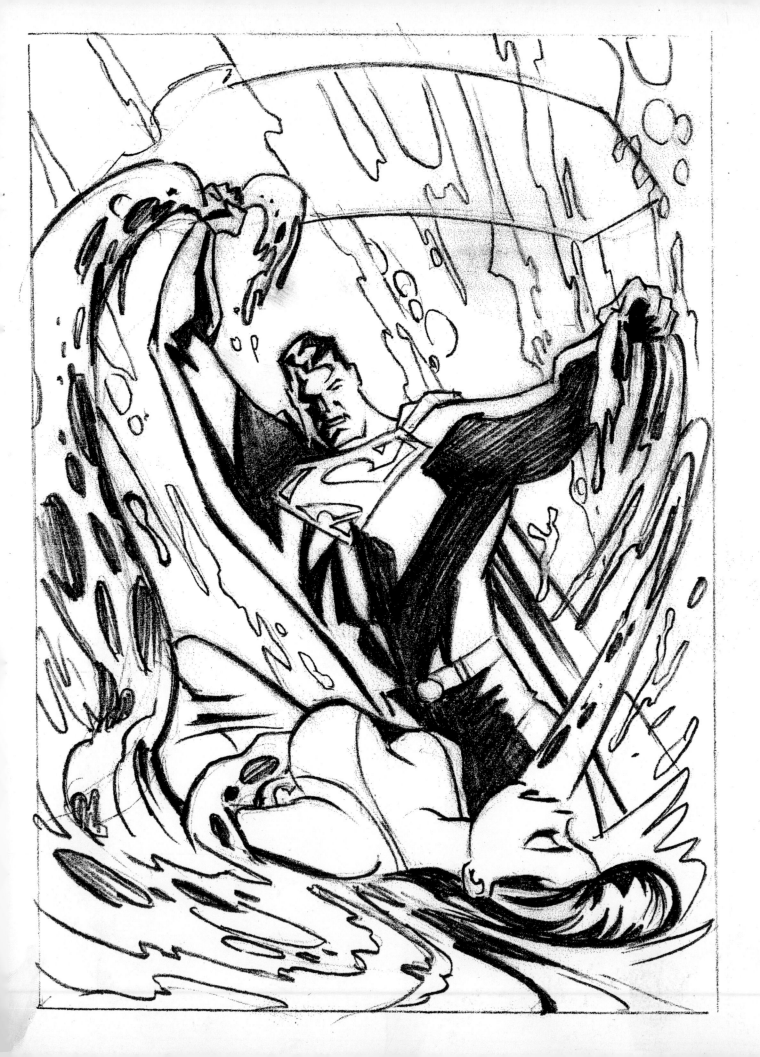

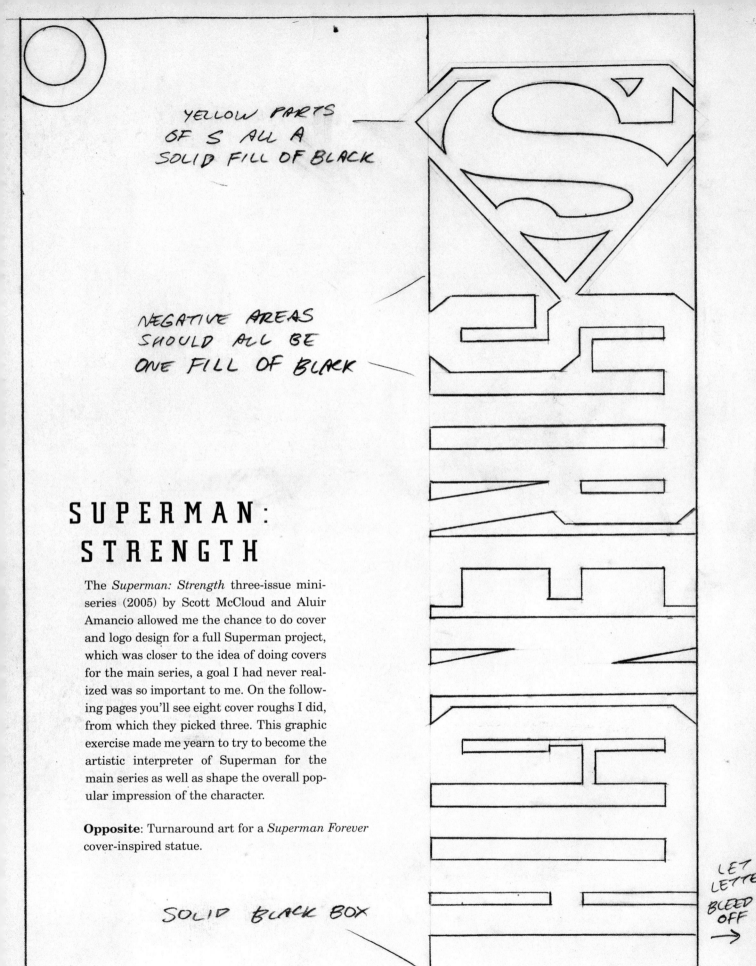

YELLOW PARTS
OF S ALL A
SOLID FILL OF BLACK

NEGATIVE AREAS
SHOULD ALL BE
ONE FILL OF BLACK

SUPERMAN:
STRENGTH

The *Superman: Strength* three-issue mini-series (2005) by Scott McCloud and Aluir Amancio allowed me the chance to do cover and logo design for a full Superman project, which was closer to the idea of doing covers for the main series, a goal I had never realized was so important to me. On the following pages you'll see eight cover roughs I did, from which they picked three. This graphic exercise made me yearn to try to become the artistic interpreter of Superman for the main series as well as shape the overall popular impression of the character.

Opposite: Turnaround art for a *Superman Forever* cover-inspired statue.

SOLID BLACK BOX

LET
LETTERS
BLEED
OFF
→

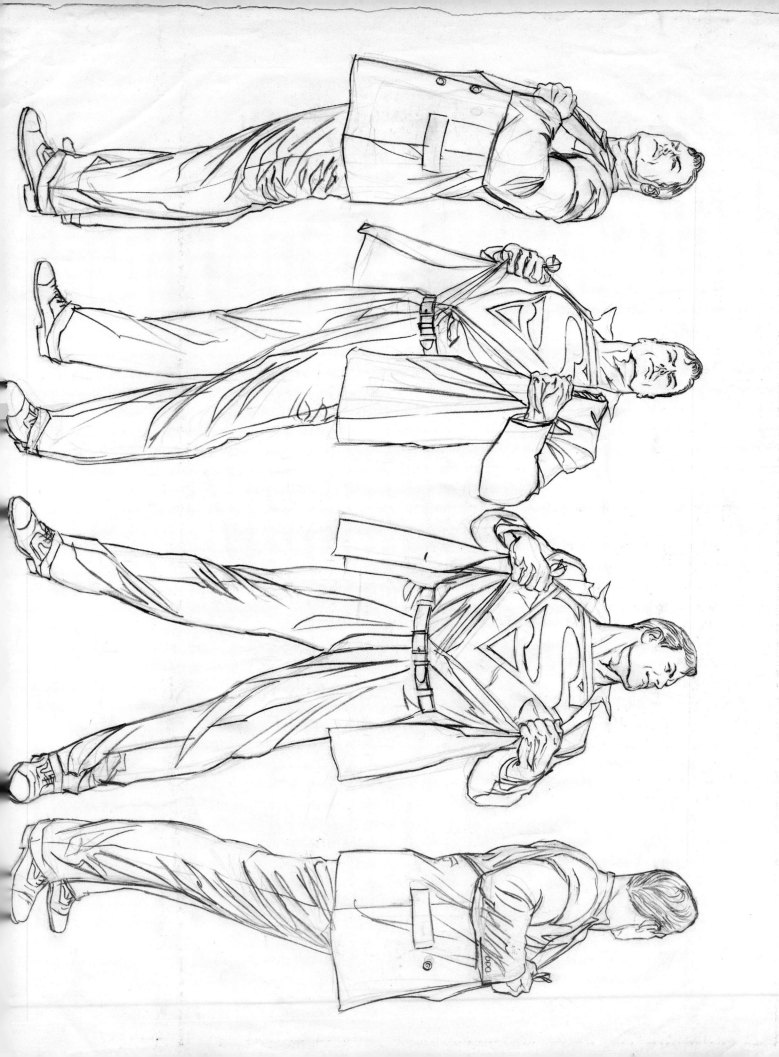

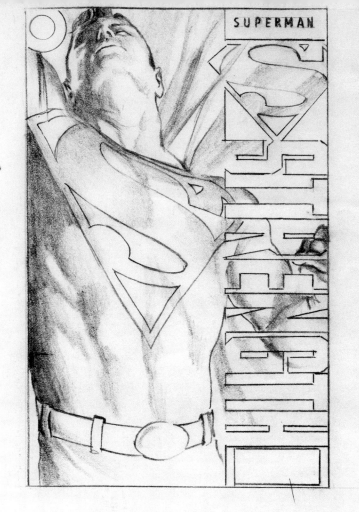

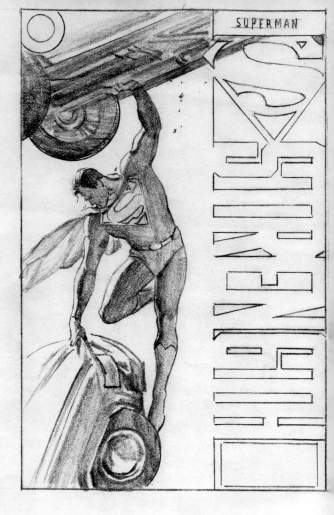

UPC BOX

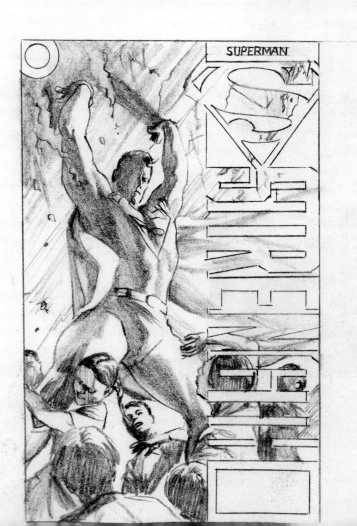

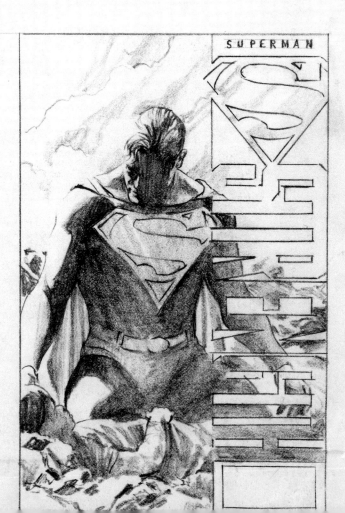

SUPERMAN COVERS

After years of petitioning for the job of doing covers for both *Superman* and *Action Comics*, I finally got the opportunity on the *Superman* comic. I pitched a logo augmentation that was intended to revert to the previous "squared-off" letters as well as a stretching of the telescoping edge to go off the cover. I did a great many cover-size tight pencil roughs to illustrate possible stand-alone compositions that could fit into the series. Given immediate shifts in storyline focus as well as changes in writers, several planned covers were scrapped or rescheduled—even one that was executed as a full painting and then canceled. The ever-changing world of mainstream comics was something I had been too insulated from in my normal experience of working largely on special projects. Here I wasn't really a close collaborator with story content, but I worked new designs to fit whatever direction was given.

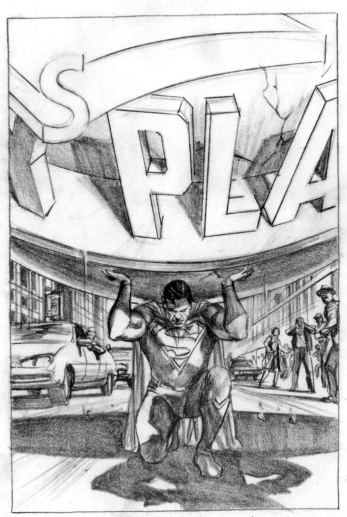

676 ATLAS' SHADOW

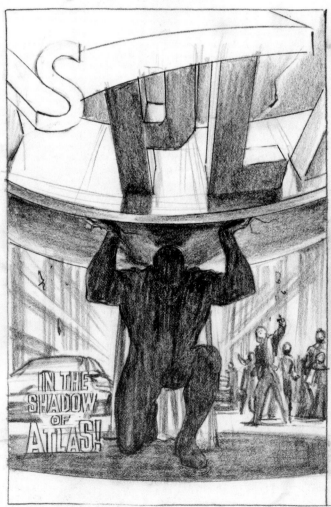

ALL IN SHADOW, WITH NO INDICATION OF ATLAS

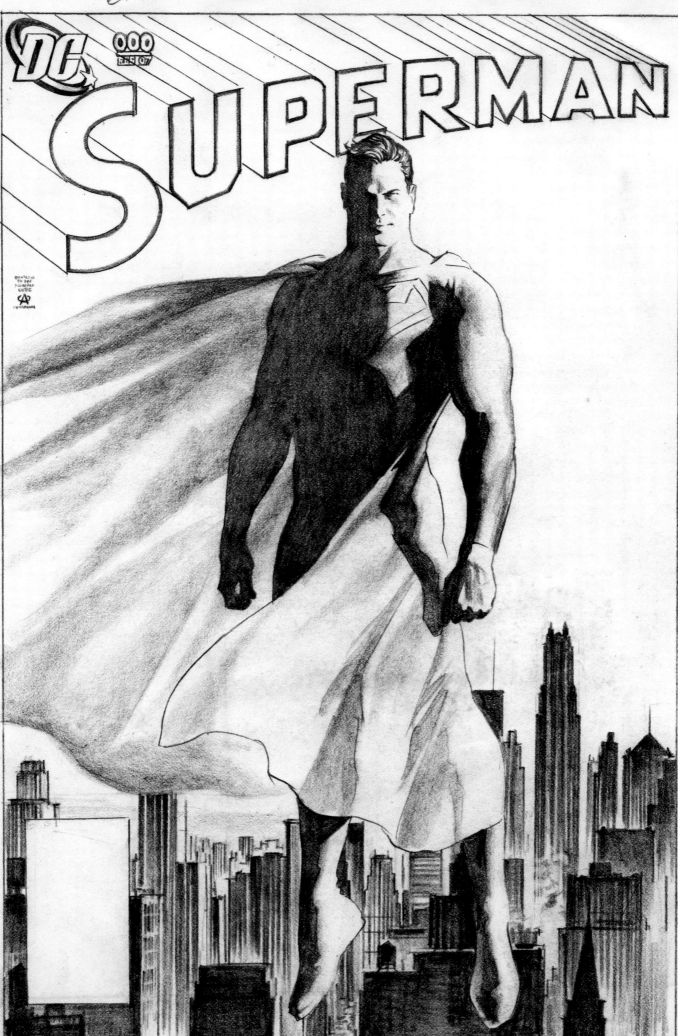

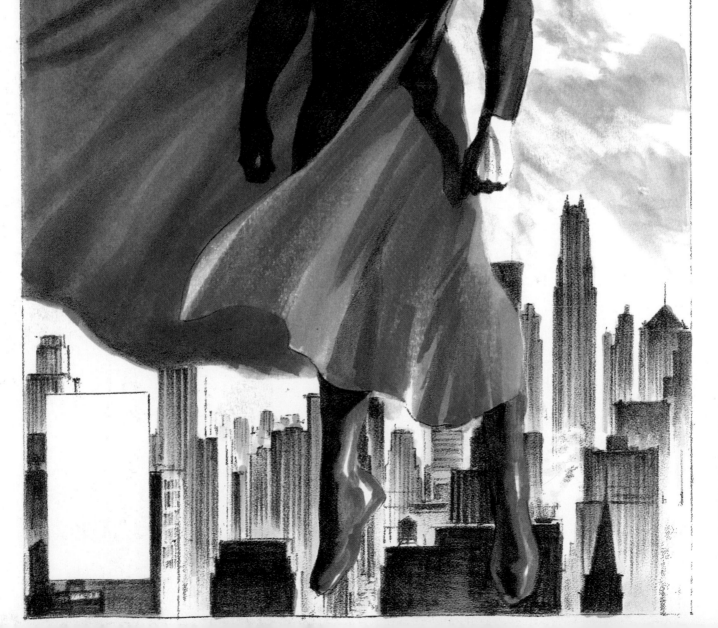

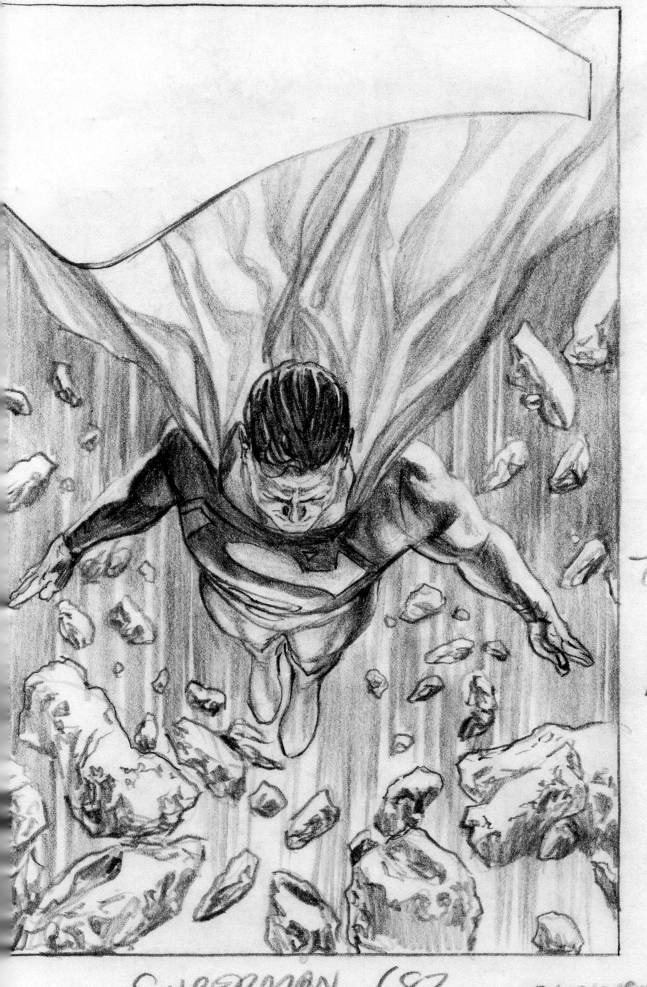

EYES
TURNED
UP
TOWARD
READER

FLYING
AT
READER

SUPERMAN 683

CHUNKS OF D...

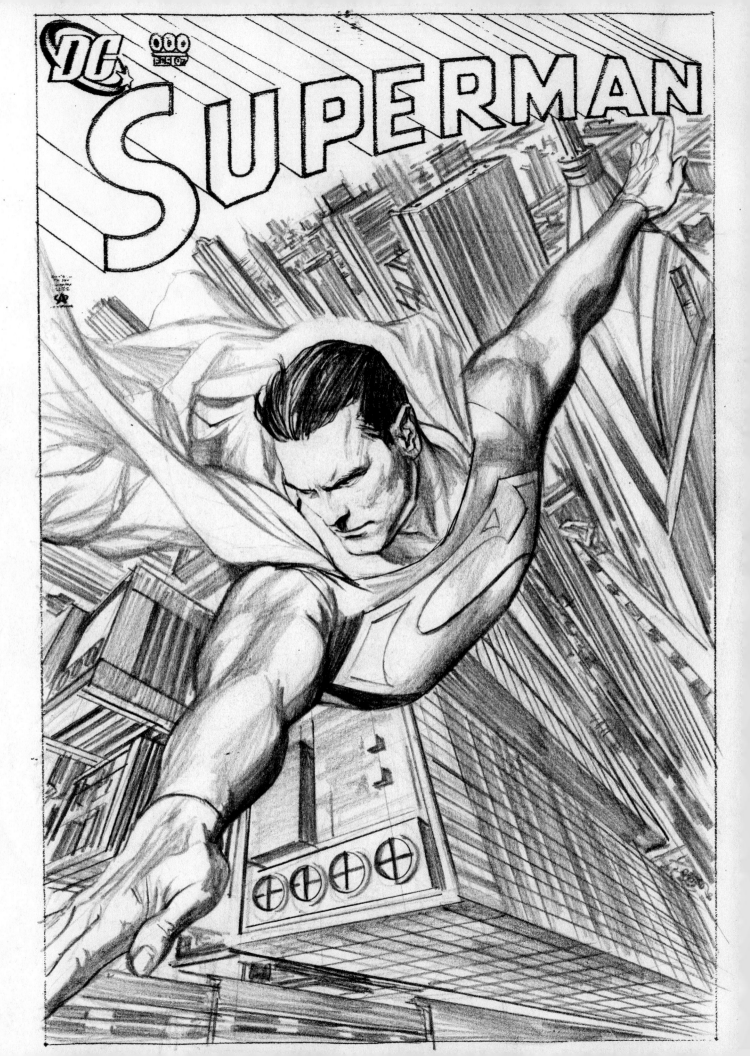

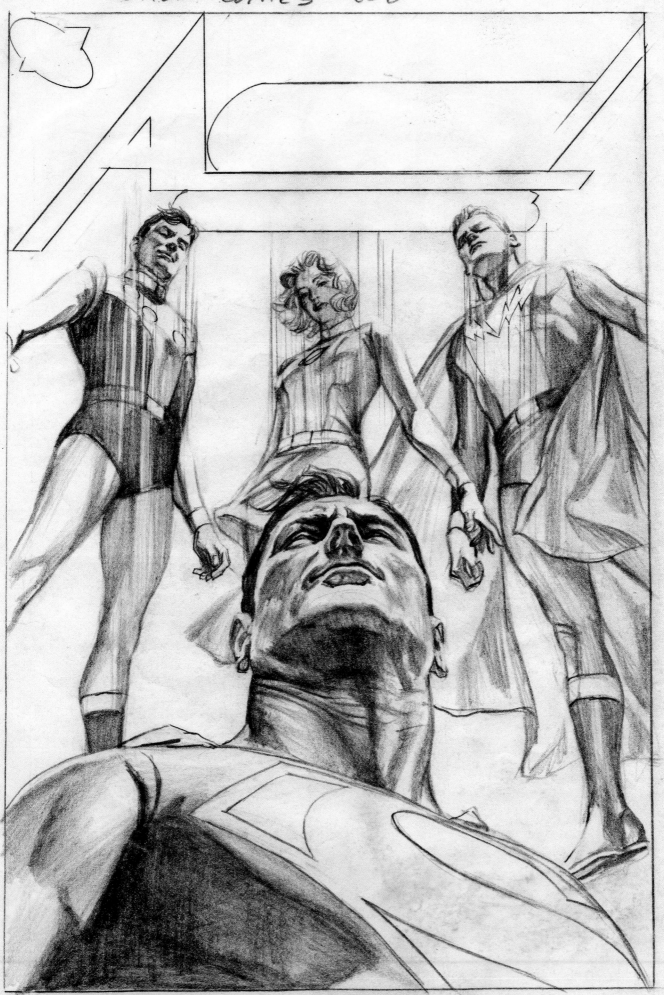

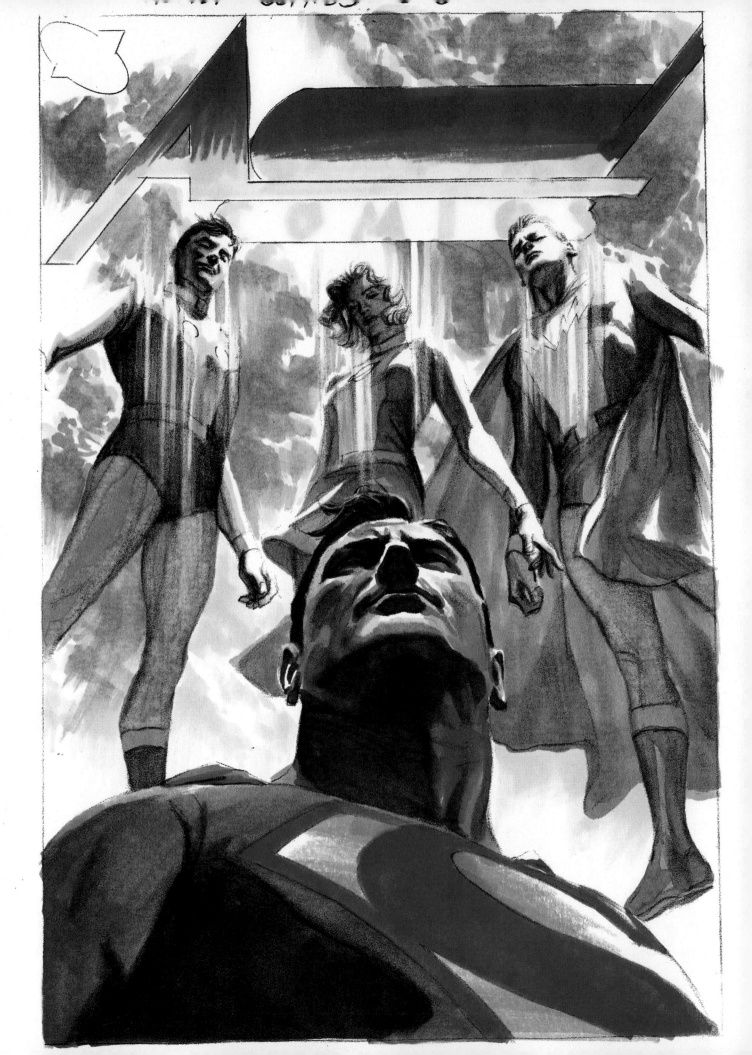

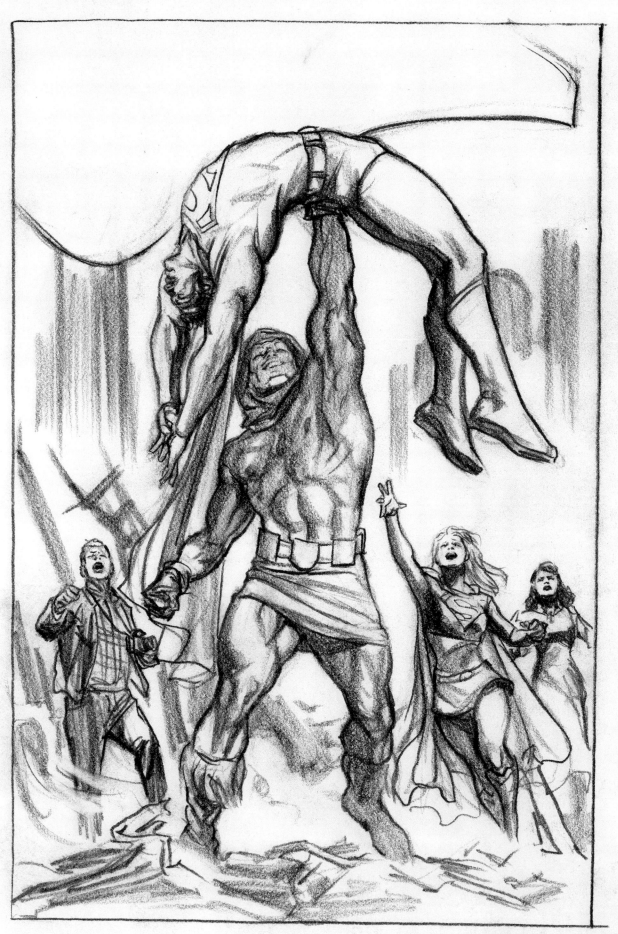

679

For me, one of the happiest moments on the series was to be part of the revival of an often-overlooked '70s Jack Kirby design of the character Atlas.

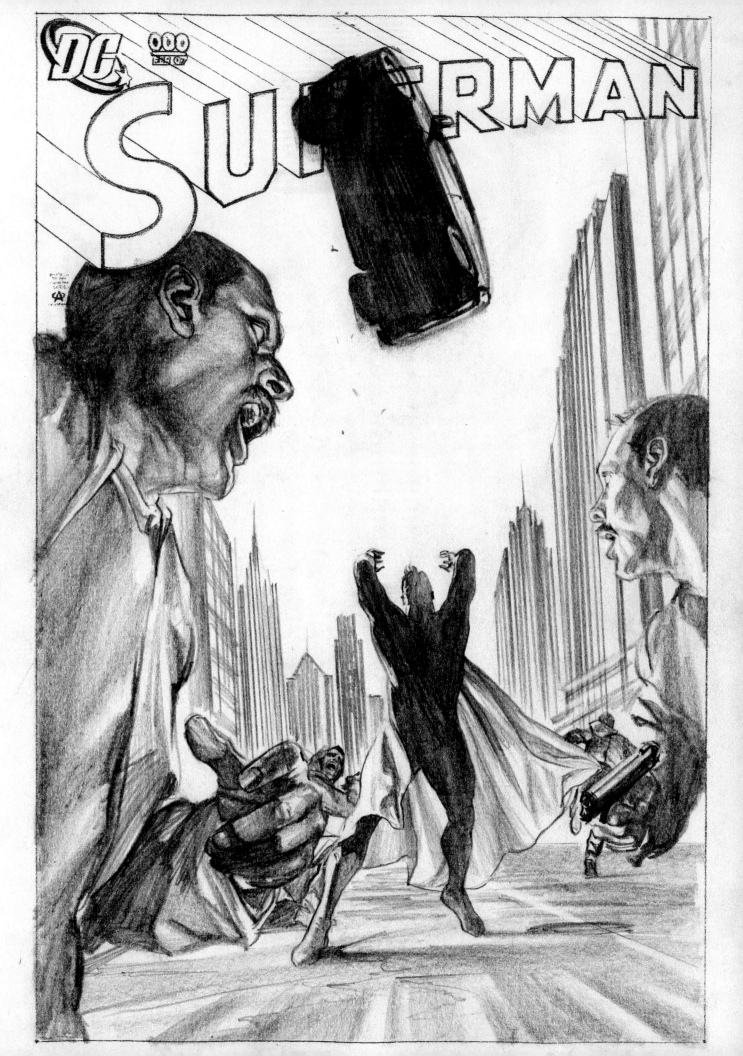

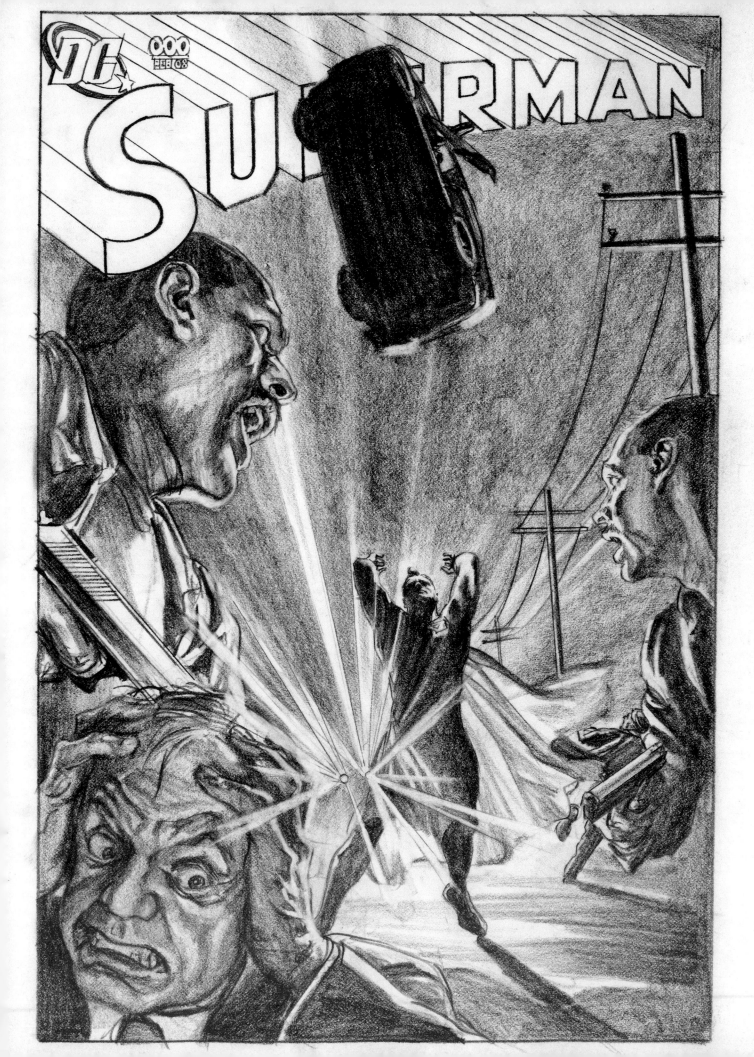

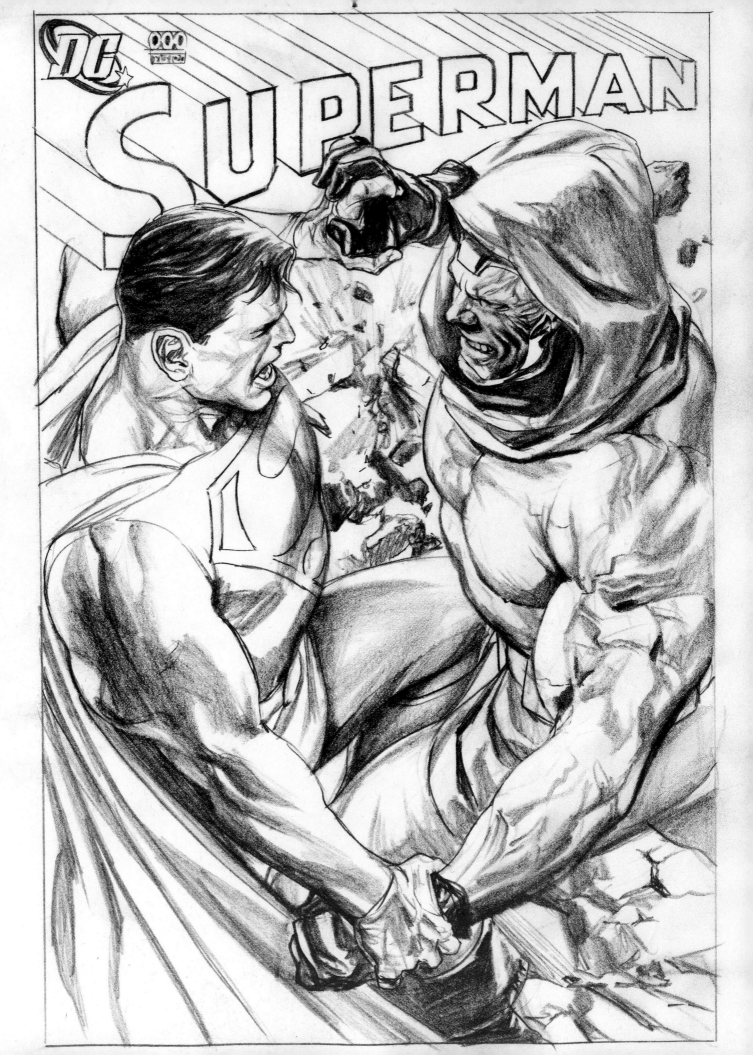

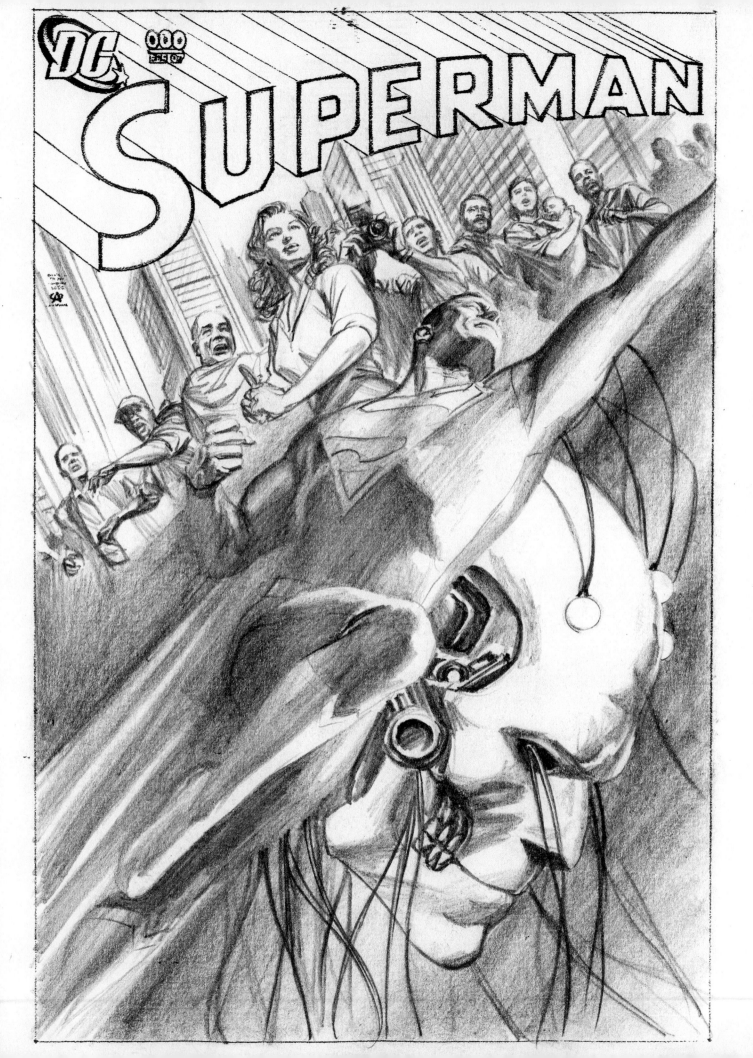

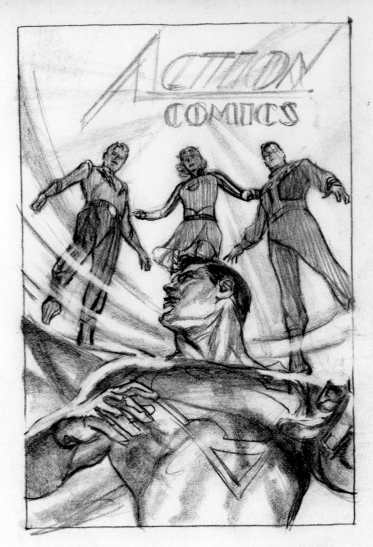

My enthusiasm for illustrating Superman has been the driving force behind my many years at DC, as well as the focus to my entire career. There are very few things I am as inspired about as the physical, unspoken graphic symbology of this character. Everything I wanted to do with him was intended to reconnect with the visual roots of Joe Shuster's design. The broader body and the squinting, hardened gaze were meant to reflect a seriousness of purpose in the man, who bore the responsibility of his power as an enormous invisible weight on his shoulders.

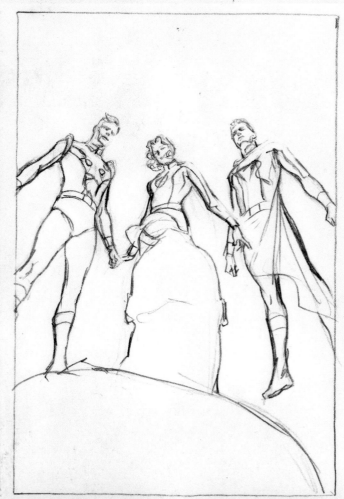

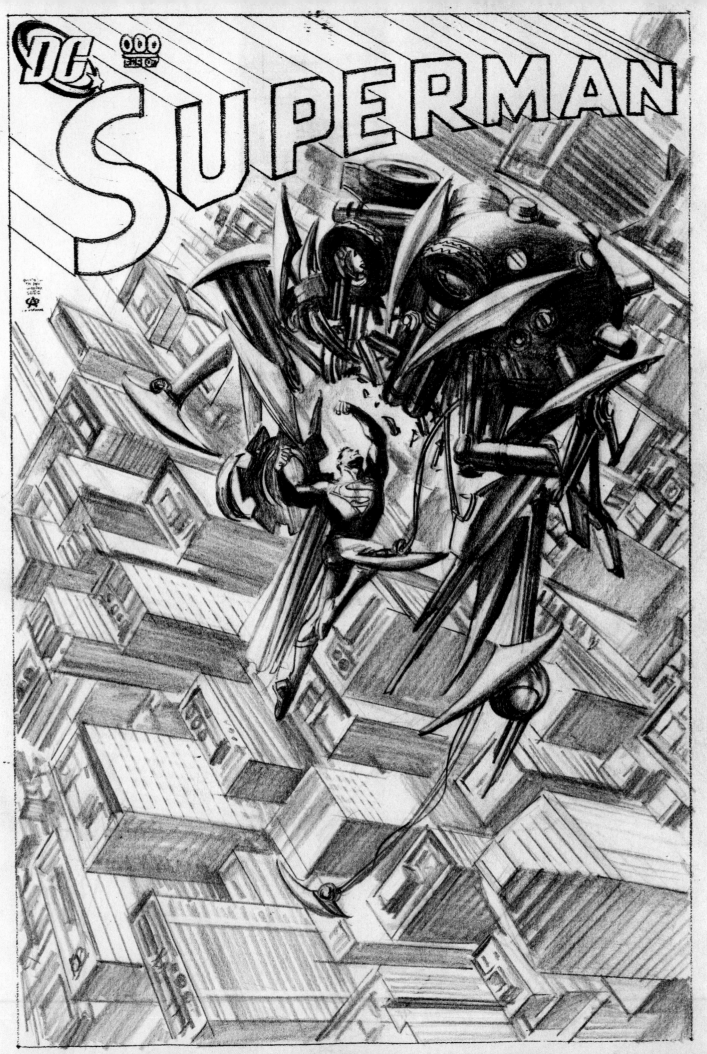

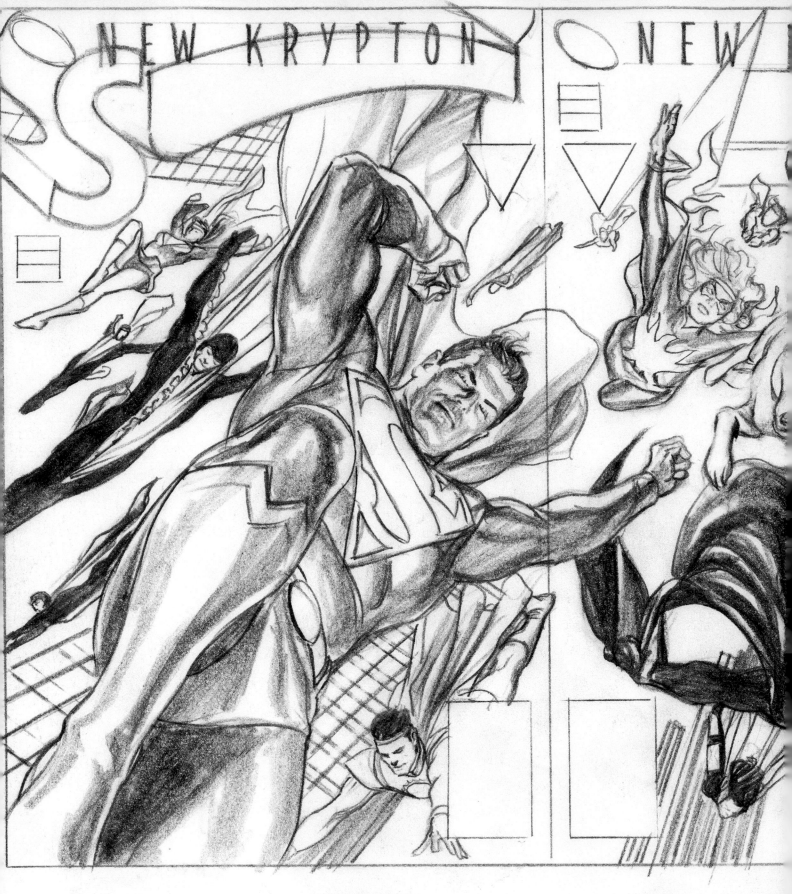

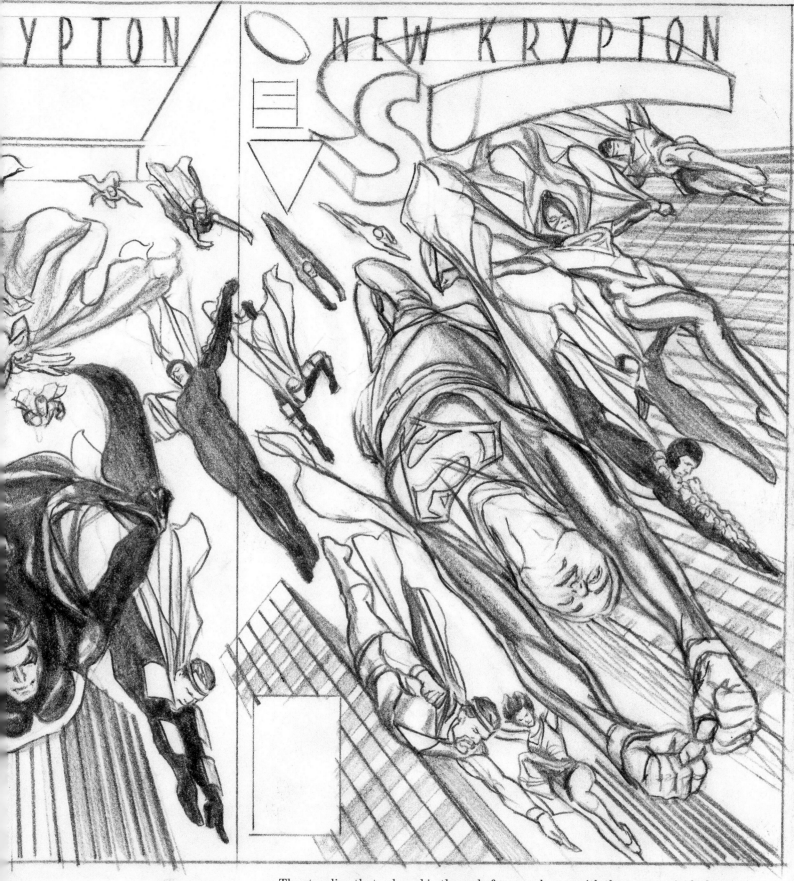

The storyline that ushered in the end of my run began with the mass revival of count-less Kryptonians, which prompted Superman to leave Earth, his job, his wife, and, strangely enough, his own title in order to go help them set up their own world, New Krypton. Somebody somewhere was going to be able to illustrate Superman; it would just no longer be me.

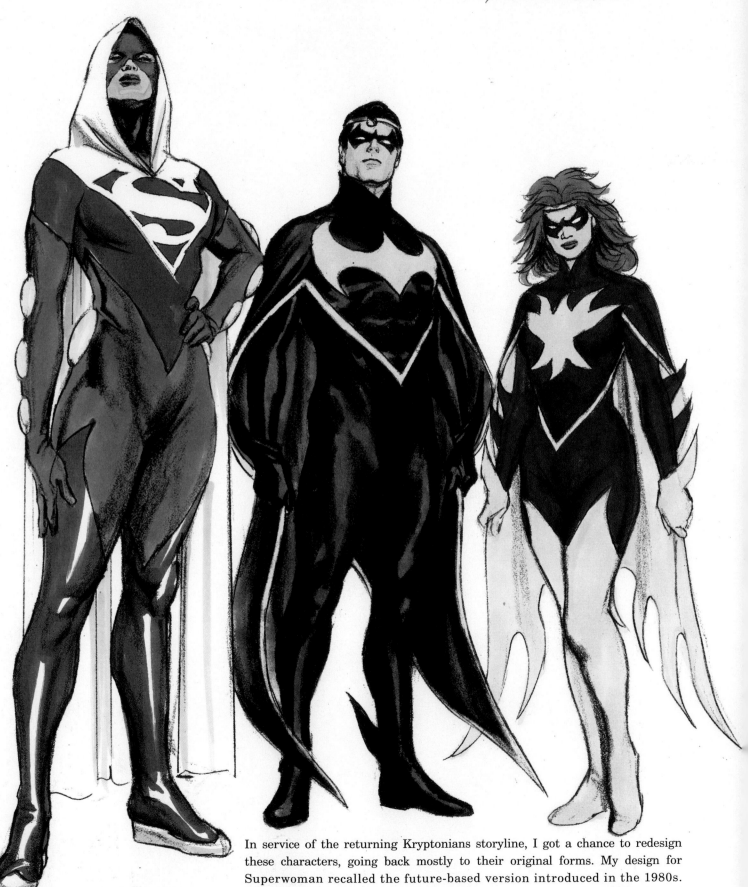

SUPERWOMAN

NIGHTWING

FLAMEBIRD

In service of the returning Kryptonians storyline, I got a chance to redesign these characters, going back mostly to their original forms. My design for Superwoman recalled the future-based version introduced in the 1980s. Nightwing had originally been just a Batman-style alter ego for Superman to use in the bottle city of Kandor, with Jimmy Olsen as a Robin-like Flamebird. New heroes now retake these names and costumes closer to where they came from.

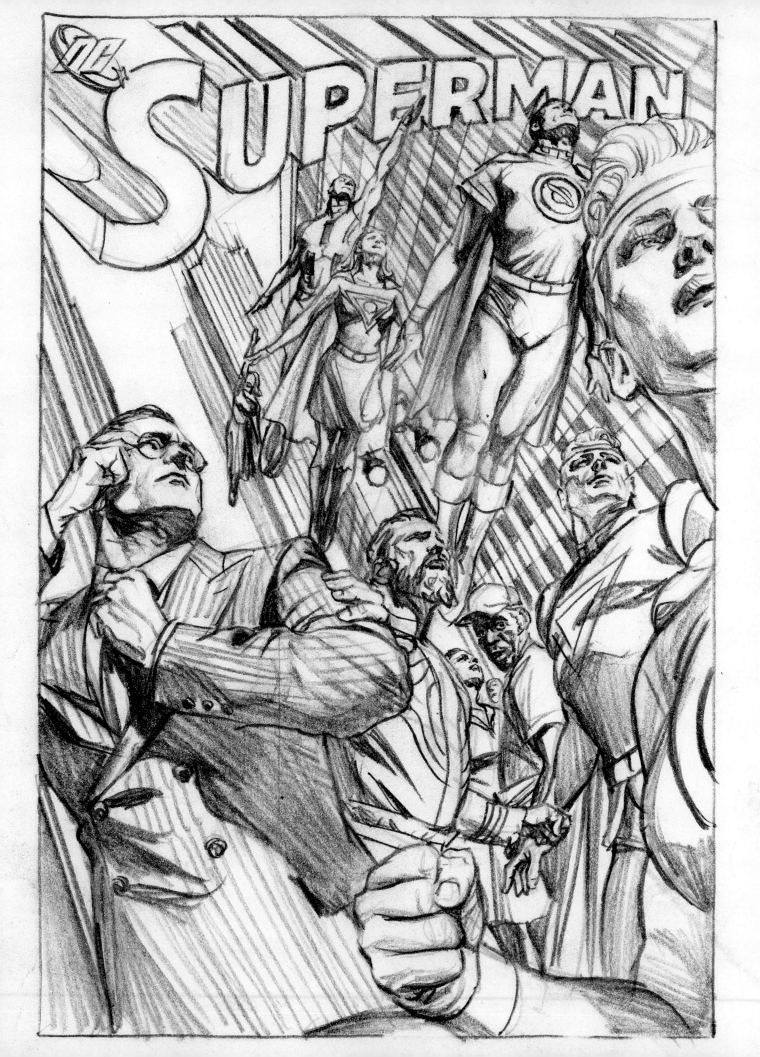

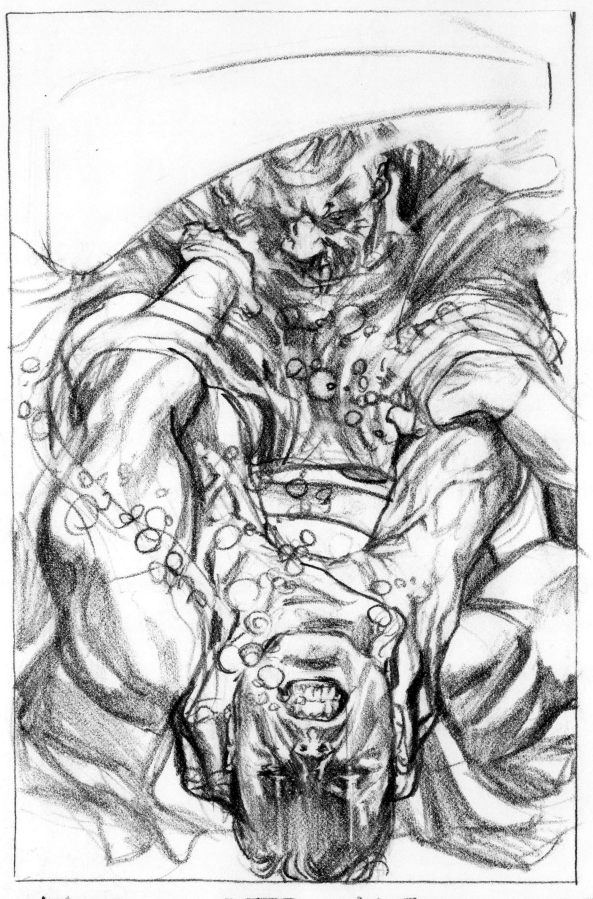

HEAD DUNKED UNDERWATER
SUPERMAN COVER

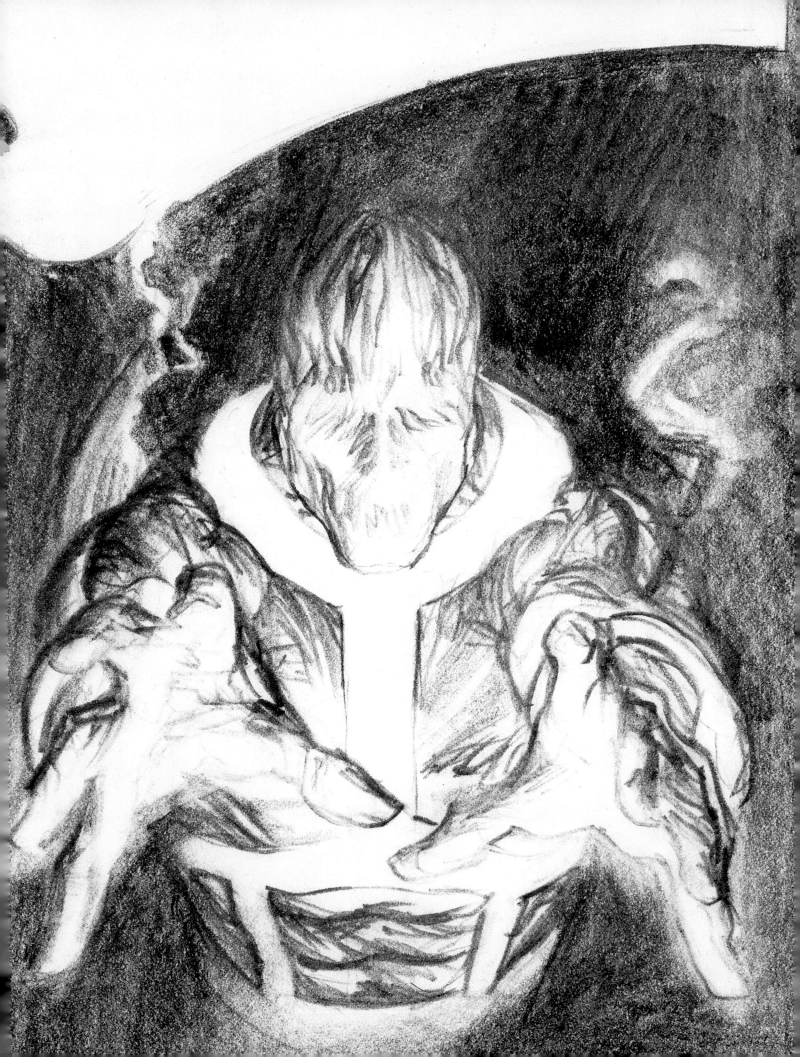

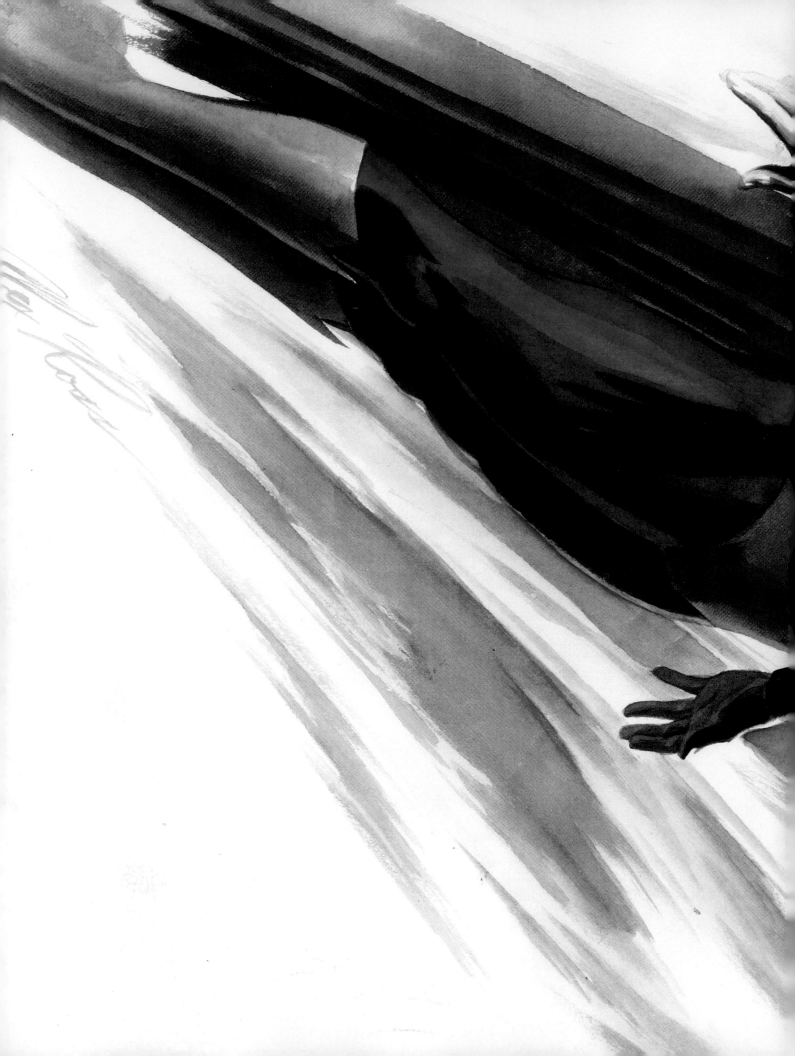

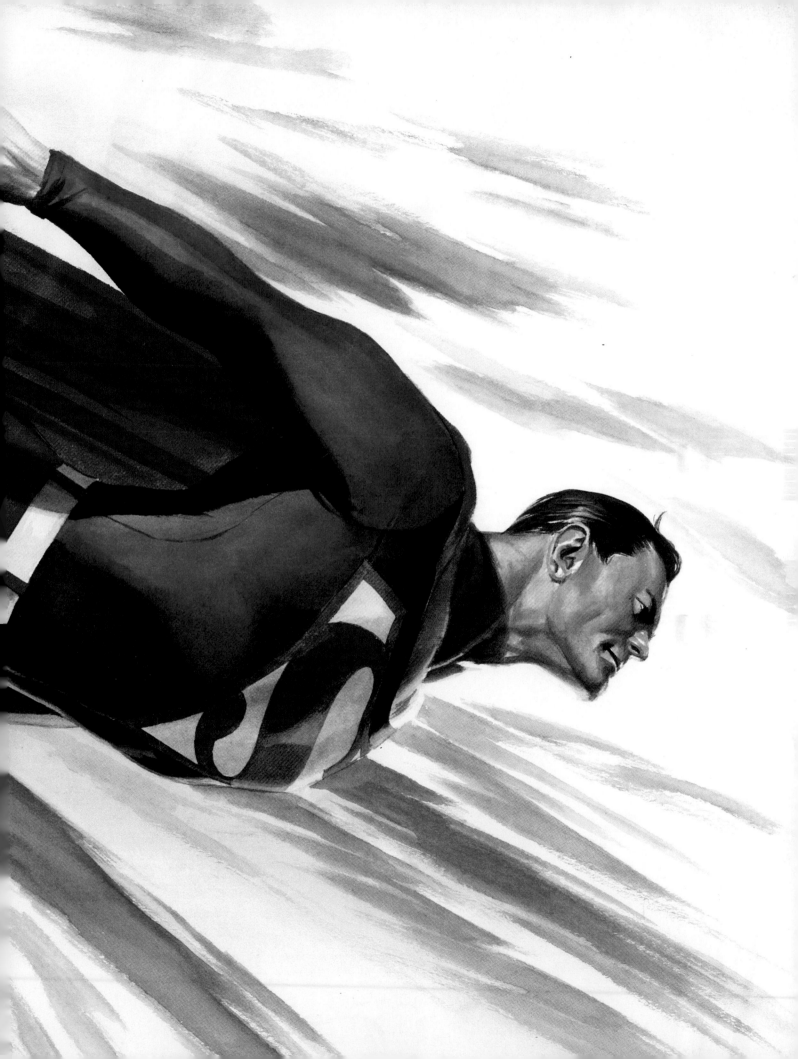

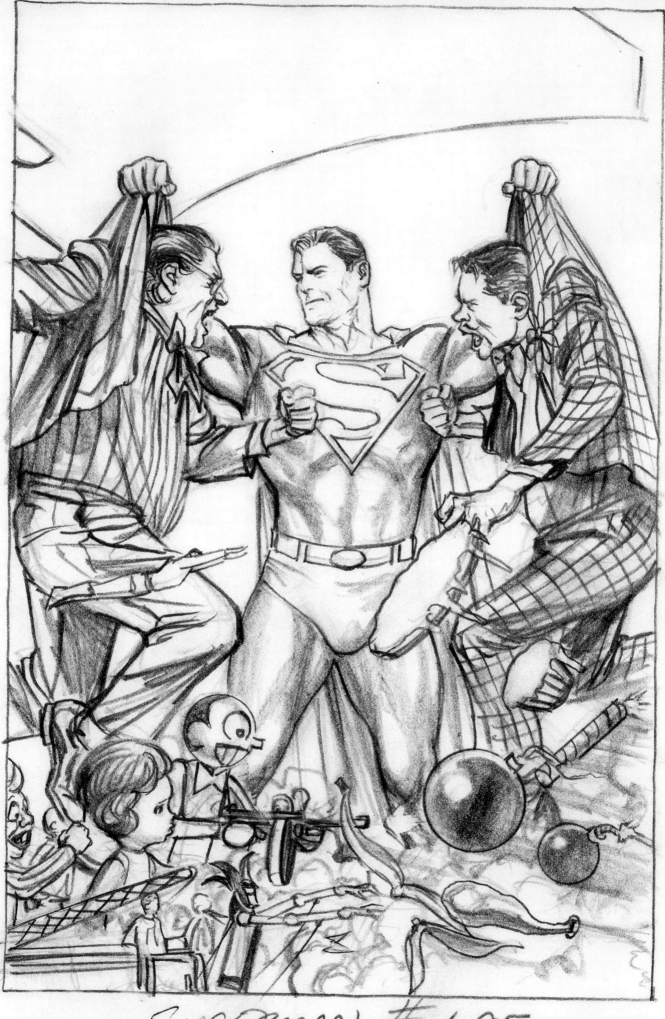

SUPERMAN # 685

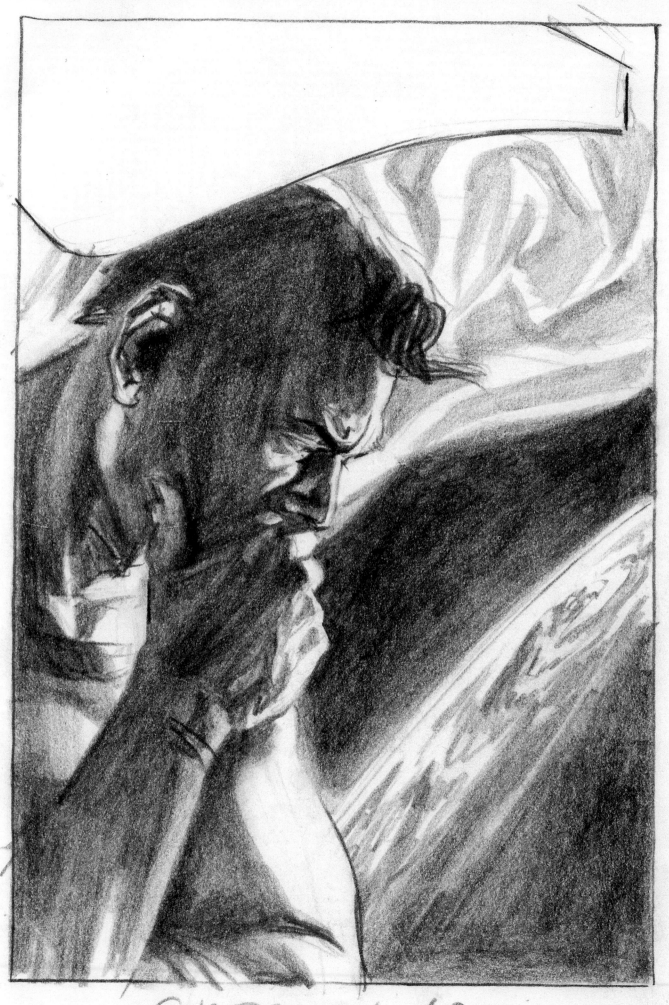

SUPERMAN 683

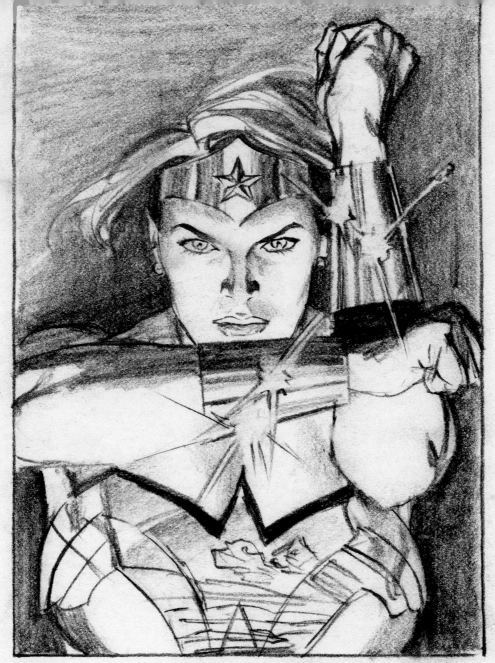

This spread: Designs inspired by the cover of *Mythology: The DC Comics Art of Alex Ross* (2003).

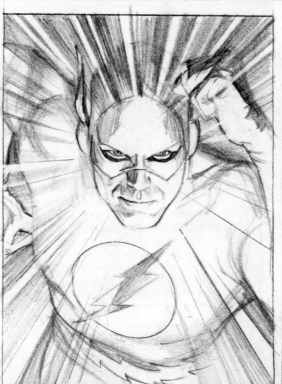

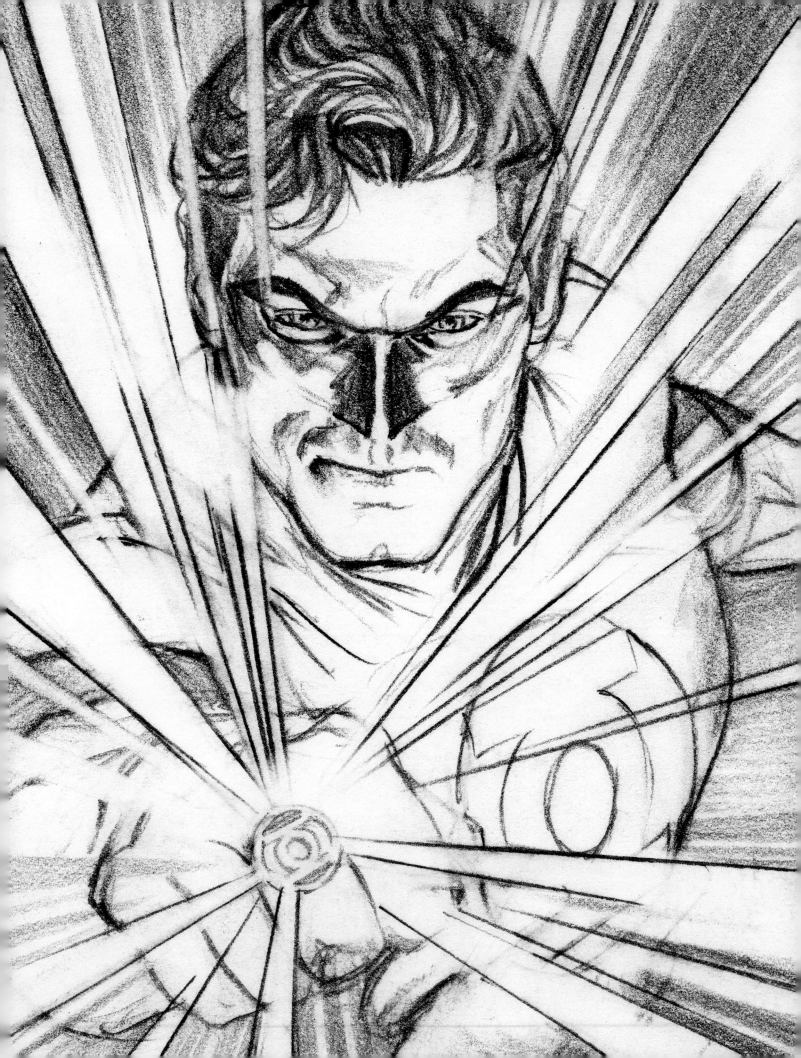

JUSTICE SOCIETY of AMERICA

BLACK BAR AT TOP

KINGDOM COME REDUX

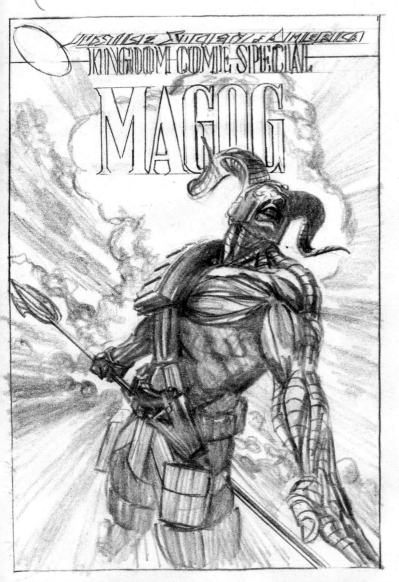

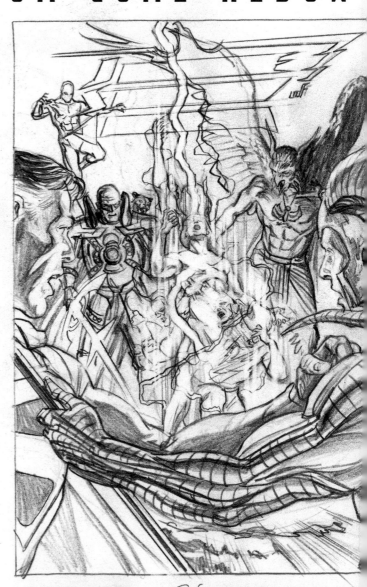

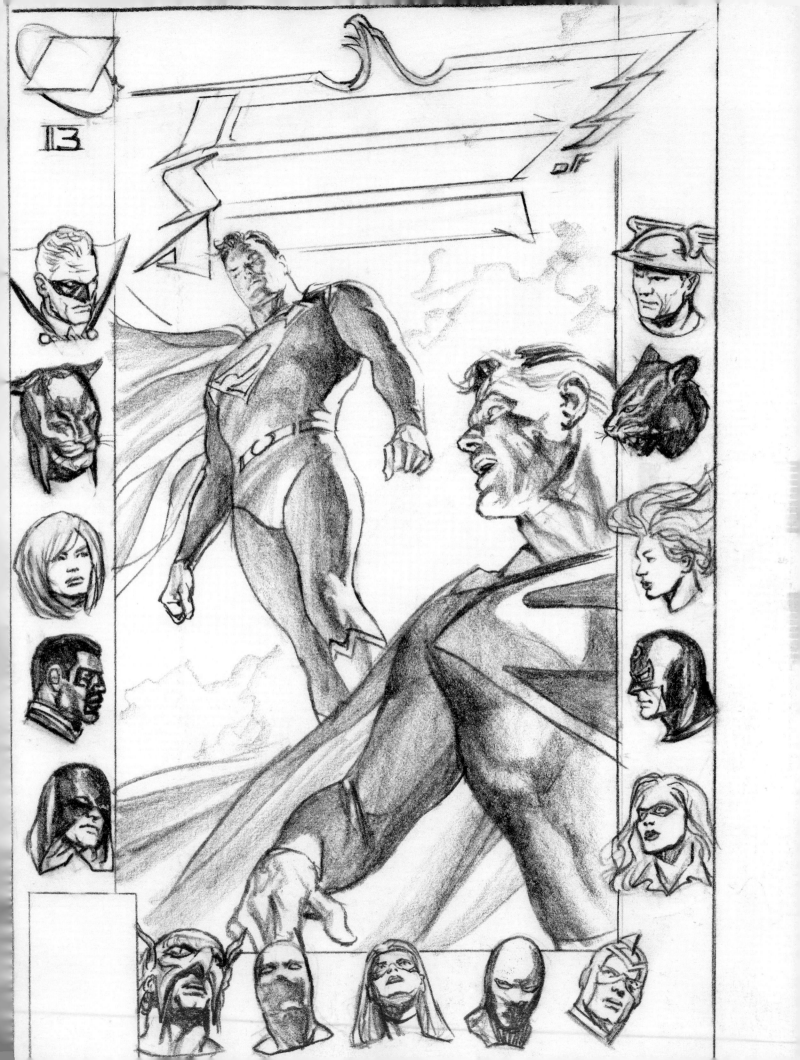

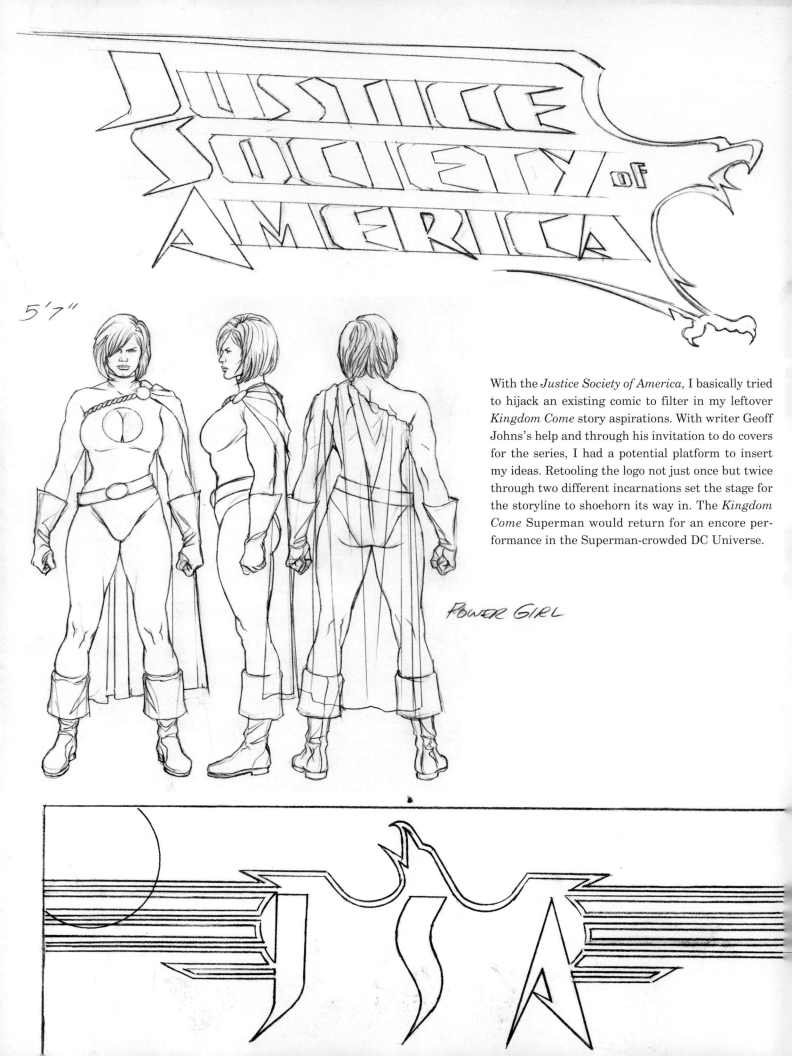

JUSTICE SOCIETY OF AMERICA

5'7"

POWER GIRL

With the *Justice Society of America*, I basically tried to hijack an existing comic to filter in my leftover *Kingdom Come* story aspirations. With writer Geoff Johns's help and through his invitation to do covers for the series, I had a potential platform to insert my ideas. Retooling the logo not just once but twice through two different incarnations set the stage for the storyline to shoehorn its way in. The *Kingdom Come* Superman would return for an encore performance in the Superman-crowded DC Universe.

JSA

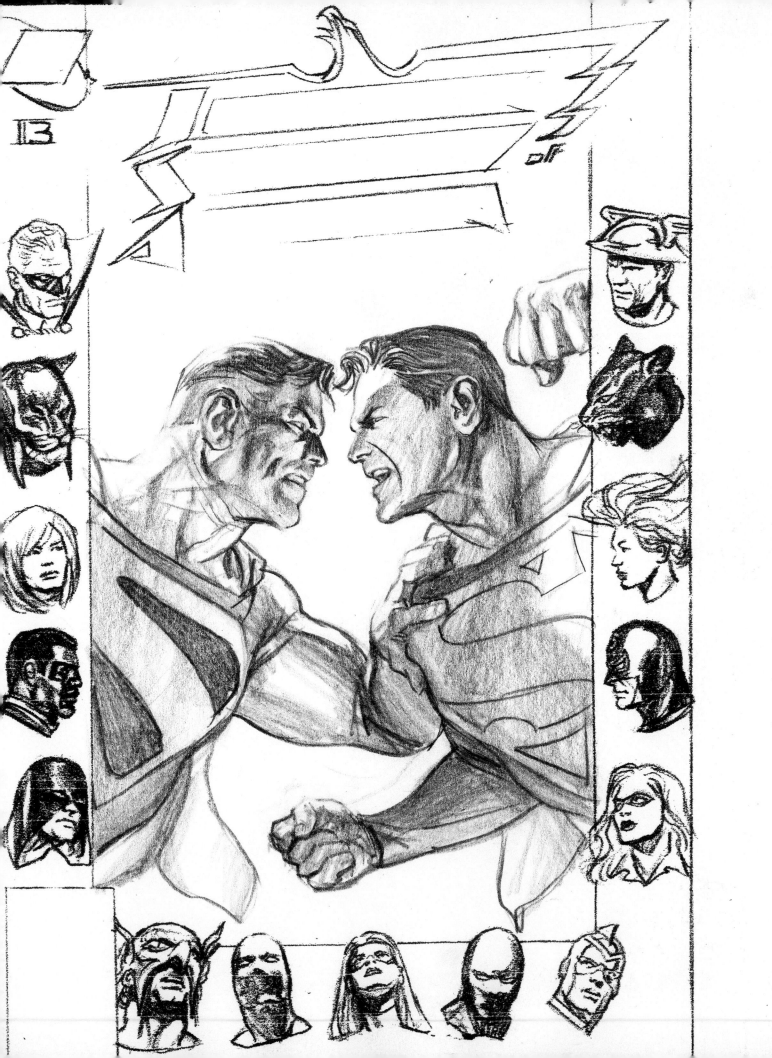

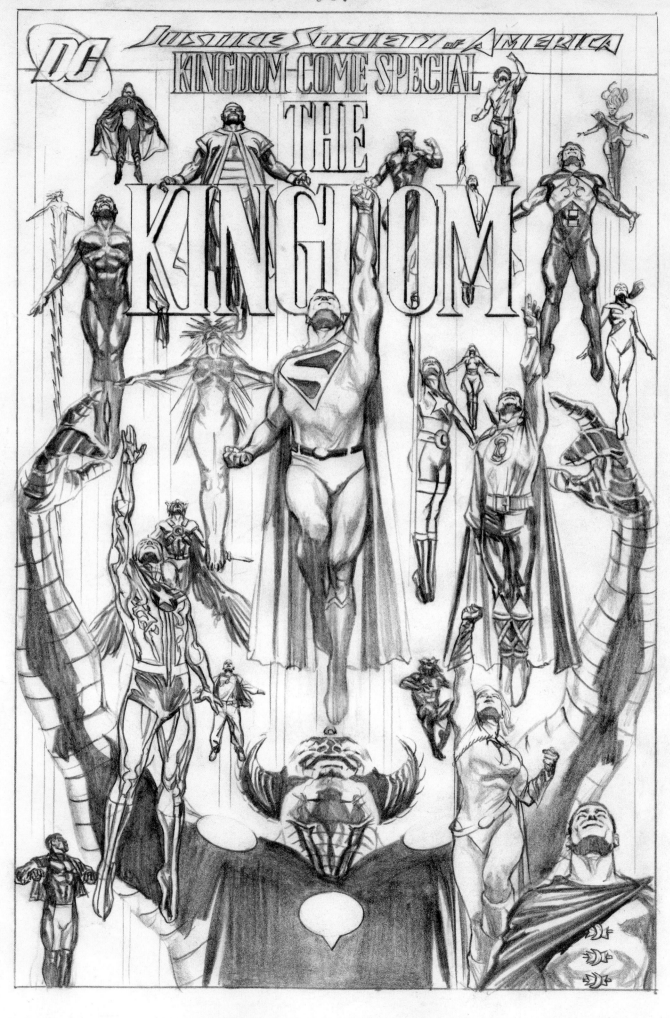

BLACK BAR AT TOP

MR. AMERICA

By reviving some decade-old concepts and unused character designs, I had a new chance to take a stab at a previous project that I had originally named *The Kingdom*, which I ultimately walked away from. The old ideas I had about the future of *Kingdom Come* haunting the present-day DCU were finding root easily in the confines of the *JSA* series.

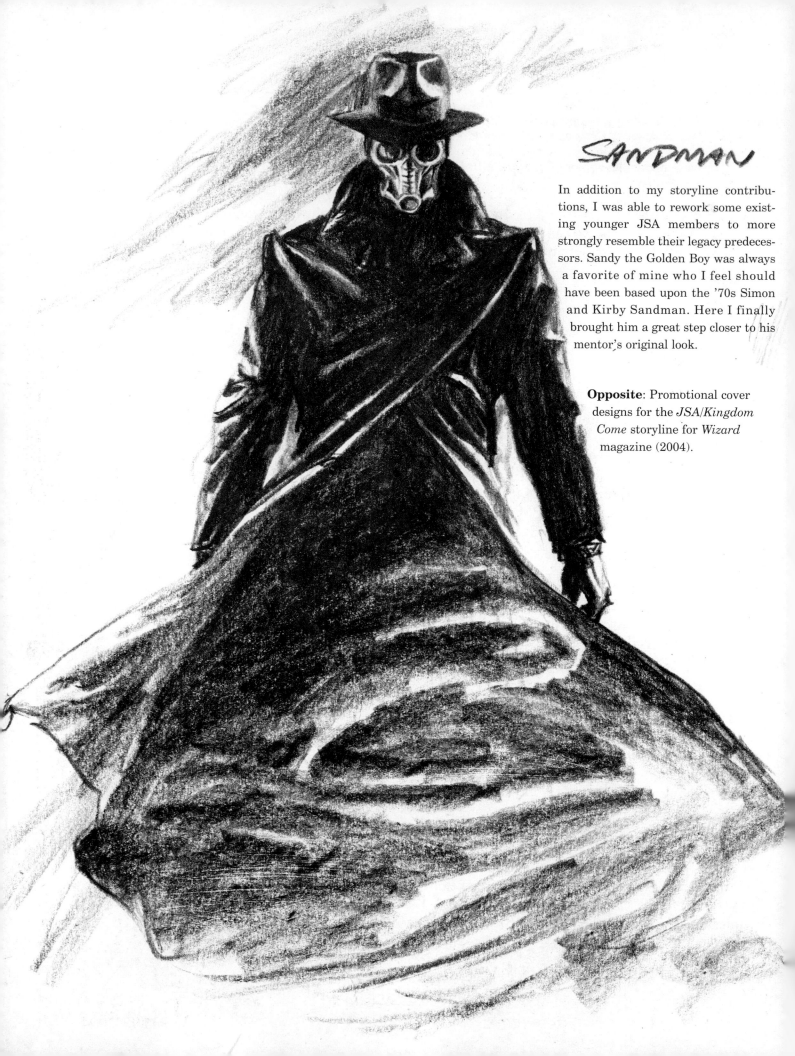

SANDMAN

In addition to my storyline contributions, I was able to rework some existing younger JSA members to more strongly resemble their legacy predecessors. Sandy the Golden Boy was always a favorite of mine who I feel should have been based upon the '70s Simon and Kirby Sandman. Here I finally brought him a great step closer to his mentor's original look.

Opposite: Promotional cover designs for the *JSA/Kingdom Come* storyline for *Wizard* magazine (2004).

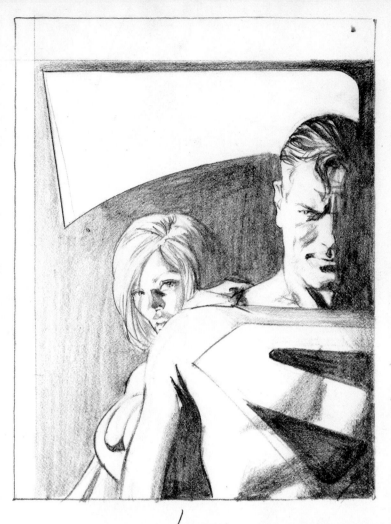

1

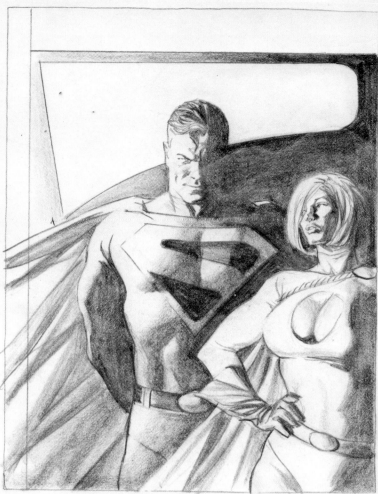

1

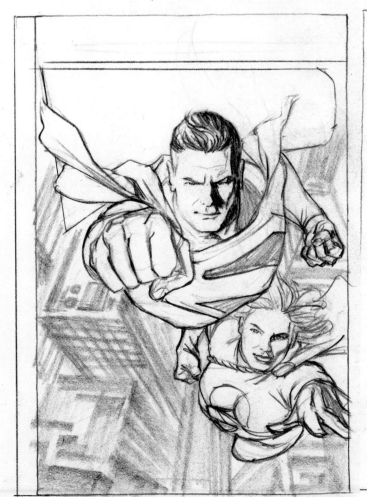

3

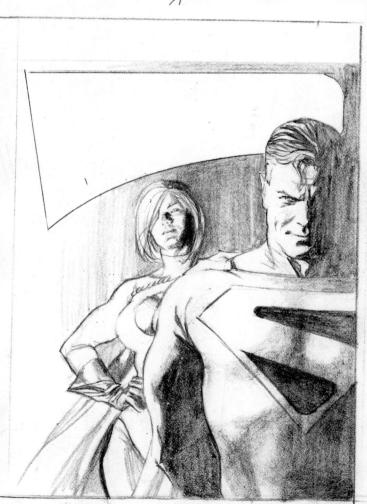

2

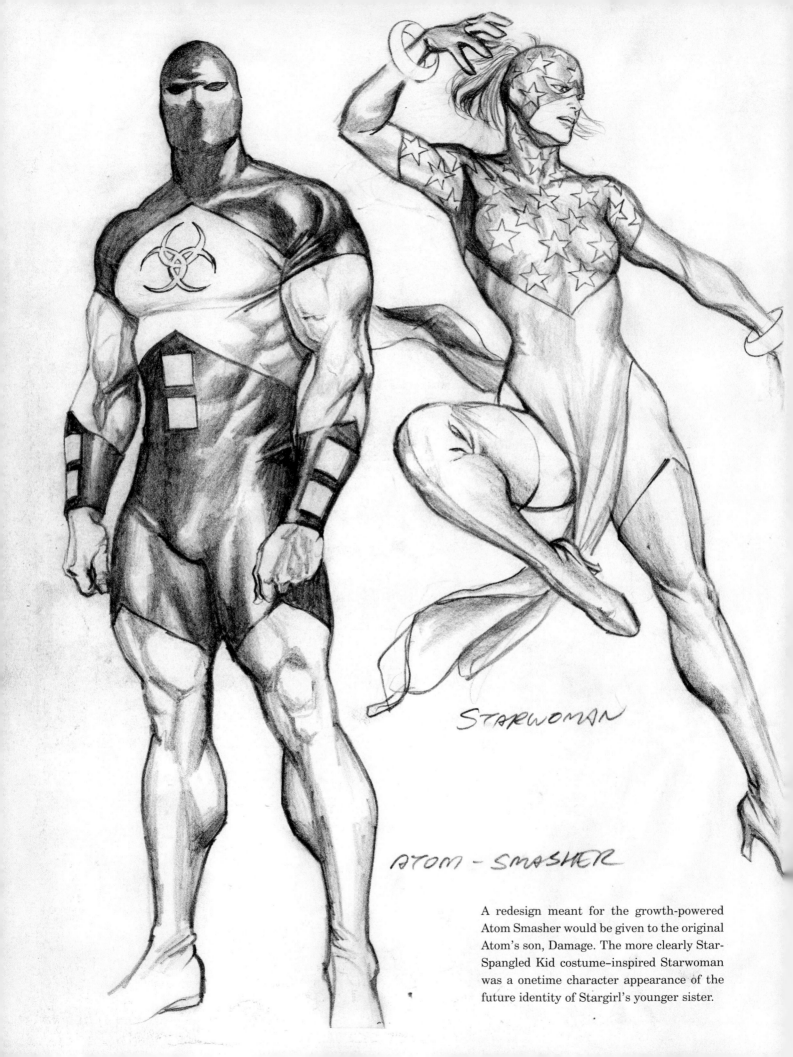

STARWOMAN

ATOM-SMASHER

A redesign meant for the growth-powered Atom Smasher would be given to the original Atom's son, Damage. The more clearly Star-Spangled Kid costume–inspired Starwoman was a onetime character appearance of the future identity of Stargirl's younger sister.

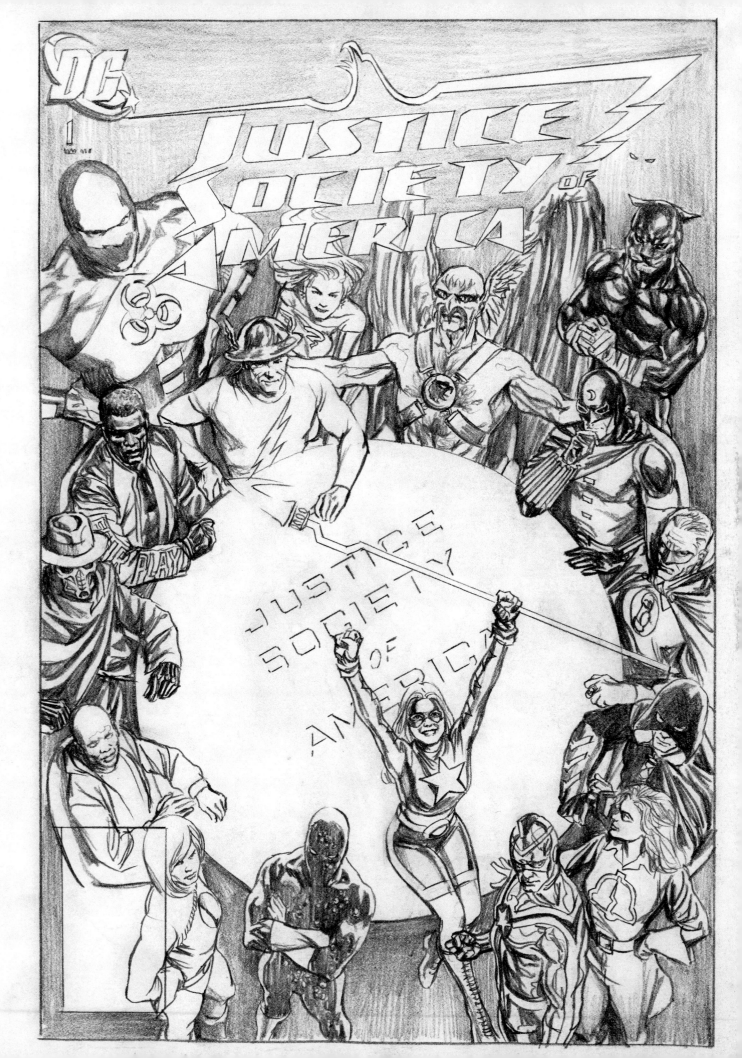

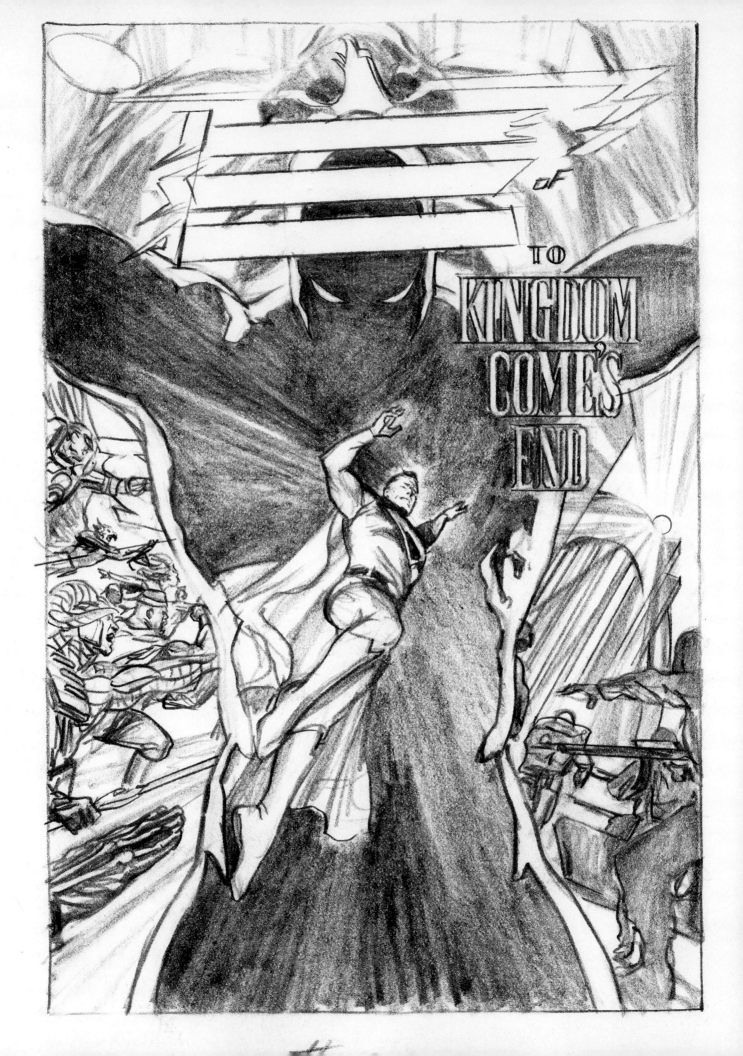

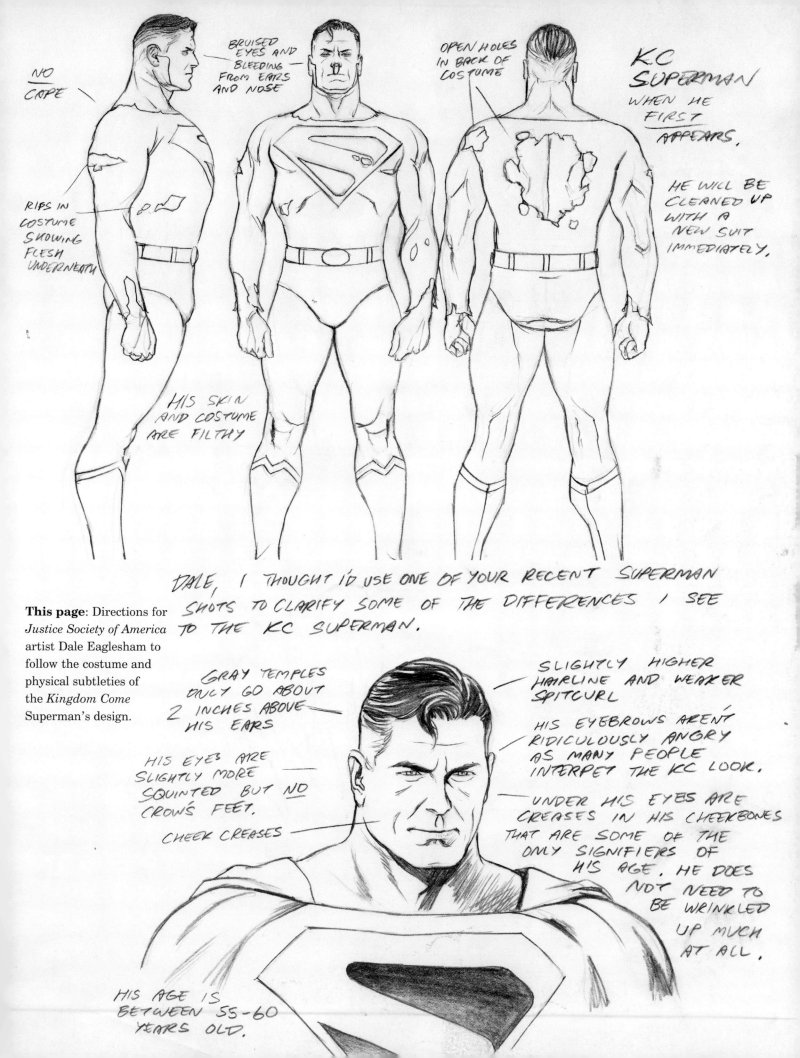

This page: Directions for *Justice Society of America* artist Dale Eaglesham to follow the costume and physical subtleties of the *Kingdom Come* Superman's design.

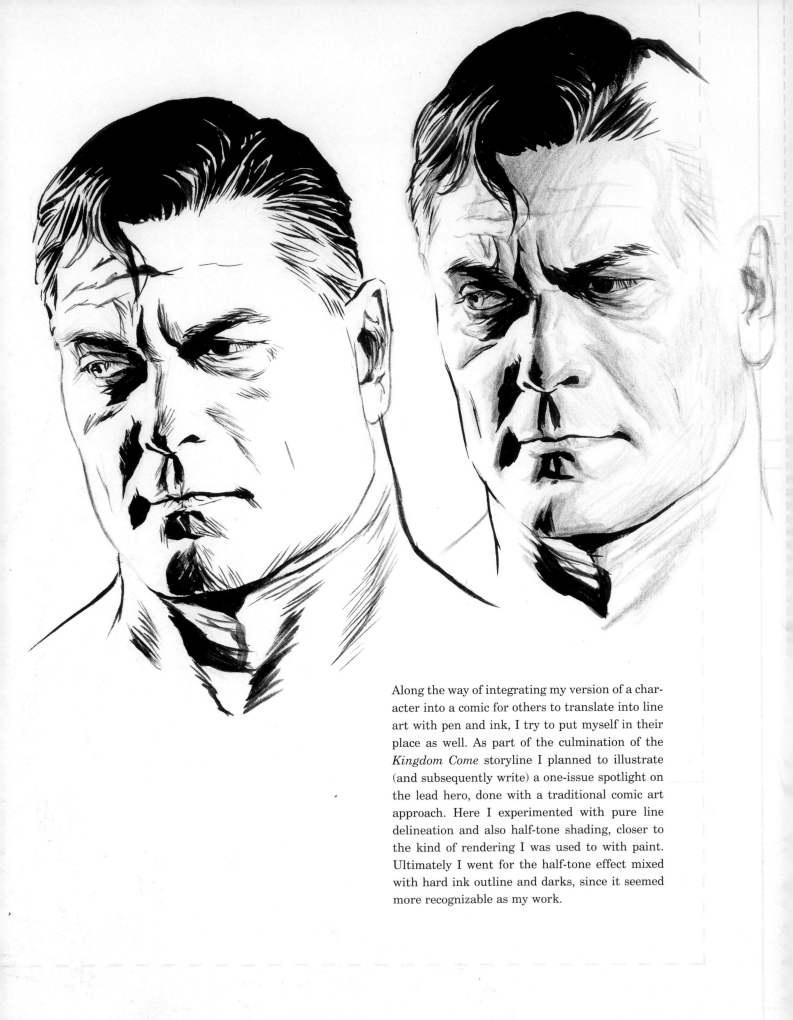

Along the way of integrating my version of a character into a comic for others to translate into line art with pen and ink, I try to put myself in their place as well. As part of the culmination of the *Kingdom Come* storyline I planned to illustrate (and subsequently write) a one-issue spotlight on the lead hero, done with a traditional comic art approach. Here I experimented with pure line delineation and also half-tone shading, closer to the kind of rendering I was used to with paint. Ultimately I went for the half-tone effect mixed with hard ink outline and darks, since it seemed more recognizable as my work.

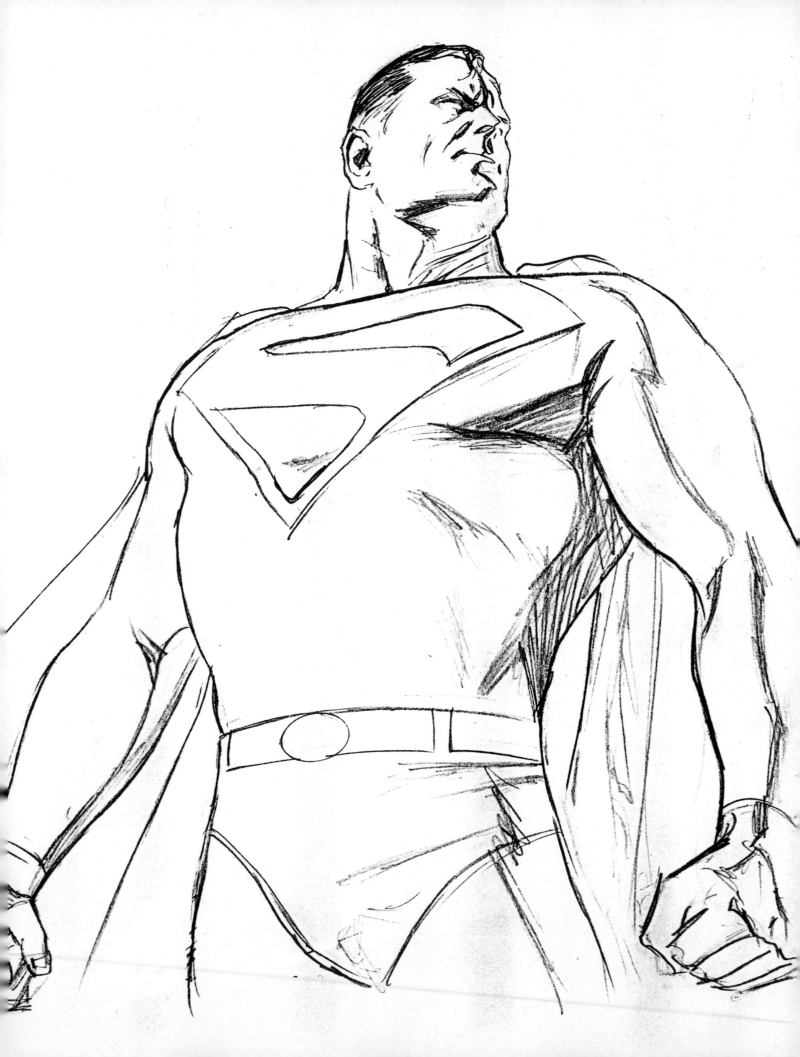

One of my greater storyline goals that never reached fruition in my time with the Justice Society was fully returning the *Kingdom Come* Starman (whom I talked Geoff Johns into introducing in the series) to his native time period and to his love, Dream Girl. Early in the collaboration with Geoff, I designed this clear cover homage to unite the JSA story with one of my favorite Mike Grell wraparound images. Ultimately the series took many turns that didn't allow this to be entirely possible. It always pains me to feel like I left a composition unexplored.

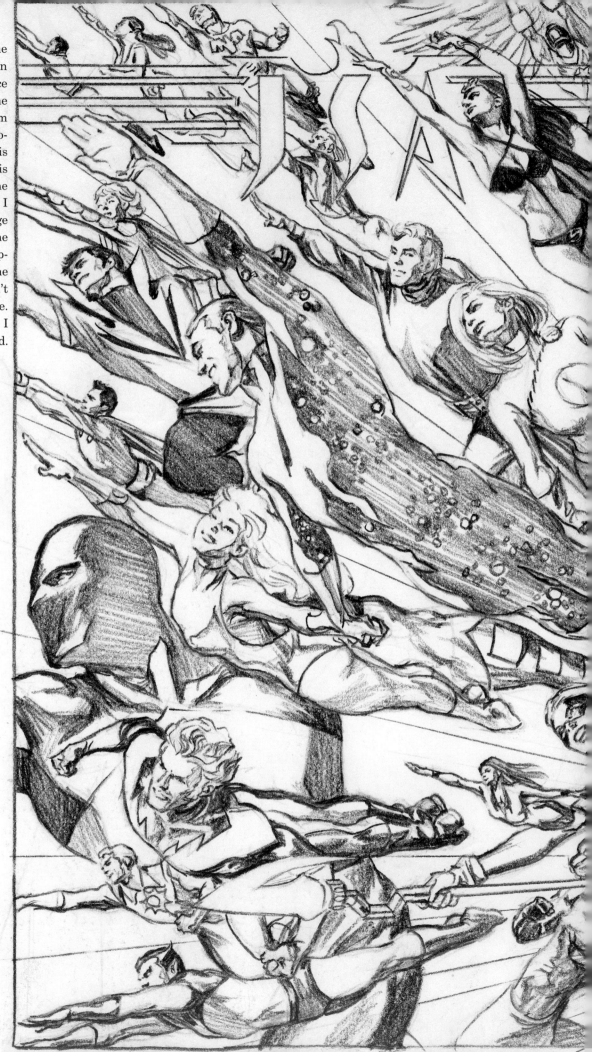

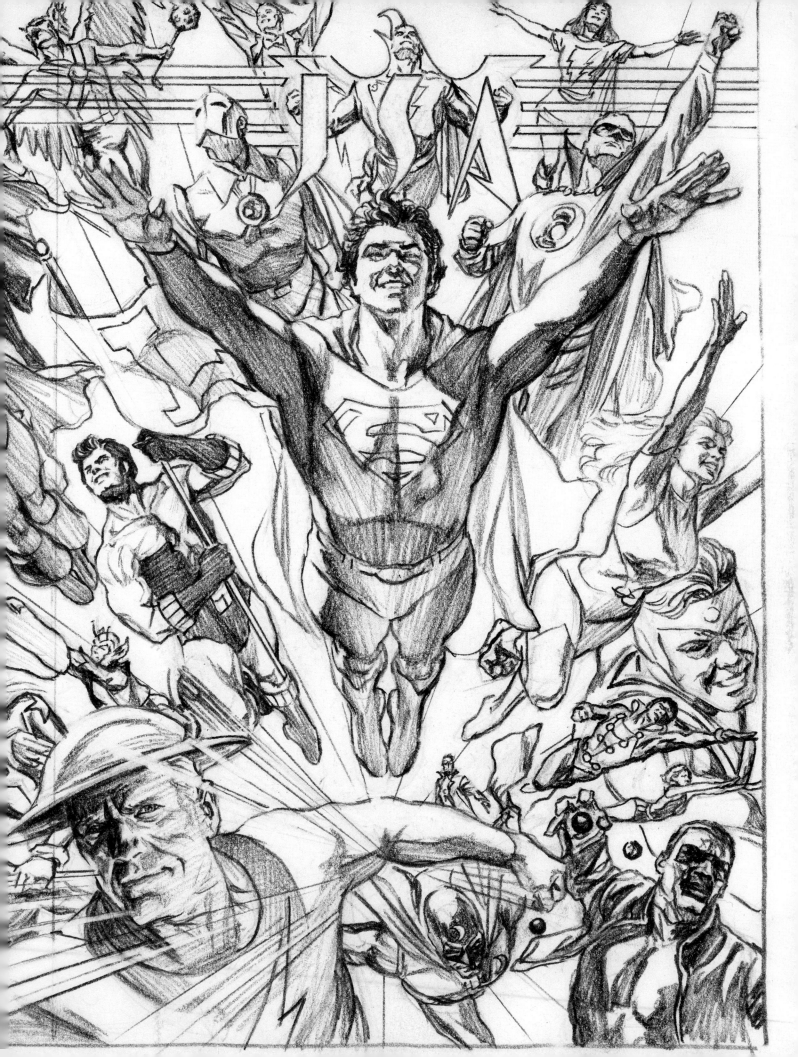

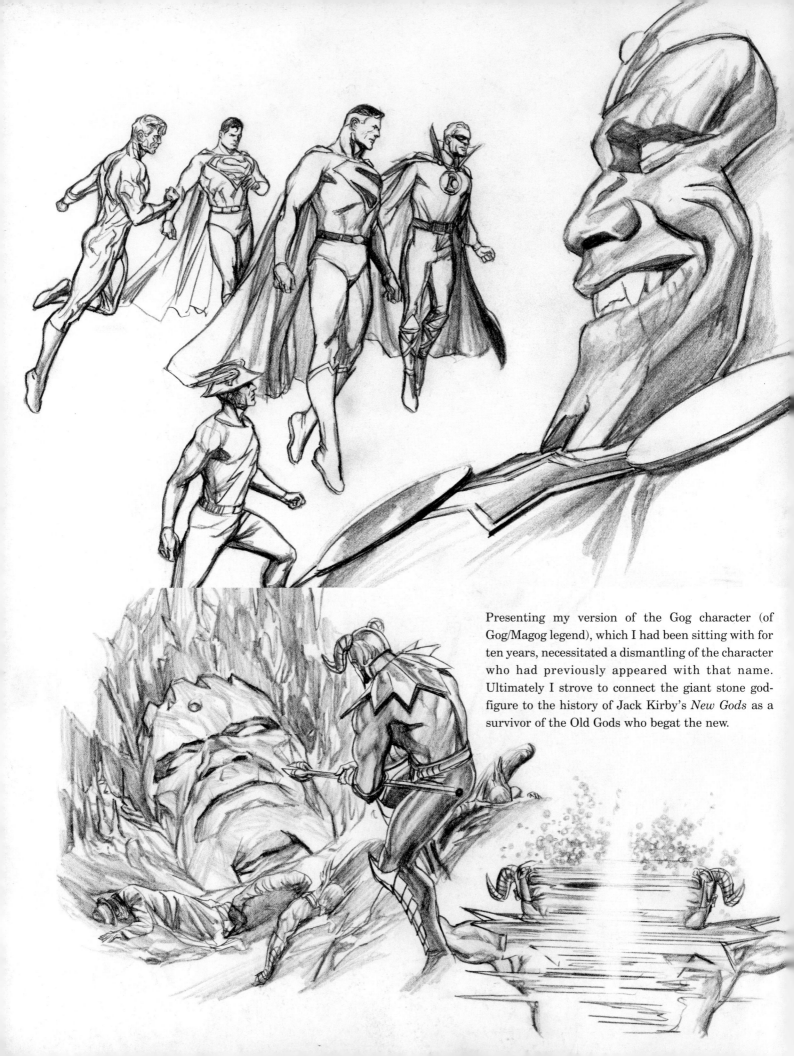

Presenting my version of the Gog character (of Gog/Magog legend), which I had been sitting with for ten years, necessitated a dismantling of the character who had previously appeared with that name. Ultimately I strove to connect the giant stone god-figure to the history of Jack Kirby's *New Gods* as a survivor of the Old Gods who begat the new.

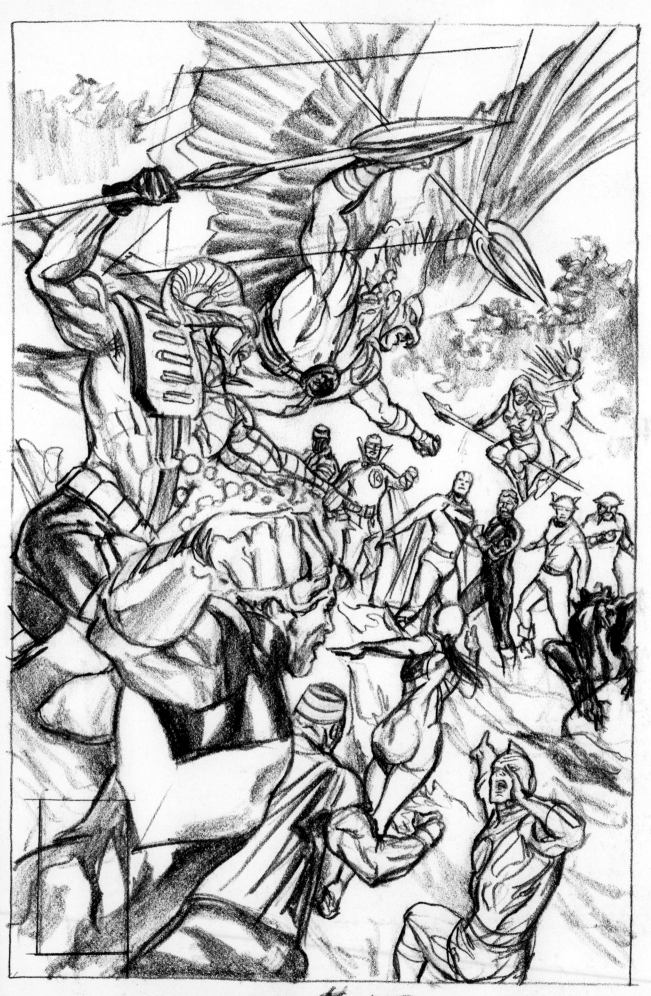

JSA #19

EARTH-22

11 ALL KC

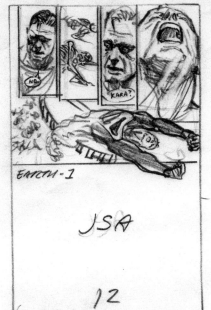

EARTH-1

JSA

12

EARTH-1

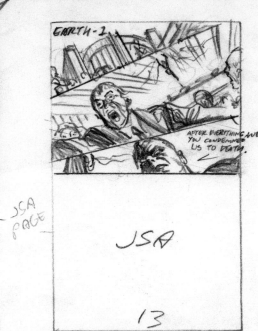

AFTER EVERYTHING WE DID FOR YOU CONDEMNED US TO DEATH.

JSA

13

JSA PAGE

EARTH-22

CLARK, DON'T.

EARTH-1

JSA

14

EARTH-22

EARTH-1

ALIVE?

JSA

15

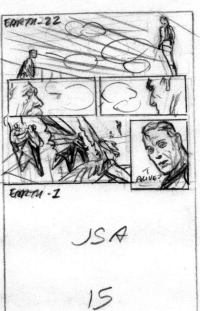

EARTH-22

MAGOG

THANK YOU.

EARTH-1

JSA

16

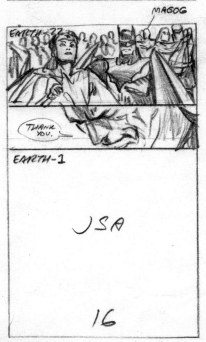

EARTH-22

UNDER PAGE

17 ALL KC

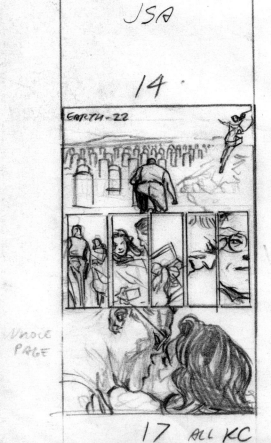

EARTH-22
10 YEARS LATER

EARTH-1

JSA

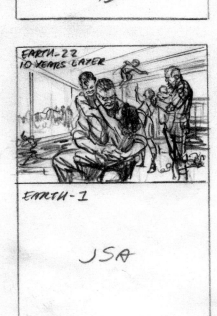

EARTH-22
20 YEARS LATER

EARTH-1

JSA

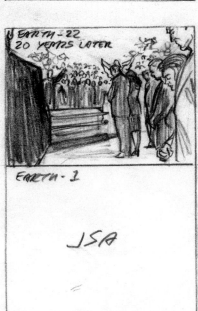

Concluding the *Kingdom Come* story, I never planned to take anything away from the original limited series. I considered the conclusion of the original series something not to be disputed or amended; the *JSA* storyline fit in a space between pages. When Superman was caught in the enormous nuclear blast that brought an end to the age of super heroes, the Kingdom Come he was blown to was the present mainstream DC world. It was always my plan to return him to his time, his world, at the exact moment he left it. He would revisit that conclusion in our pages with our knowing that the story played out as it had originally, with the added insight that he experiences an additional heart-wrenching adventure elsewhere that he feels damns him to belong to the world of *Kingdom Come*. Once returned, though, things got better, and as the new pages I created for the issues' conclusion showed, Superman had a long, rich life ahead of him, and a happier ending than we had revealed before.

REPLACE
JUDOMASTER
CITIZEN STEEL WITH
AMAZING MAN

20

LIBERTY BELLE
HOURMAN
MR. TERRIFIC

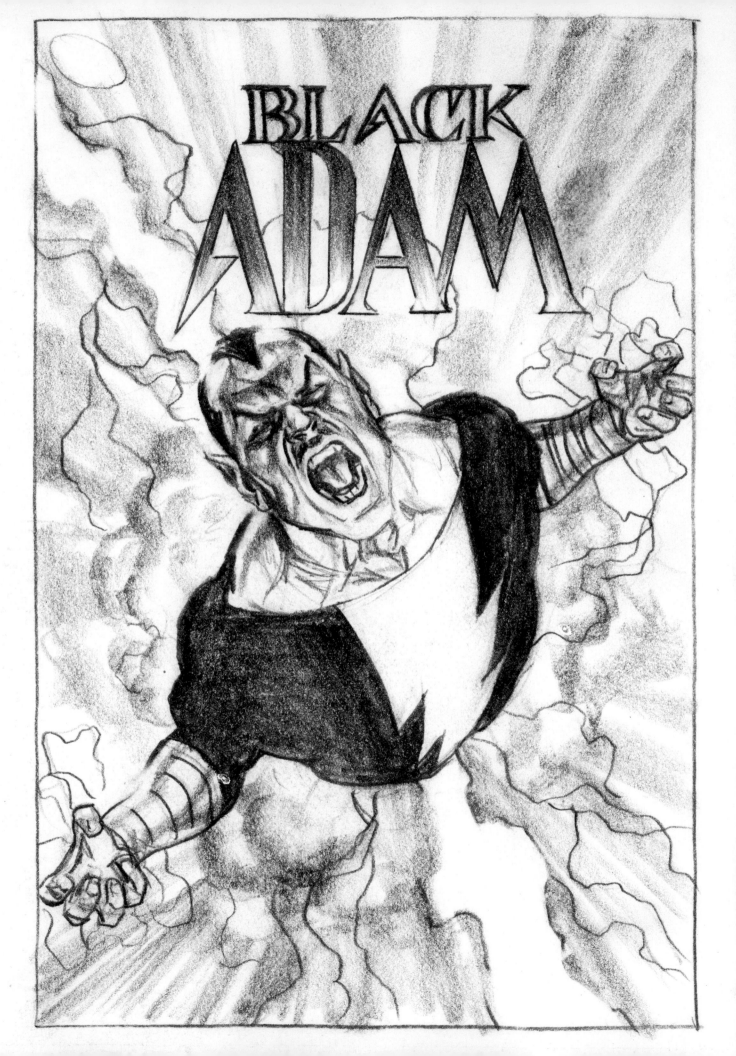

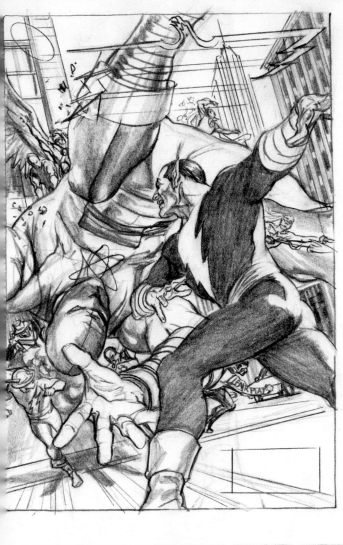
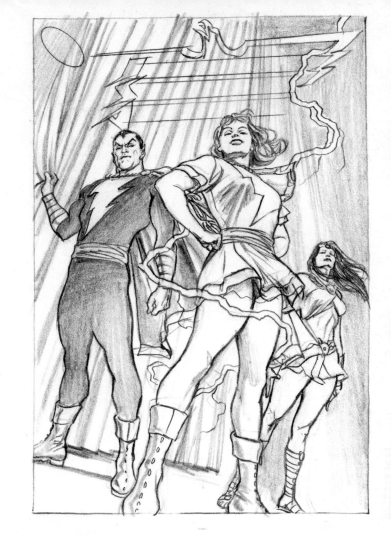

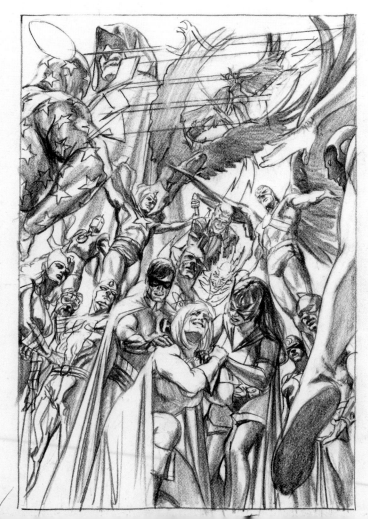

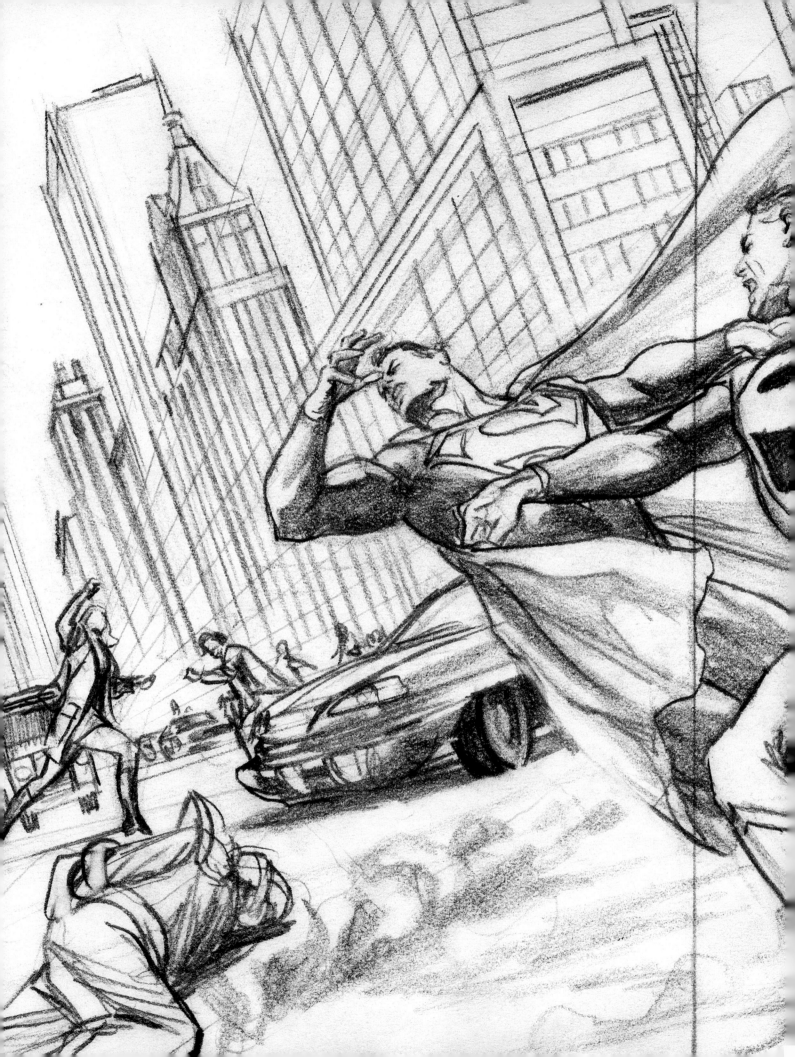

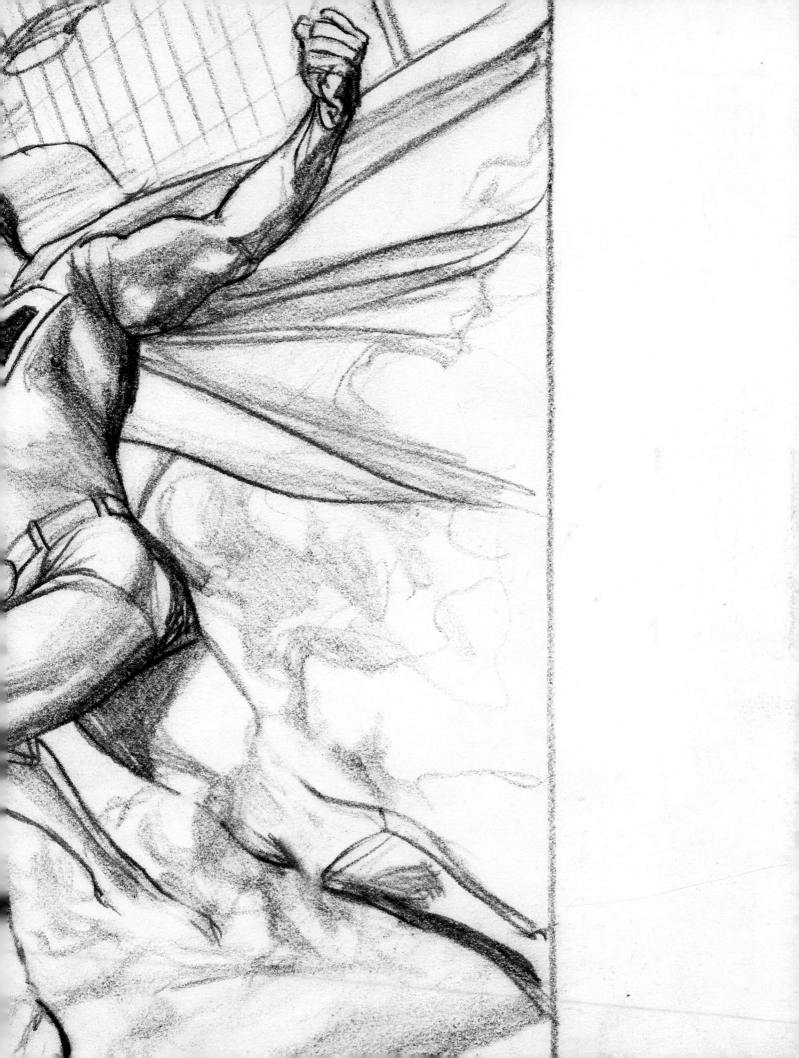

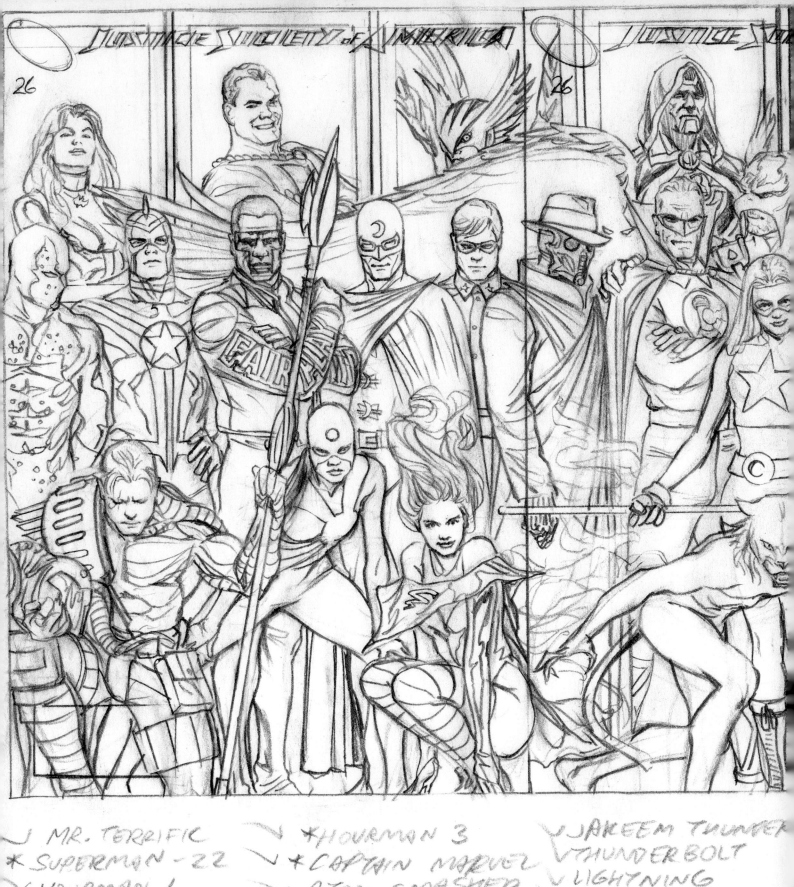

✓ MR. TERRIFIC

✗ SUPERMAN - 22

✓ HOURMAN 1

✓ HOURMAN 2

✓ STARGIRL

✓ DAMAGE

✓ CITIZEN STEEL

✓ FLASH 1

✓ GREEN LANTERN

✓ ✗ HOURMAN 3

✓ ✗ CAPTAIN MARVEL

✓ ATOM SMASHER

✓ OBSIDIAN

✓ ✗ HAWKGIRL

✓ SANDMAN 3

DR. MIDNIGHT 2

✓ HAWKMAN 1

✓ WILDCAT 1

✓ JAKEEM THUNDER

✓ THUNDERBOLT

✓ LIGHTNING

✓ AMAZING MAN 2

✓ ✗ DR. FATE

✓ STARMAN LEGION

✓ POWER GIRL

✓ LIBERTY BELLE

✓ ✗ STARMAN (JACK

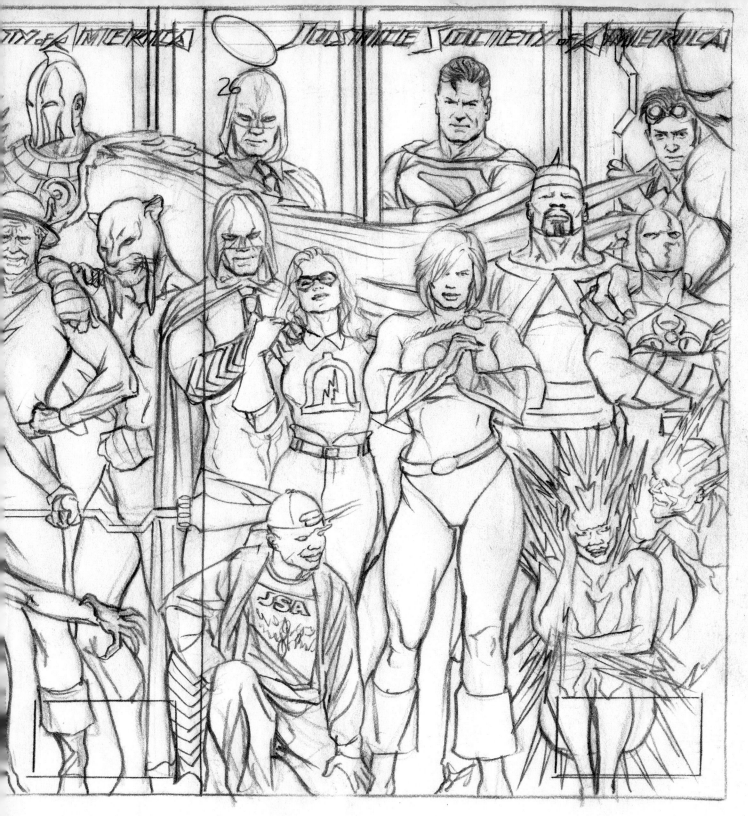

MAGOG
UDO MASTER
MR. AMERICA

Closing out my time as the cover artist and part-time story contributor, I wanted to create a complementary design for a double cover I did for *Justice League of America* #12. This image was meant to be a celebration of an era of storytelling by Geoff Johns and the extensive ranks of the team where we left it, acknowledging the past members of this era in portraits behind the group. The Justice Society was about community among super heroes, forging lines across generations.

GOLDEN AGE
GREEN LANTERN

6'1"

Below: Turnaround art for Golden Age Green Lantern action figure for *Justice Society of America* wave 1.

Opposite: Turnaround art for Golden Age Flash action figure for *Justice Society of America* wave 1.

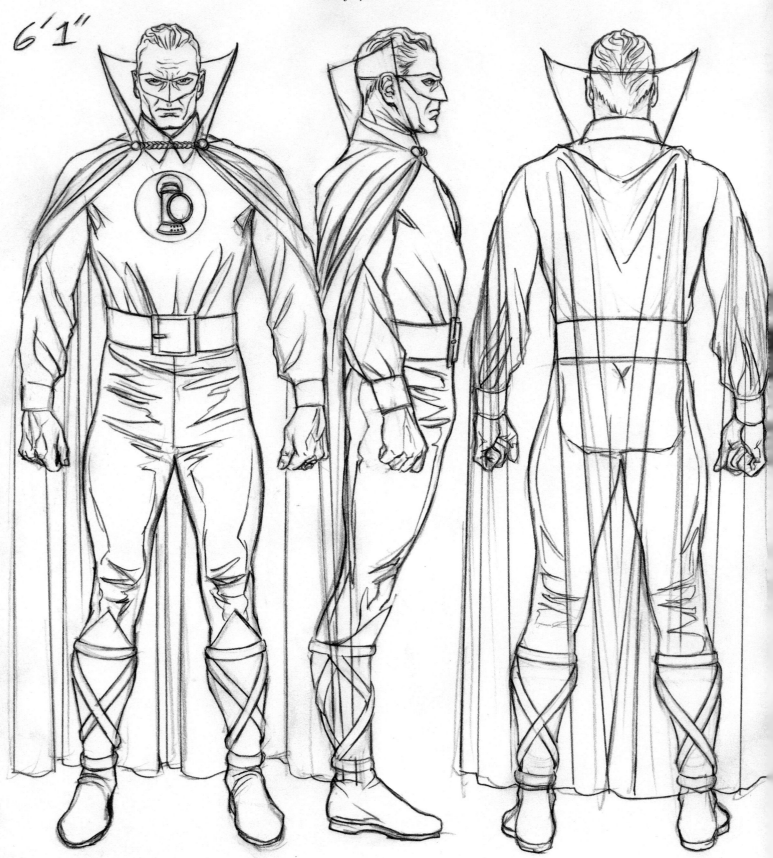

GOLDEN AGE
FLASH

5'11"

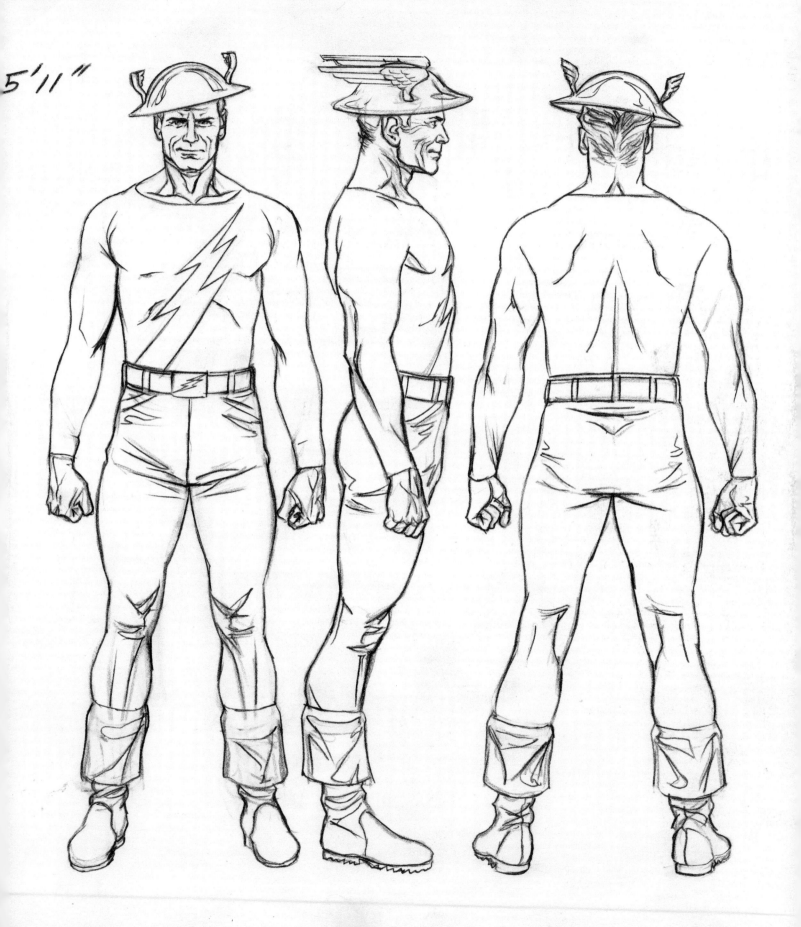

In first approaching designs for the *JSA* series, I intended all the single-figure covers to be pieced together into one giant poster composition that we would fulfill much later. Given that the series was stopped in its numbering not long before it would have hit issue #100 and restarted as the *Justice Society of America* with a new #1, we never circled back around to this goal. In the end, I didn't get to draw all of the team members for individual cover shots, but there is a big extended bleed image for the Spectre cover that was created for this purpose.

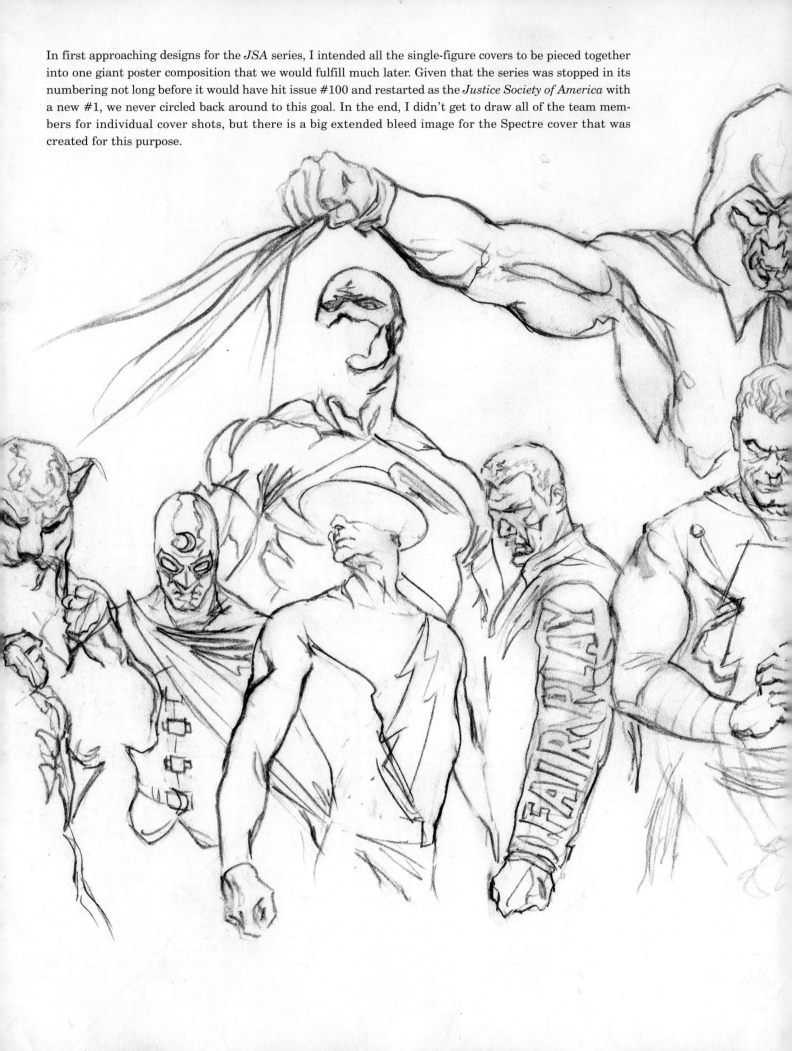

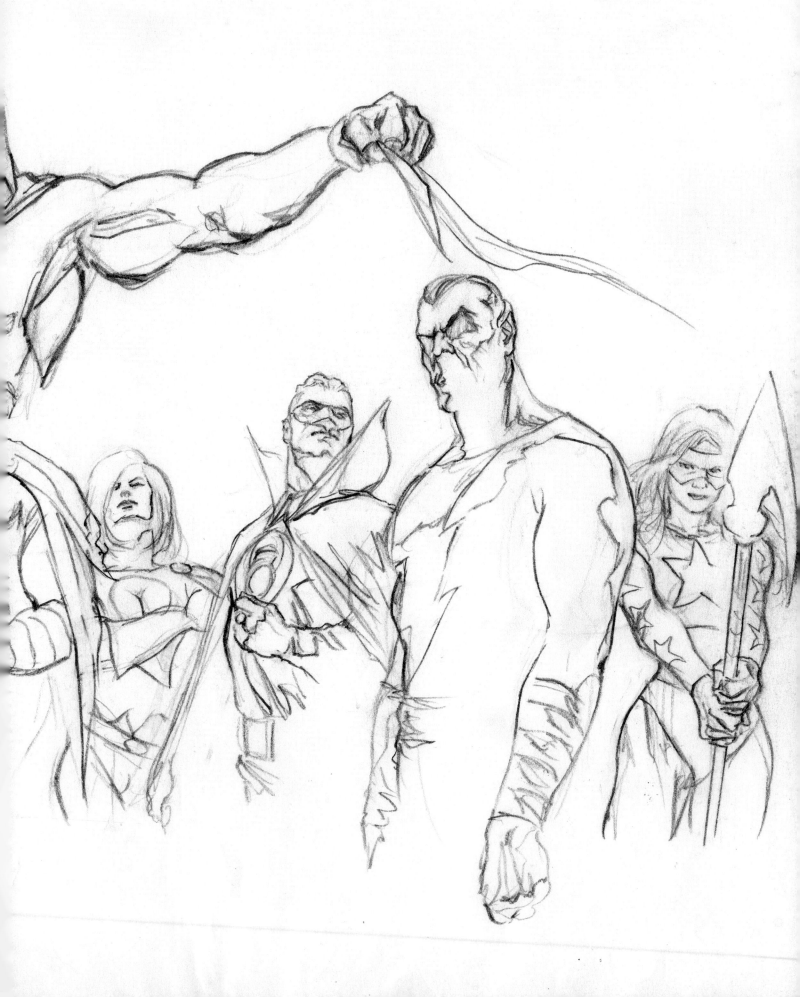

SAY MY NAME— SHAZAM!

CAPTAIN MARVEL PROPOSAL

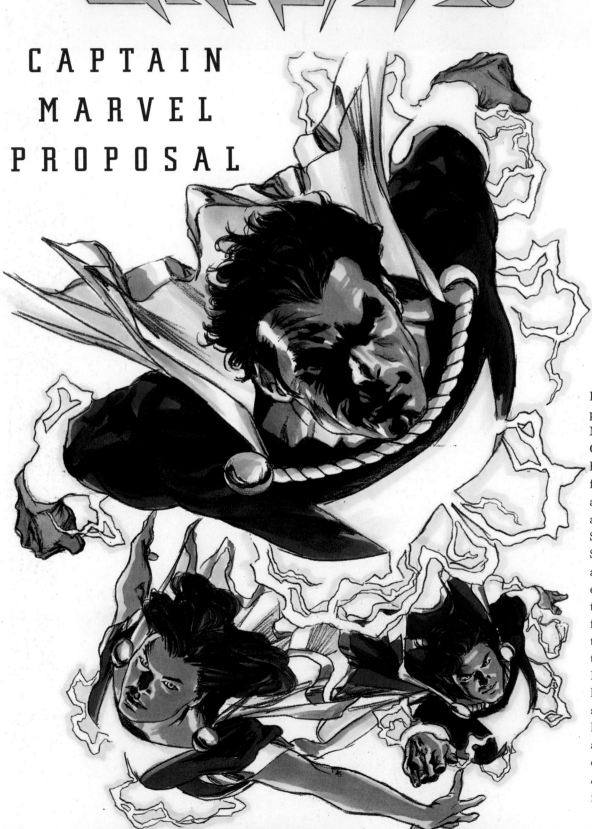

In 2005 I made a passionate pitch to take command of the Marvel Family corner of DC. Captain Marvel and his kin had long been personal favorites of mine that I always aspired to do more with, if not a complete creative takeover. Since new changes in the Shazam storyline were in the air, I was more inspired than ever before to clarify my ambitions. Attempting to sex up the franchise, I imagined a more teen-friendly interpretation of the characters and their look. Billy Batson had, in my mind, long since been interpreted successfully as a hipper, long-haired young man because of actor Michael Gray's portrayal of him from the 1970s *Shazam!* TV series (my first introduction to the Captain).

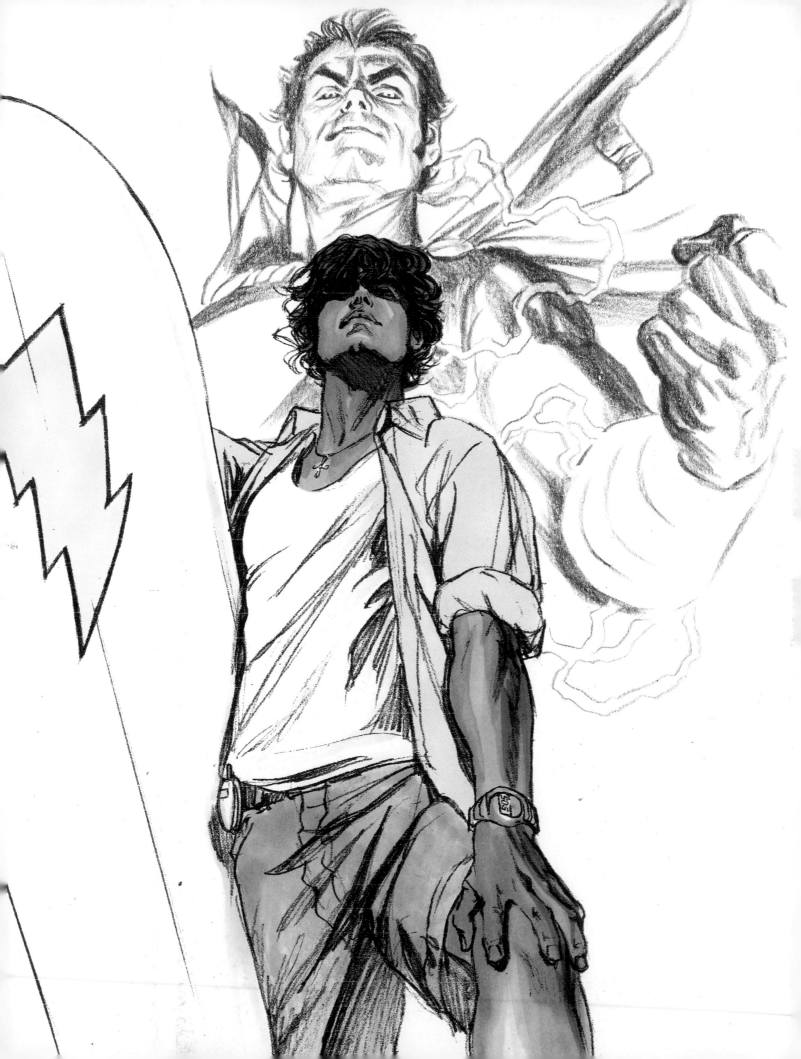

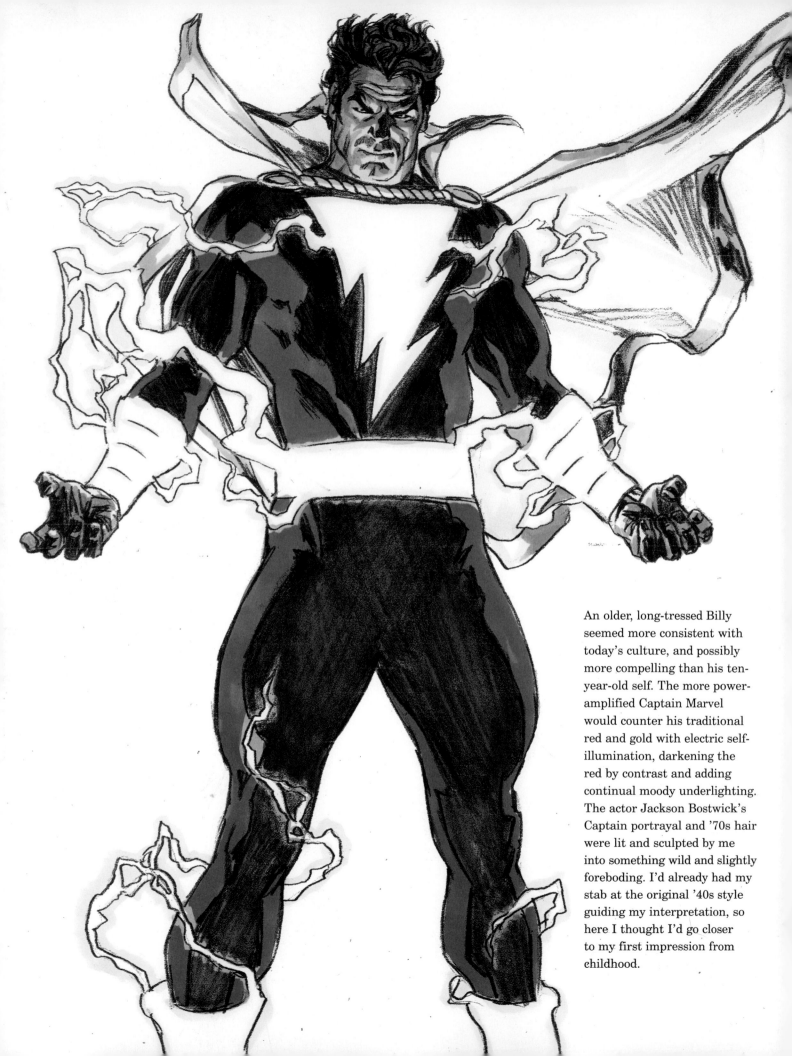

An older, long-tressed Billy seemed more consistent with today's culture, and possibly more compelling than his ten-year-old self. The more power-amplified Captain Marvel would counter his traditional red and gold with electric self-illumination, darkening the red by contrast and adding continual moody underlighting. The actor Jackson Bostwick's Captain portrayal and '70s hair were lit and sculpted by me into something wild and slightly foreboding. I'd already had my stab at the original '40s style guiding my interpretation, so here I thought I'd go closer to my first impression from childhood.

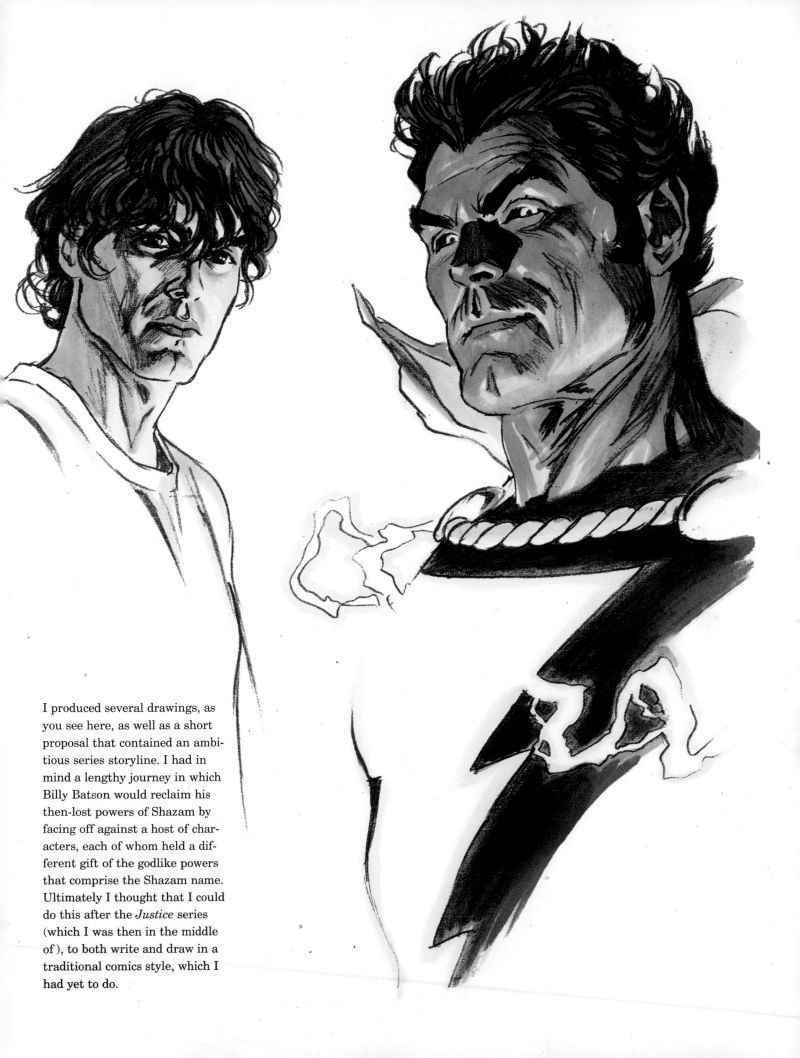

I produced several drawings, as
you see here, as well as a short
proposal that contained an ambi-
tious series storyline. I had in
mind a lengthy journey in which
Billy Batson would reclaim his
then-lost powers of Shazam by
facing off against a host of char-
acters, each of whom held a dif-
ferent gift of the godlike powers
that comprise the Shazam name.
Ultimately I thought that I could
do this after the *Justice* series
(which I was then in the middle
of), to both write and draw in a
traditional comics style, which I
had yet to do.

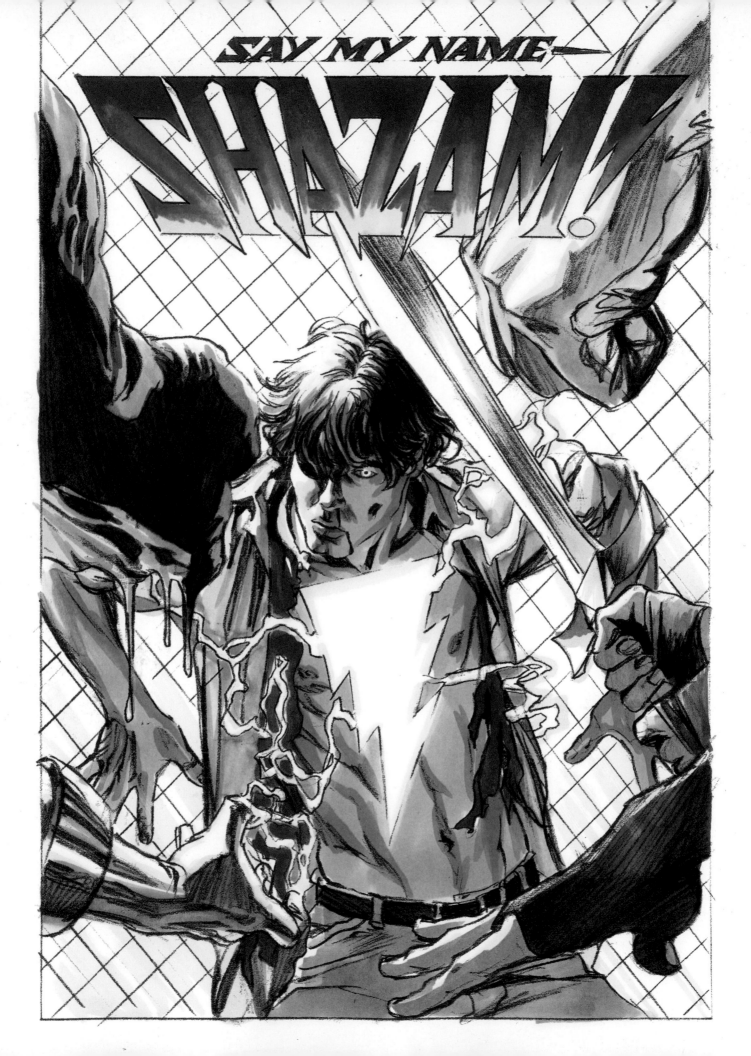

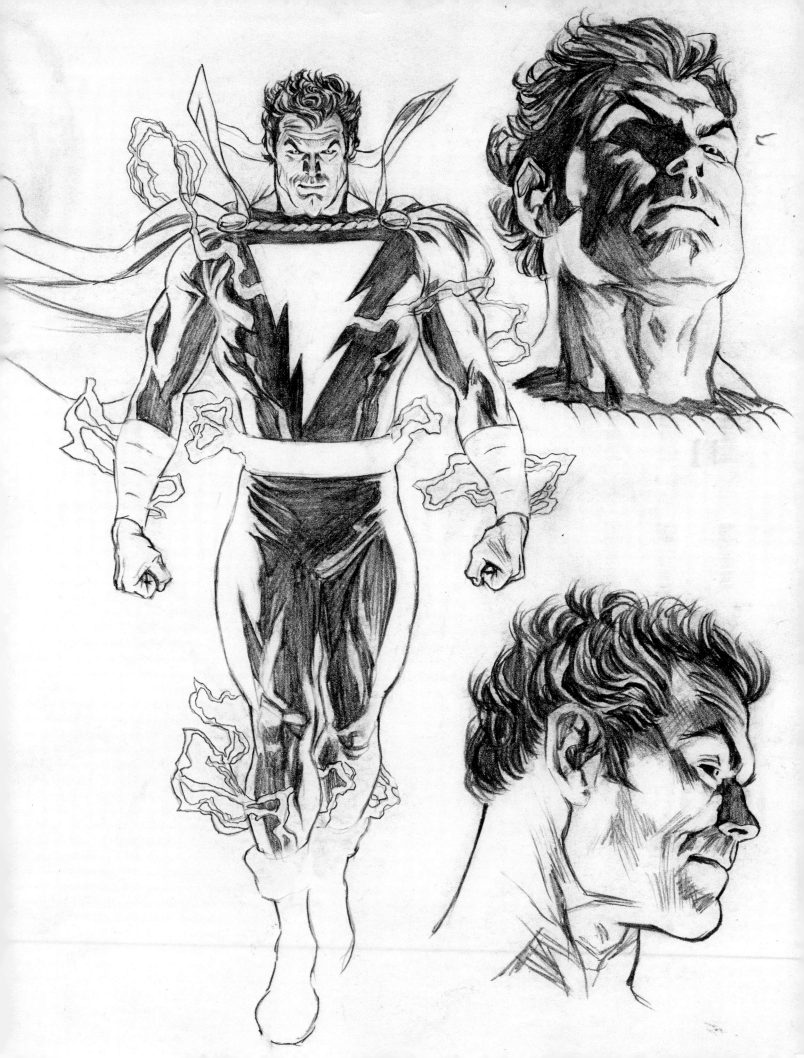

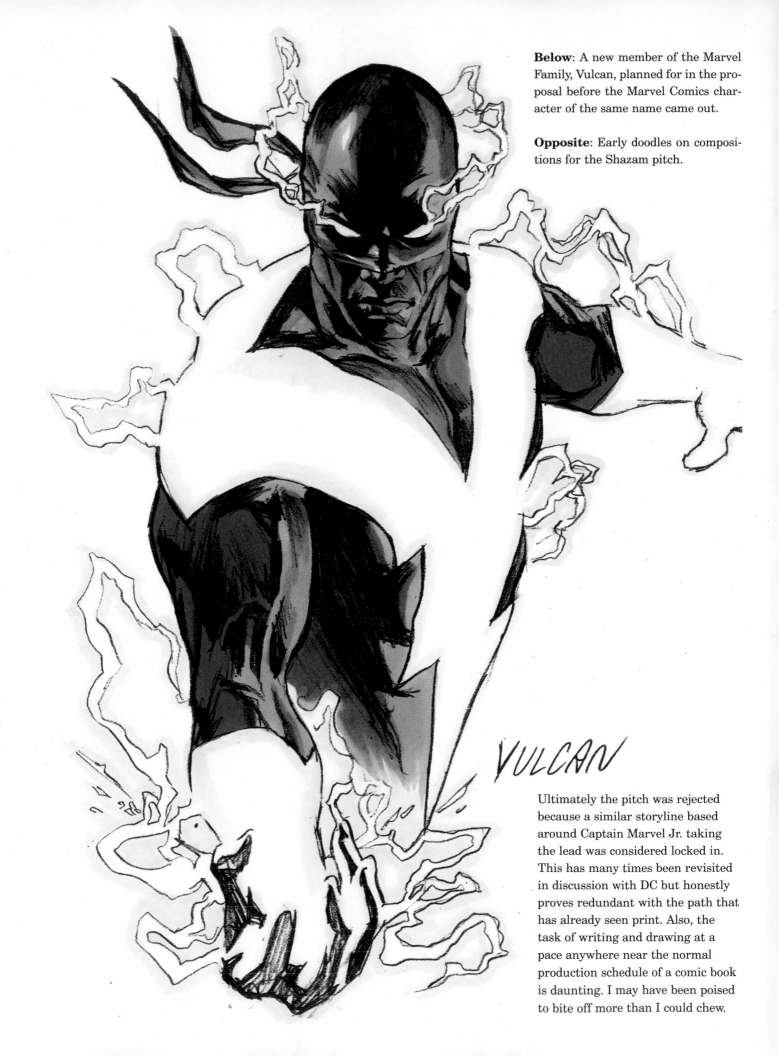

Below: A new member of the Marvel Family, Vulcan, planned for in the proposal before the Marvel Comics character of the same name came out.

Opposite: Early doodles on compositions for the Shazam pitch.

VULCAN

Ultimately the pitch was rejected because a similar storyline based around Captain Marvel Jr. taking the lead was considered locked in. This has many times been revisited in discussion with DC but honestly proves redundant with the path that has already seen print. Also, the task of writing and drawing at a pace anywhere near the normal production schedule of a comic book is daunting. I may have been poised to bite off more than I could chew.

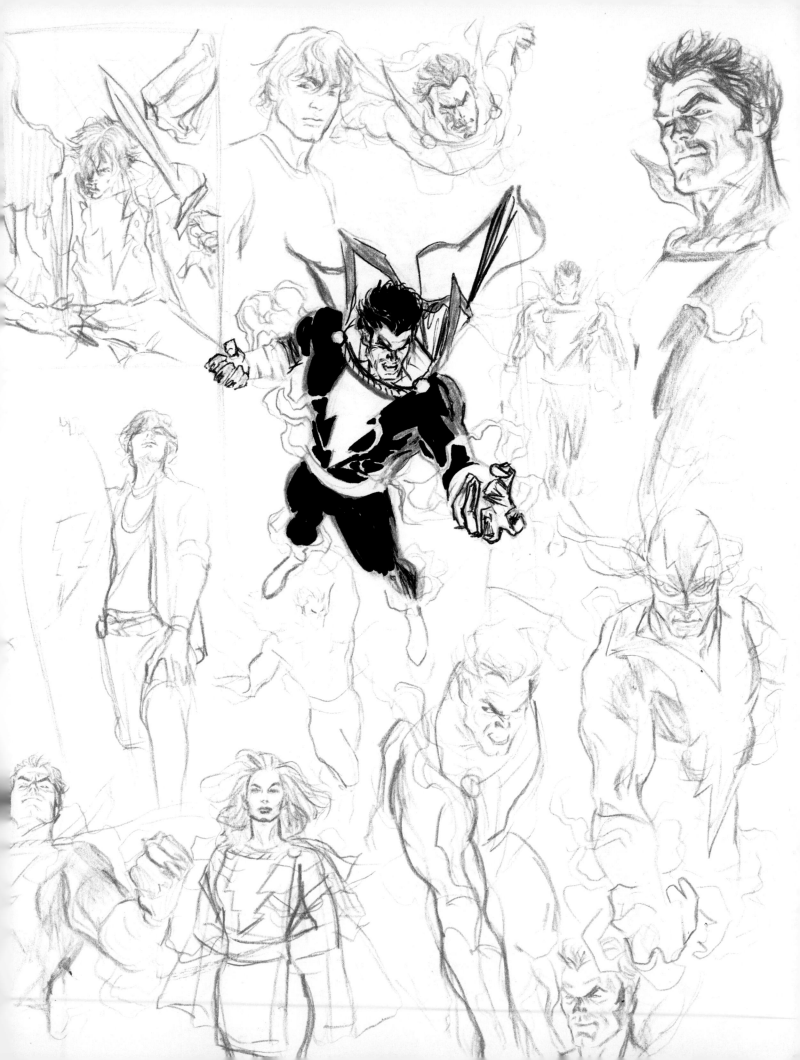

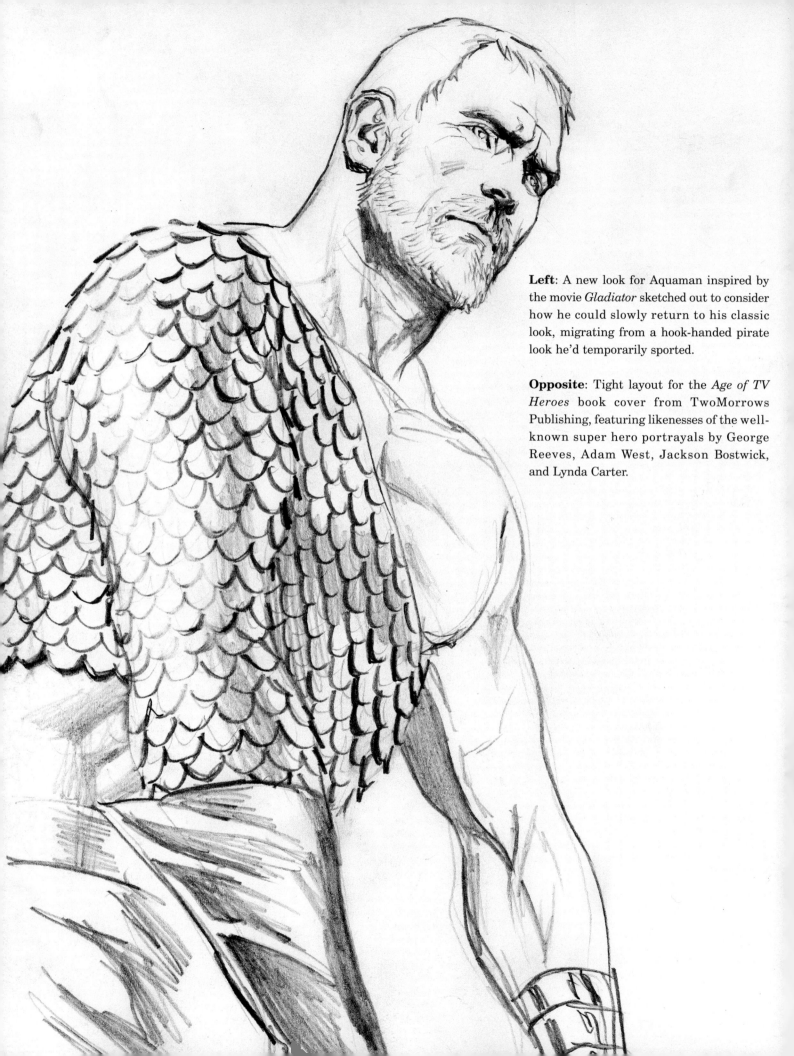

Left: A new look for Aquaman inspired by the movie *Gladiator* sketched out to consider how he could slowly return to his classic look, migrating from a hook-handed pirate look he'd temporarily sported.

Opposite: Tight layout for the *Age of TV Heroes* book cover from TwoMorrows Publishing, featuring likenesses of the well-known super hero portrayals by George Reeves, Adam West, Jackson Bostwick, and Lynda Carter.

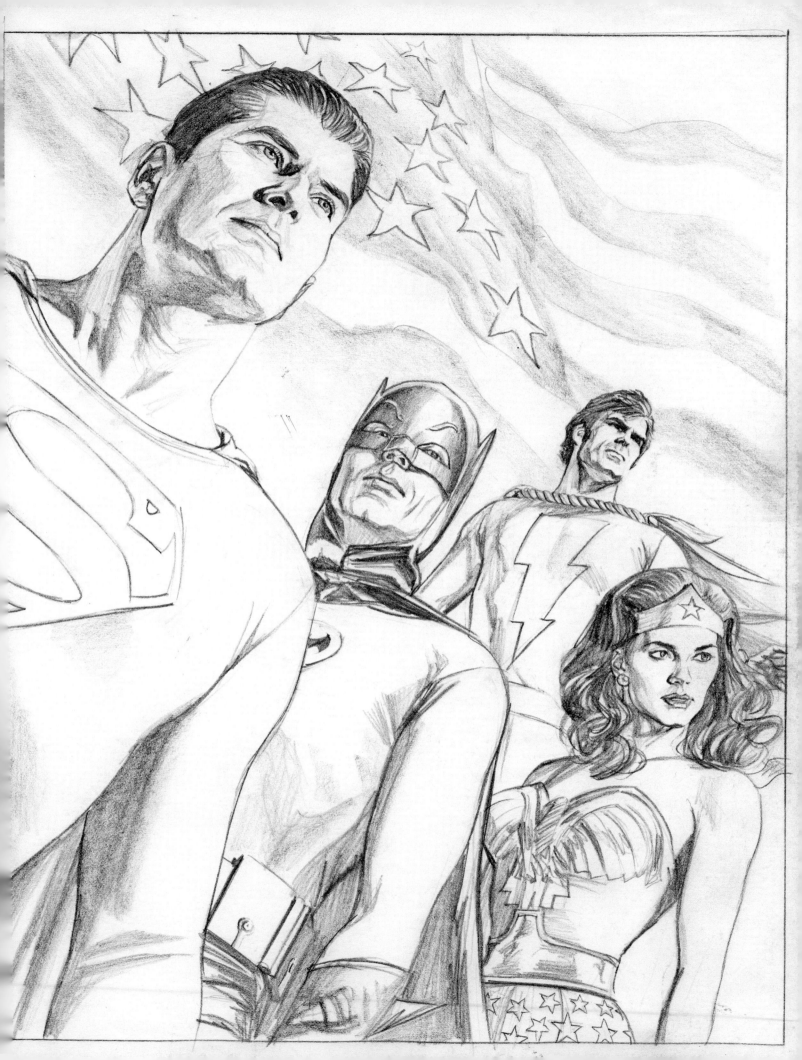

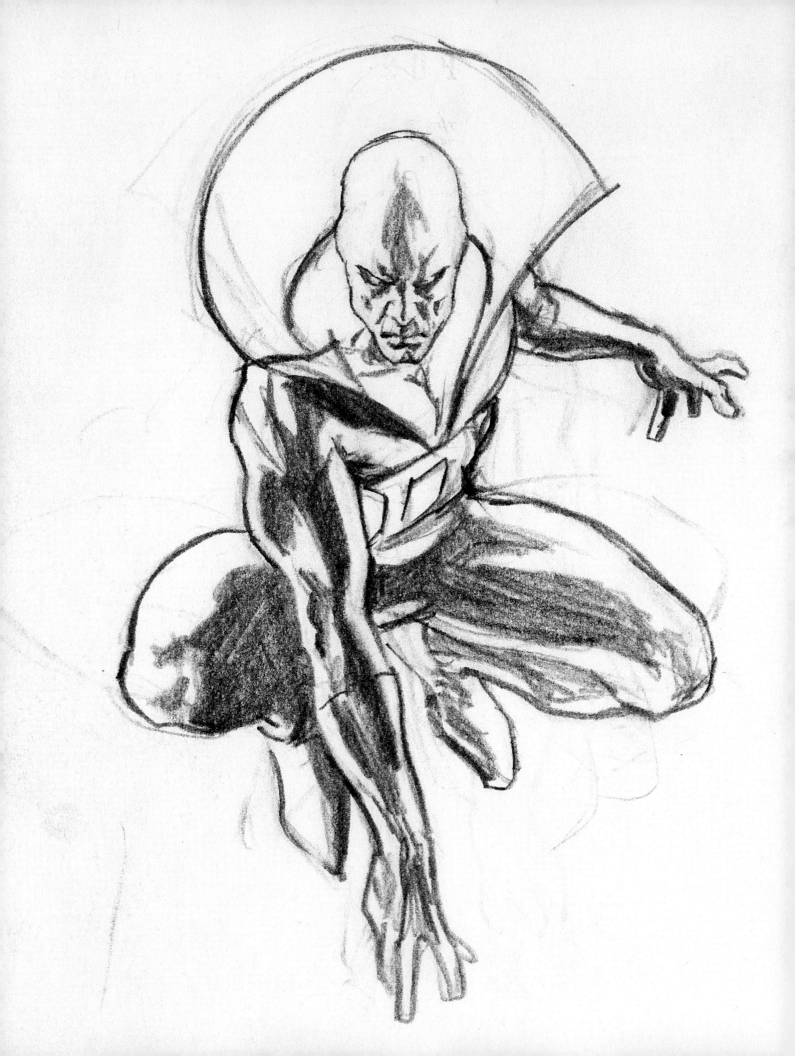

CHARACTER POSTER DESIGNS

For years spanning the turn to this century from the last, I was fortunate to be able to create a unique program of "life-size" poster portraits for many of DC's greatest heroes, comprising most of the Justice League's roster. Beginning with an initial commission of a full-size Superman figure intended to be blown up for a life-size (six-foot-plus tall) cardboard standee comic book display, I was able to extend the concept to posters. Creating what I hoped were iconic figure poses that could be used in multiple applications, as single life-size, cropped-in posters, to connected full-figure compositions, I barged my way through a wide array of DC's characters.

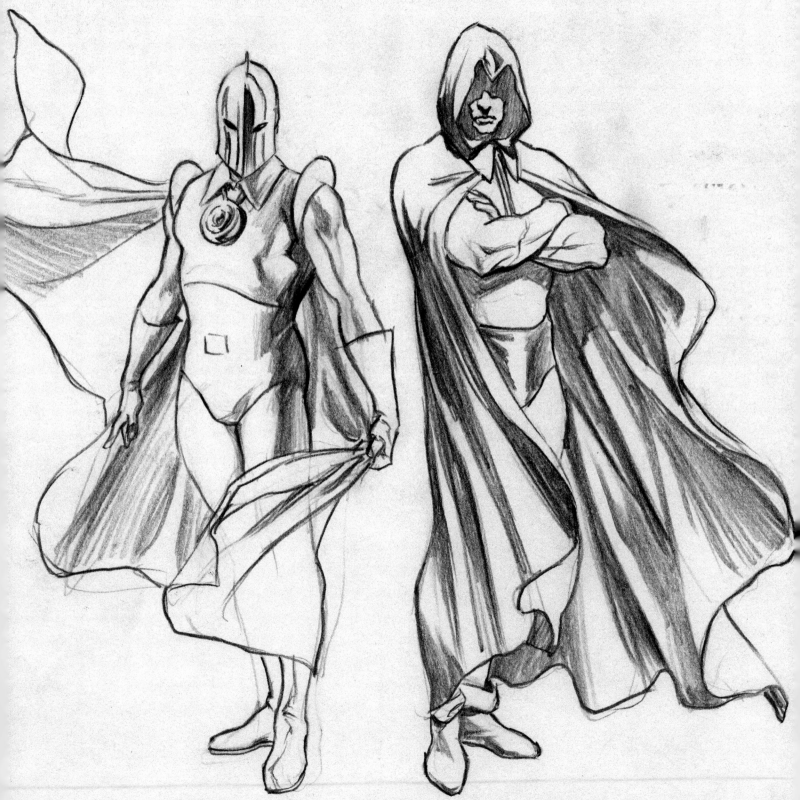

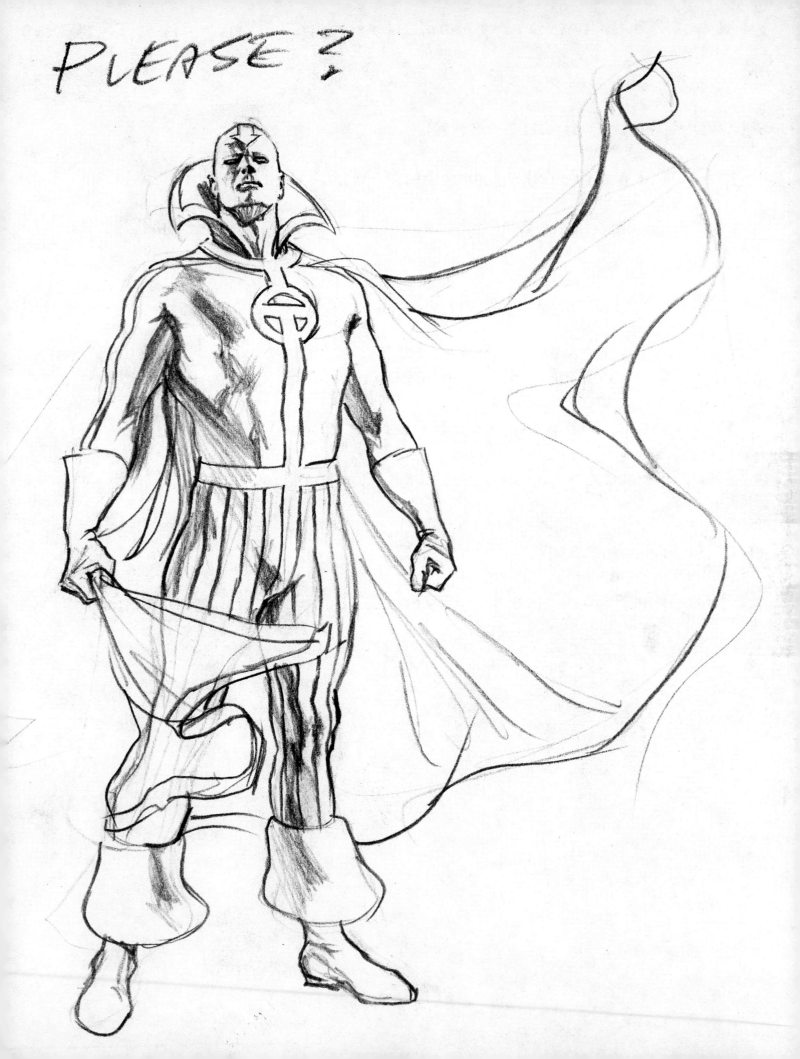

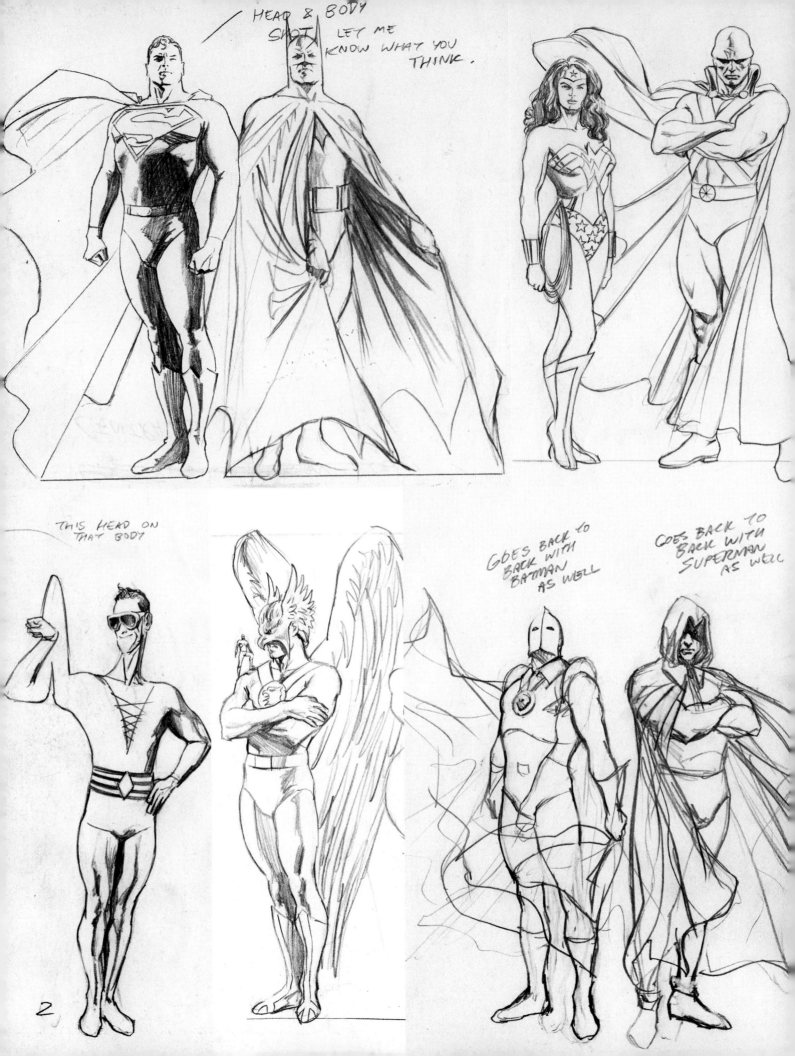

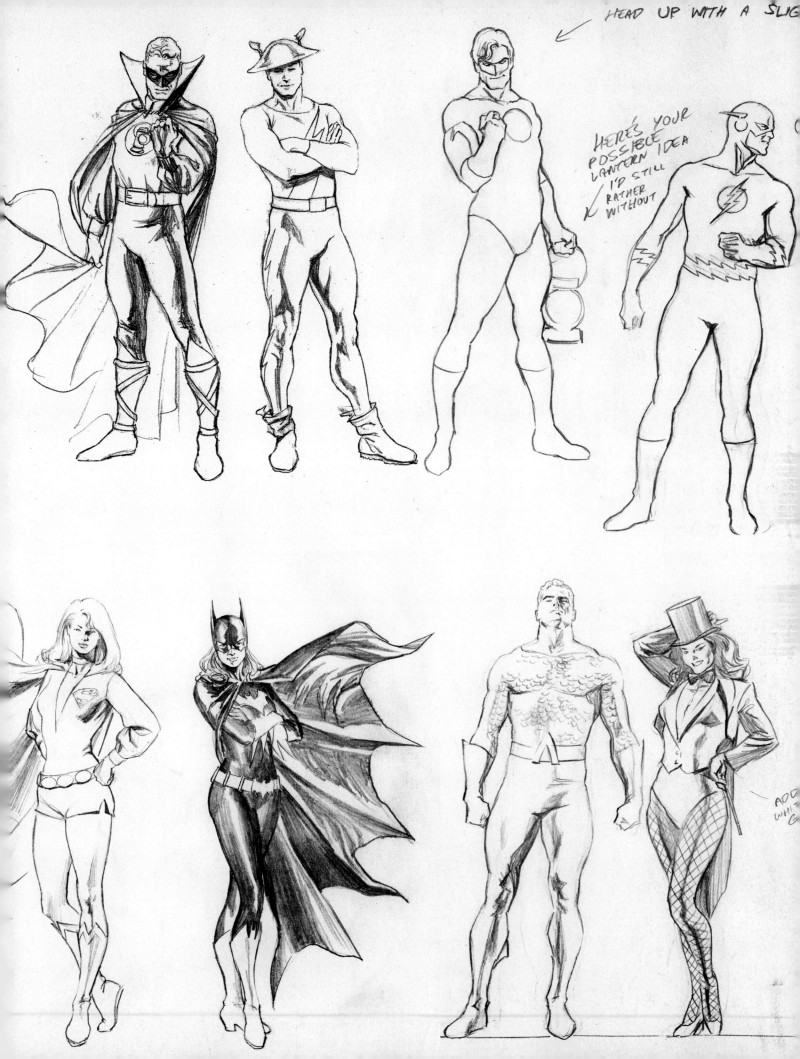

HEAD UP WITH A SLIG[

HERE'S YOUR POSSIBLE LANTERN IDEA I'D STILL RATHER WITHOUT

AD[
WHI[
G[

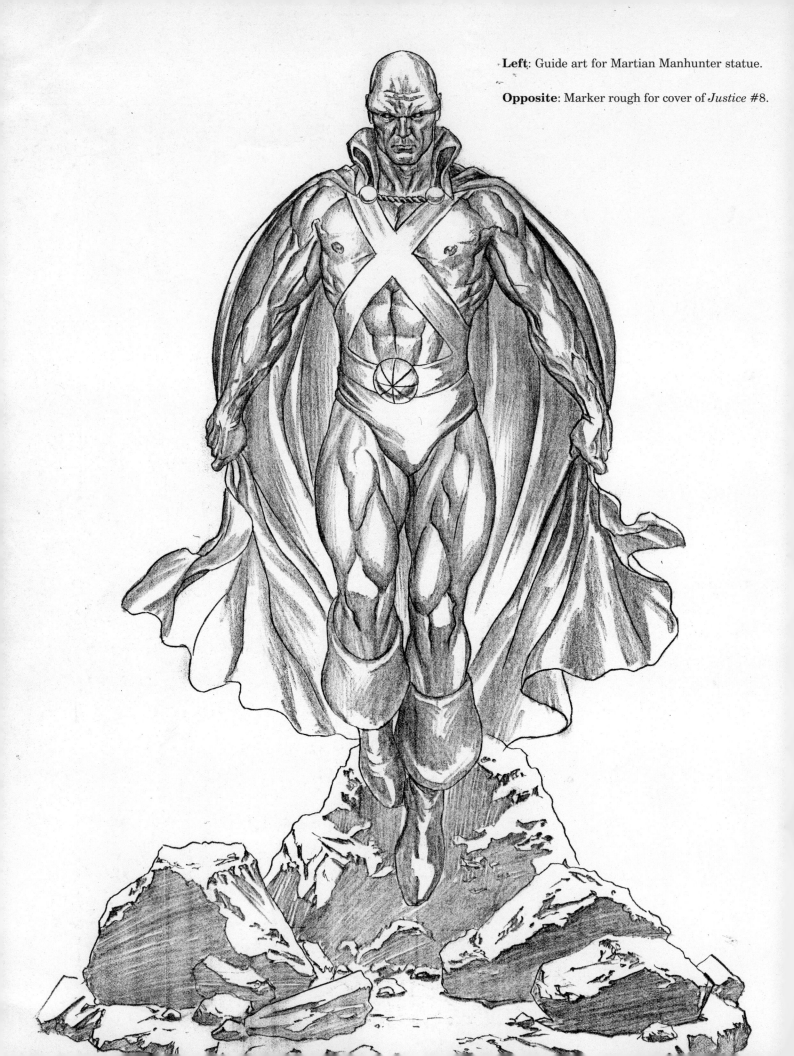

Left: Guide art for Martian Manhunter statue.

Opposite: Marker rough for cover of *Justice* #8.

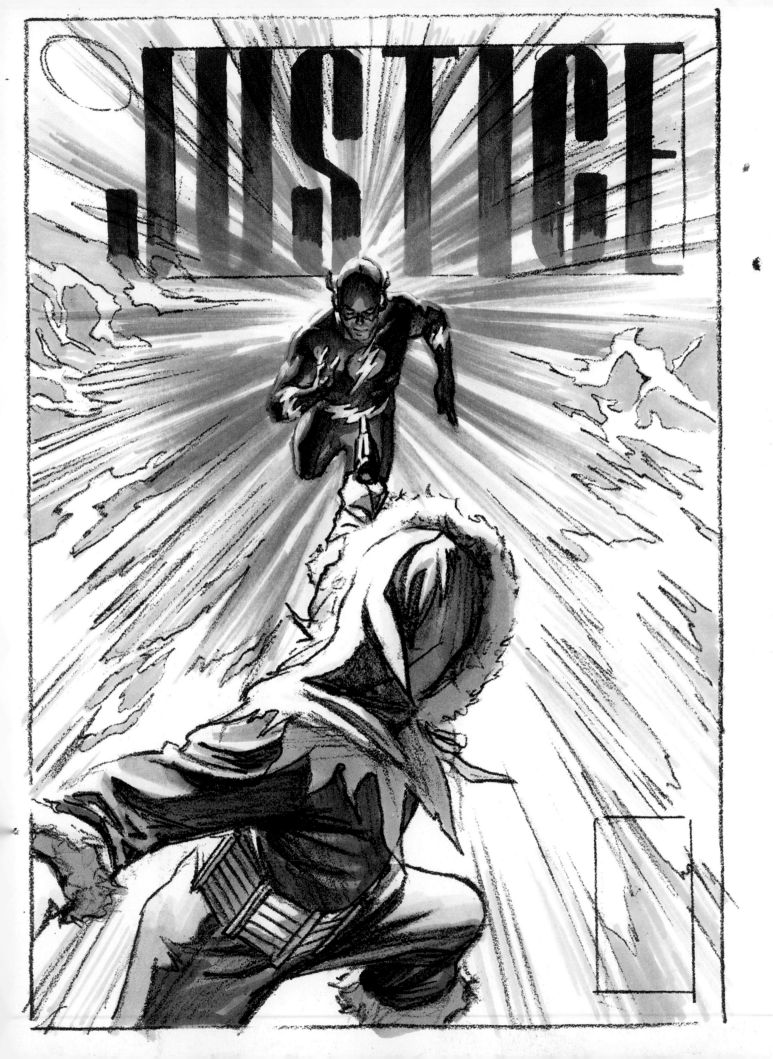

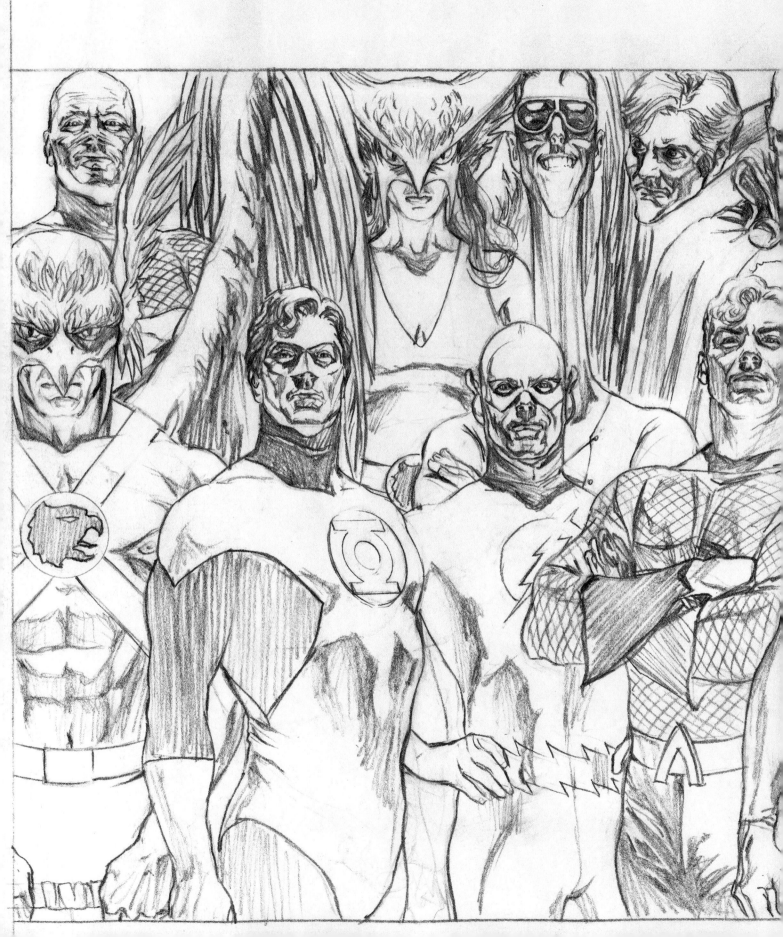

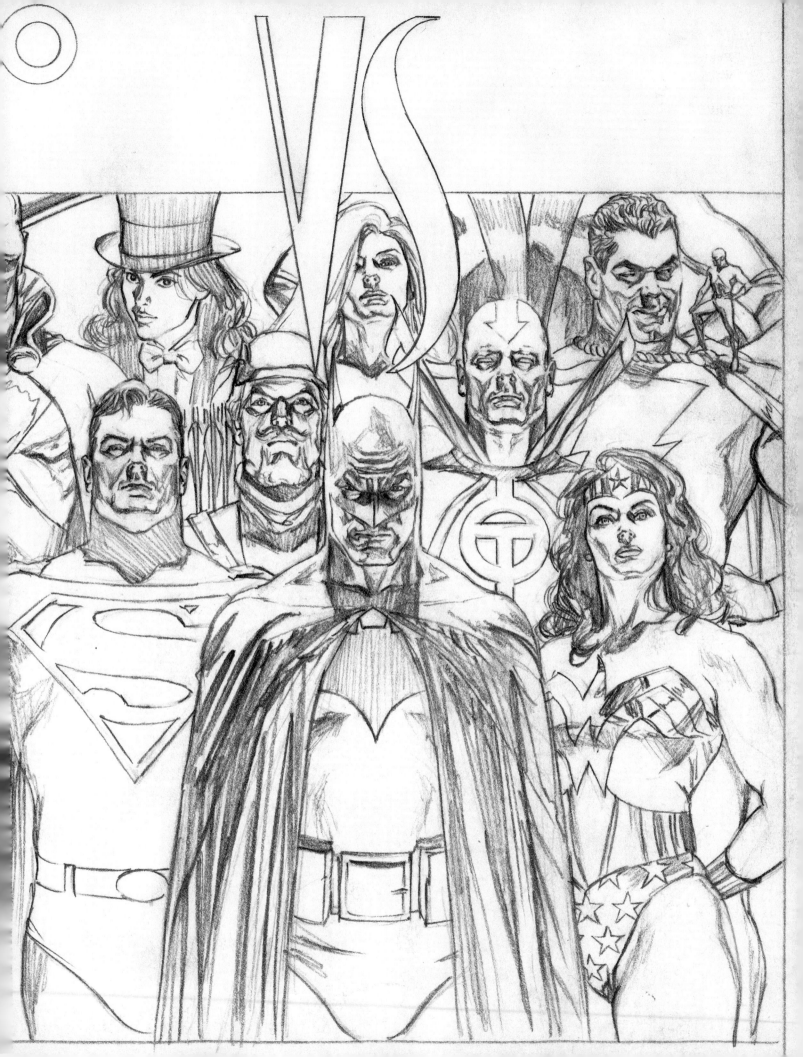

Previous spread: Initial pencil rough for eventual first-volume hardcover collection of *Justice*, when it was still a project titled *Vs*.

This spread: Initial pencil rough for eventual second-volume hardcover collection of *Justice*.

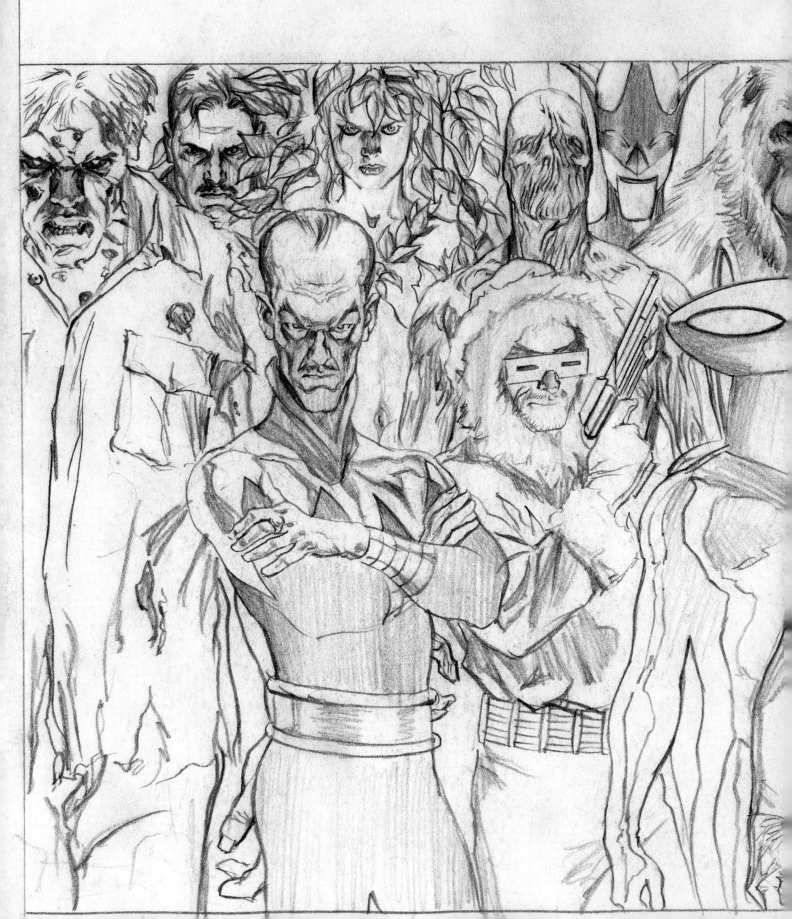

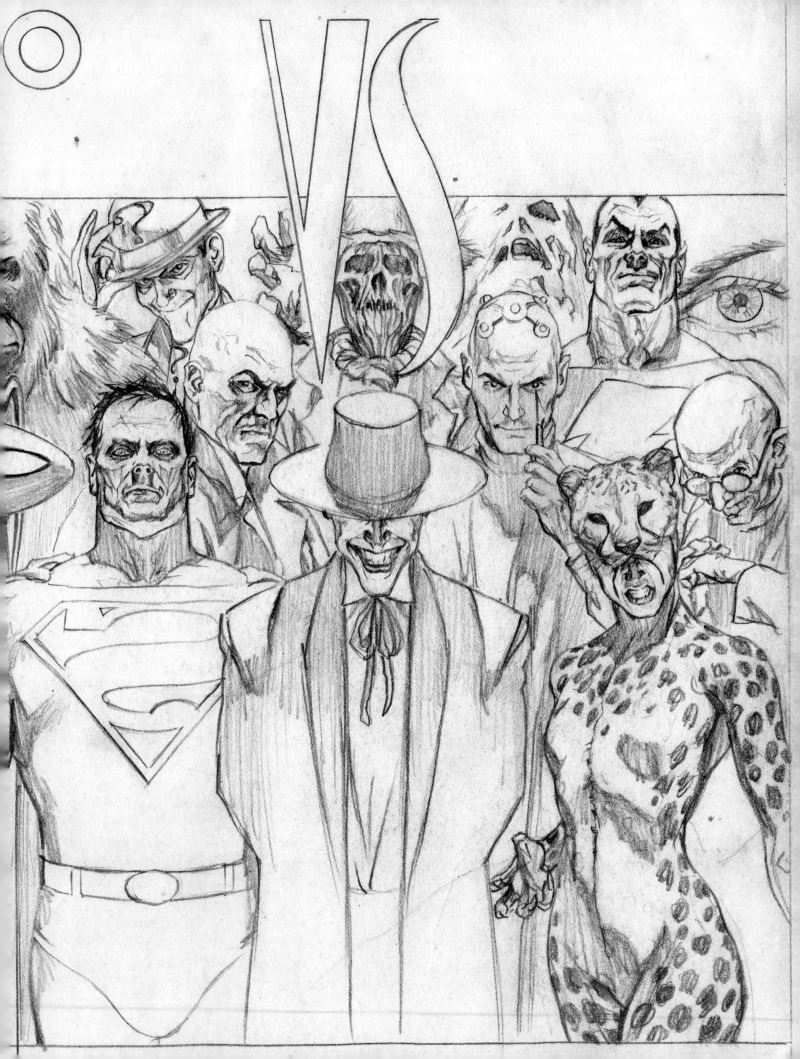

LIGHT
PANELS

p. 24-25

← SUPERMAN'S EYES

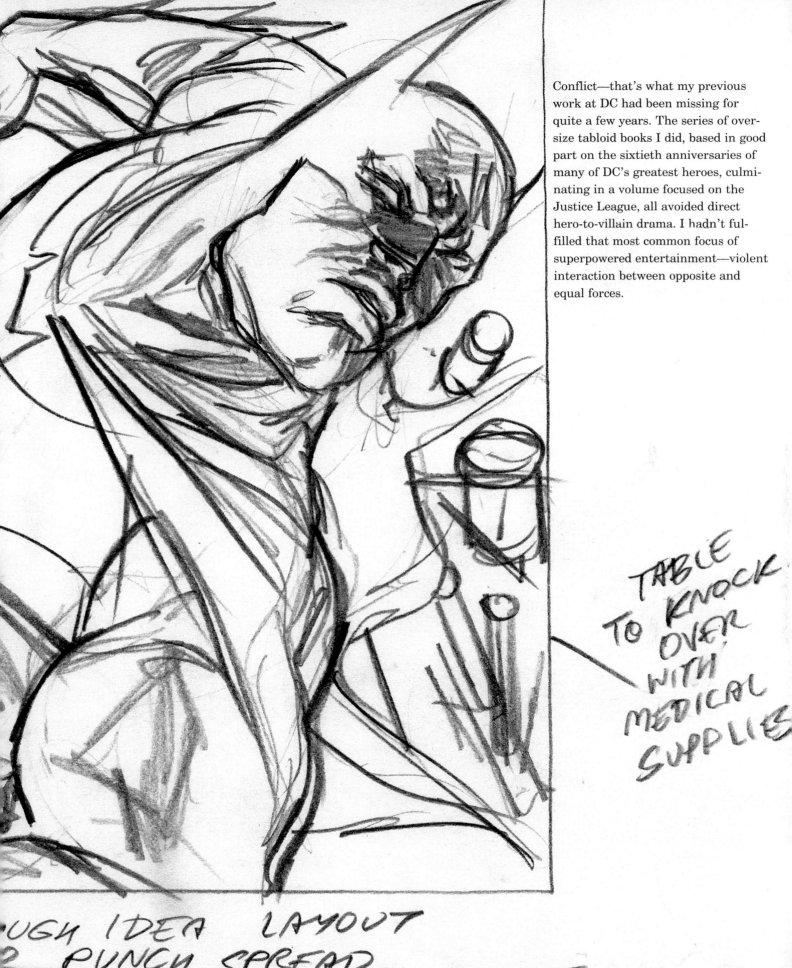

Conflict—that's what my previous work at DC had been missing for quite a few years. The series of over-size tabloid books I did, based in good part on the sixtieth anniversaries of many of DC's greatest heroes, culminating in a volume focused on the Justice League, all avoided direct hero-to-villain drama. I hadn't fulfilled that most common focus of superpowered entertainment—violent interaction between opposite and equal forces.

TABLE TO KNOCK OVER WITH MEDICAL SUPPLIES

UGH IDEA LAYOUT
2 PUNCH SPREAD.
IS PROBABLY TOO CLOSE
IE JIM LEE INSPIRATION.

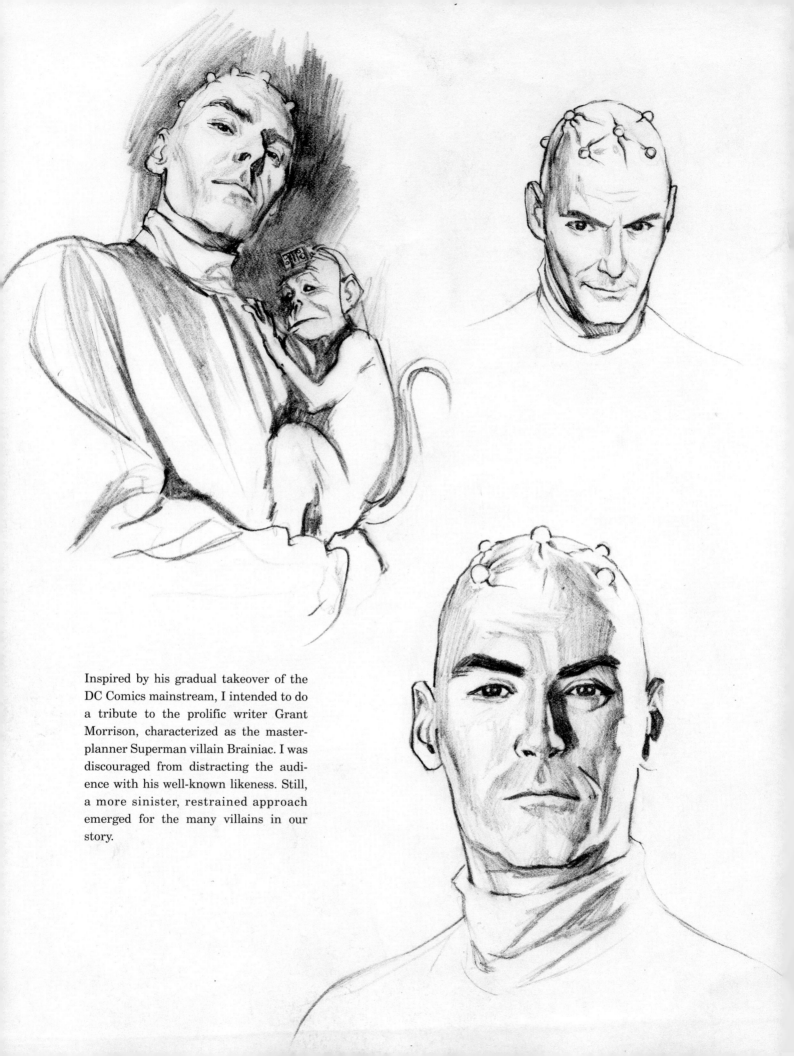

Inspired by his gradual takeover of the DC Comics mainstream, I intended to do a tribute to the prolific writer Grant Morrison, characterized as the master-planner Superman villain Brainiac. I was discouraged from distracting the audience with his well-known likeness. Still, a more sinister, restrained approach emerged for the many villains in our story.

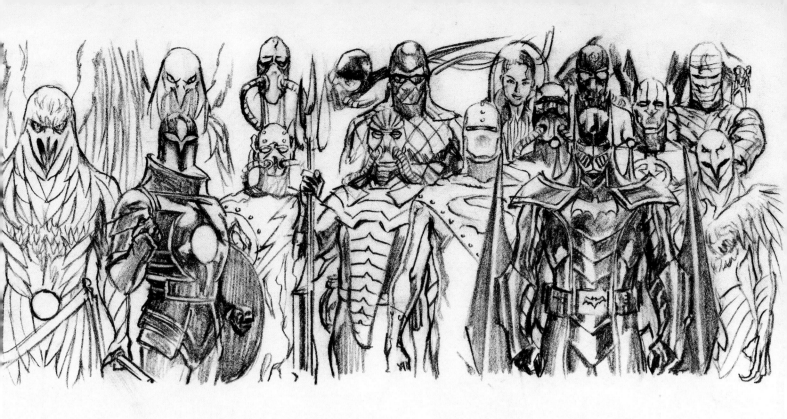

Above: Armored designs for the Justice League and early layout for the eventual cover of the *Justice* third-volume hardcover.

The story approach here was intended to reveal that the villains we traditionally encounter in comics would attack without mercy, showing little moral restraint, if handled realistically. An assembly of such villains would likely be a onetime arrangement, given their larger societal incompatibility. To unify them once with deadly, well-thought-out purpose would be the series' goal. We wanted the greatest tension to come not from among the heroes, as is often the case in comics, but from the fact that these men and women could largely adhere to their diligent idealistic portrayals because their counterparts were so much the opposite.

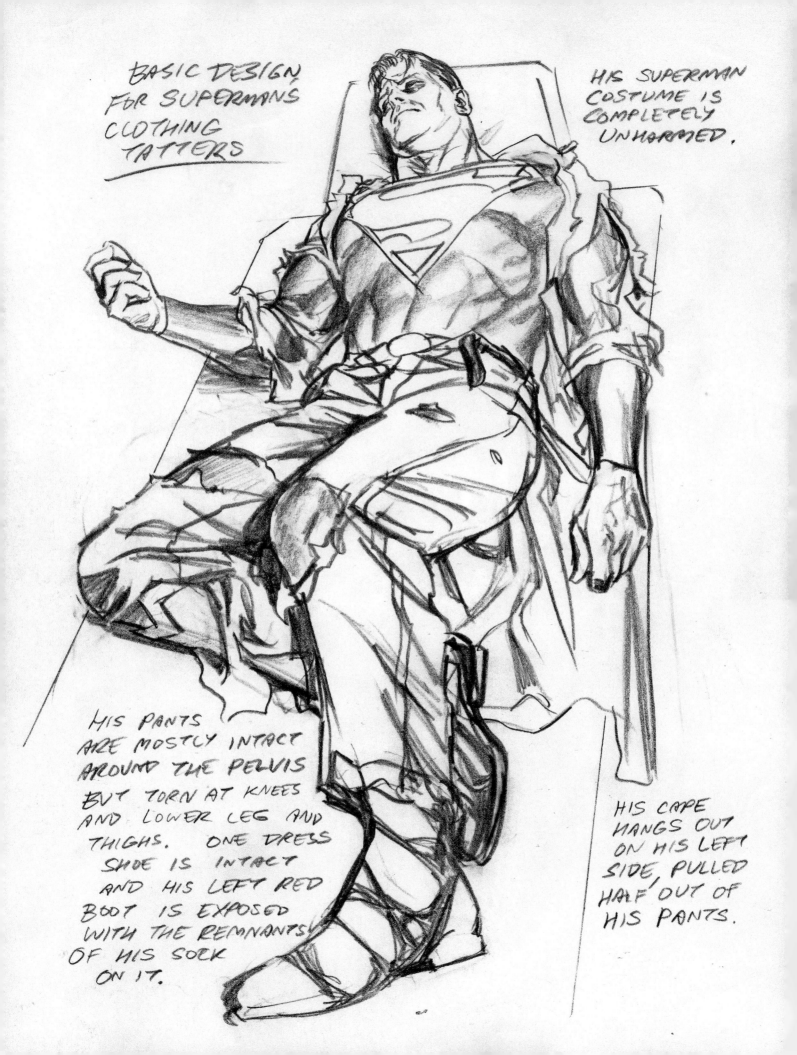

BASIC DESIGN
FOR SUPERMANS
CLOTHING
TATTERS

HIS SUPERMAN
COSTUME IS
COMPLETELY
UNHARMED.

HIS PANTS
ARE MOSTLY INTACT
AROUND THE PELVIS
BUT TORN AT KNEES
AND LOWER LEG AND
THIGHS. ONE DRESS
SHOE IS INTACT
AND HIS LEFT RED
BOOT IS EXPOSED
WITH THE REMNANTS
OF HIS SOCK
ON IT.

HIS CAPE
HANGS OUT
ON HIS LEFT
SIDE, PULLED
HALF OUT OF
HIS PANTS.

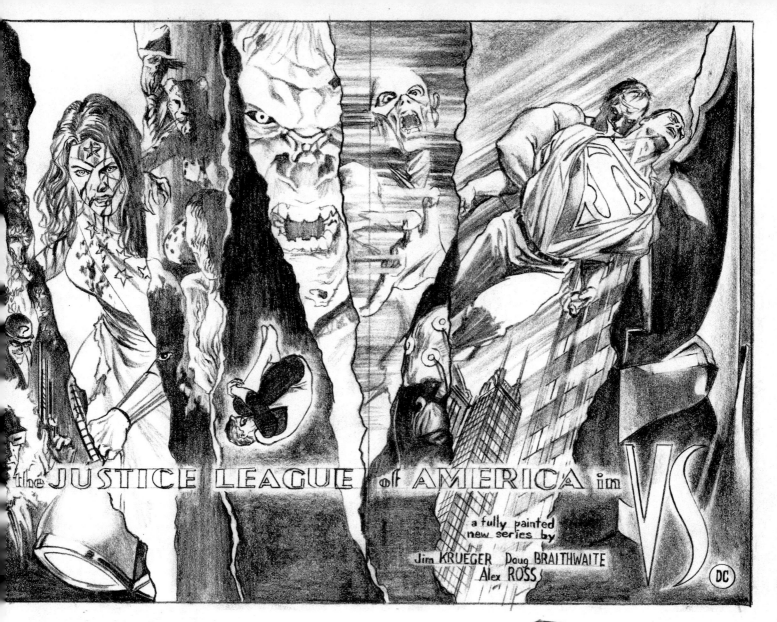

the **JUSTICE LEAGUE** of **AMERICA** in **VS**

a fully painted
new series by

Jim KRUEGER Doug BRAITHWAITE
Alex ROSS

DC

Above: Unused teaser of *Vs.* project as a two-page advertisement.

Right: Action figure guide art for Captain Cold.

To make the story seem serious and the threat credible, the heroes had to undergo hardships and trials that hadn't been thought of before, if at all possible. I wanted to create dilemmas for them to face that resembled some of the distress they had gone through in mainstream continuity (through various deaths and reinterpretations). Some were direct and some were more symbolic parallels.

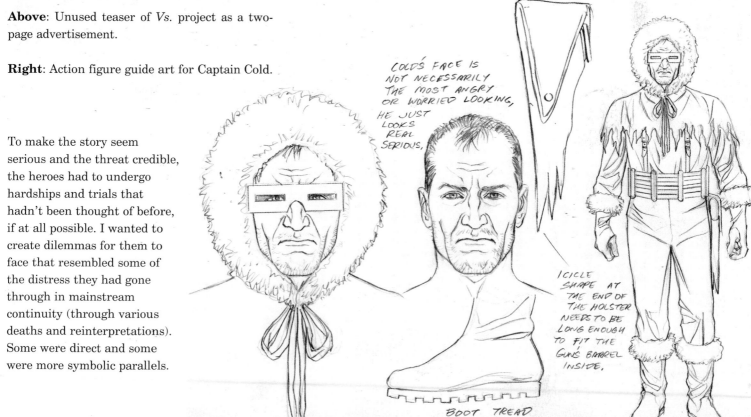

COLD'S FACE IS NOT NECESSARILY THE MOST ANGRY OR WORRIED LOOKING, HE JUST LOOKS REAL SERIOUS.

ICICLE SHAPE AT THE END OF THE HOLSTER NEEDS TO BE LONG ENOUGH TO FIT THE GUN'S BARREL INSIDE.

BOOT TREAD

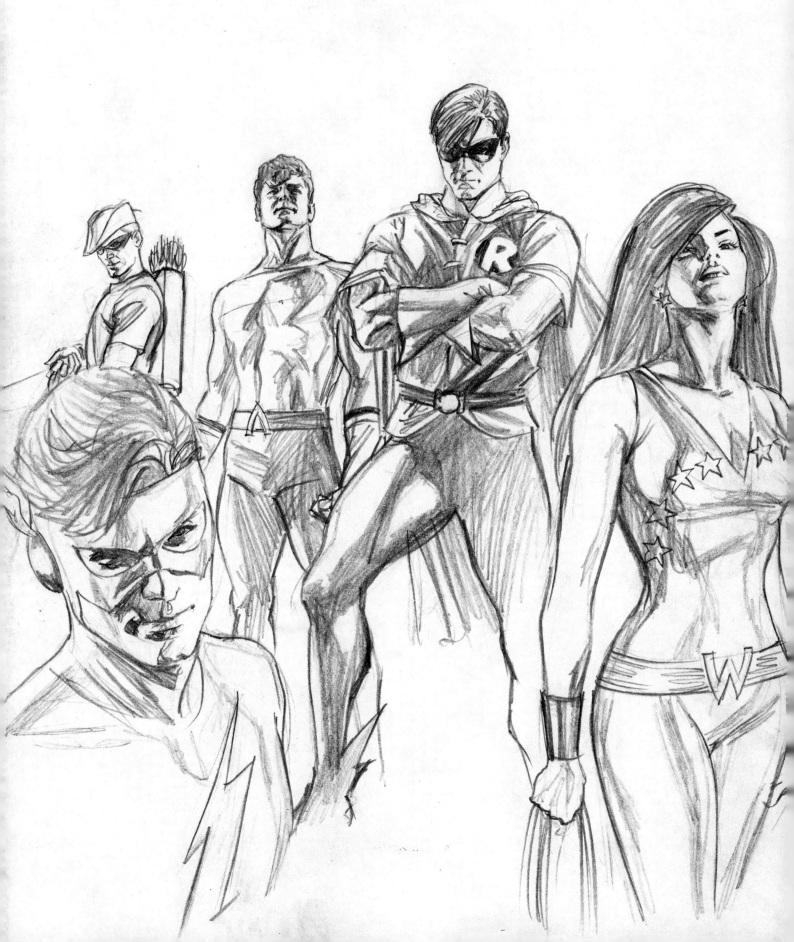

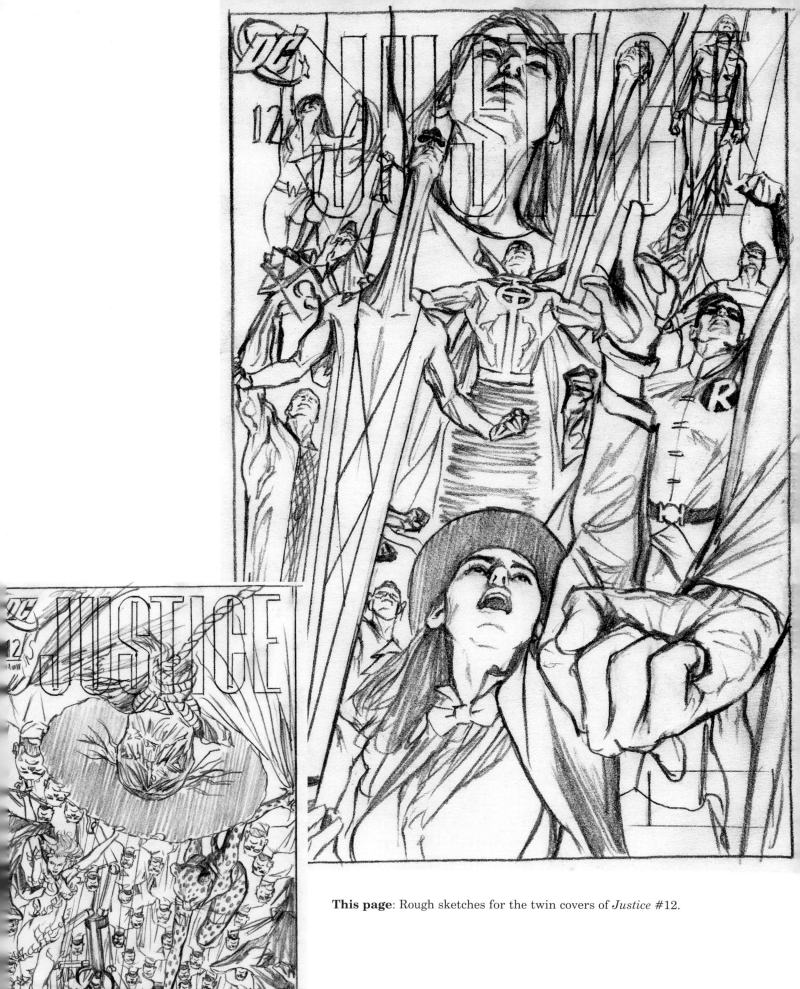

This page: Rough sketches for the twin covers of *Justice* #12.

PLASTIC MAN ARMOR

TIN'S FACE IS MORE APPARENT ON THE BACK OF PLAS' HEAD

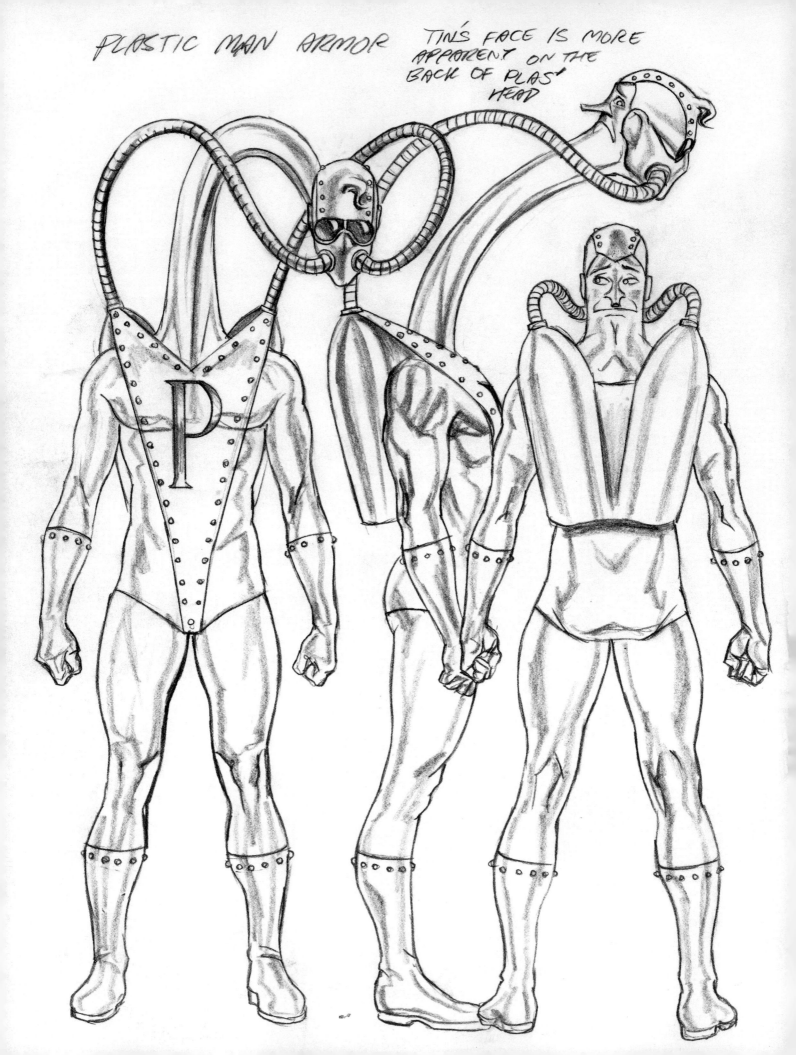

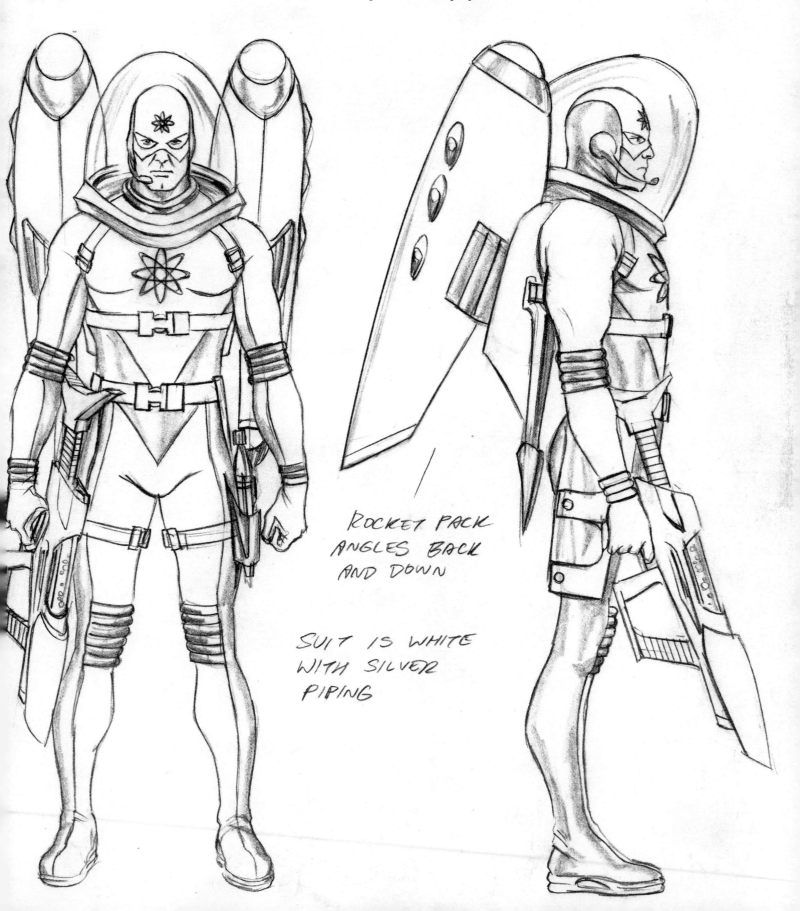

ATOM SUIT

Opposite: Protective suits for battle with the villains used various styles and even other characters, here showing Tin of the Metal Men covering Plastic Man, a fellow stretchy character.

Below: Atom is wearing less armor but more of a spacesuit design for rapid travel and propulsion.

ROCKET PACK
ANGLES BACK
AND DOWN

SUIT IS WHITE
WITH SILVER
PIPING

HAWKGIRL ARMOR

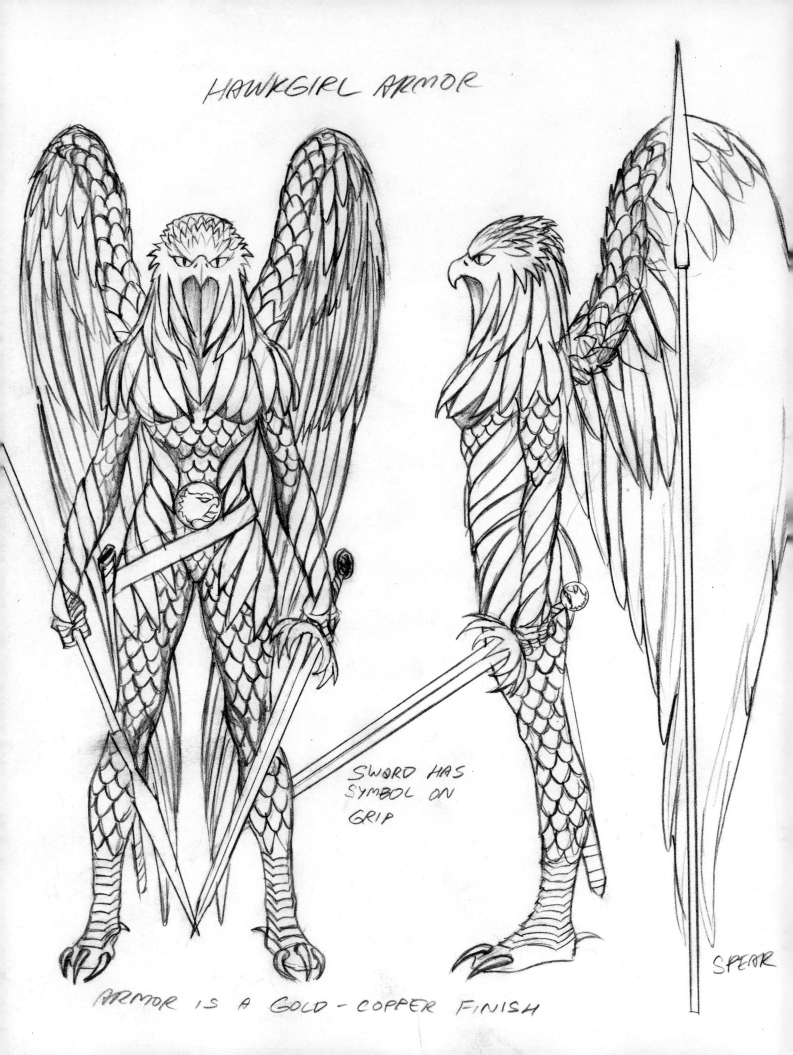

SWORD HAS
SYMBOL ON
GRIP

SPEAR

ARMOR IS A GOLD-COPPER FINISH

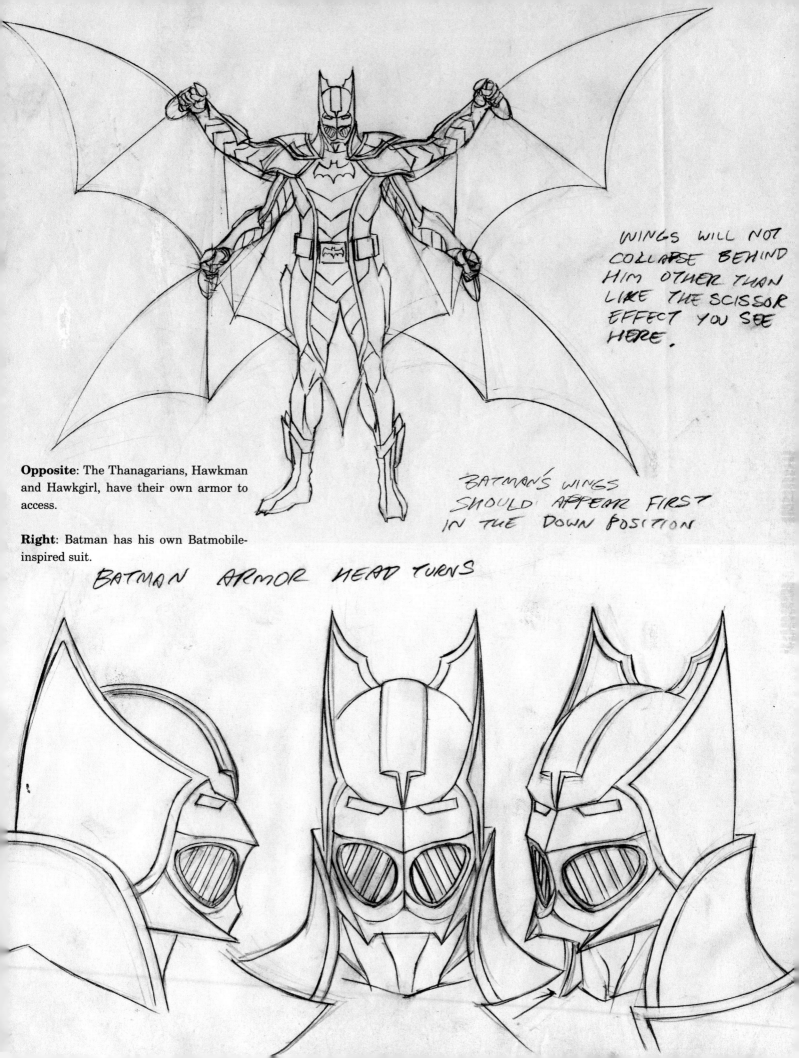

Opposite: The Thanagarians, Hawkman and Hawkgirl, have their own armor to access.

Right: Batman has his own Batmobile-inspired suit.

WINGS WILL NOT COLLAPSE BEHIND HIM OTHER THAN LIKE THE SCISSOR EFFECT YOU SEE HERE.

BATMAN'S WINGS SHOULD APPEAR FIRST IN THE DOWN POSITION

BATMAN ARMOR HEAD TURNS

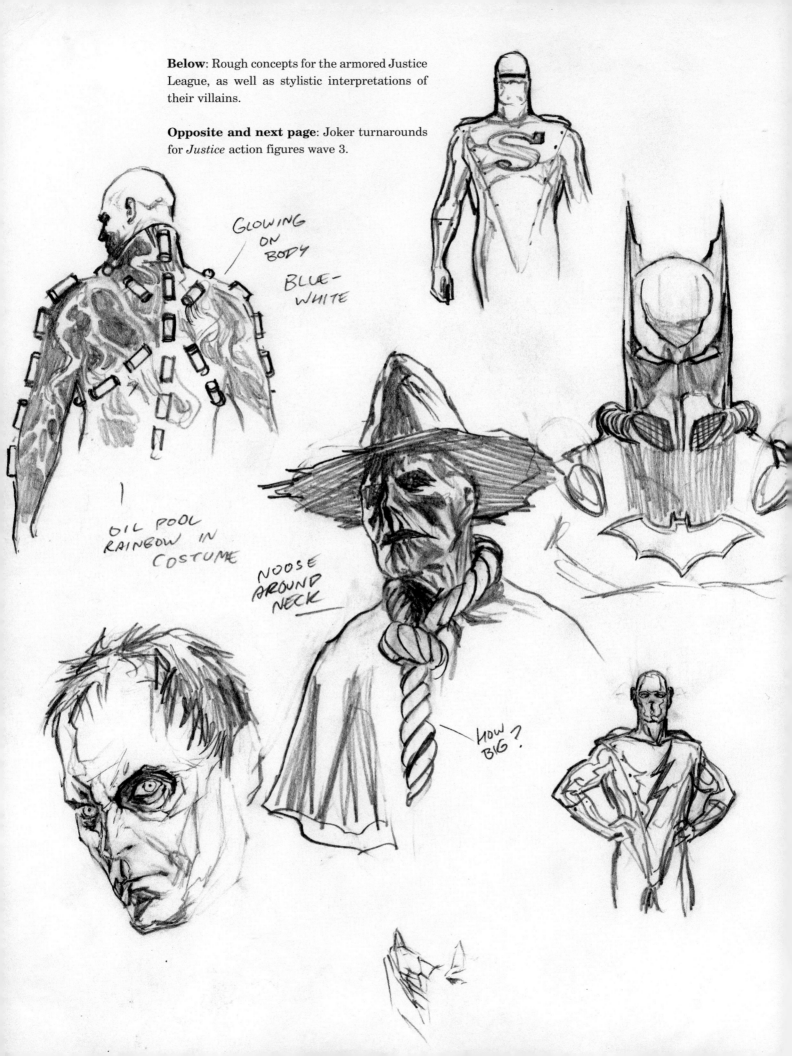

Below: Rough concepts for the armored Justice League, as well as stylistic interpretations of their villains.

Opposite and next page: Joker turnarounds for *Justice* action figures wave 3.

GLOWING ON BODY BLUE-WHITE

OIL POOL RAINBOW IN COSTUME

NOOSE AROUND NECK

HOW BIG?

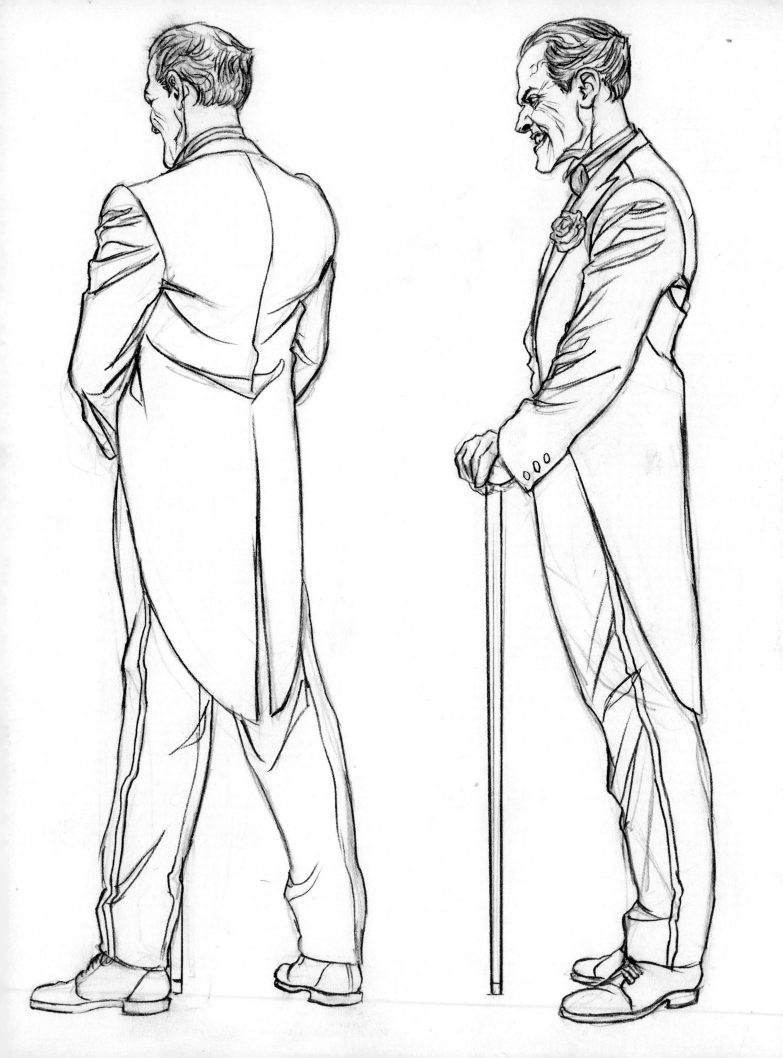

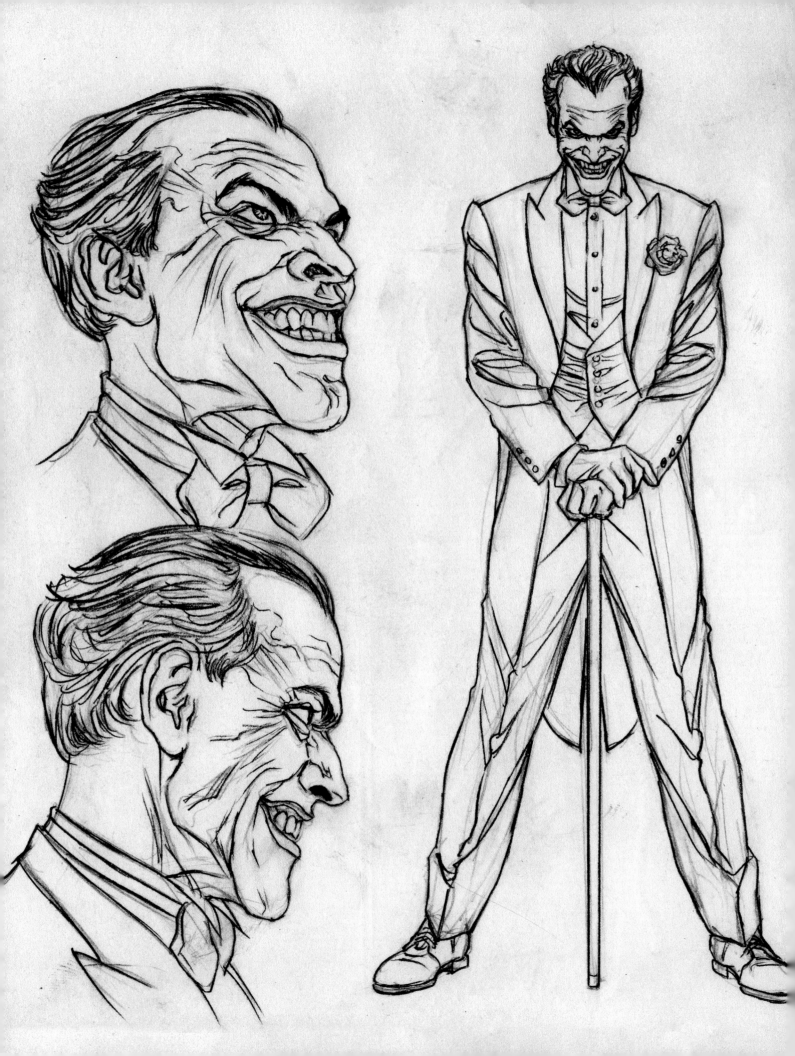

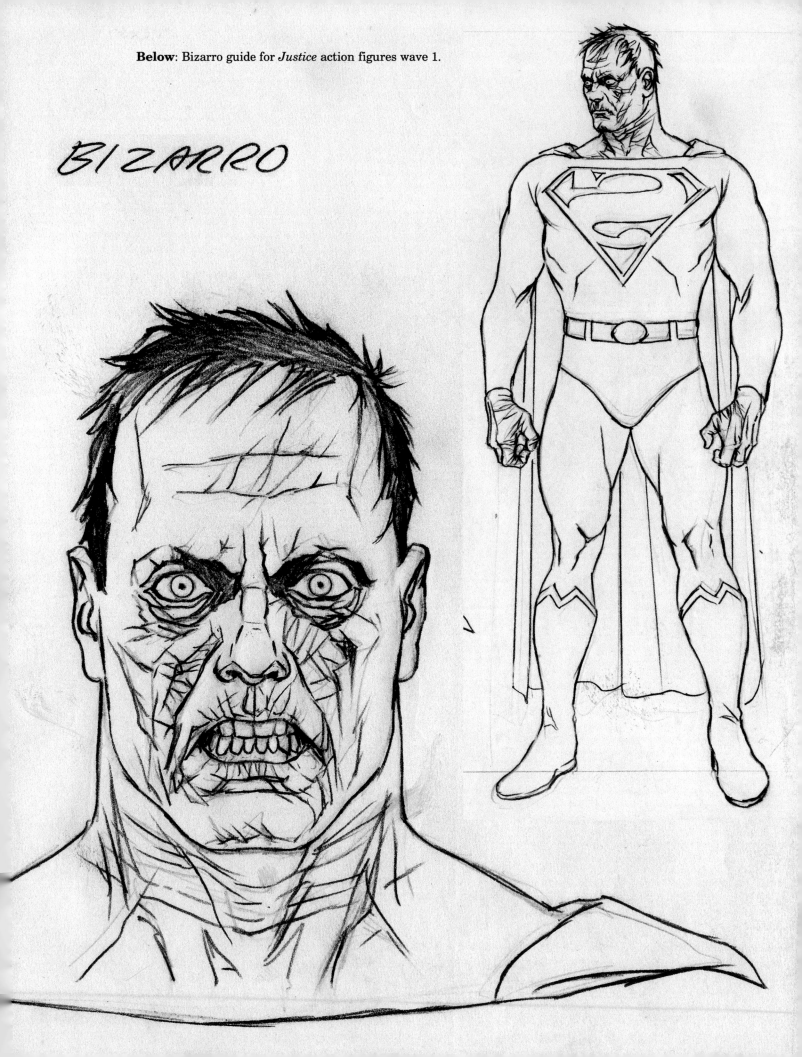

Below: Bizarro guide for *Justice* action figures wave 1.

BIZARRO

Below: Batgirl turnarounds for *Justice* action figures wave 8.

Opposite: Zatanna turnarounds for *Justice* action figures wave 4.

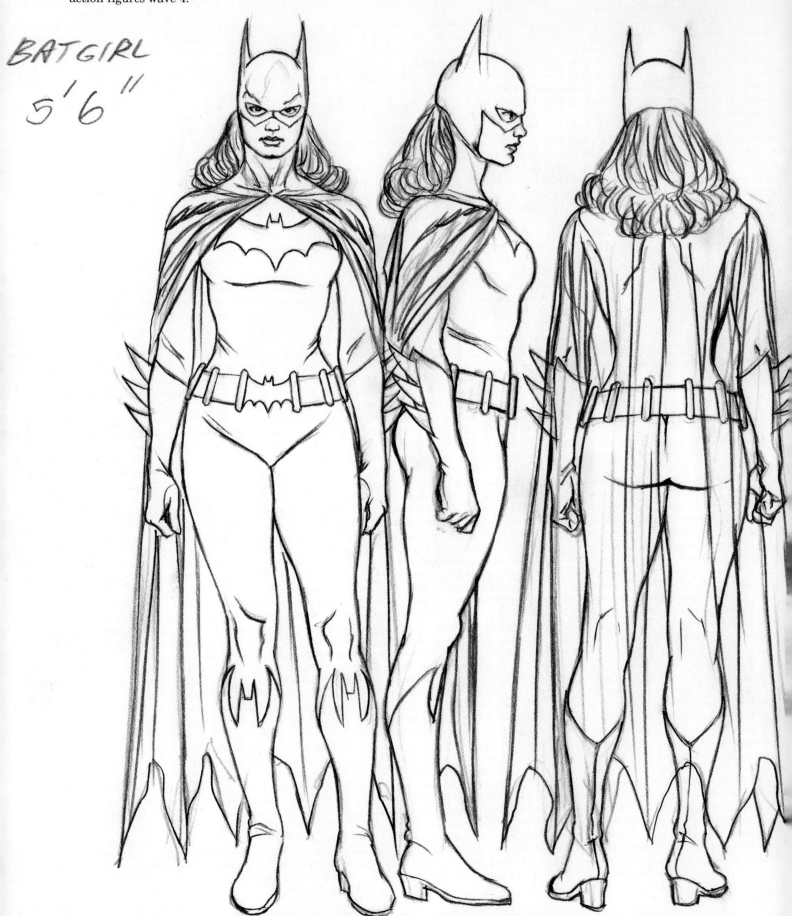

BATGIRL
5'6"

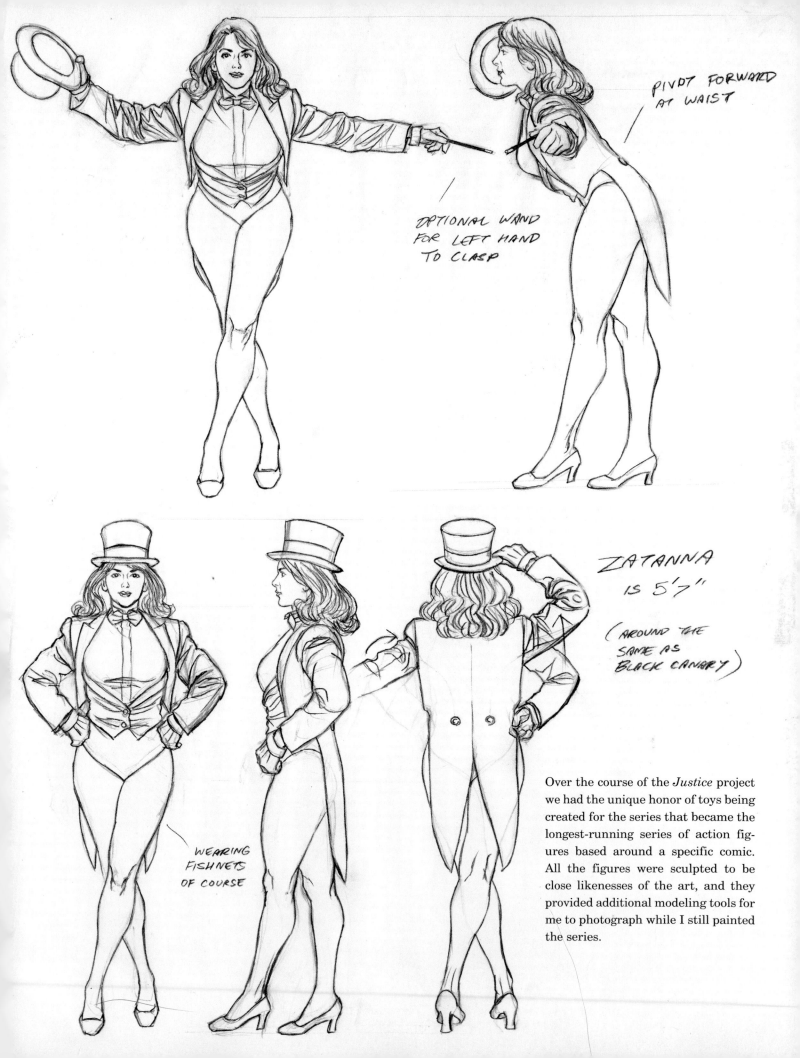

OPTIONAL WAND FOR LEFT HAND TO CLASP

PIVOT FORWARD AT WAIST

ZATANNA IS 5'7"

(AROUND THE SAME AS BLACK CANARY)

WEARING FISHNETS OF COURSE

Over the course of the *Justice* project we had the unique honor of toys being created for the series that became the longest-running series of action figures based around a specific comic. All the figures were sculpted to be close likenesses of the art, and they provided additional modeling tools for me to photograph while I still painted the series.

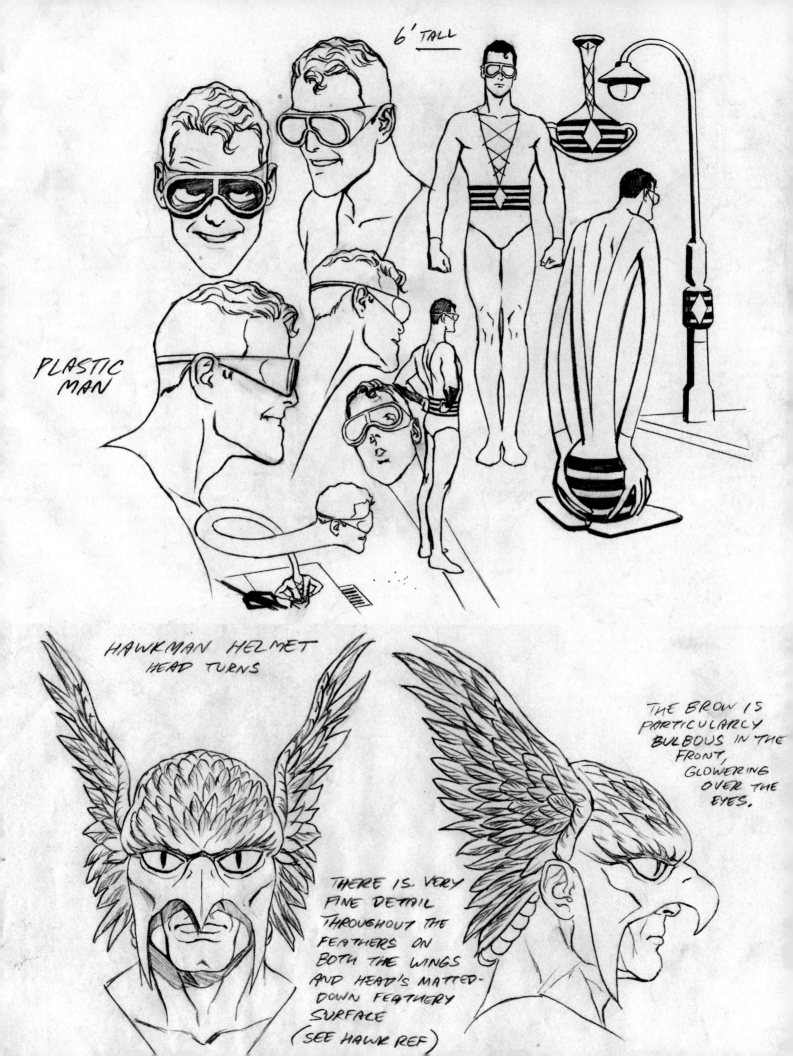

6' TALL

PLASTIC MAN

HAWKMAN HELMET
HEAD TURNS

THERE IS VERY FINE DETAIL THROUGHOUT THE FEATHERS ON BOTH THE WINGS AND HEAD'S MATTED-DOWN FEATHERY SURFACE
(SEE HAWK REF)

THE BROW IS PARTICULARLY BULBOUS IN THE FRONT, GLOWERING OVER THE EYES.

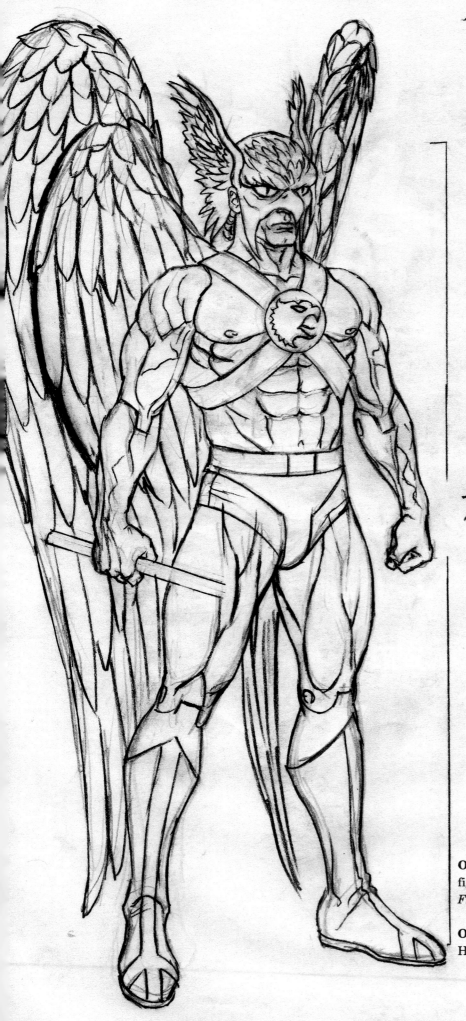

THIS IS THE EXACT HEIGHT OF WHAT THE ACTION FIGURE SHOULD WIND UP AT, INCLUDING ARTICULATION.

$8\frac{1}{4}$" THE OTHER DRAWINGS ARE LESS EXAGGERATED IN HEIGHT AS THIS ONE APPEARS. BEING A 6'6" MAN, HAWKMAN SHOULD LOOK FAIRLY LONG-LEGGED AS WELL AS FILLED OUT.

$7\frac{1}{4}$"

WITH THE HELMET BEING PRETTY LARGE, WE DON'T WANT IT TO LOOK DISPROPORTIONATE TO THE REST OF THE BODY.

Opposite (top): Plastic Man study for *Justice* action figures wave 3 that was based on Alex Toth's *Super Friends* model sheet.

Opposite (bottom), this page, and following page: Hawkman guide for *Justice* action figures wave 4.

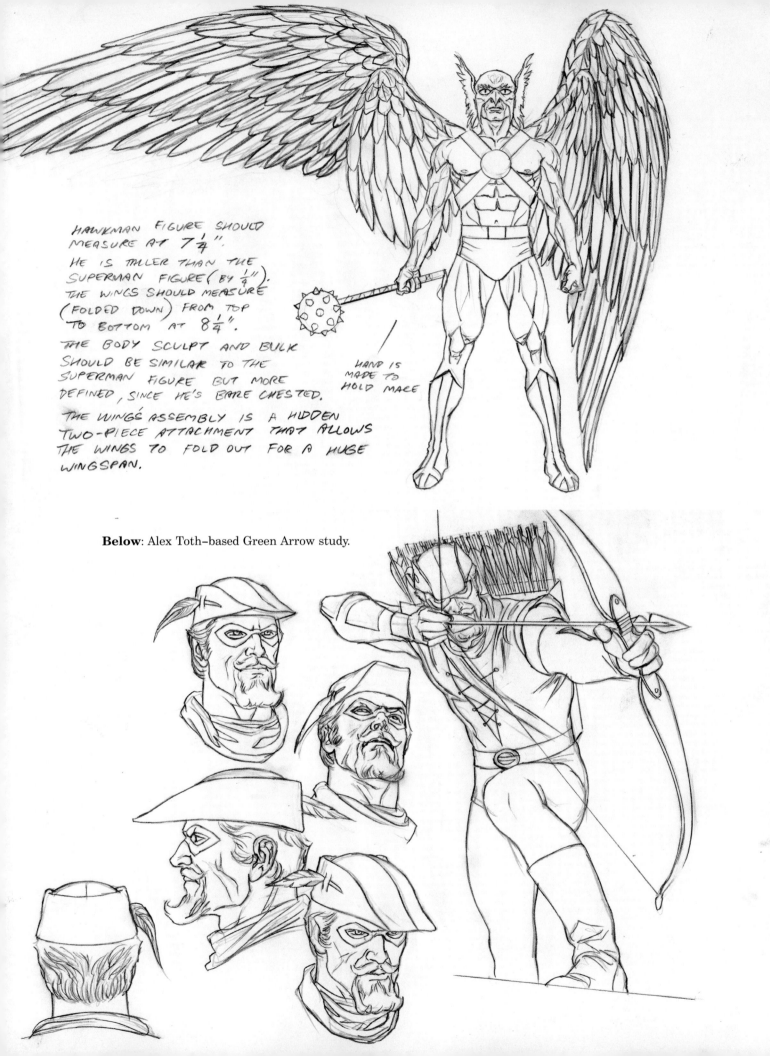

HAWKMAN FIGURE SHOULD
MEASURE AT 7¼".
HE IS TALLER THAN THE
SUPERMAN FIGURE (BY ¼").
THE WINGS SHOULD MEASURE
(FOLDED DOWN) FROM TOP
TO BOTTOM AT 8¼".
THE BODY SCULPT AND BULK
SHOULD BE SIMILAR TO THE
SUPERMAN FIGURE BUT MORE
DEFINED, SINCE HE'S BARE CHESTED.

THE WINGS ASSEMBLY IS A HIDDEN
TWO-PIECE ATTACHMENT THAT ALLOWS
THE WINGS TO FOLD OUT FOR A HUGE
WINGSPAN.

HAND IS
MADE TO
HOLD MACE

Below: Alex Toth–based Green Arrow study.

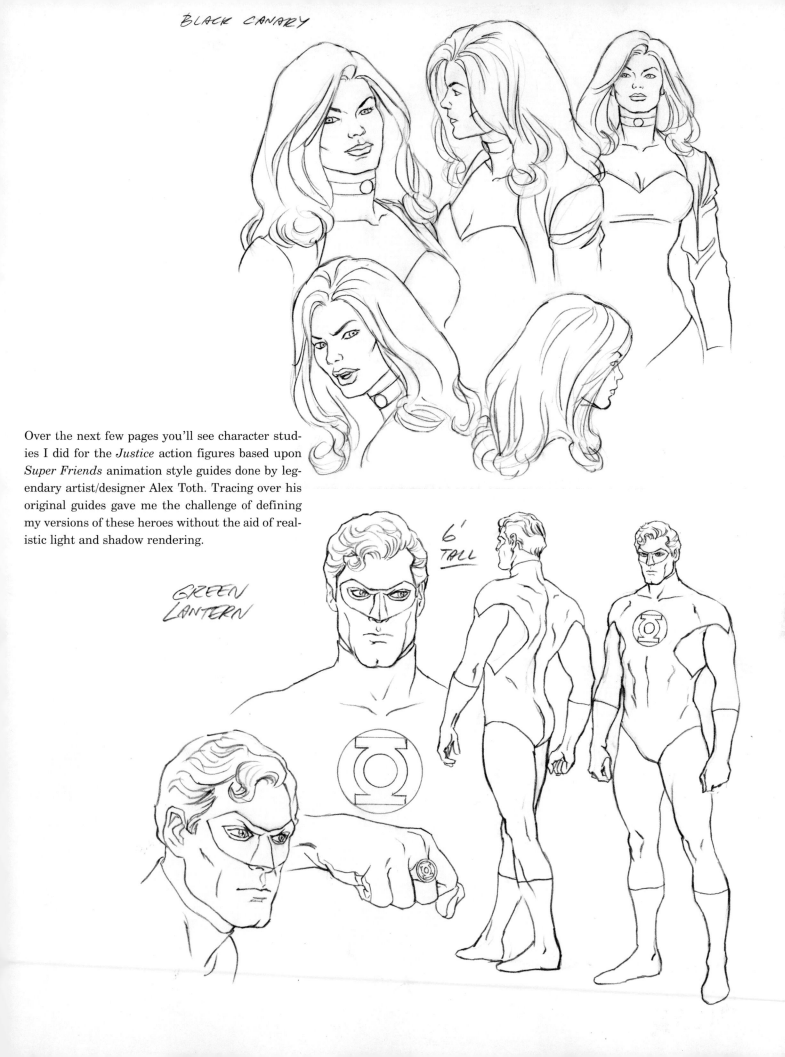

BLACK CANARY

Over the next few pages you'll see character studies I did for the *Justice* action figures based upon *Super Friends* animation style guides done by legendary artist/designer Alex Toth. Tracing over his original guides gave me the challenge of defining my versions of these heroes without the aid of realistic light and shadow rendering.

GREEN LANTERN

6' TALL

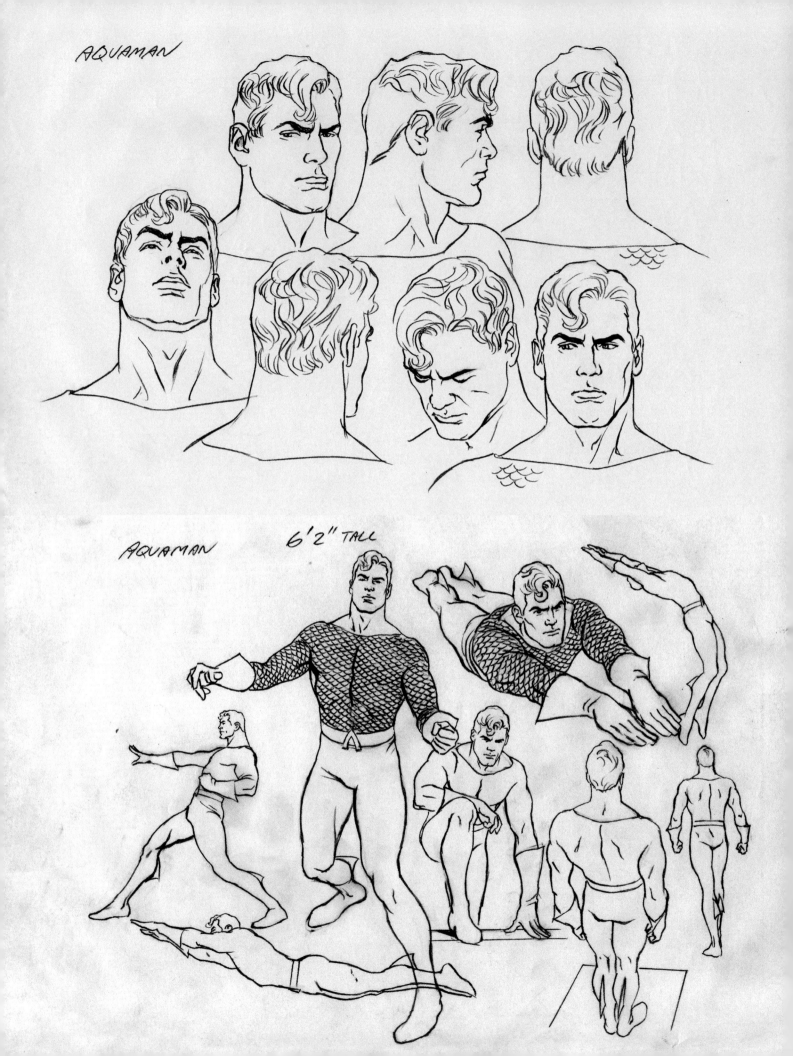

AQUAMAN

AQUAMAN 6'2" TALL

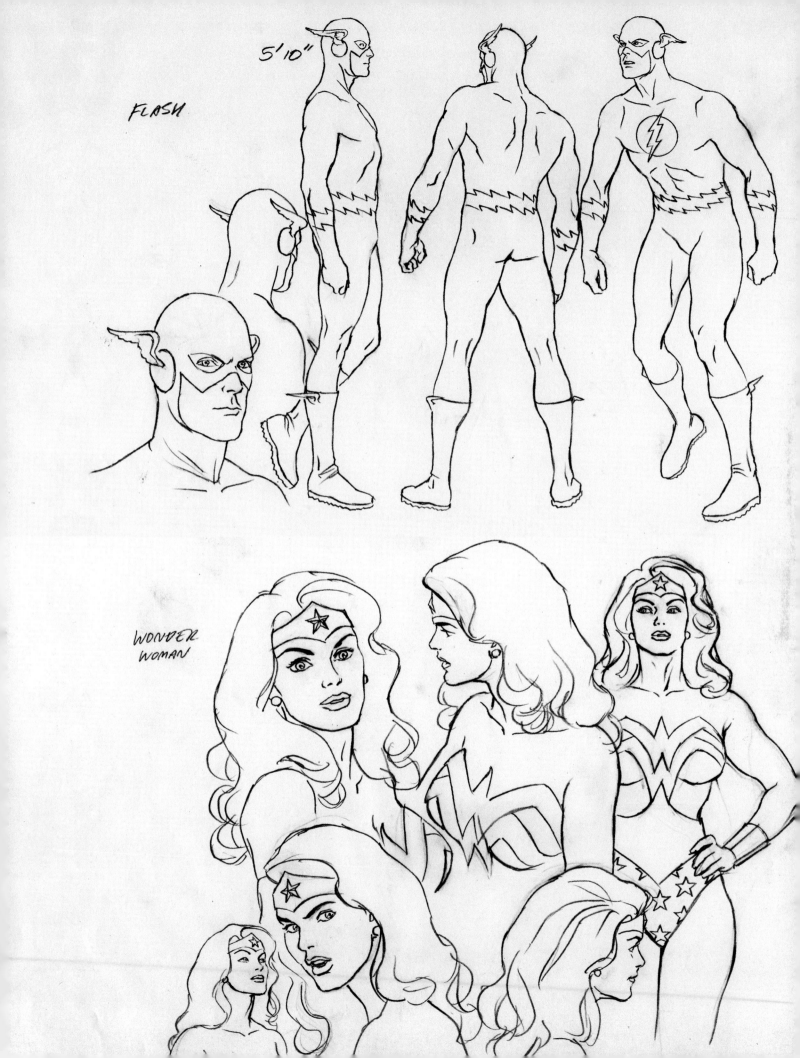

FLASH

5'10"

WONDER WOMAN

Below: Batman turns for *Batman: Black and White* statue.

Opposite: More Toth-based model sheets for *Justice* action figures wave 2.

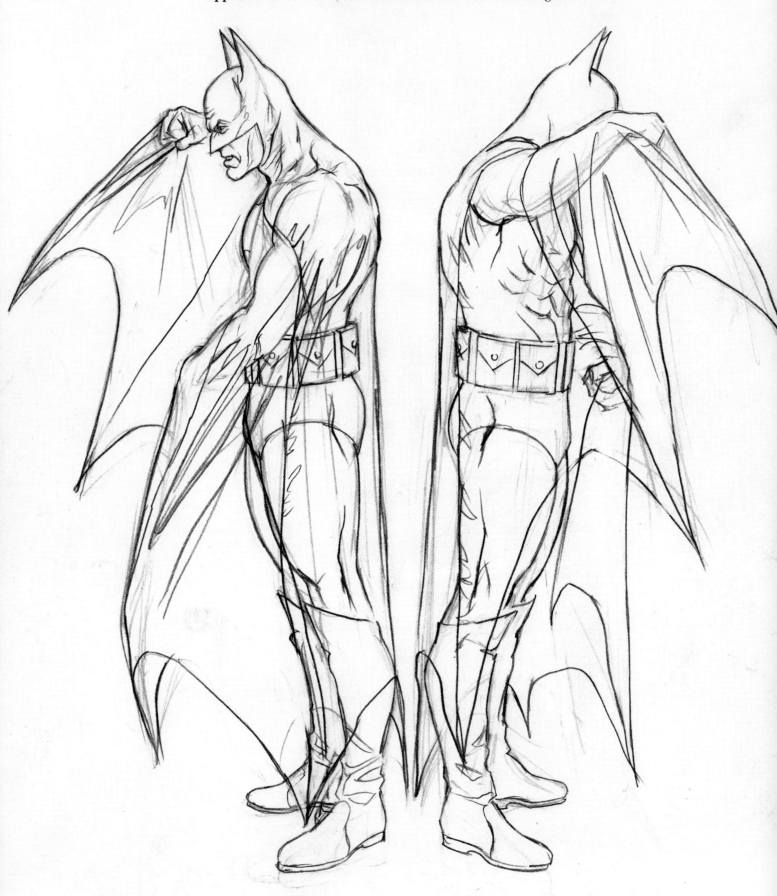

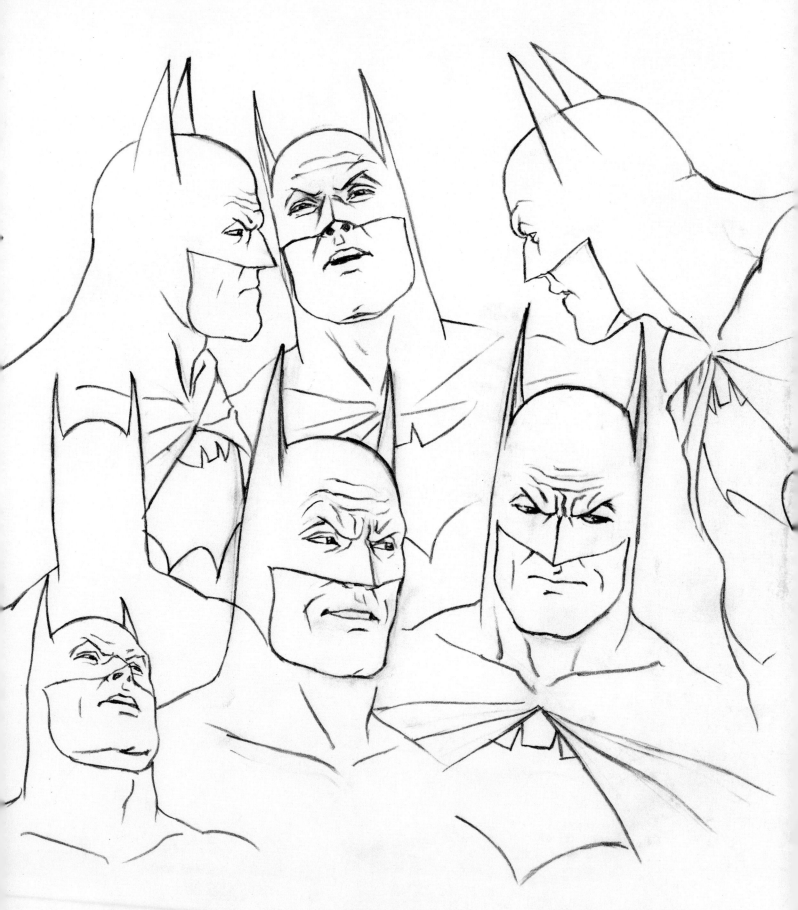

Following spread: Head studies for variant figure of Superman, as well as additional Toth-based model sheets for *Justice* action figures wave 1. The current-to-altered body comparisons are for a thirteen-inch *Kingdom Come* Superman action figure.

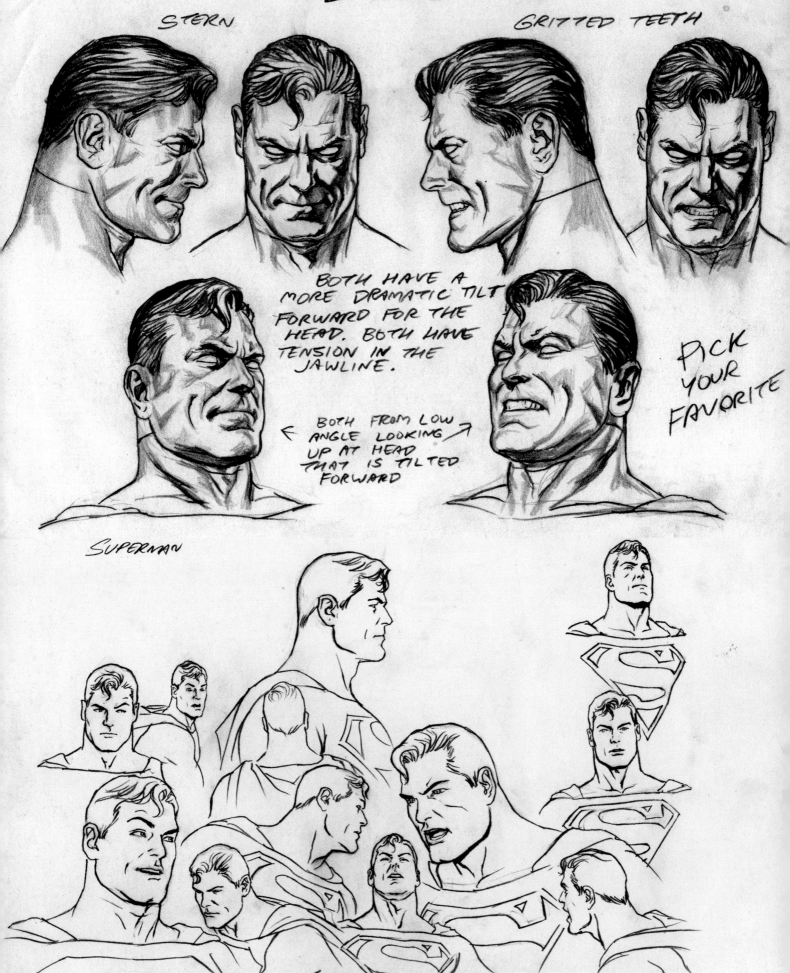

HEAT VISION HEAD
2 VIEWS

STERN

GRITTED TEETH

BOTH HAVE A MORE DRAMATIC TILT FORWARD FOR THE HEAD. BOTH HAVE TENSION IN THE JAWLINE.

← BOTH FROM LOW ANGLE LOOKING UP AT HEAD THAT IS TILTED FORWARD →

PICK YOUR FAVORITE

SUPERMAN

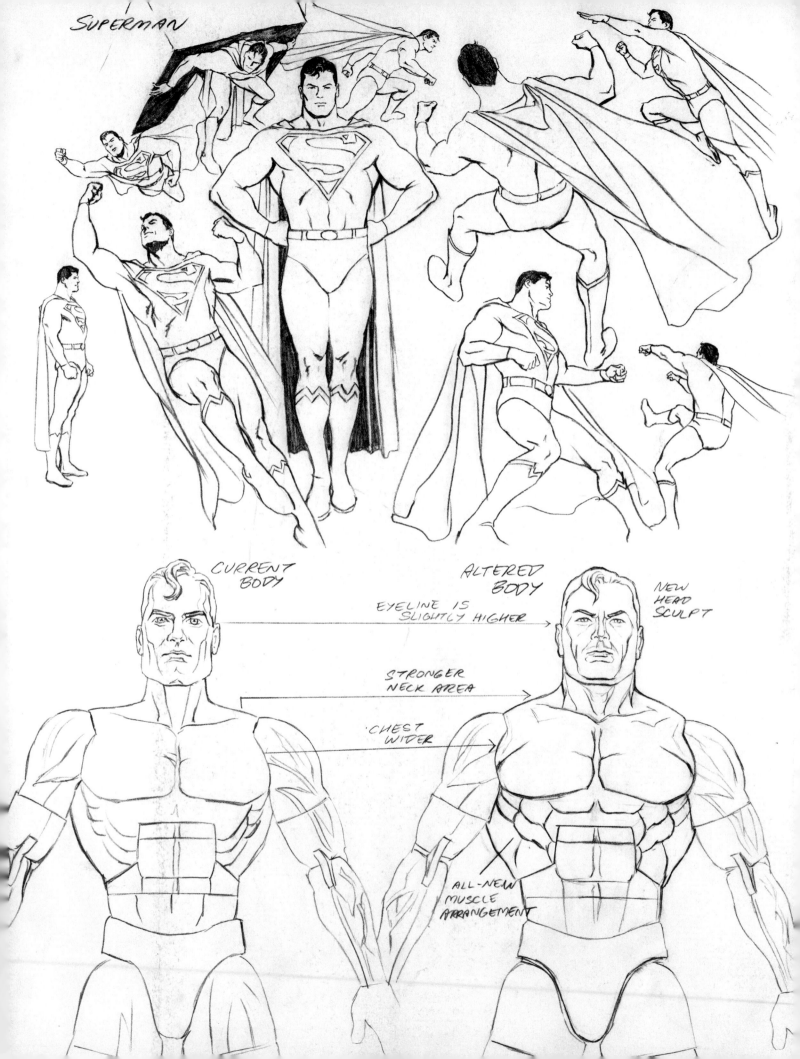

SUPERMAN

CURRENT BODY

ALTERED BODY

EYELINE IS SLIGHTLY HIGHER

NEW HEAD SCULPT

STRONGER NECK AREA

CHEST WIDER

ALL-NEW MUSCLE ARRANGEMENT

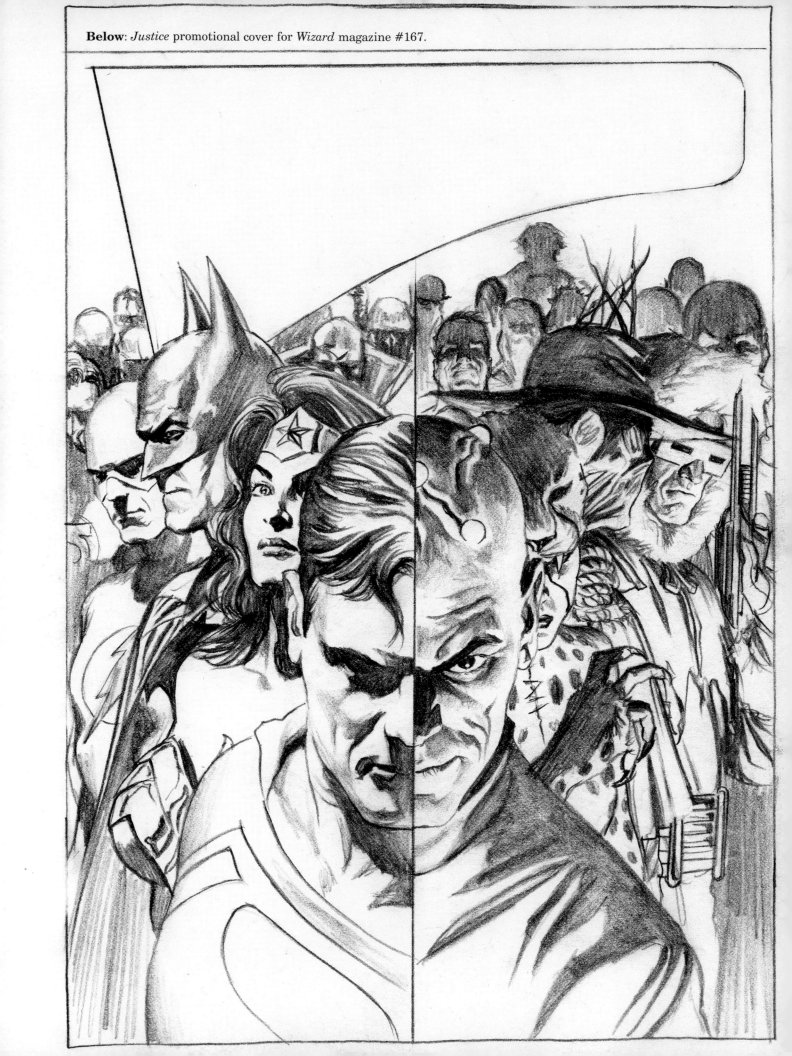

DESIGNING THE
JUSTICE BATMOBILE

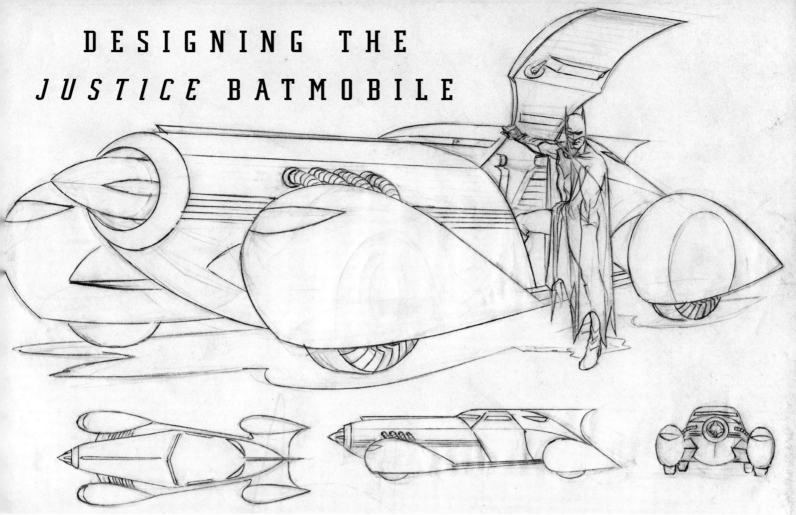

Designing a personal interpretation of what the Batmobile could or should be is a challenge taken up by almost all artists who ever get to work with Batman. For all the years of automotive history reflected in previous Batmobiles, one can find inspiration in numerous variations. Everyone has their favorite, but if you aspire to somehow also conceive the vehicle as sensible, your favorite version may not apply.

My first thought was to go back to the original, where it was not a bat-styled vehicle but a sporty roadster. This 1939-style car would look more idiosyncratic if adapted for the road today. Still, some element of the hero's unique style must affect the vehicle, if not turn it into a winged object.

With additional artists' input, I began to push the car's contours into something more sleek and streamlined, not large and bulky as the older styles had been. I added subtle affectations of the big '40s Bat-head on the back of the car, as well as a relatively tiny Bat-fin across the hood. The front grill would still remain mostly old-school, surrounded by sharper pontoons that covered the wheels and emulated Bat-ears from an aerial view.

The function of the car would be to drive exclusively by infrared (which is really green) inside the black-windowed cabin, and the front nose cone is a harpoon that can fire forward and "catch" a vehicle that Batman chases.

The Batmobile's design is ever-evolving, and I, like many, am never fully satisfied to leave it alone (which you'll see later in this book).

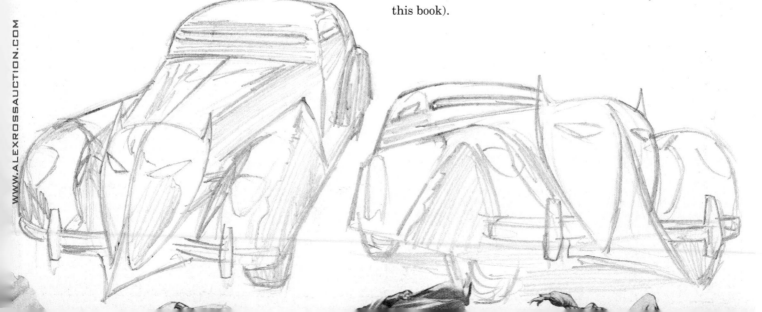

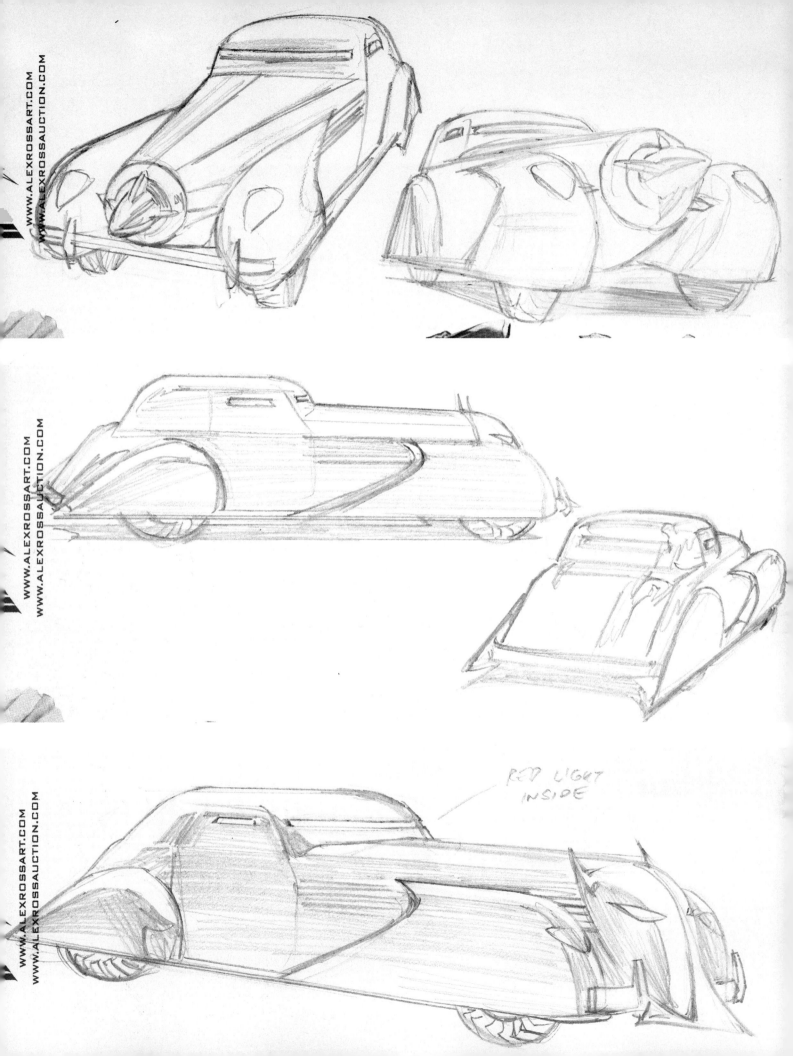

RED LIGHT
INSIDE

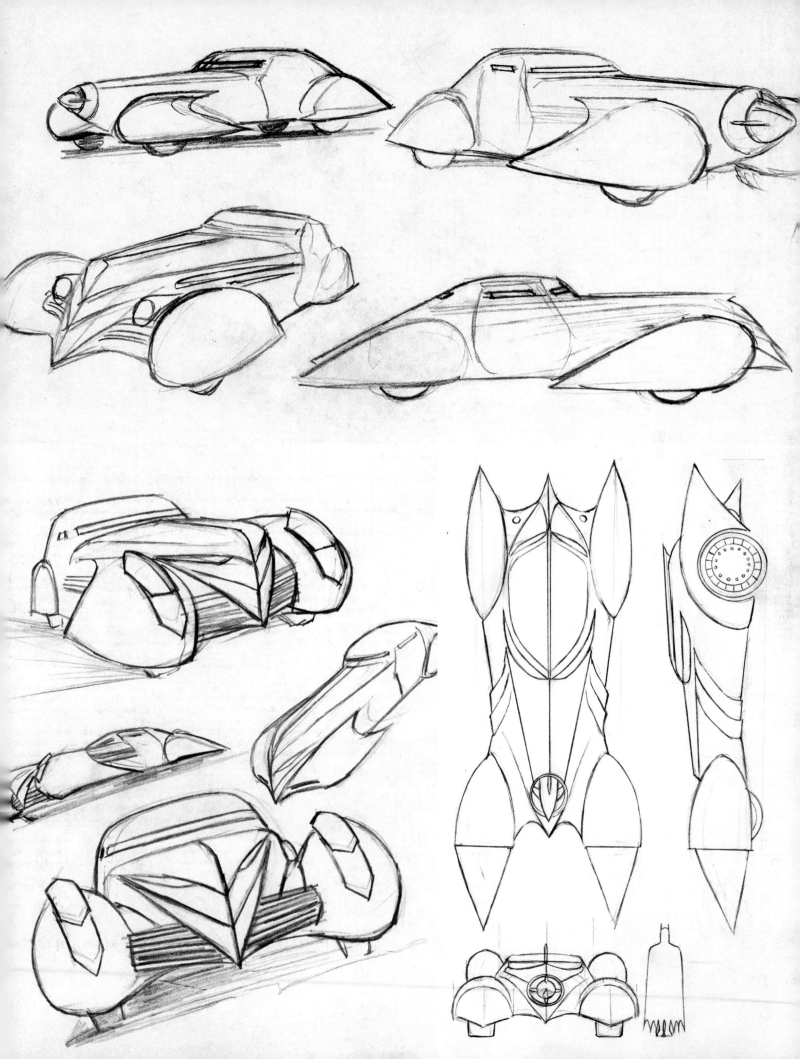

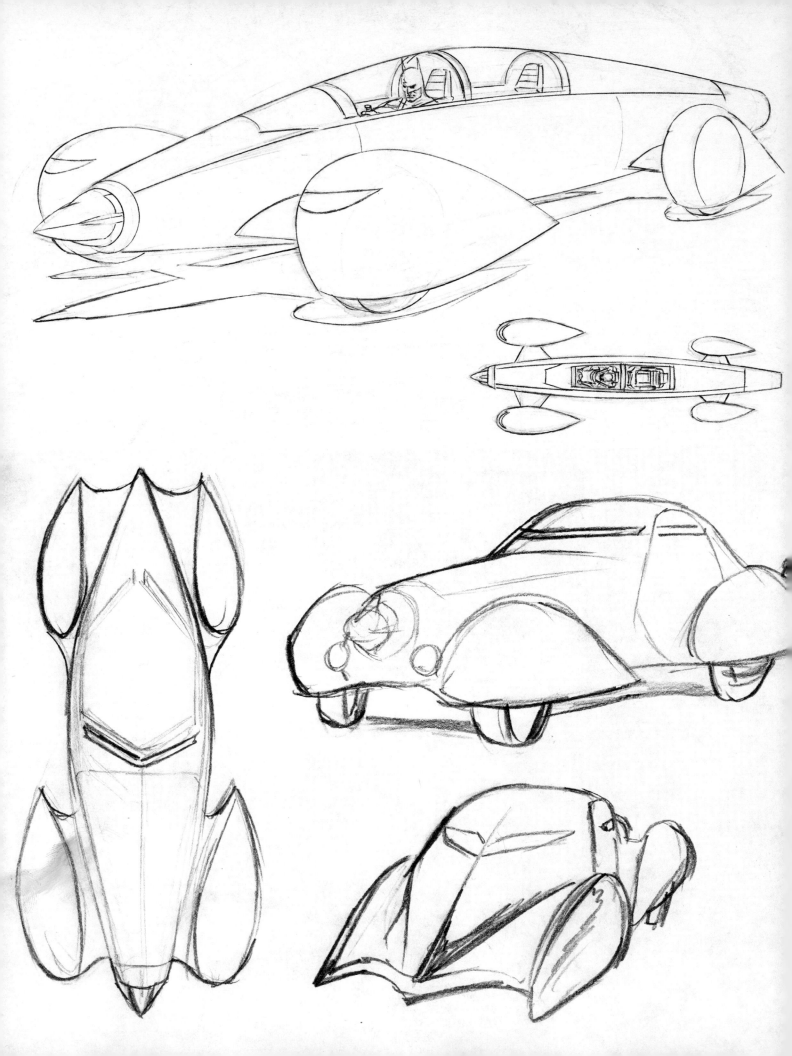

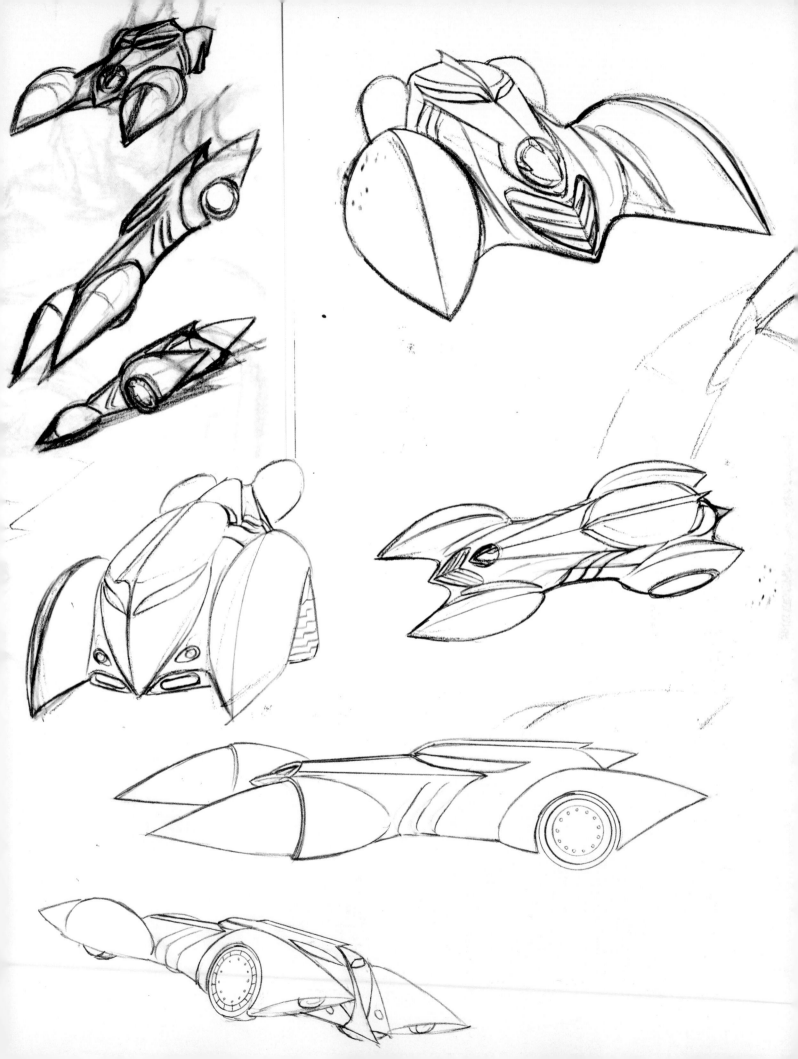

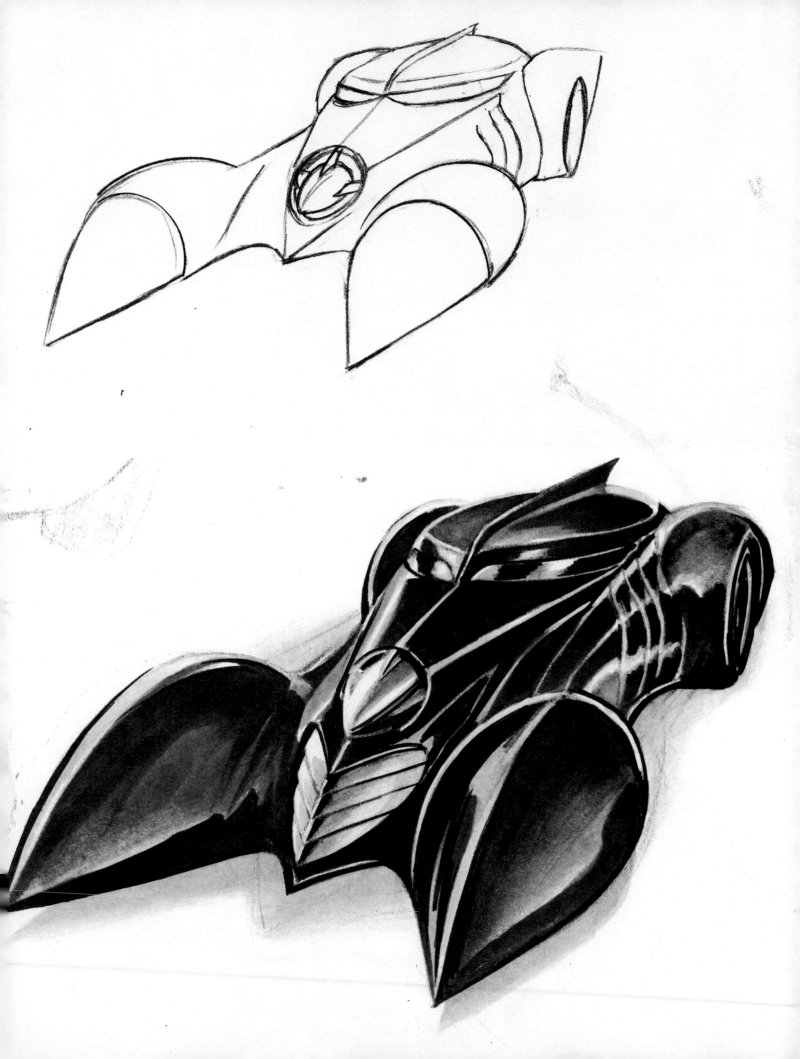

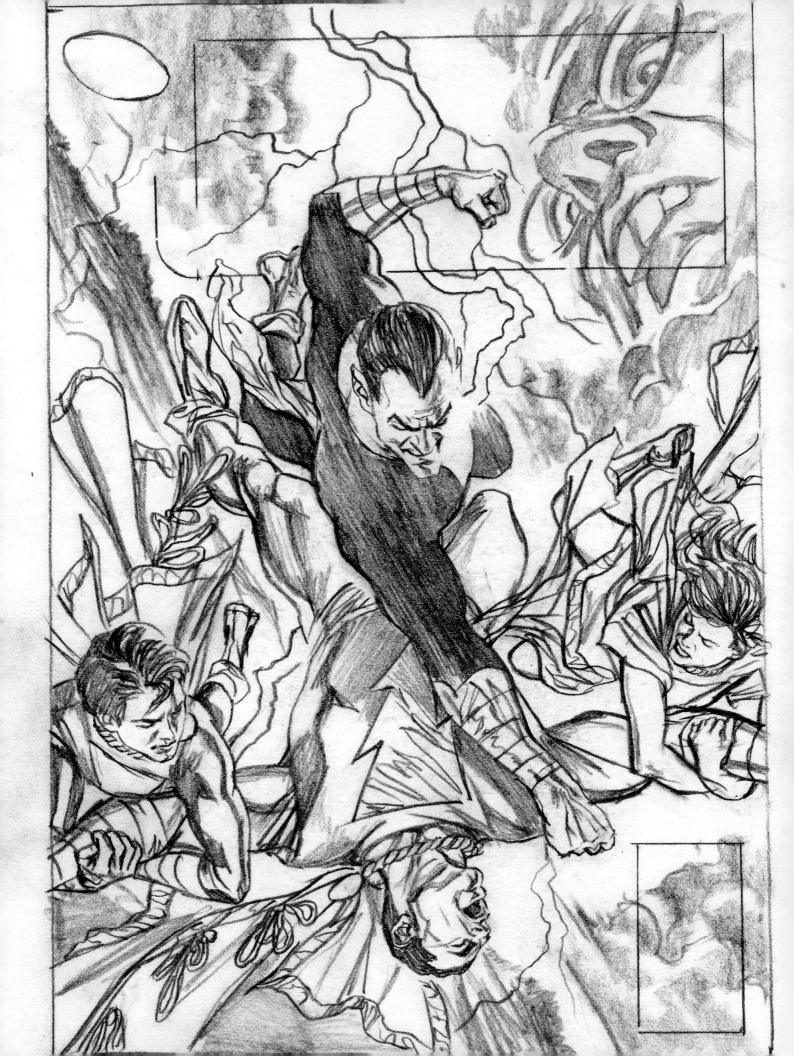

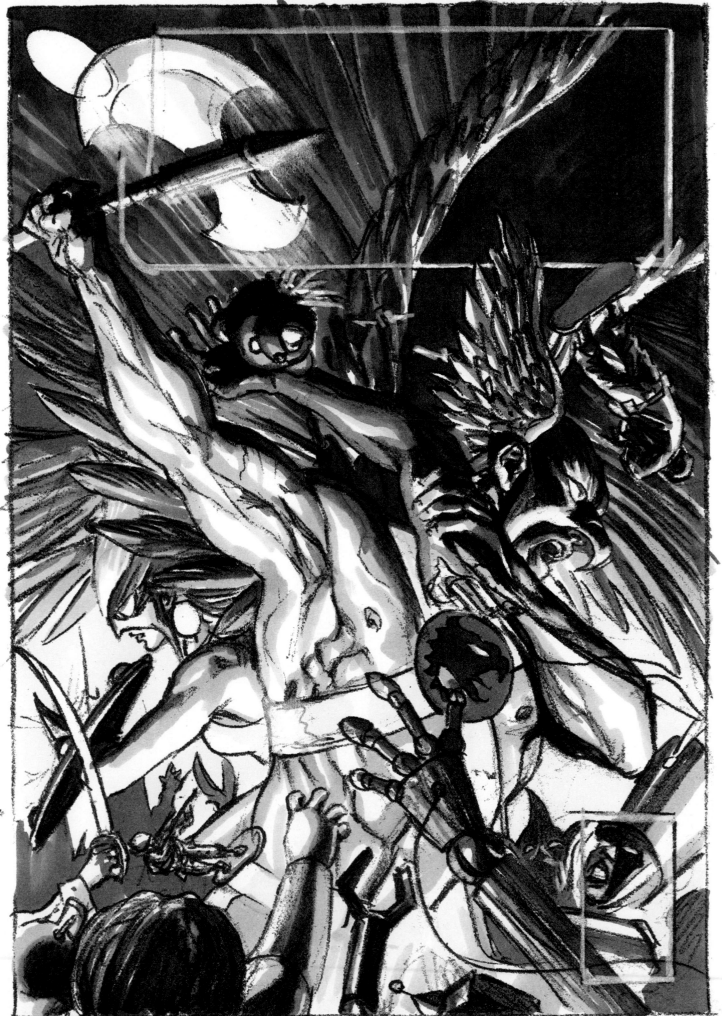

Previous spread: Roughs for *Justice* covers #9 and #7.

Below: Videogame cover/poster design for Justice League: Heroes game (2006).

JUSTICE LEAGUE : HEROES

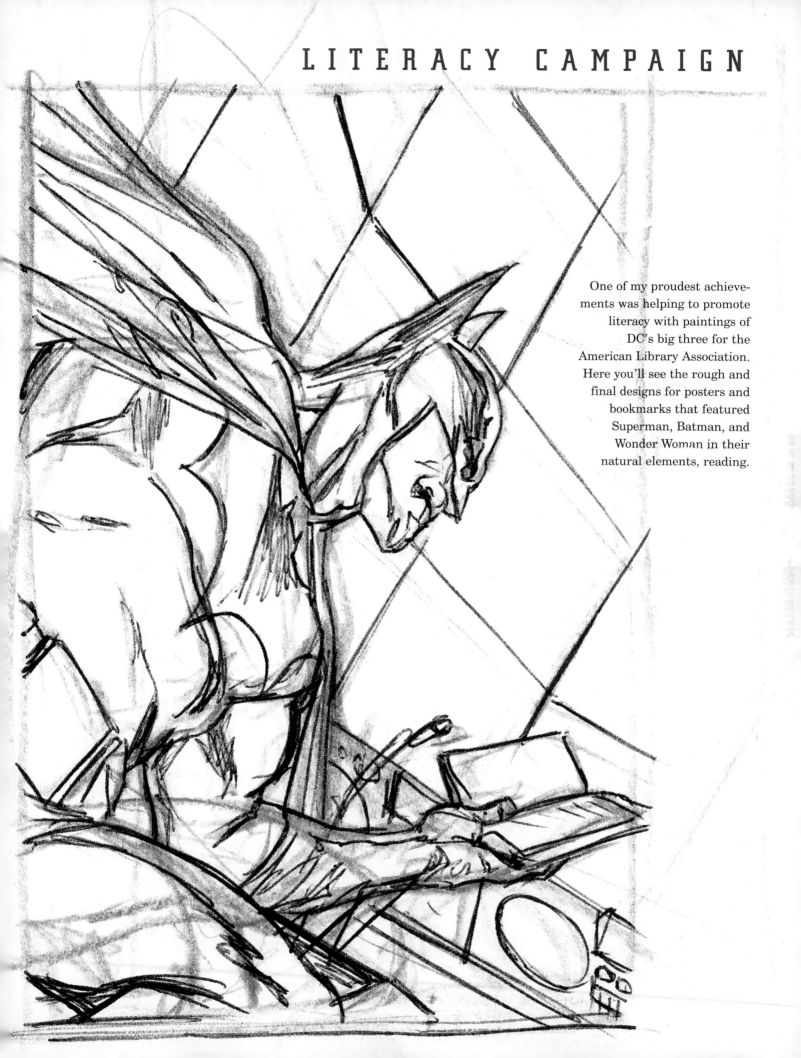

LITERACY CAMPAIGN

One of my proudest achievements was helping to promote literacy with paintings of DC's big three for the American Library Association. Here you'll see the rough and final designs for posters and bookmarks that featured Superman, Batman, and Wonder Woman in their natural elements, reading.

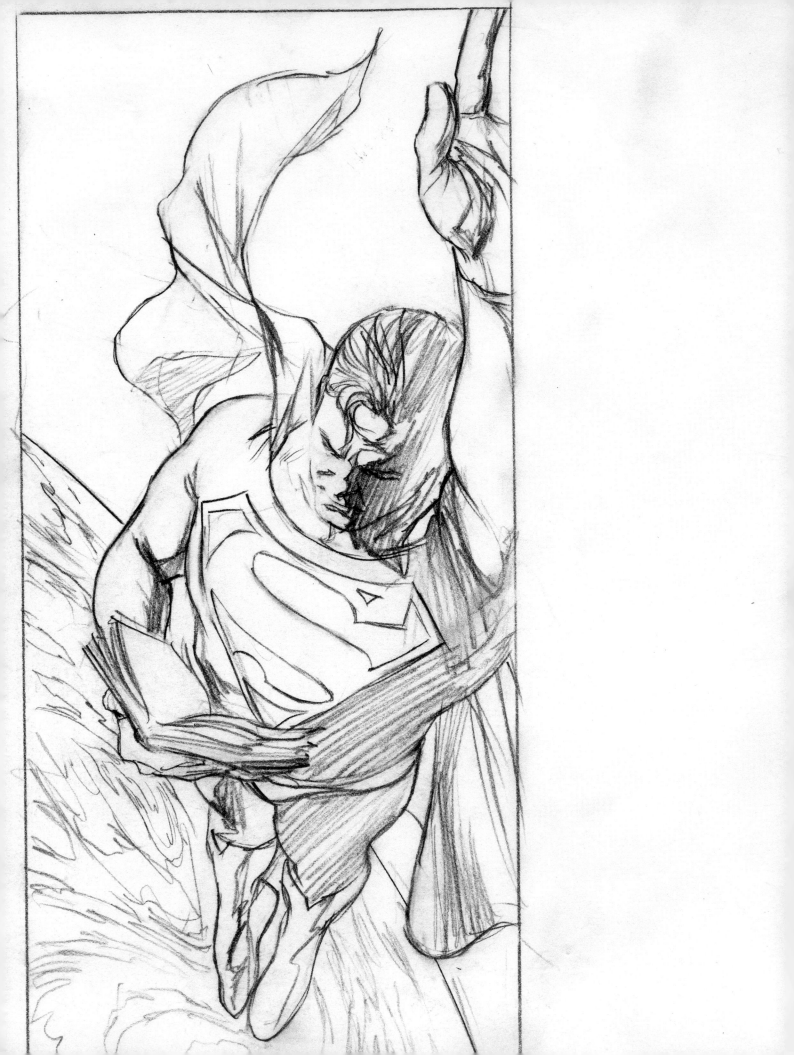

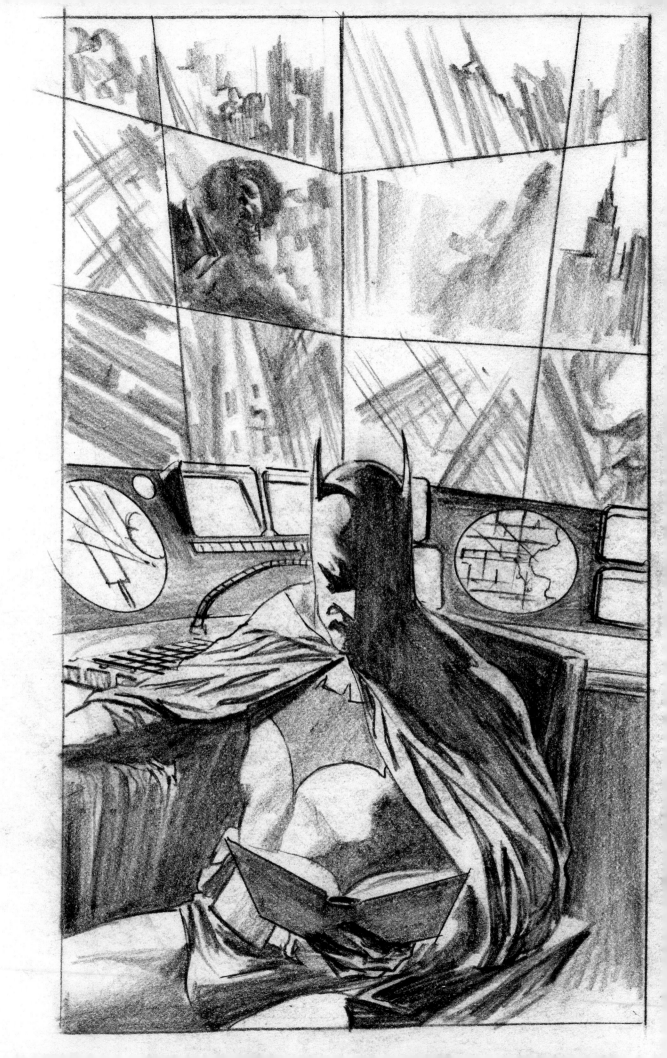

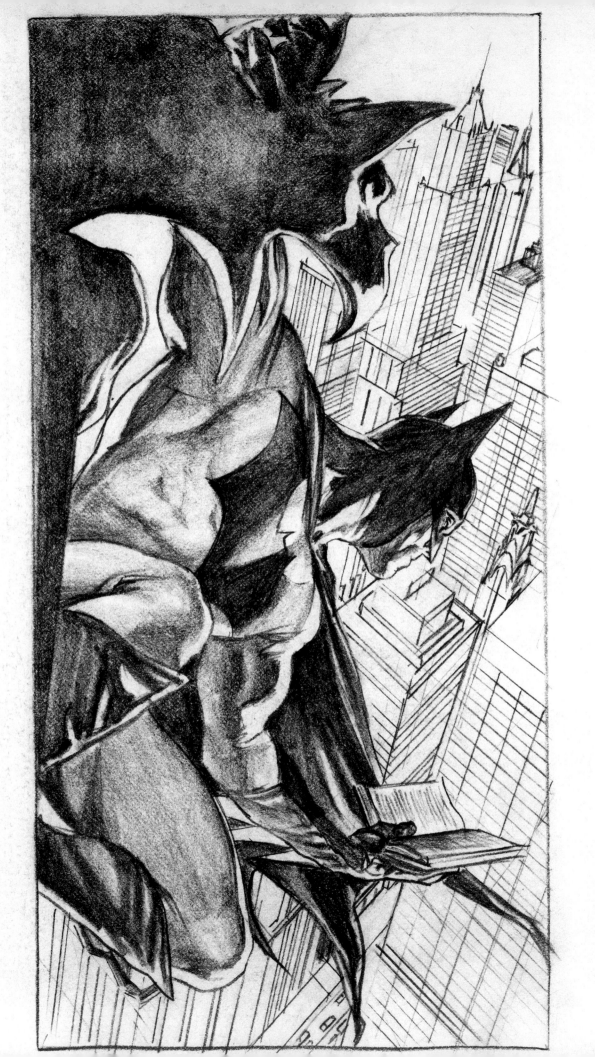

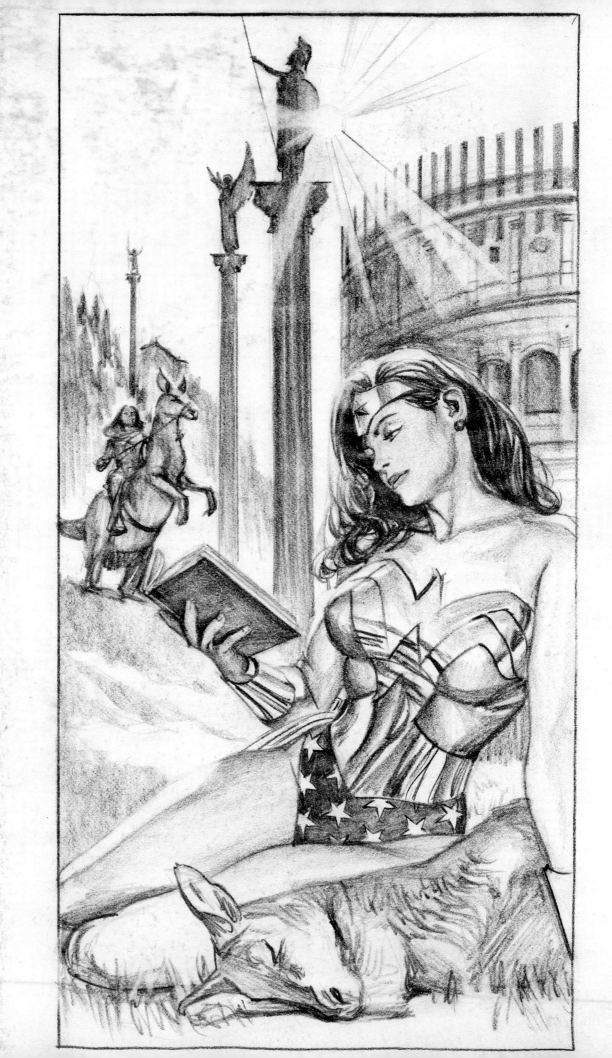

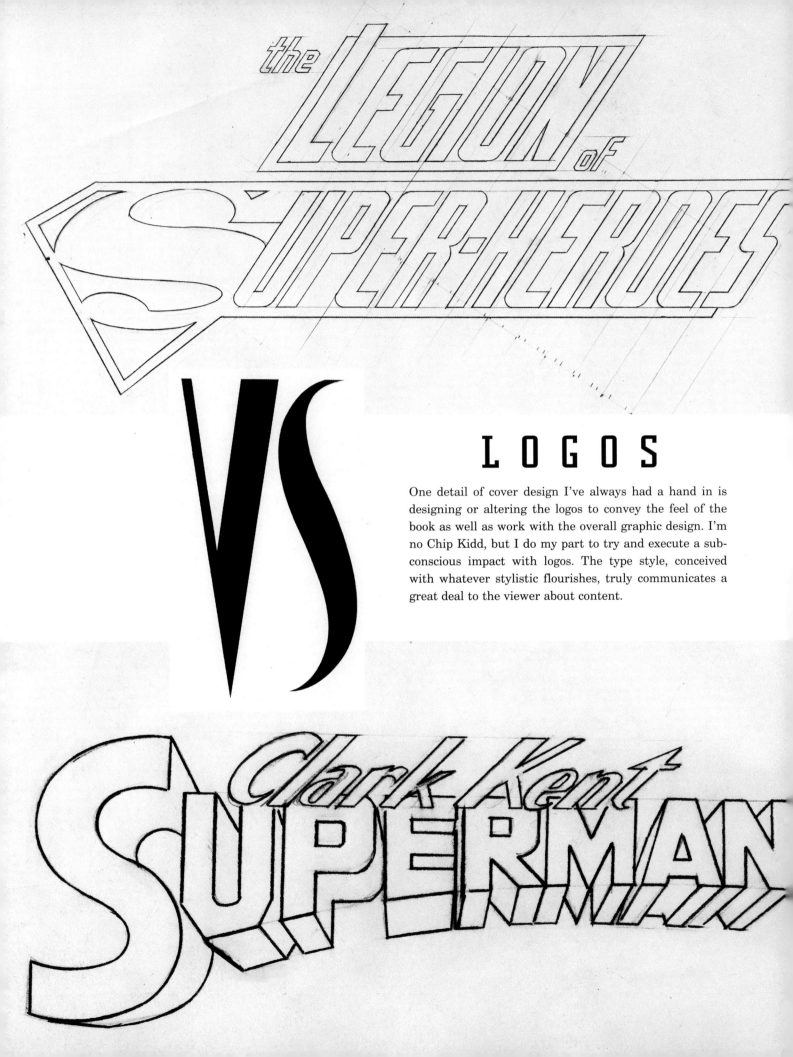

LOGOS

One detail of cover design I've always had a hand in is designing or altering the logos to convey the feel of the book as well as work with the overall graphic design. I'm no Chip Kidd, but I do my part to try and execute a subconscious impact with logos. The type style, conceived with whatever stylistic flourishes, truly communicates a great deal to the viewer about content.

THIS IS A LITTLE MORE
CLASSIC STYLE

ALL $\frac{3}{4}$" WIDTH

$\frac{2"}{16}$

1"

$2\frac{3}{4}$"

$\frac{7"}{16}$

$\frac{7"}{8}$

LEG
FALLS
IN MIDDLE

$\frac{7"}{8}$

$\frac{2"}{16}$

1"

$\frac{3"}{8}$

LEG
FALLS
IN MIDDLE

BOTTOM

$\frac{5"}{8}$

$\frac{3"}{32}$

$\frac{5"}{8}$

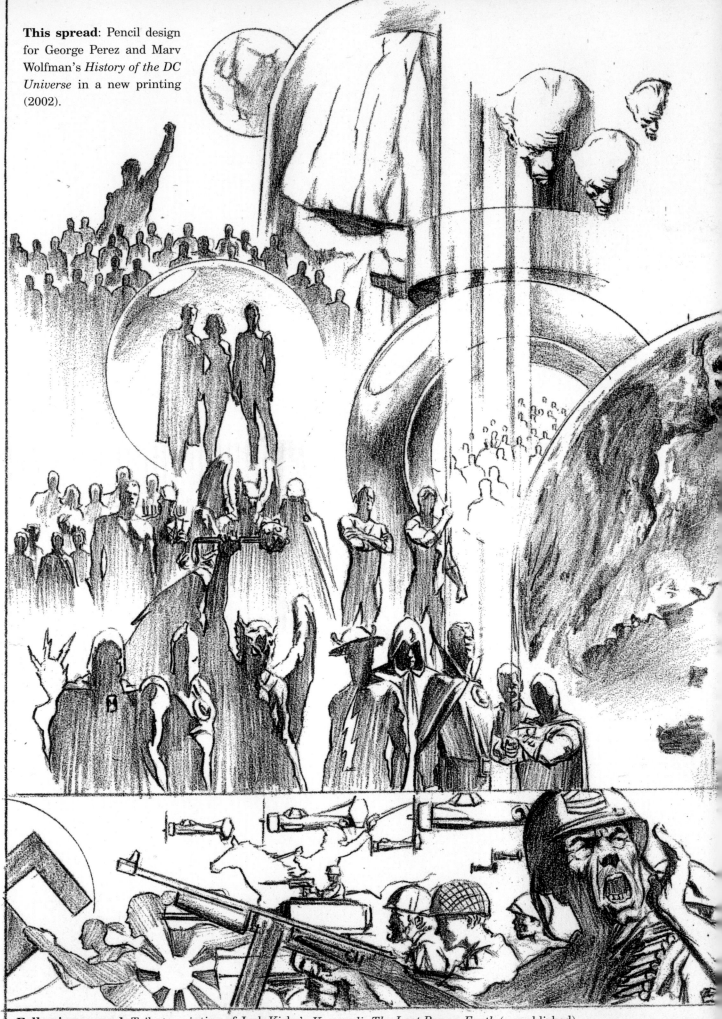

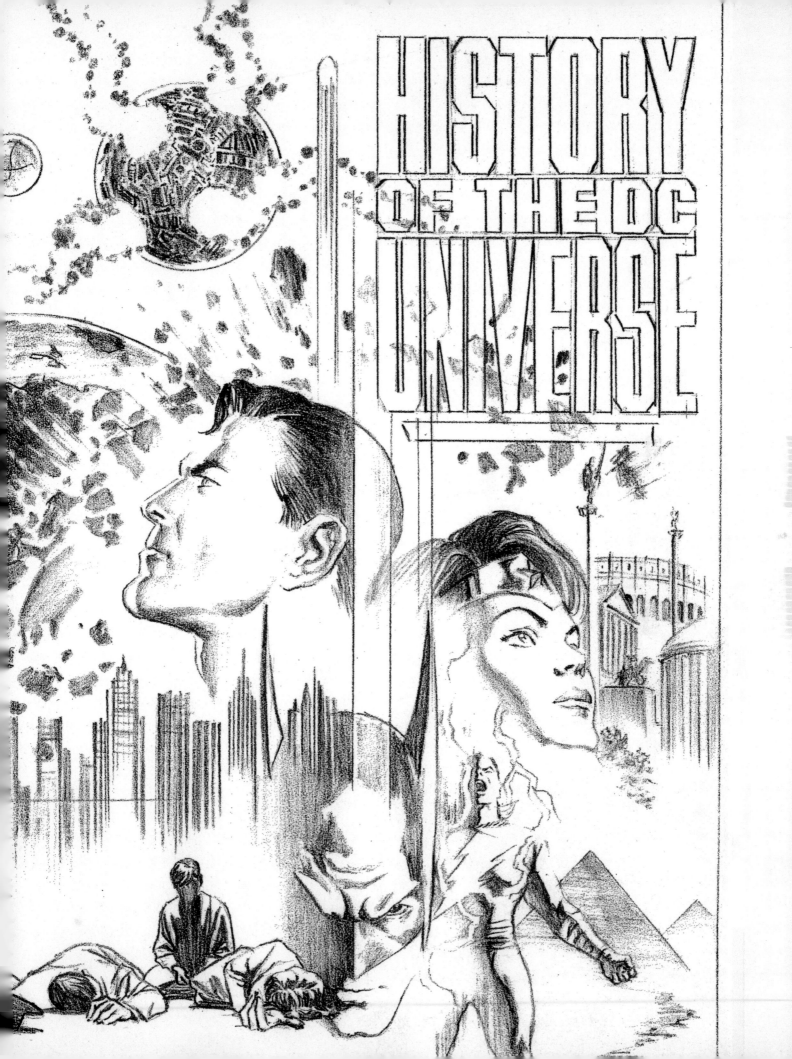

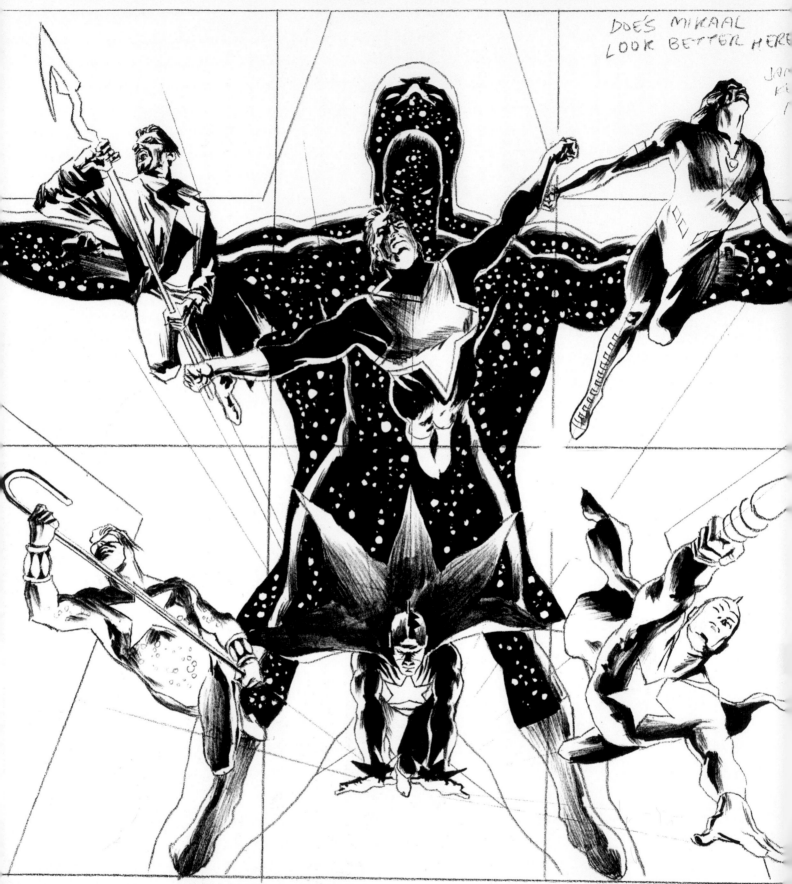

In the image, handwritten annotations read:

"DOES MIKAAL LOOK BETTER HERE"

"WE'RE GOING WITH THE TED KNIGHT SHO..."

Above: Six-cover layout design for *Starman* covers #57–62, placing *Kingdom Come* Starman version at the center (2000).

Opposite: Ink and pencil test of Superman for black-and-white art technique used on *JSA Kingdom Come Special: Superman* one-shot (2008).

Following spread: Supergirl and Batgirl poster sketches (2002).

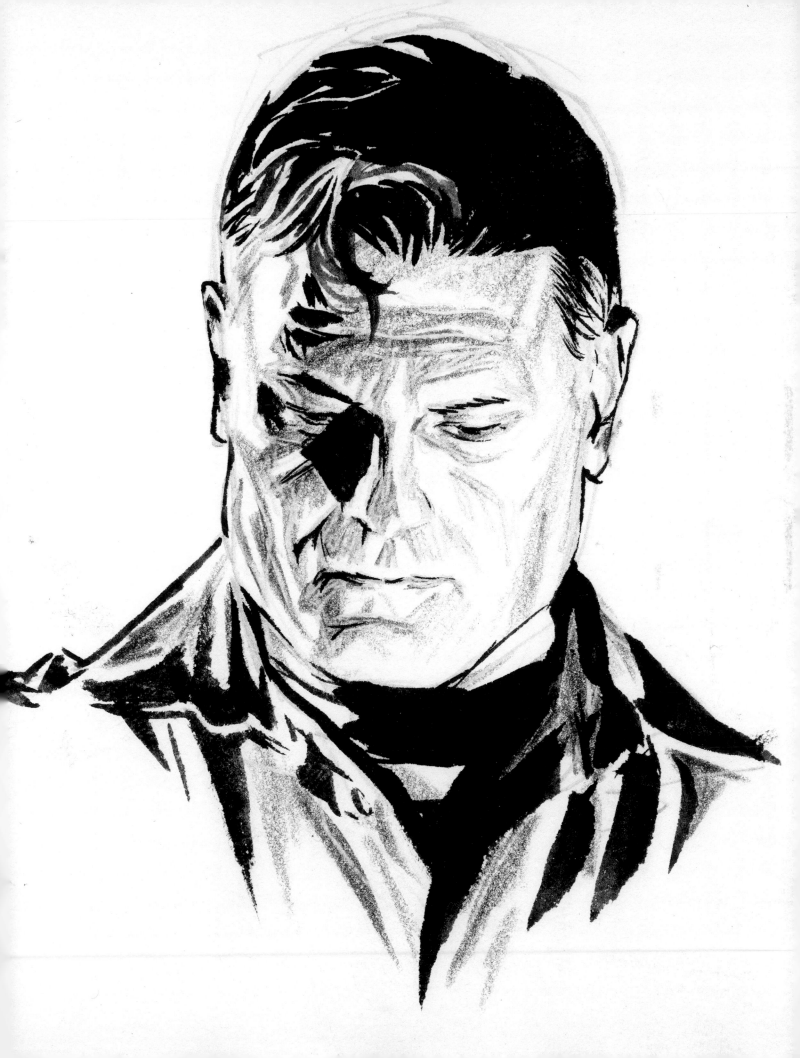

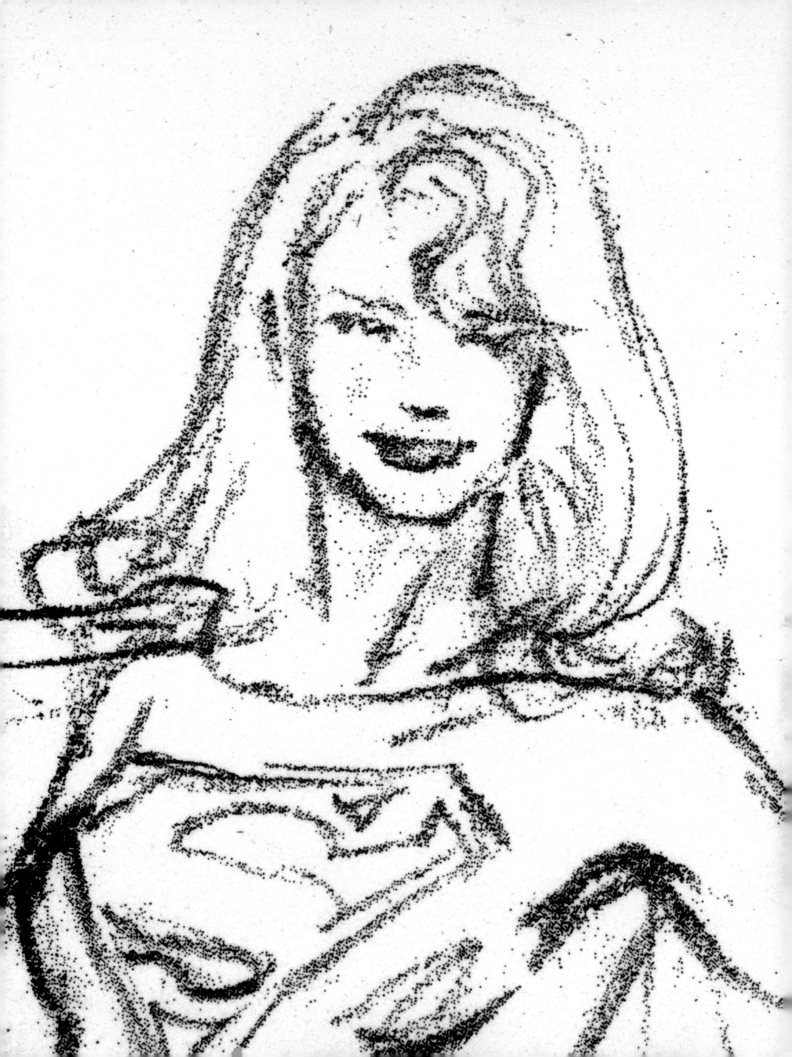

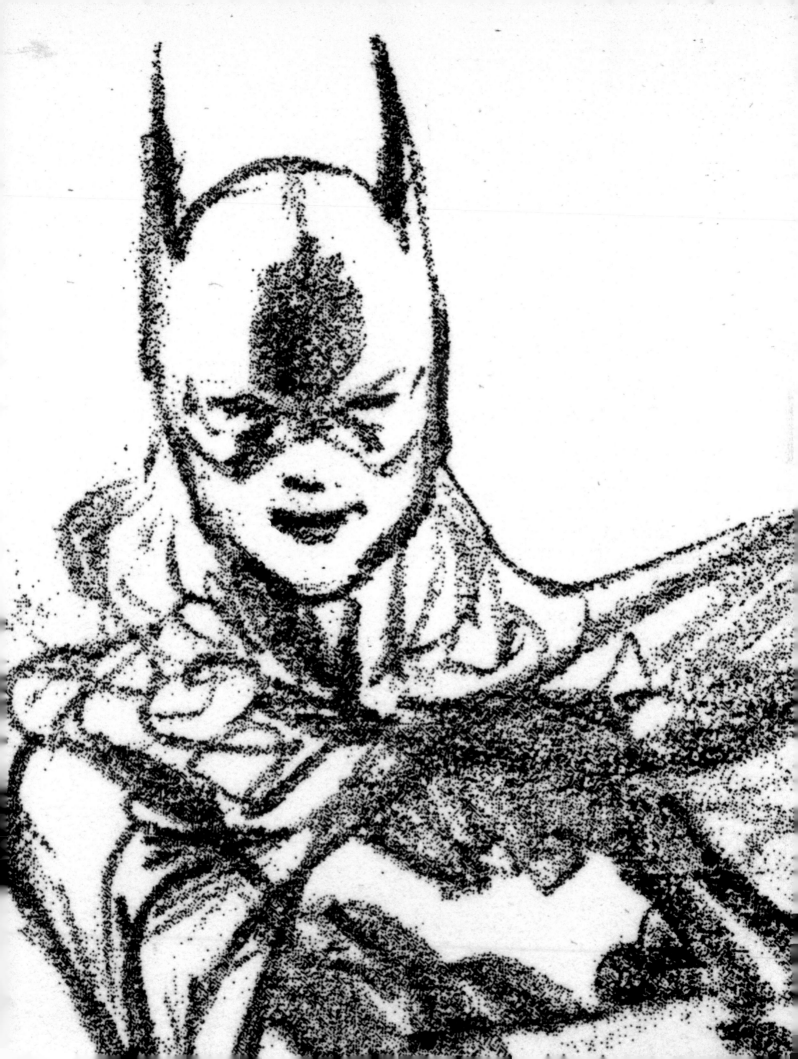

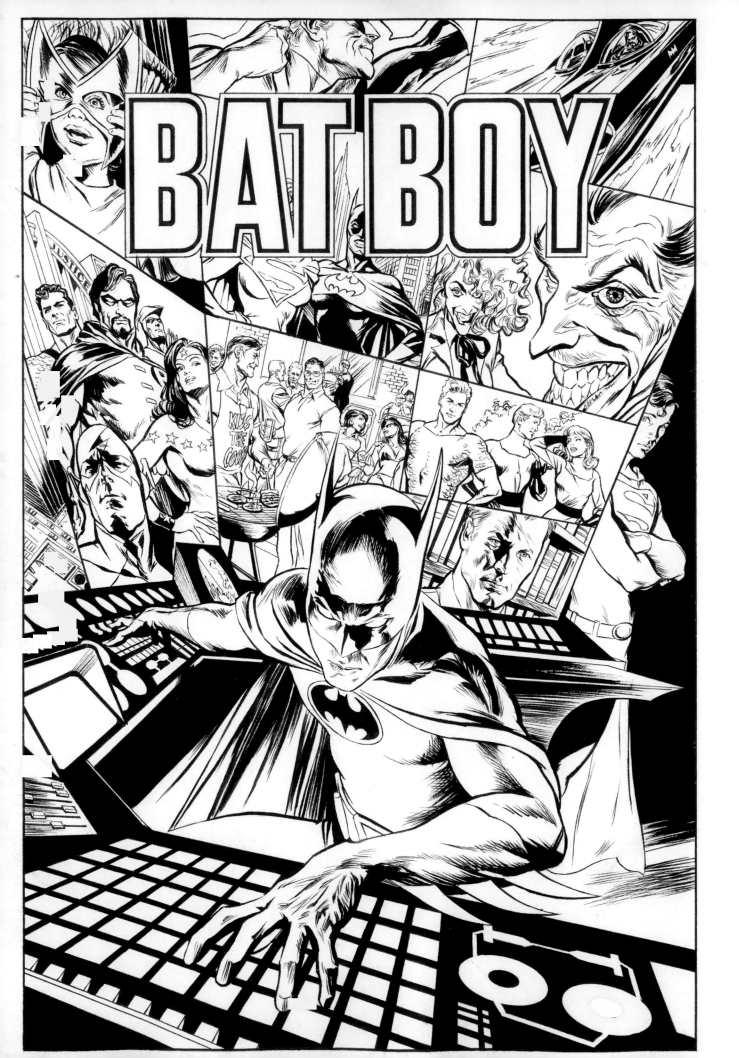

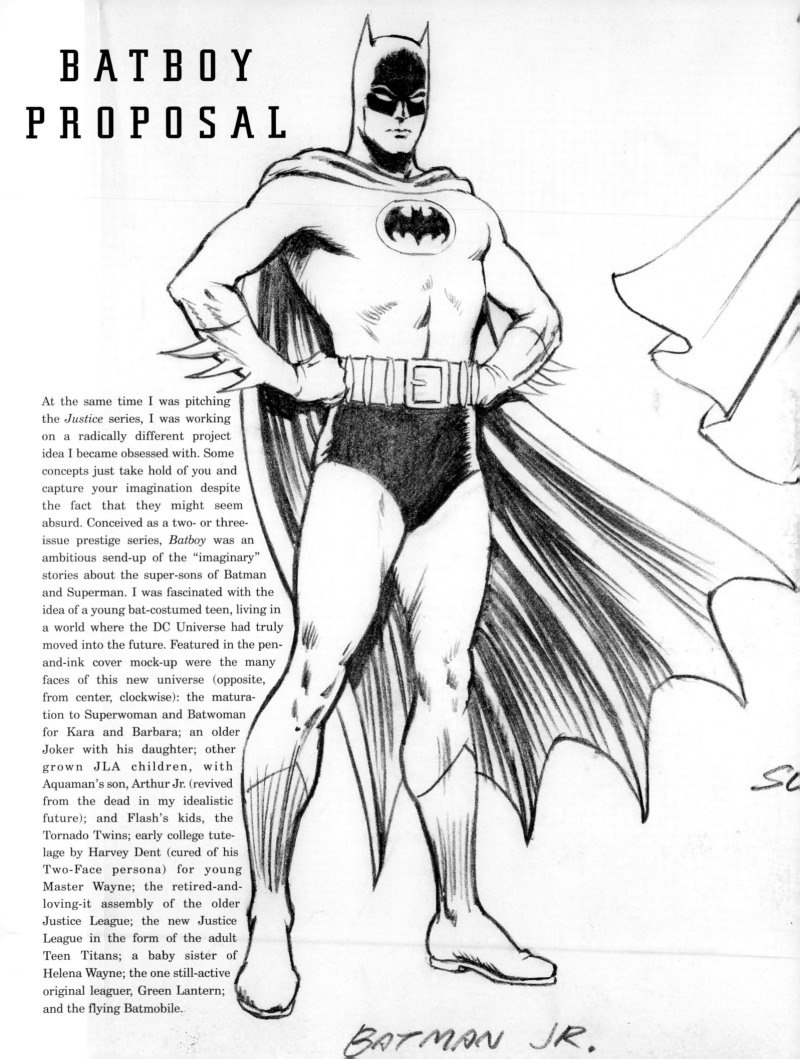

BATBOY PROPOSAL

At the same time I was pitching the *Justice* series, I was working on a radically different project idea I became obsessed with. Some concepts just take hold of you and capture your imagination despite the fact that they might seem absurd. Conceived as a two- or three-issue prestige series, *Batboy* was an ambitious send-up of the "imaginary" stories about the super-sons of Batman and Superman. I was fascinated with the idea of a young bat-costumed teen, living in a world where the DC Universe had truly moved into the future. Featured in the pen-and-ink cover mock-up were the many faces of this new universe (opposite, from center, clockwise): the maturation to Superwoman and Batwoman for Kara and Barbara; an older Joker with his daughter; other grown JLA children, with Aquaman's son, Arthur Jr. (revived from the dead in my idealistic future); and Flash's kids, the Tornado Twins; early college tutelage by Harvey Dent (cured of his Two-Face persona) for young Master Wayne; the retired-and-loving-it assembly of the older Justice League; the new Justice League in the form of the adult Teen Titans; a baby sister of Helena Wayne; the one still-active original leaguer, Green Lantern; and the flying Batmobile.

BATMAN JR.

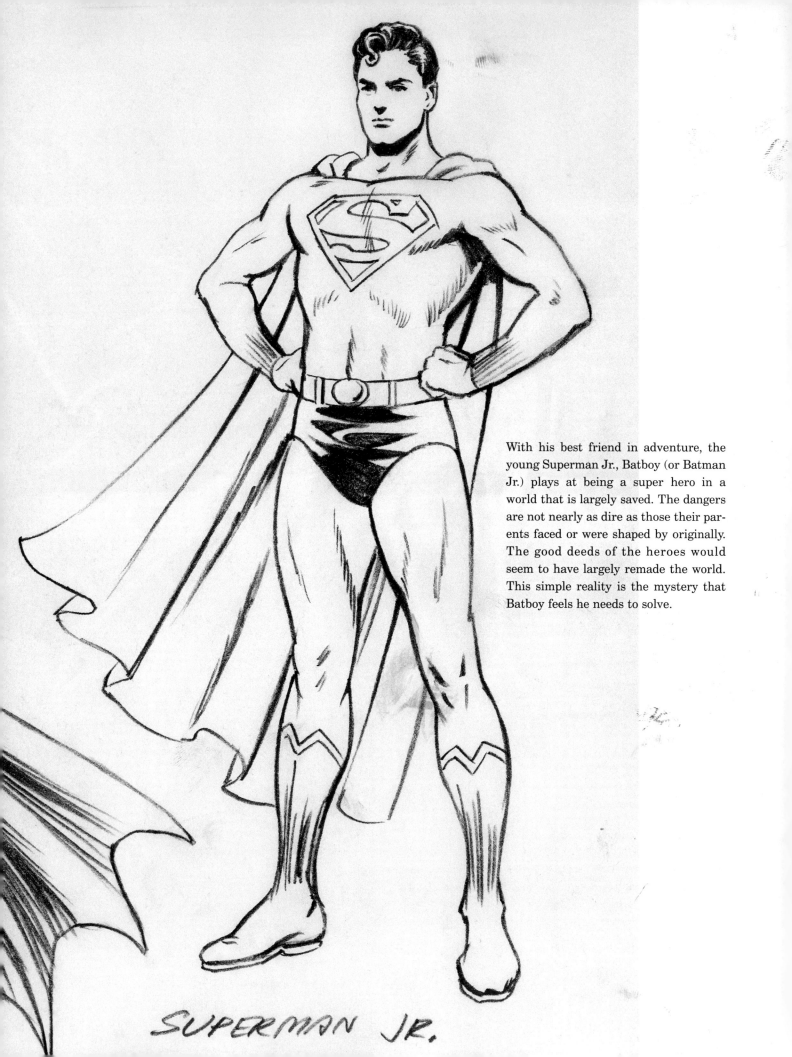

With his best friend in adventure, the young Superman Jr., Batboy (or Batman Jr.) plays at being a super hero in a world that is largely saved. The dangers are not nearly as dire as those their parents faced or were shaped by originally. The good deeds of the heroes would seem to have largely remade the world. This simple reality is the mystery that Batboy feels he needs to solve.

SUPERMAN JR.

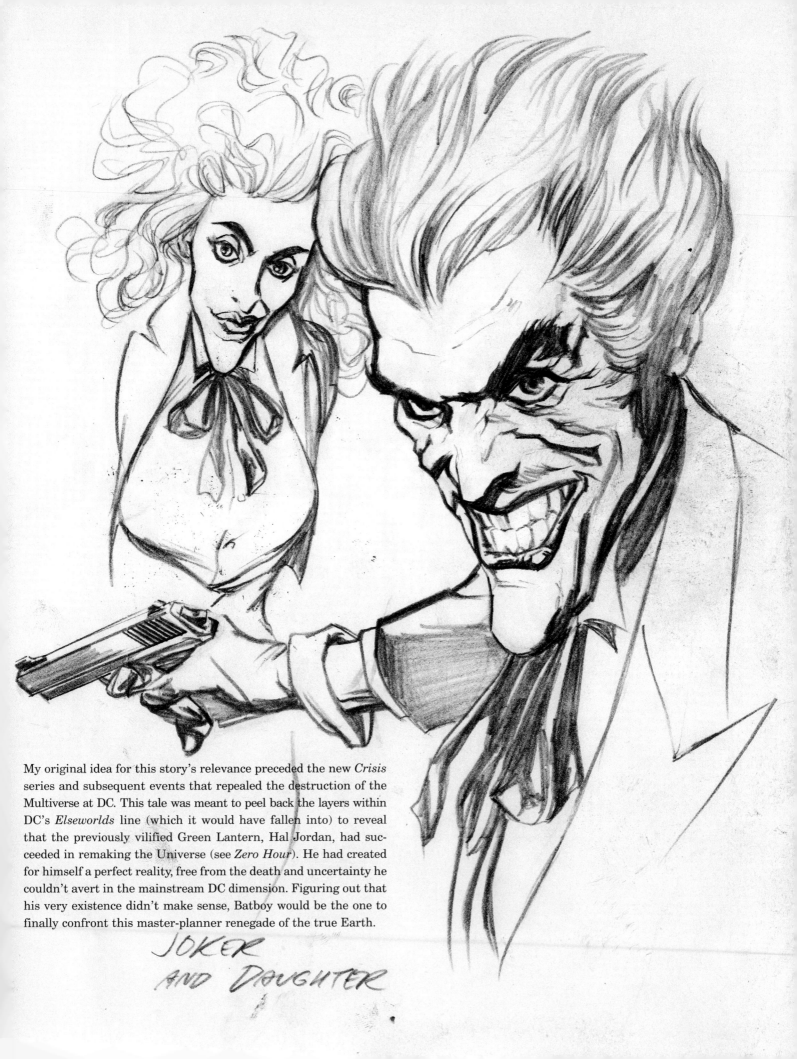

My original idea for this story's relevance preceded the new *Crisis* series and subsequent events that repealed the destruction of the Multiverse at DC. This tale was meant to peel back the layers within DC's *Elseworlds* line (which it would have fallen into) to reveal that the previously vilified Green Lantern, Hal Jordan, had succeeded in remaking the Universe (see *Zero Hour*). He had created for himself a perfect reality, free from the death and uncertainty he couldn't avert in the mainstream DC dimension. Figuring out that his very existence didn't make sense, Batboy would be the one to finally confront this master-planner renegade of the true Earth.

JOKER
AND DAUGHTER

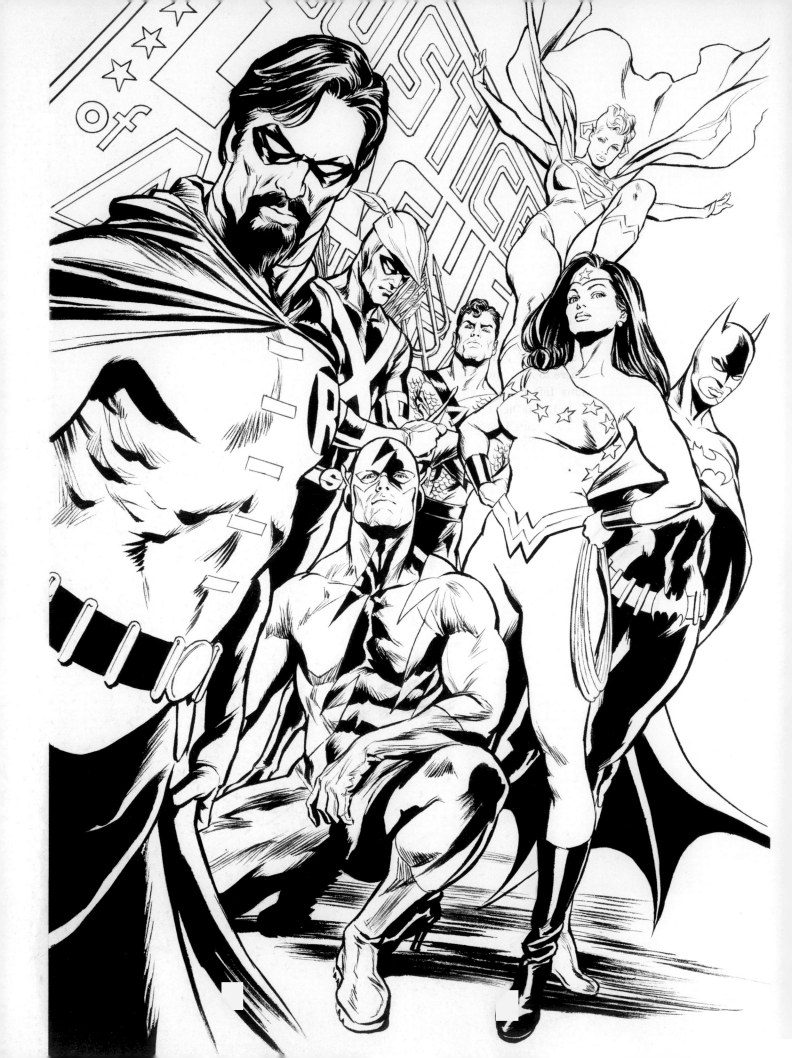

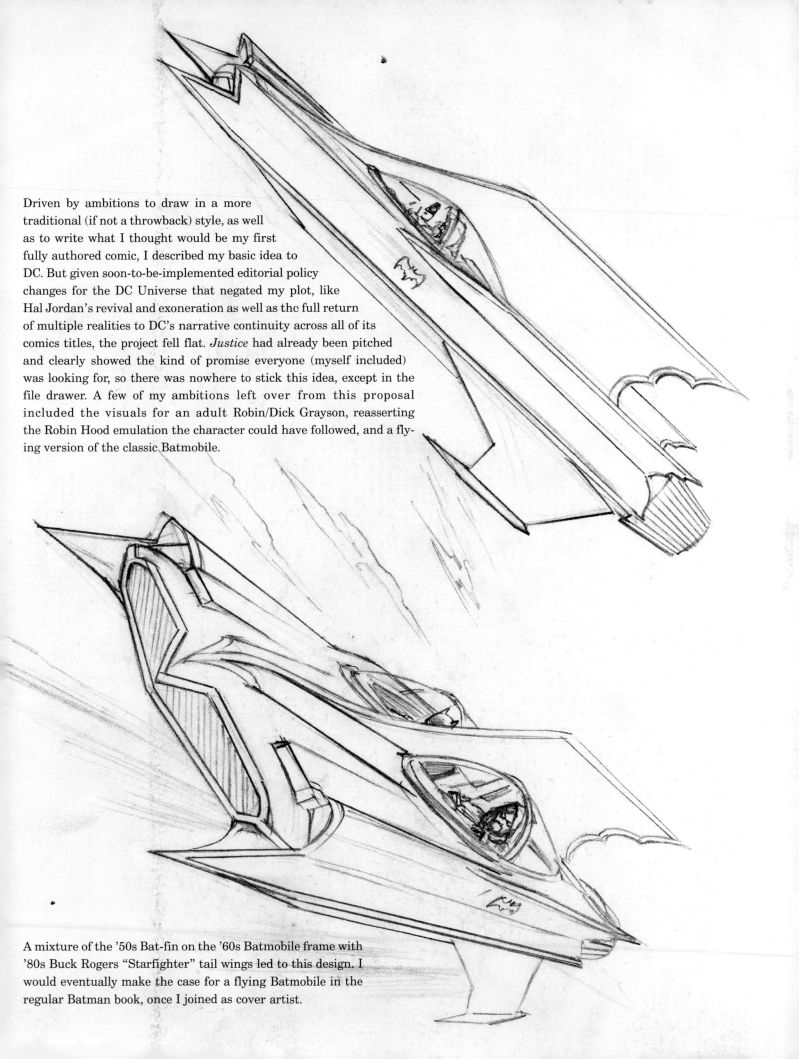

Driven by ambitions to draw in a more traditional (if not a throwback) style, as well as to write what I thought would be my first fully authored comic, I described my basic idea to DC. But given soon-to-be-implemented editorial policy changes for the DC Universe that negated my plot, like Hal Jordan's revival and exoneration as well as the full return of multiple realities to DC's narrative continuity across all of its comics titles, the project fell flat. *Justice* had already been pitched and clearly showed the kind of promise everyone (myself included) was looking for, so there was nowhere to stick this idea, except in the file drawer. A few of my ambitions left over from this proposal included the visuals for an adult Robin/Dick Grayson, reasserting the Robin Hood emulation the character could have followed, and a flying version of the classic Batmobile.

A mixture of the '50s Bat-fin on the '60s Batmobile frame with '80s Buck Rogers "Starfighter" tail wings led to this design. I would eventually make the case for a flying Batmobile in the regular Batman book, once I joined as cover artist.

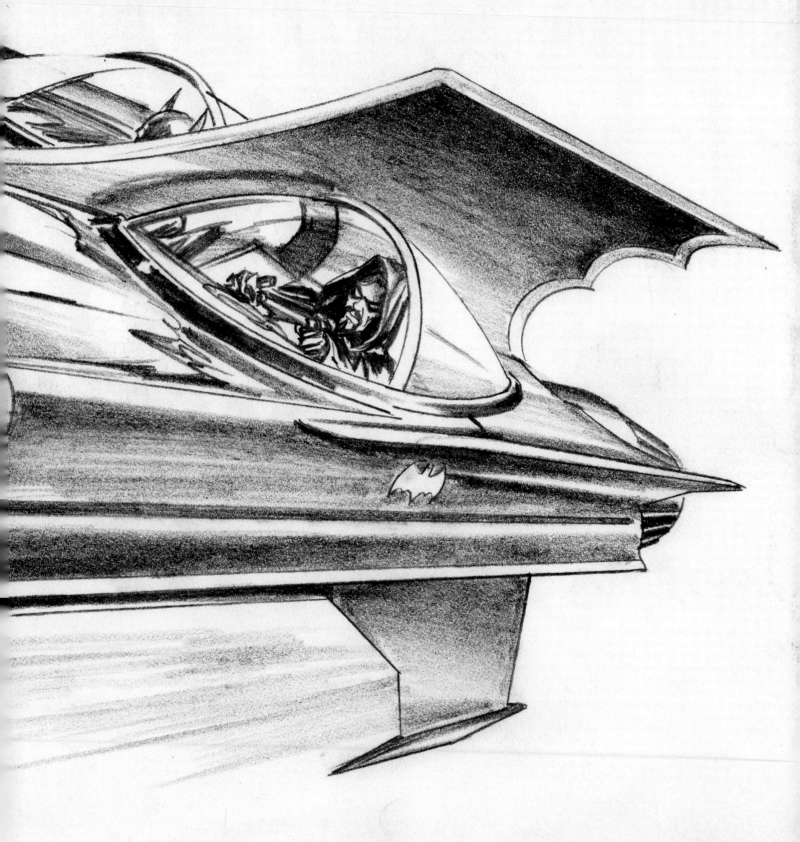

THE FLYING
BATMOBILE

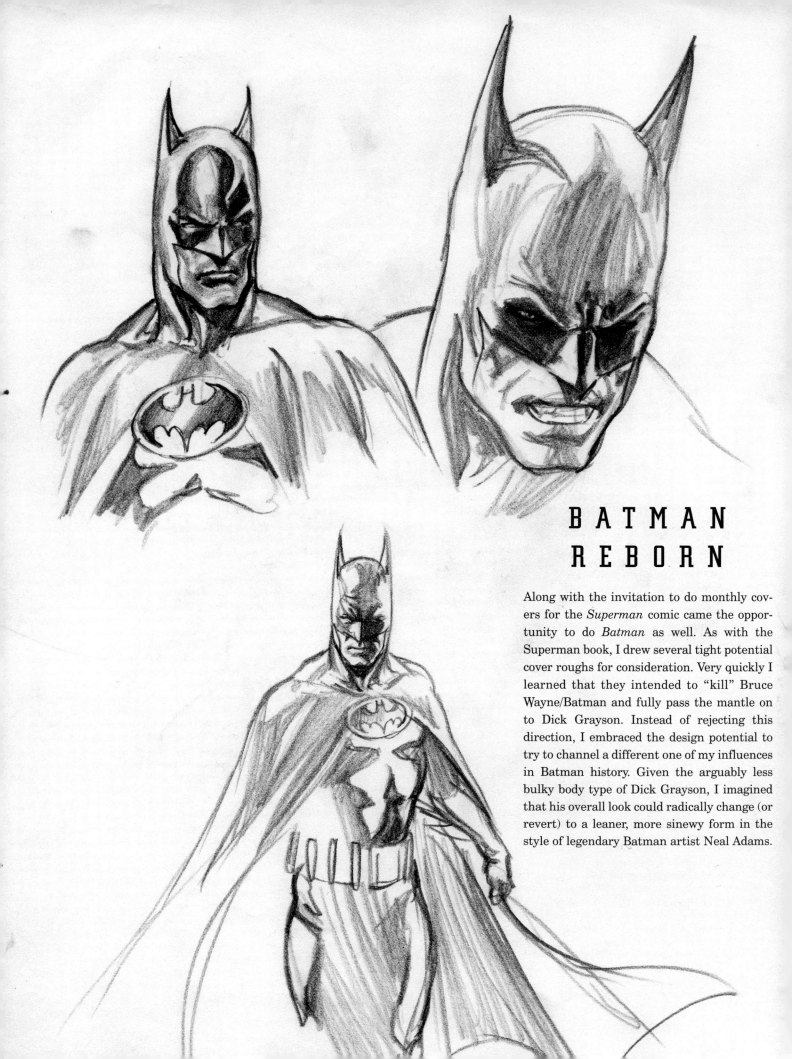

BATMAN REBORN

Along with the invitation to do monthly covers for the *Superman* comic came the opportunity to do *Batman* as well. As with the Superman book, I drew several tight potential cover roughs for consideration. Very quickly I learned that they intended to "kill" Bruce Wayne/Batman and fully pass the mantle on to Dick Grayson. Instead of rejecting this direction, I embraced the design potential to try to channel a different one of my influences in Batman history. Given the arguably less bulky body type of Dick Grayson, I imagined that his overall look could radically change (or revert) to a leaner, more sinewy form in the style of legendary Batman artist Neal Adams.

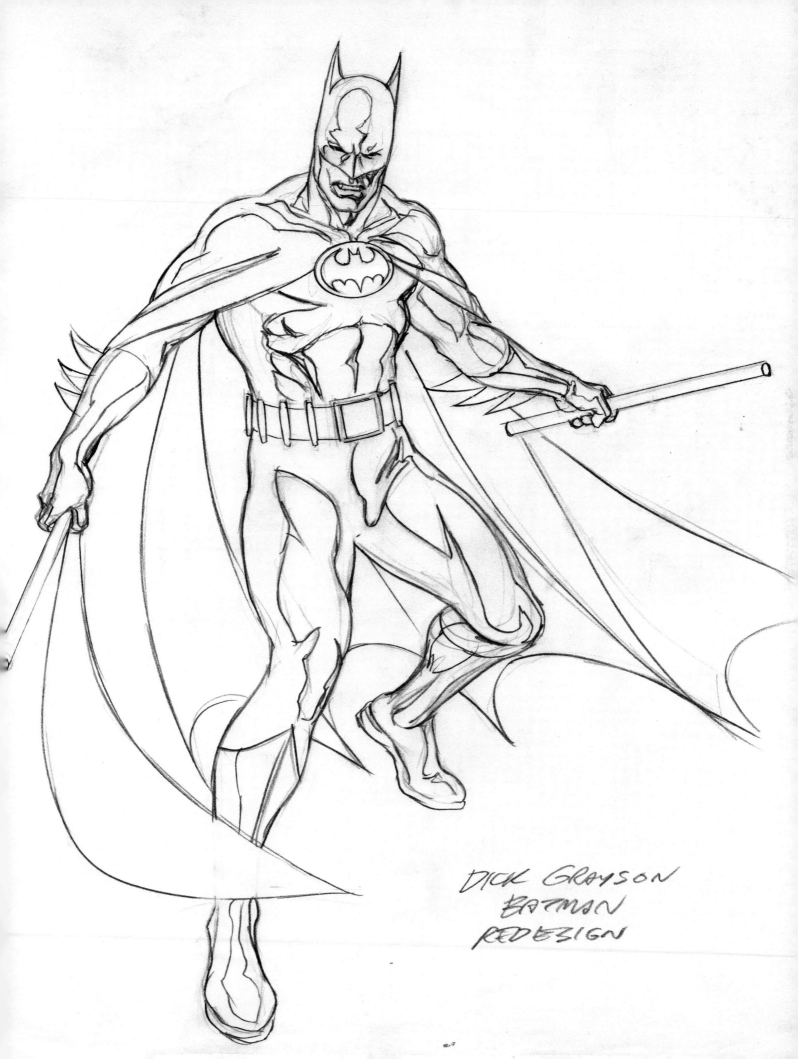

DICK GRAYSON
BATMAN
REDESIGN

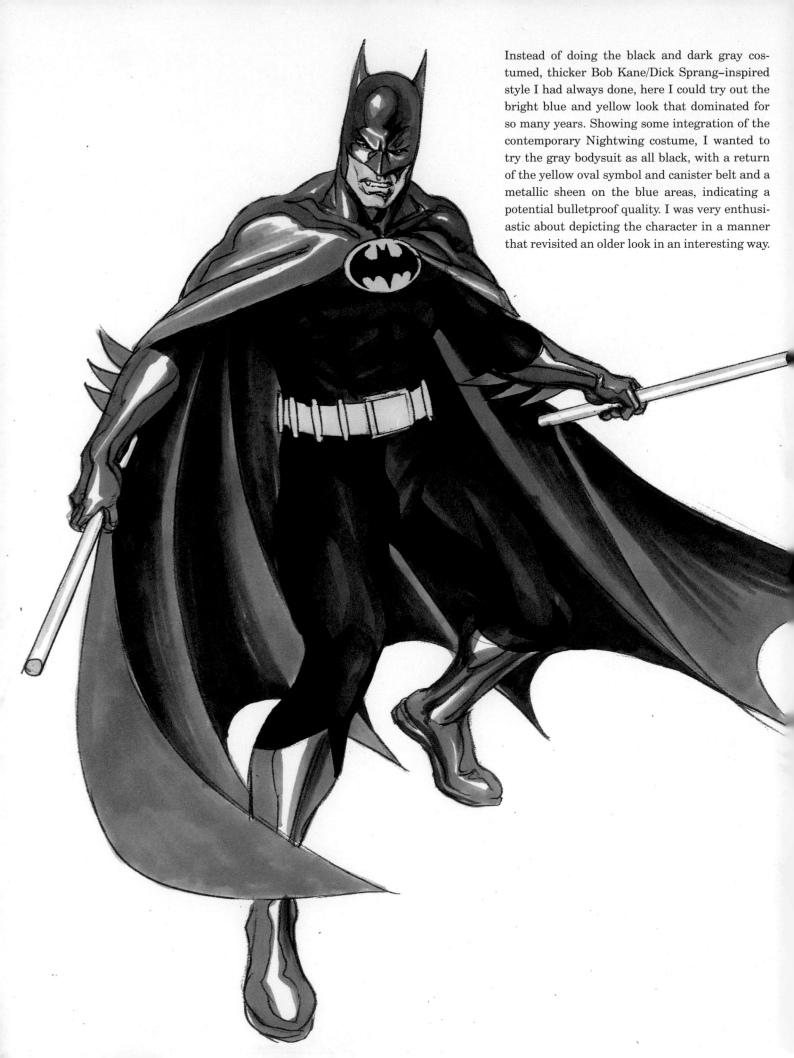

Instead of doing the black and dark gray costumed, thicker Bob Kane/Dick Sprang–inspired style I had always done, here I could try out the bright blue and yellow look that dominated for so many years. Showing some integration of the contemporary Nightwing costume, I wanted to try the gray bodysuit as all black, with a return of the yellow oval symbol and canister belt and a metallic sheen on the blue areas, indicating a potential bulletproof quality. I was very enthusiastic about depicting the character in a manner that revisited an older look in an interesting way.

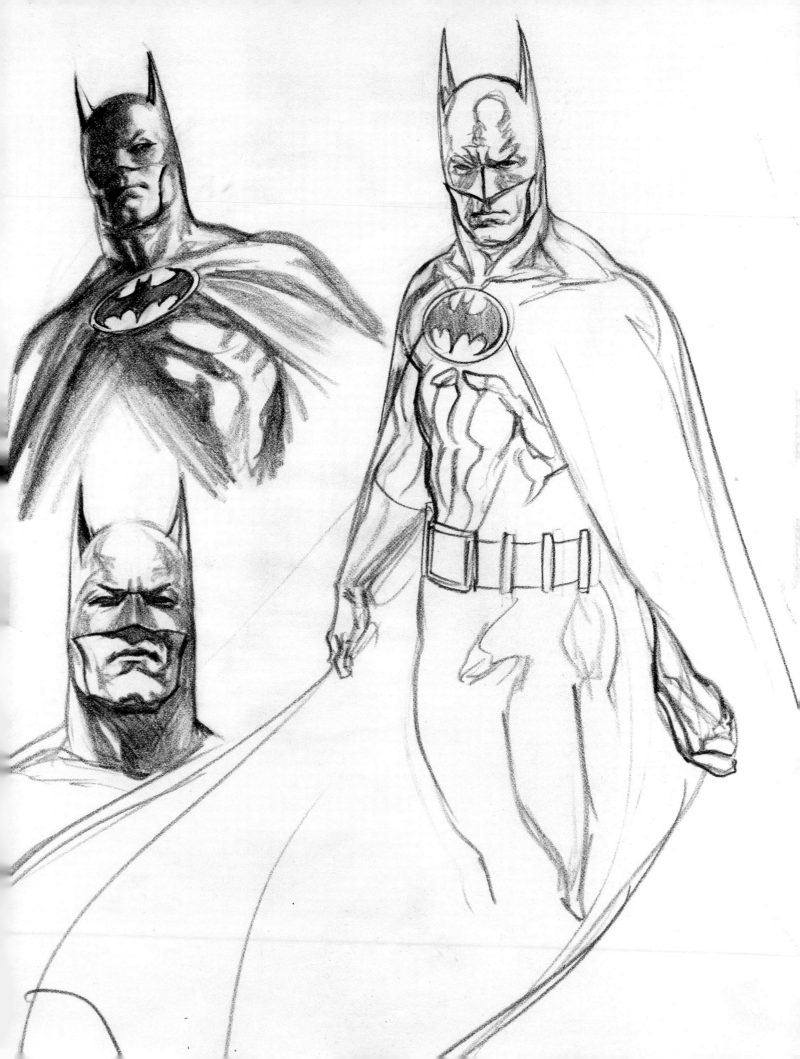

BATMAN R.I.P. COVERS

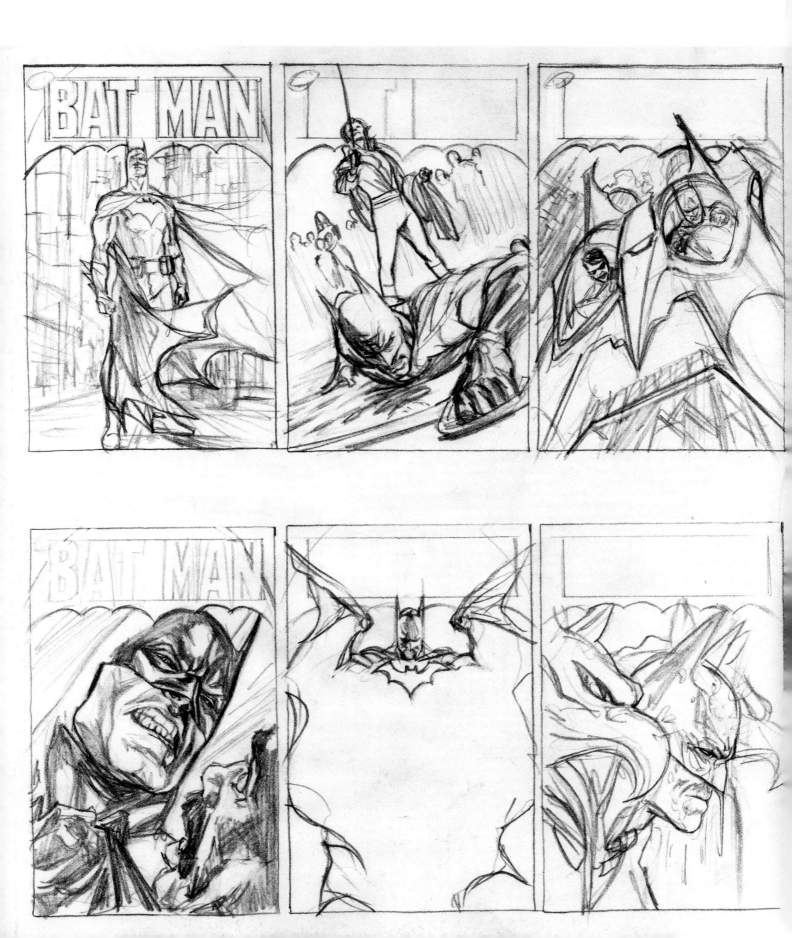

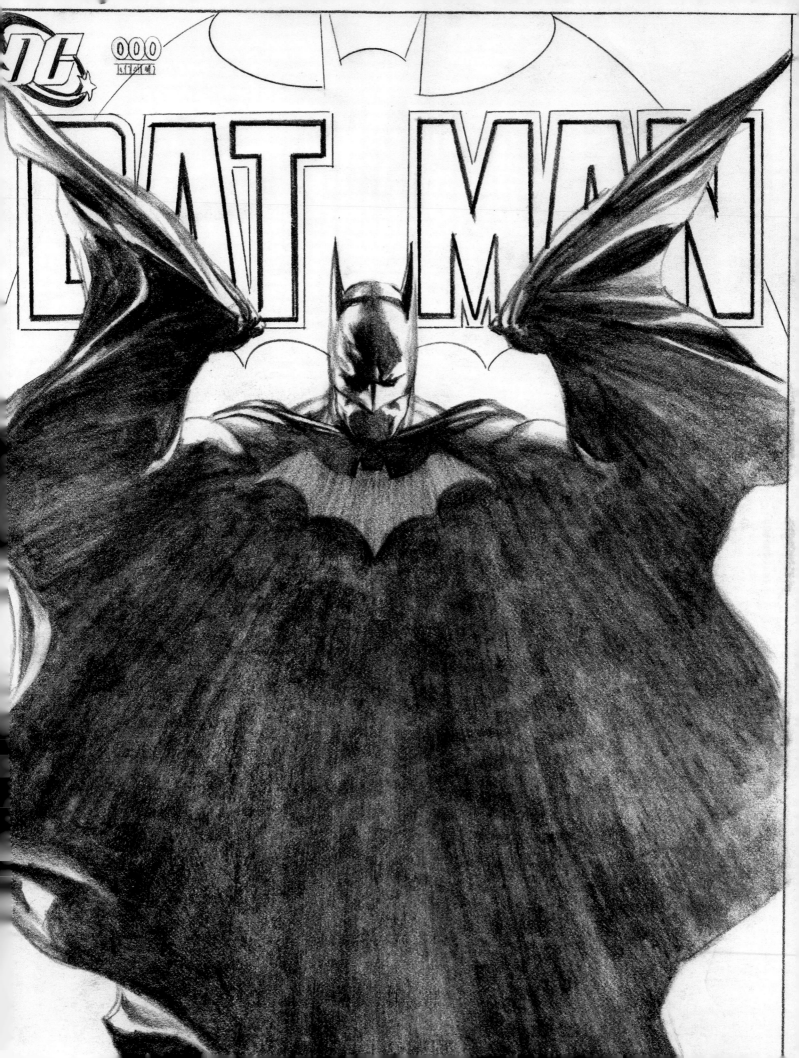

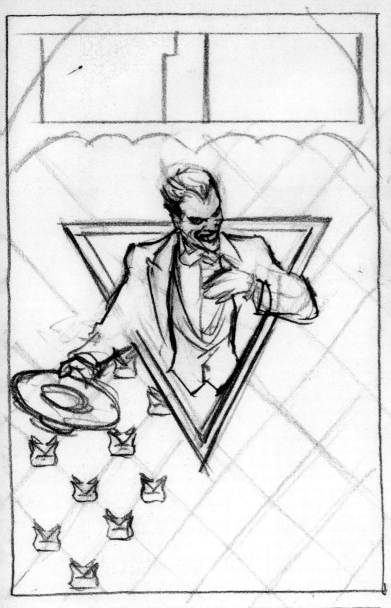

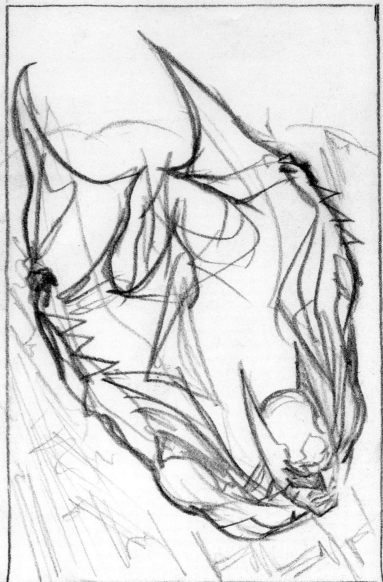

As it turned out, the *Batman* covers I initially laid out were applied to a good many story points for final painting execution. Unfortunately, I had just missed out on storylines that linked to the Joker and Rā's al Ghūl, so sketches I included them in could not apply. The older logo style was a cause I passionately pursued; I wanted to reassert the bold lines and Bat-emblem contour, which I felt would strengthen the covers overall. As it worked out, the progression of this storyline to Bruce Wayne's ultimate departure coincided with Superman's leaving his own title altogether, and it seemed a fitting point for my own departure as well. Artistic drive and passion can often be an impediment to collaboration as much as they can be assets. My work on both titles may have been best suited to a brief run that was tied to my continued interest in trying to commune with the characters' classic, most timeless forms.

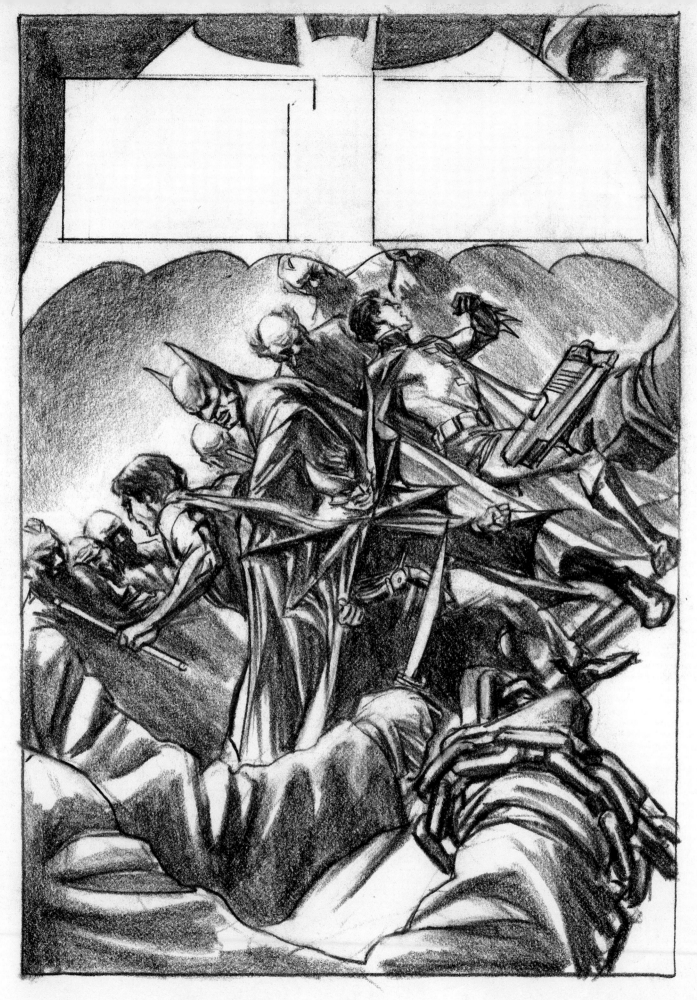

\# 680

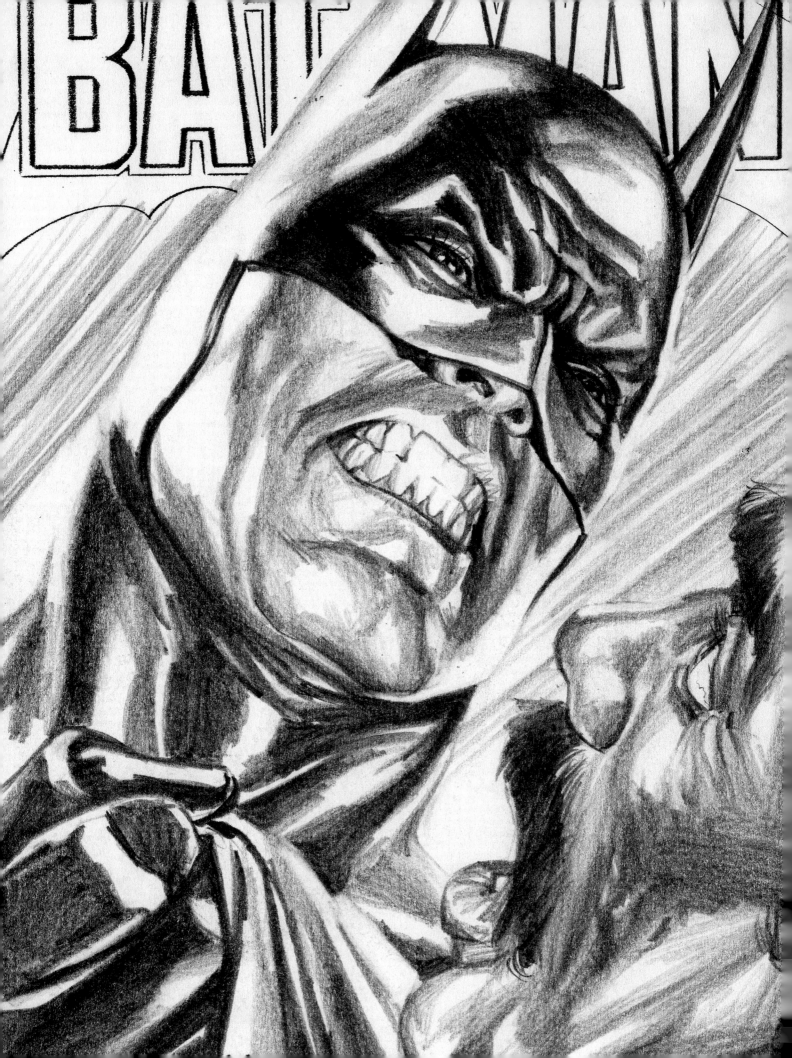

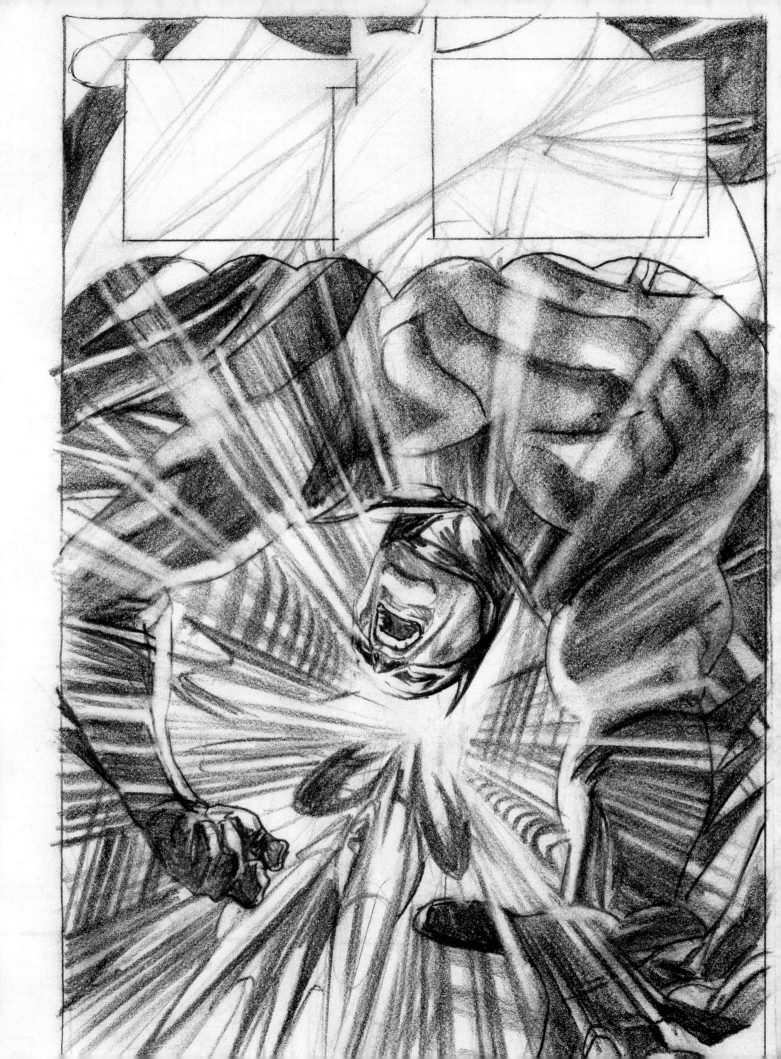

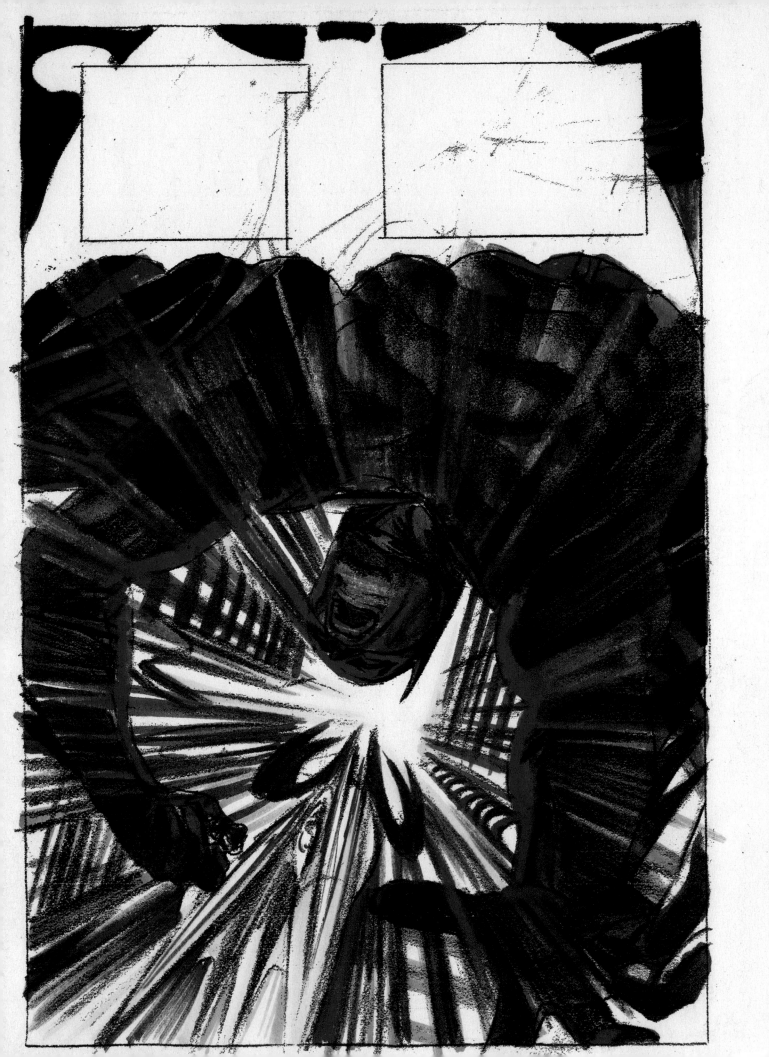

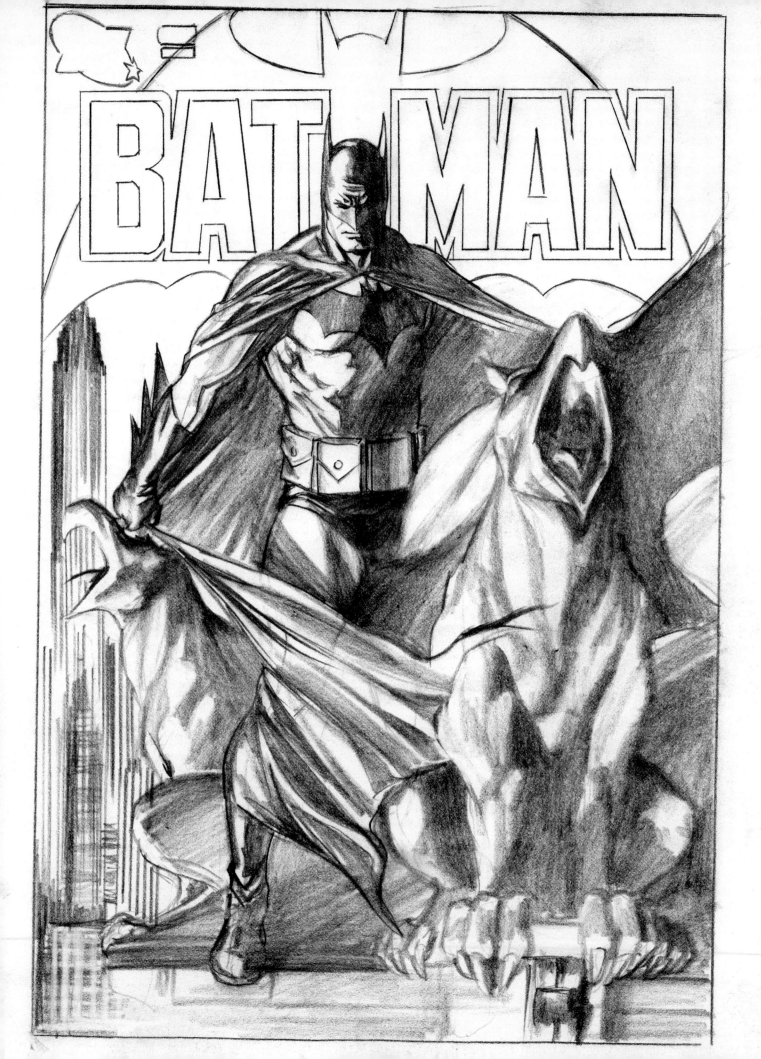

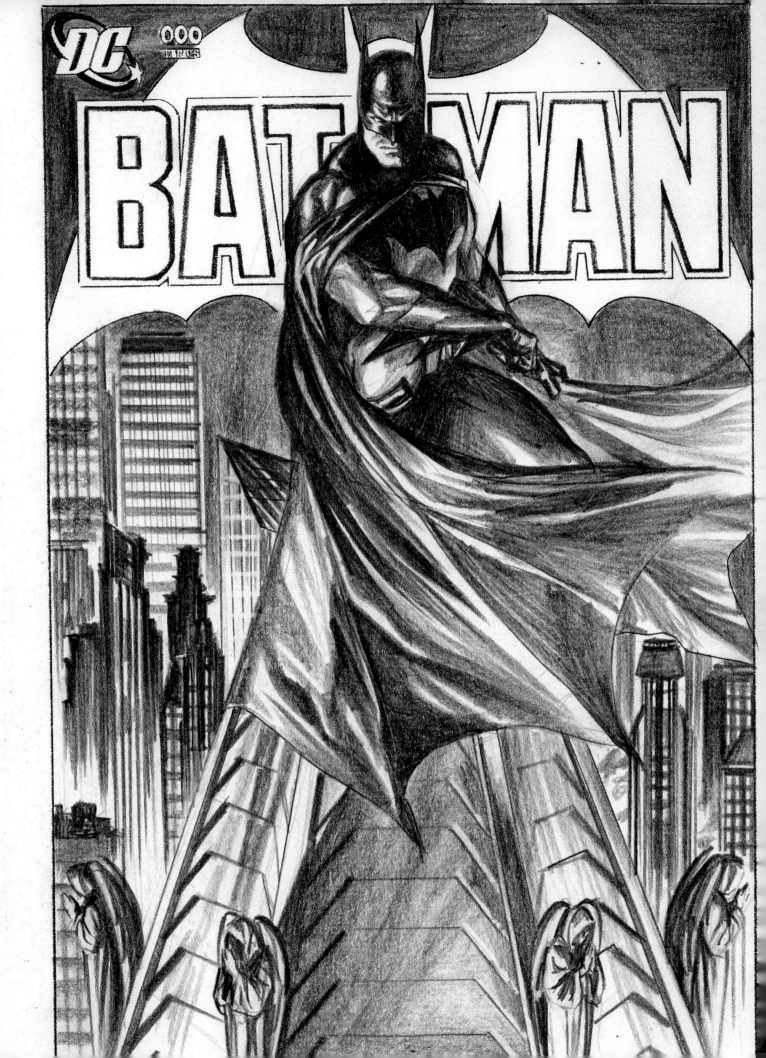

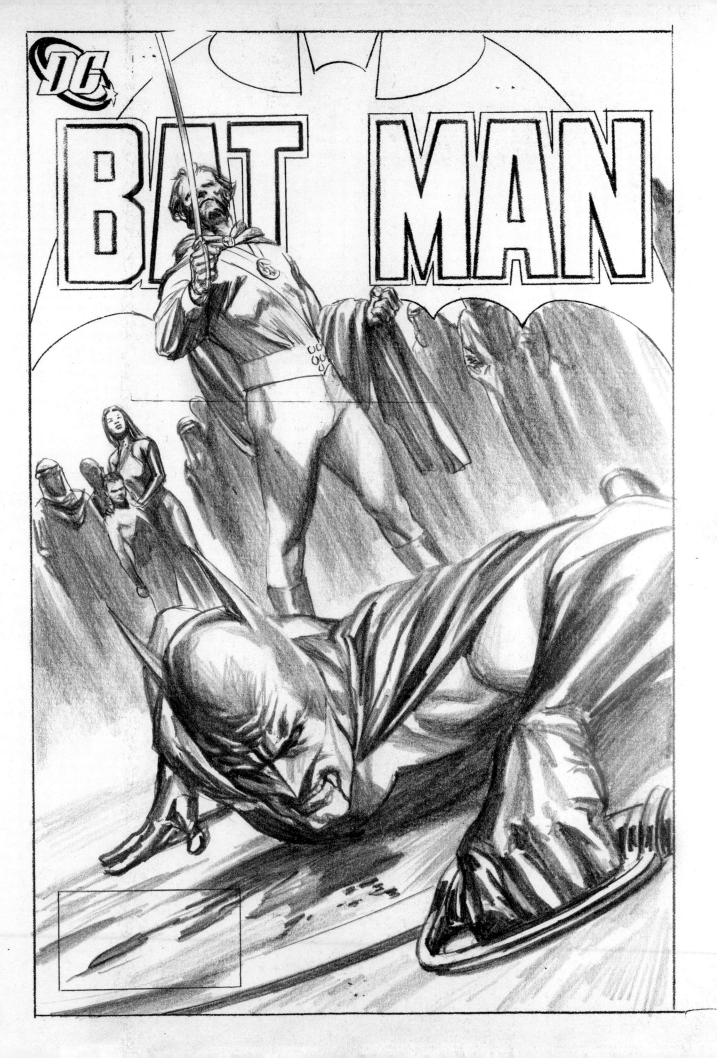

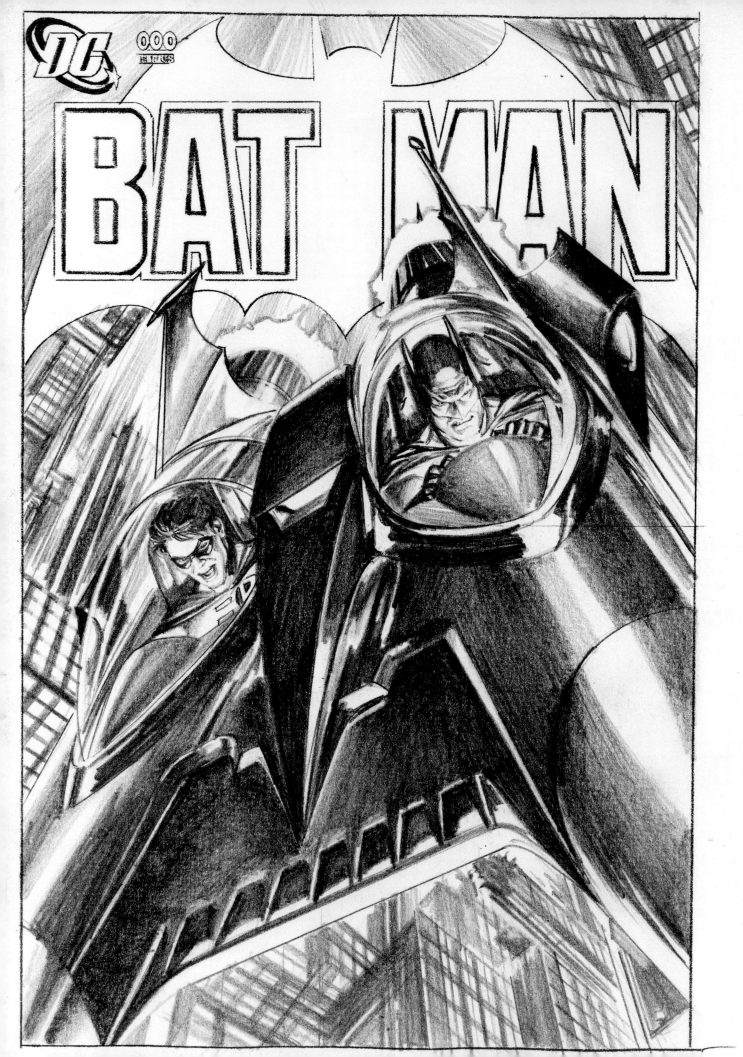

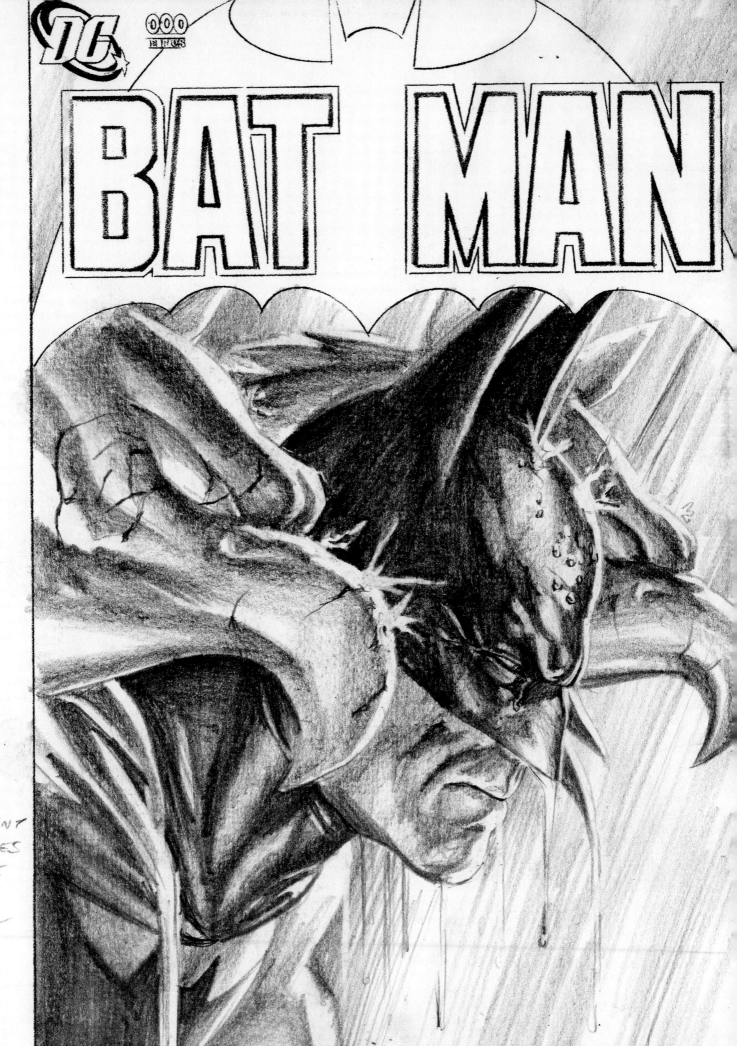

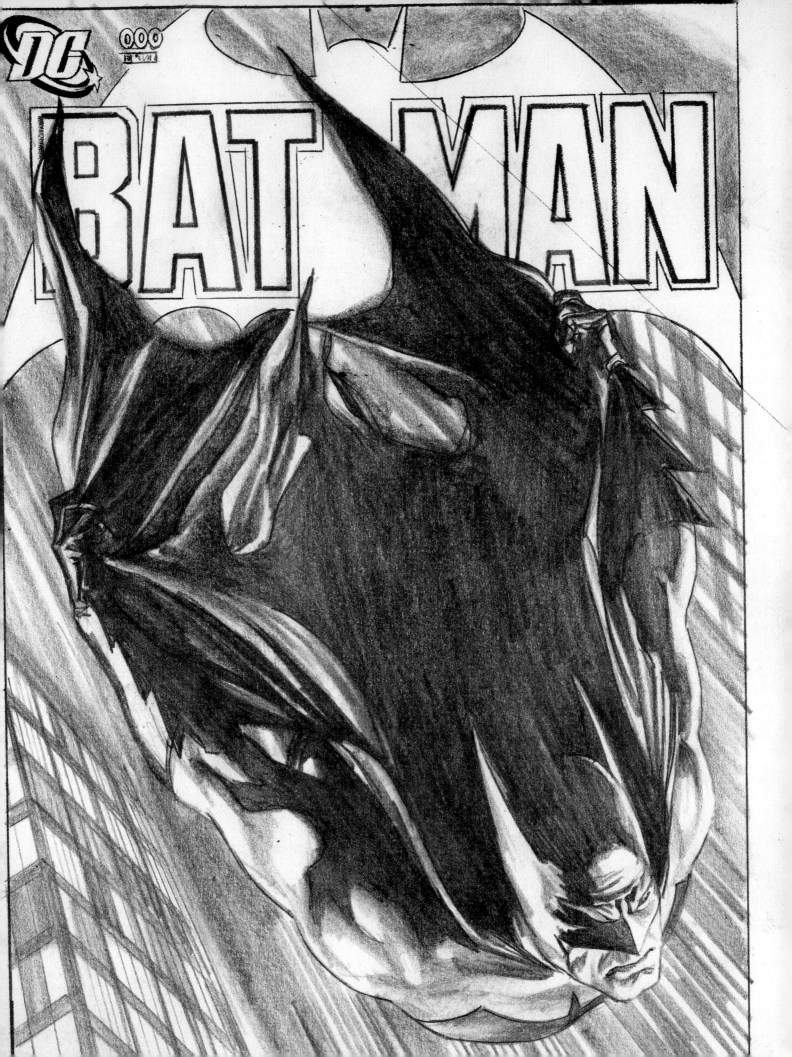

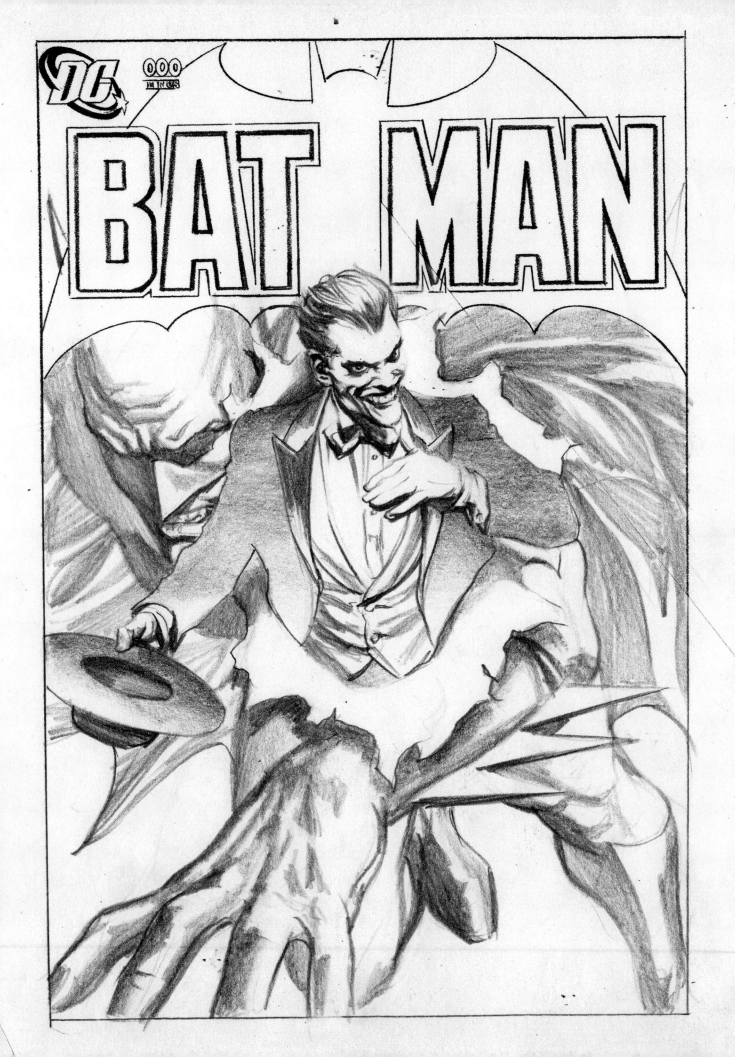

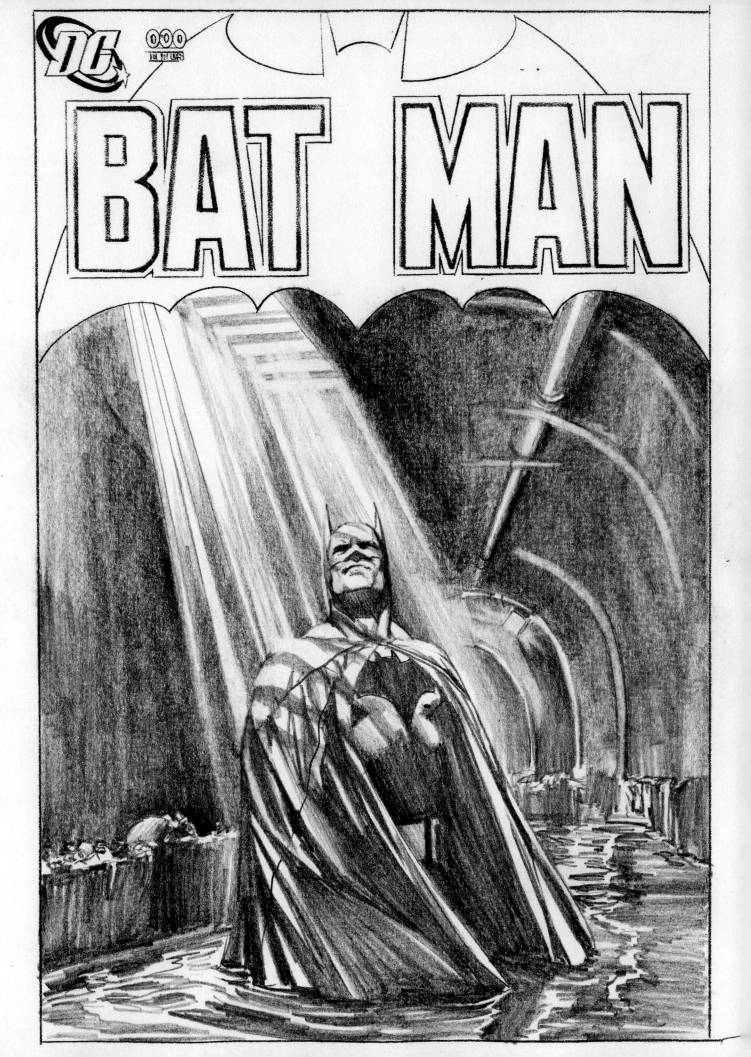

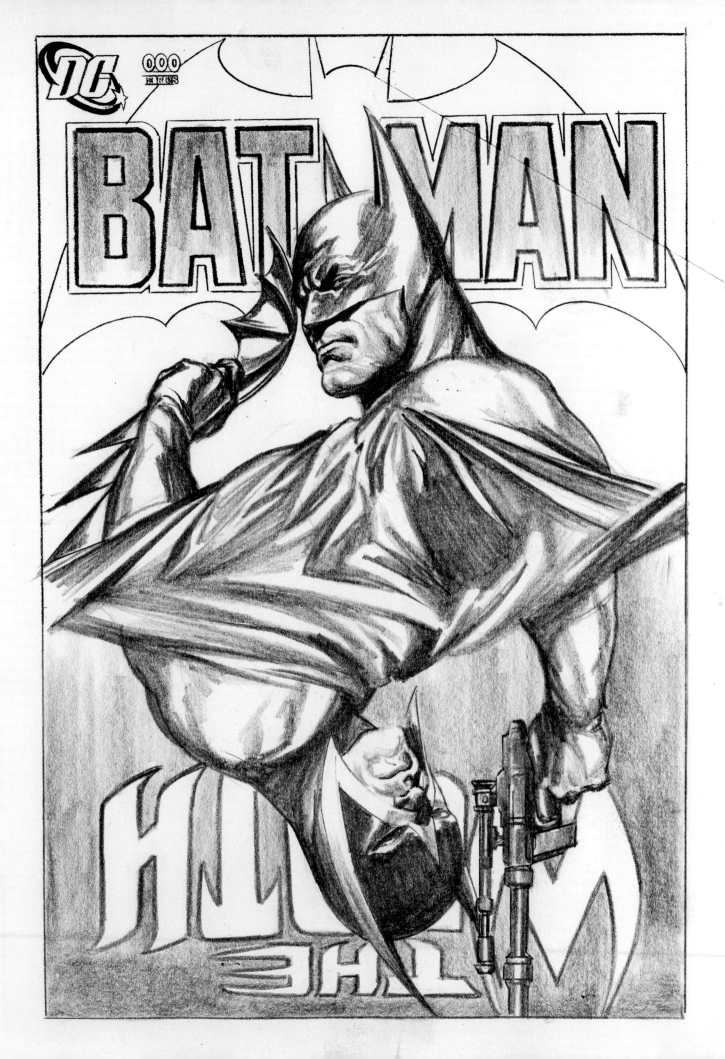

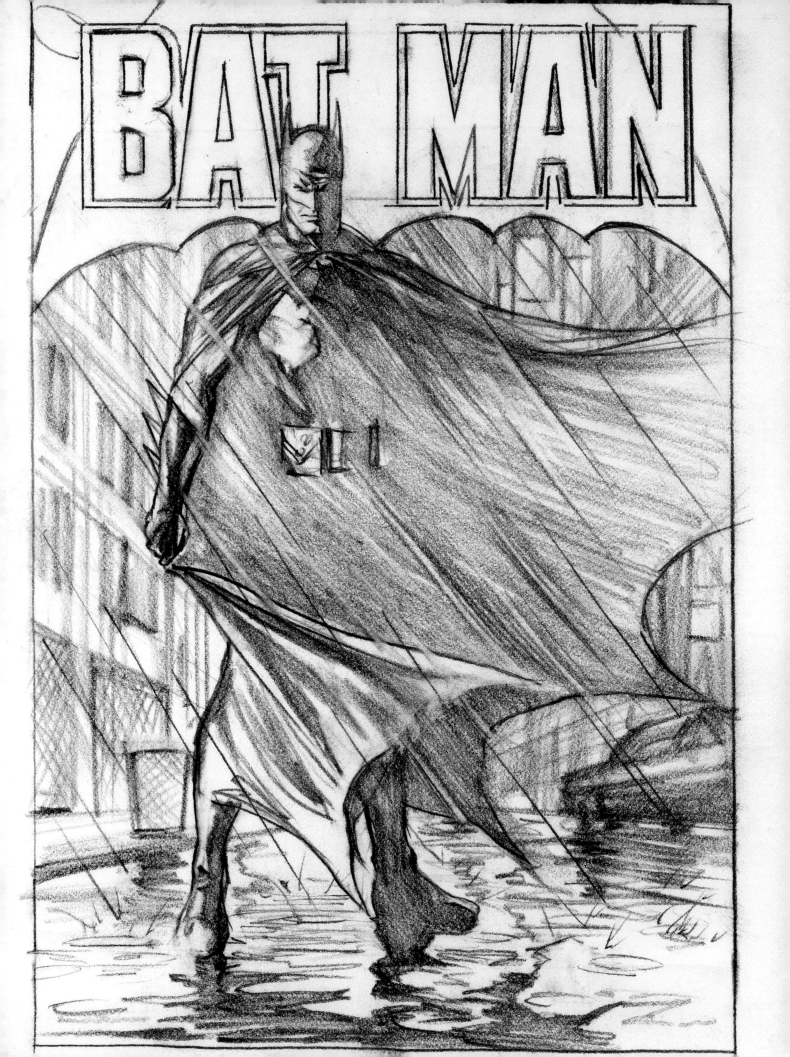

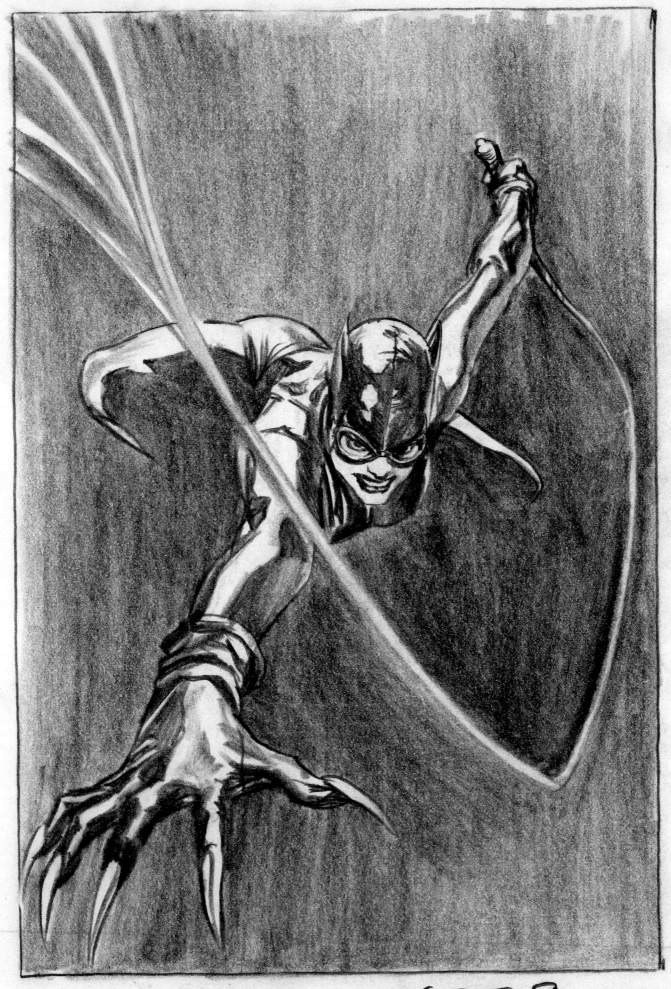

BATMAN 685?

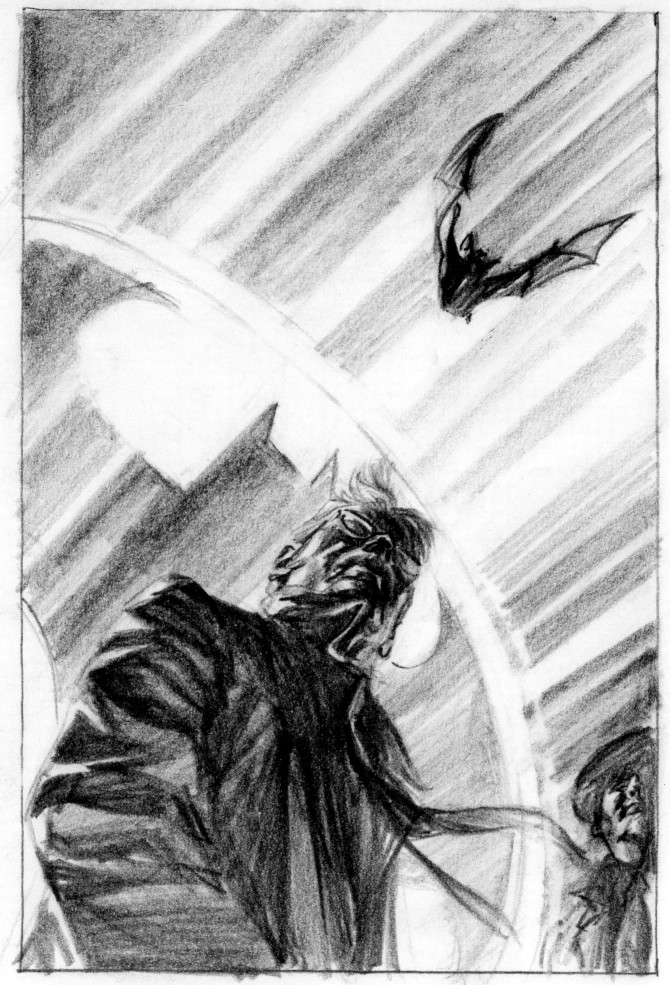

BATMAN 684

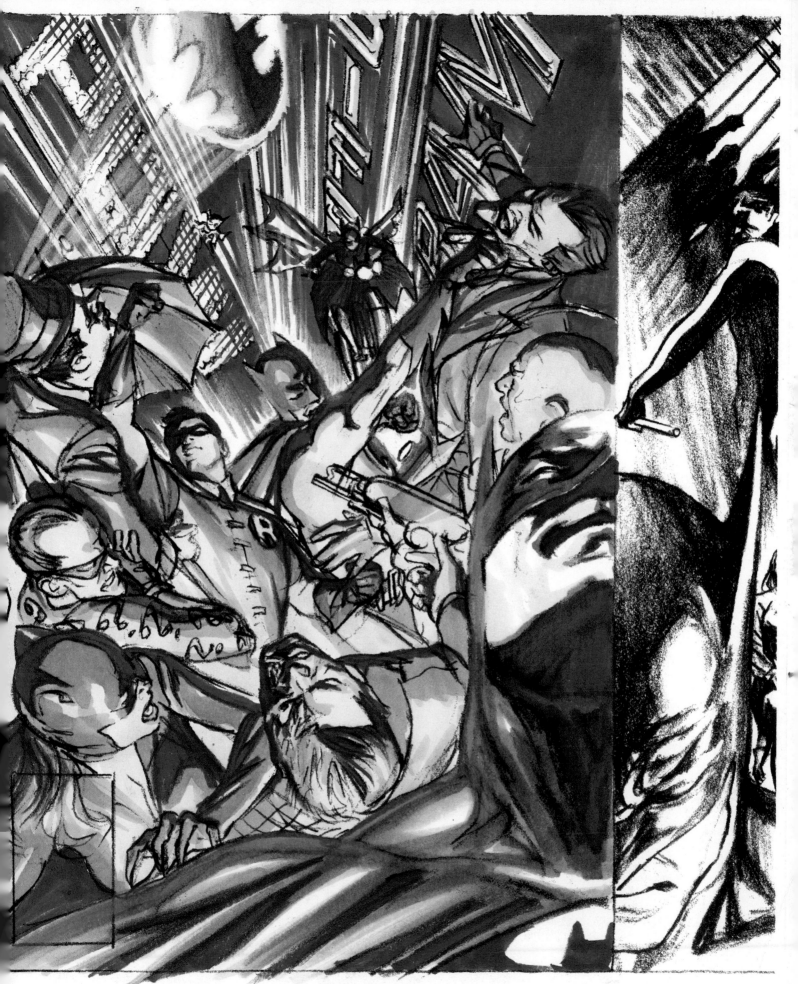

682

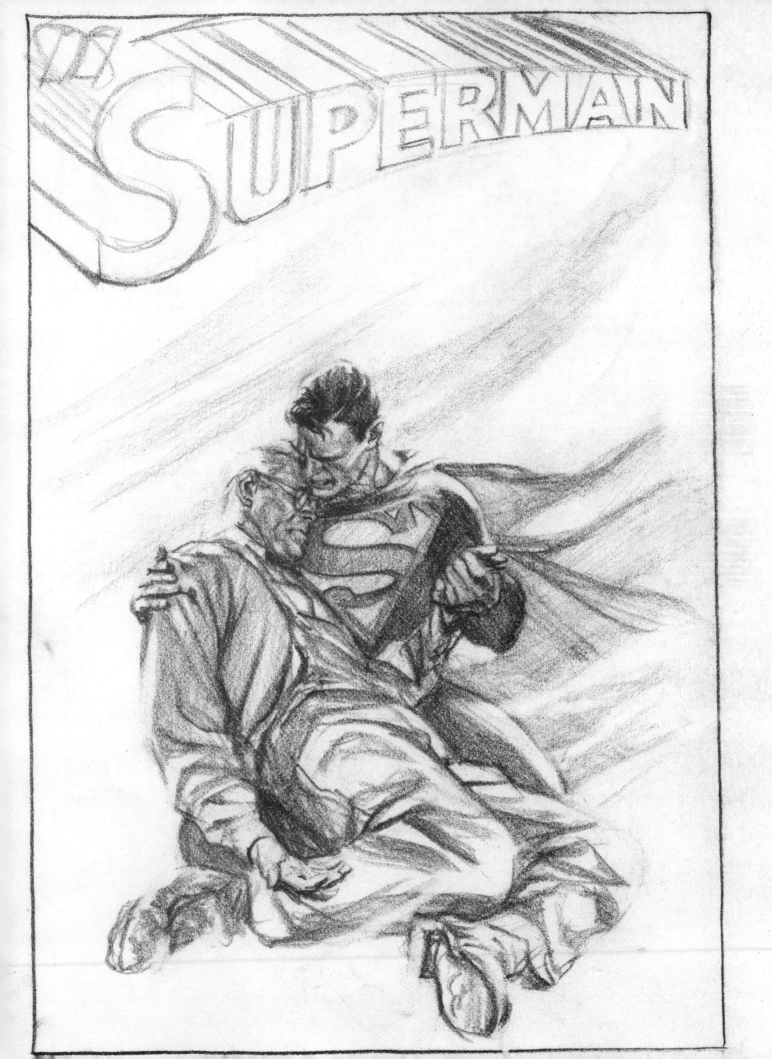

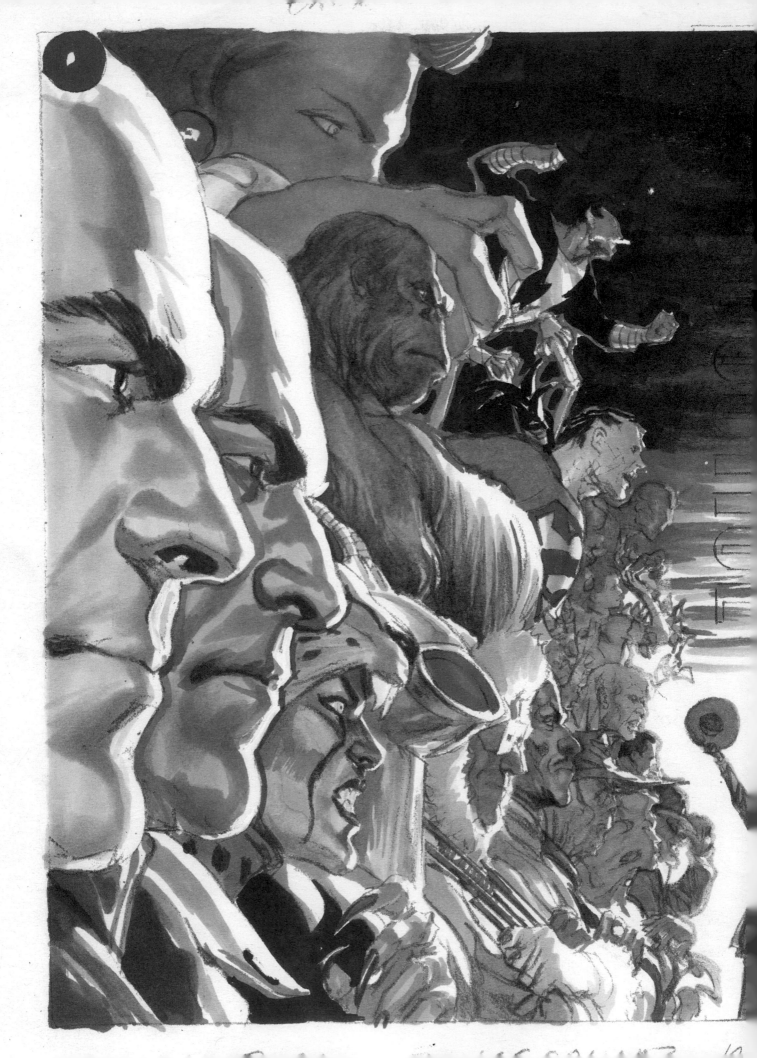